Prebles'
ARTFORMS

An Introduction to the Visual Arts

eighth EDITION

PATRICK Frank

PEARSON

Prentice Hall

Upper Saddle River, NJ 07458

Library of Congress Cataloging-in-Publication Data
Frank, Patrick,
 Prebles' artforms : an introduction to the visual arts / Patrick Frank.—8th ed.
 p. cm.
 Rev. ed. of: Artforms / Duane Preble, Sarah Preble ; revised by Patrick Frank. c2004.
 Includes bibliographical references and index.
 ISBN 0-13-193081-8
 1. Composition (Art) 2. Visual perception. 3. Art—History.
I. Title: Artforms. II. Preble, Duane. Artforms. III. Title.

N7430.P69 2005
701'.8—dc22 2004057645

EDITOR IN CHIEF: Sarah Touborg
ACQUISITIONS EDITOR: Amber Mackey
EDITORIAL ASSISTANT: Keri Molinari
EDITOR IN CHIEF, DEVELOPMENT: Rochelle Diogenes
DEVELOPMENTAL EDITOR: Margaret Manos
MEDIA PROJECT MANAGER: Anita Castro
EXECUTIVE MARKETING MANAGER: Sheryl Adams
MARKETING ASSISTANT: Cherron Gardner
AVP, DIRECTOR OF PRODUCTION AND MANUFACTURING:
 Barbara Kittle
SENIOR MANAGING EDITOR: Lisa Iarkowski
PRODUCTION ASSISTANT: Marlene Gassler
PRODUCTION EDITOR: Harriet Tellem
MANUFACTURING MANAGER: Nick Sklitsis
MANUFACTURING BUYER: Sherry Lewis
CREATIVE DESIGN DIRECTOR: Leslie Osher
ART DIRECTOR: Nancy Wells
INTERIOR AND COVER DESIGN: Michelle Wiggins
COPY EDITOR: Karen Verde

PROOFREADER: Alison Lorber
DIRECTOR, IMAGE RESOURCE CENTER: Melinda Reo
MANAGER, RIGHTS AND PERMISSIONS: Zina Arabia
MANAGER, VISUAL RESEARCH: Beth Brenzel
MANAGER, COVER VISUAL RESEARCH AND PERMISSIONS:
 Karen Sanatar
COVER IMAGE COORDINATOR: Gladys Soto
IMAGE PERMISSION COORDINATOR: Carolyn Gauntt
PHOTO RESEARCHER: Francelle Carapetyan
CENTRAL SCANNING SERVICES: Gregg Harrison, Corrin Skidds,
 Robert Uibelhoer, Ron Walko, Shayle Keating
SITE SUPERVISOR: Joe Conti
COMPOSITION: Preparé
PRINTER/BINDER: Courier/Kendallville
COVER PRINTER: Phoenix Color Corporation
COVER PHOTO: Paul Klee. *Insula Dulcamara*, 1938. Oil and black paste
 on newspaper, mounted on burlap. 34⅝" × 69¼" (88 × 176 cm).
 Courtesy of the Paul Klee Foundation, Berne.
 © 2004 Artists Rights Society (ARS), NY/VG Bild-Kunst, Bonn.

Pearson Education LTD.
Pearson Education Australia PTY, Limited
Pearson Education Singapore, Pte. Ltd
Pearson Education North Asia Ltd

Pearson Education, Canada, Ltd
Pearson Educación de Mexico, S.A. de C.V.
Pearson Education—Japan
Pearson Education Malaysia, Pte. Ltd

10 9 8 7 6 5 4 3 2 1

ISBN 0-13-193081-8

ABOUT THE COVER

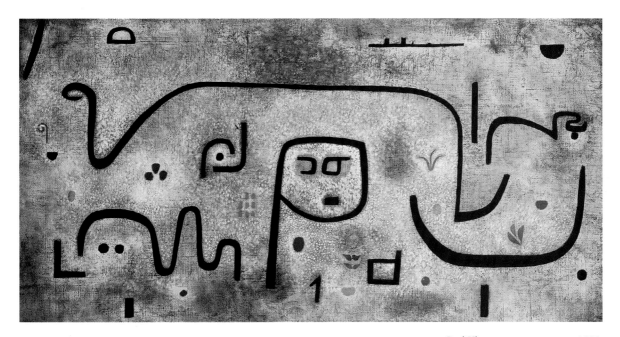

Paul Klee, INSULA DULCAMARA, 1938.
Oil and black paste on newspaper, mounted on burlap. 34⅝" × 69¼" (88 × 176 cm).
Courtesy of the Paul Klee Foundation, Berne.
© 2004 Artists Rights Society (ARS) NY/VG Bild-Kunst, Bonn.

The Swiss-born Paul Klee (1879–1940) is among the most important Modern artists; he generally painted in an expressionist style, in which he represented not external reality but rather his inner state. There are two keys that help unlock some of the meanings in this work, one personal and the other global. The title refers to an imaginary island (*insula*) where the medicinal herb *dulcamara* grows. The artist may have been thinking of such a place to help relieve him of the illness he was suffering when he painted this work near the end of his life. The work thus expresses the hope of healing. The other key lies in the global interactions that strongly influenced Modern artists in many countries. Klee made two trips to North Africa, where he saw and studied Muslim calligraphy. He did not know how to translate these writings, but he believed that the dancing lines of the Arabic script could communicate a feeling beyond words.

TO ALL WHO COME TO KNOW THE ARTIST WITHIN

BRIEF CONTENTS

CONTENTS

ABOUT THE AUTHOR

Patrick Frank has taught in several higher education environments, from rural community colleges to private research universities. His recent scholarly work has focused on Latin American graphic arts. He is author of *Posada's Broadsheets: Mexican Popular Imagery 1890–1910* and *Los Artistas del Pueblo: Prints and Workers' Culture in Buenos Aires* (University of New Mexico Press). He has also published studies of social protest printmakers from Argentina and Uruguay. He has curated five exhibitions of Latin American prints. His writings have appeared in *Goya: Revista de Arte, Revista del Instituto de Cultura Puertorriqueña, Third Text, Studies in Latin American Popular Culture* and in the alternative publications *Drunken Boat* and *Anarchy: A Journal of Desire Armed*. He has also edited a volume of artists' writings, *Readings in Latin American Modern Art* (Yale University Press). He earned M.A. and Ph.D. degrees at George Washington University in Washington, D.C. His involvement with *Artforms* began when he first taught from it in 1991.

PATRICK FRANK, 2004

ACKNOWLEDGMENTS

greatly appreciate the help and encouragement of the many people who have been directly involved in this eighth edition. A few people deserve special mention for their major contributions.

Editor Amber Mackey was a constant source of creative ideas on how to present our new material. Production Editor Harriet Tellem has a laser-like focus which keeps this book on track from year to year. Researching and acquiring pictures gets more complicated with each edition as ARTFORMS reaches further across the globe, and Francelle Carapetyan was in every way equal to the at-times strange demands that I placed upon her. Every reader of this book should be grateful to Developmental Editor Margaret Manos for cleaning up my at-times convoluted prose. The multimedia team under the leadership of Anita Castro developed many bridges between these printed pages and the digital world of CD-ROMs and websites. I received valuable assistance on specialized content areas from Charles James, Philip James, Allan Wallis, and Burke Griggs. Invaluable assistance was also provided by Natasha Isadora Frank. All of these persons made special contributions to this book, and their efforts and dedication mark its every page.

I am also grateful to original authors Duane and Sarah Preble. As this book continues to evolve to meet changing times, it will always remain faithful to the original vision that they had.

I express my appreciation to the following reviewers, who offered many helpful suggestions during the revision of the text:

Ann Boland, *Panola College*
Ken Burchett, *University of Central Arkansas*
Michelle Coakes, *Lincoln Land Community College*
Kathleen Desmond, *Central Missouri State University*
Jon Kitner, *Miami Dade College*
Beverly Marchant, *Marshall University*
Vicki Mayhan, *Collin County Community College*
Lynn Metcalf, *St. Cloud State University*
Anita Monsebroten, *University of North Dakota*
Barbara Nesin, *Spelman College*
Karin Skiba, *Riverside Community College*

Crucial to this book are the artists, past and present, known and unknown, whose art is presented here, and those people who have had the foresight to preserve meaningful products of human creativity. It has indeed been an awe-inspiring experience to be part of a cooperative venture as large and complex as the publication of ARTFORMS.

PATRICK FRANK

preface

From the first edition in 1972, ARTFORMS **has been as visually exciting as the individual works of art that are reproduced in it.** ARTFORMS grew out of a desire to introduce art through an engaging visual experience. It is written and designed to help readers build an informed foundation for individual understanding and enjoyment of art. By introducing art theory, practice, and history in a single volume, this book aims to draw students into a new or expanded awareness of the visual arts. The goal is to engage readers in the process of realizing their own innate creativity.

The title of this book has a dual meaning. Besides the expected discussion of the various forms of art, the title also reflects the fact that art does indeed help to form us as people. As we create forms, we are in turn formed by what we have created. In the Eighth Edition, the title has been modified to PREBLES' ARTFORMS, acknowledging the pioneering contribution of the original authors, Duane and Sarah Preble, to the study of art. Their vision and spirit have touched hundreds of thousands of students who have studied ARTFORMS.

Beyond fostering appreciation of major works of art, this book's primary concern is to open students' eyes and minds to the richness of the visual arts as unique forms of human communication and to convey the idea that the arts enrich life best when we experience, understand, and enjoy them as integral parts of the process of living.

ORGANIZATION

■ *Part One: Art Is . . .* (Chapters 1 and 2) introduces the nature of art, aesthetics, and creativity, and discusses the purposes of art and visual communication. Strongly believing that we are all artists at heart, I include an essay on children and their *Early Encounters with the Artist Within,* and a section on the works of untrained artists.

■ *Part Two: The Language of Visual Experience* (Chapters 3-5) presents the language of vision, visual elements, and principles of design. Experience with the language of visual form introduced in those chapters provides a foundation for developing critical thinking and for considering evaluation and art criticism, discussed in Chapter 5.

■ The visual and verbal vocabulary covered in *Part Two* prepares the reader to sample the broad range of art disciplines, media, and processes presented in *Part Three: The Media of Art* (Chapters 6-13). In this part we consider the classical media used in drawing, painting, sculpture, and architecture and the latest developments in photography, video, film, digital imaging, and industrial design.

■ *Part Four: Art as Cultural Heritage* (Chapters 14-19) and *Part Five: The Modern World* (Chapters 20-24) introduce historic world styles and related cultural values. Three chapters cover artistic traditions outside the Western world. That each new technique in the history of art relies heavily on its predecessors becomes obvious in these chapters.

■ *Part Six: The Postmodern World* and its Chapter 25 discuss art of the last two decades and the multifaceted and changing roles of artists today. It includes a section on the Global Present, emphasizing the international aspects of the contemporary art world.

In addition to a revised *Glossary, Pronunciation Guide,* and *Selected Readings,* the back matter of PREBLES' ARTFORMS includes a brief listing of Web sites related to art: Images, artists, museums, art organizations, magazines, and other sources. The three-page Timeline is illustrated and includes additional information on both Western and non-Western art.

Special Features

Throughout the book, three types of essays enrich the presentation. *Biography* essays profile important artists from across time. Newly named for the Eighth Edition, *Art in the World* essays address how art affects our society once it leaves the artist's studio and how we may encounter these issues in our everyday lives. *Artists at Work* essays highlight interviews with six contemporary artists, showing that artists' creativity is a rational process of making choices in order to arrive at a statement that expresses their vision.

INSTRUCTORS also have access to PowerPoint™ slides outlining the main points for each chapter of PREBLES' ARTFORMS, EIGHTH EDITION in addition to PowerPoint™ slides containing many images with captions from the text.

STUDENTS are able to test their knowledge for each of the chapters in the textbook with interactive practice exams, videos, and flashcards containing terms, definitions, and pronunciation guides.

OneKey offers students incredible tools, including access to **Research Navigator**™, a powerful research database with help on the research and writing process. The ***Student Toolbox*** section offers useful links to art resources, writing help and reference tools, and information on careers and graduate study.

faculty and student resources
to accompany the text

DIGITAL AND VISUAL RESOURCES

■ **OneKey** is Prentice Hall's exclusive online resource that delivers instructor and student online resources —all in one place—all organized to accompany PREBLES' ARTFORMS, EIGHTH EDITION. For details, visit www.prenhall.com/onekey, or see details on preceding pages of this text.

■ **Fine Art Slides and Videos.** Slides and videos to accompany this text are available to qualified adopters. Contact your local Prentice Hall sales representative for more information.

ADDITIONAL RESOURCES

■ **TIME Magazine Special Edition: Art.** From environmental design to exhibition reviews to performance art, **Prentice Hall's TIME Special Edition: Art** offers the same accessible writing style and bold coverage/photography for which TIME is known. This is the perfect complement for discussion groups, in-class debates, or research assignments. FREE when packaged with PREBLES' ARTFORMS, EIGHTH EDITION.

■ **ArtNotes.** This notebook lecture companion for students features reproductions of the works in the text, with captions and page references for each. Space is provided next to each object for note taking in class. FREE when packaged with PREBLES' ARTFORMS, EIGHTH EDITION.

■ **Instructor's Manual with Test Bank.** Designed for both the novice and seasoned professor, this invaluable guide includes the following for each chapter: An overview, objectives, outline, key terms, lecture and discussion ideas, assignments and project, further resources, and a test bank. The test bank contains multiple choice, true/false, short answer, and essay questions. Contact your local Prentice Hall representative for more information.

■ **TestGen.** This commercial-quality computerized test management program for Windows™ or Macintosh® allows instructors to select test bank items to design their own exams. Contact your local Prentice Hall sales representative for more information.

■ **Companion Website at www.prenhall.com/preble.** This site features unique study/support tools for every chapter of PREBLES' ARTFORMS, EIGHTH EDITION:

Objectives, internet projects, image links and more. Multiple choice and short answer quizzes provide instant scoring and feedback to help students' self-study, or they can e-mail essay responses and graded quizzes directly to their instructors.

■ **OneSearch with Research Navigator: Art 2005.** In addition to offering handy information on citing sources and avoiding plagiarism, this guide gives students easy

access to three exclusive research databases: *The New York Times* Search by Subject Archive, ContentSelect Academic Journal Database, and Link Library. FREE when packaged with PREBLES' ARTFORMS, EIGHTH EDITION.

■ **Discovering Art 2.0 CD-ROM—contained in every new copy of** PREBLES' ARTFORMS, EIGHTH EDITION. This interactive CD-ROM offers students a highly visual

exploration of art. Students will see and hear video demonstrations of studio processes, view 200 images in a virtual image gallery, and learn how—and where—to visit a museum. Plus, interactive exercises help students to review and reinforce the material under study. **Turn the page for details on this innovative resource contained for FREE in every new copy of** PREBLES' ARTFORMS, EIGHTH EDITION.

For details about these resources, or to order a value package for PREBLES' ARTFORMS, EIGHTH EDITION, contact your local Prentice Hall sales representative (use our rep locator at *www.prenhall.com*), or e-mail us: art_service@prenhall.com.

FACULTY AND STUDENT RESOURCES

DISCOVERING ART 2.0 CD-ROM
AN OVERVIEW

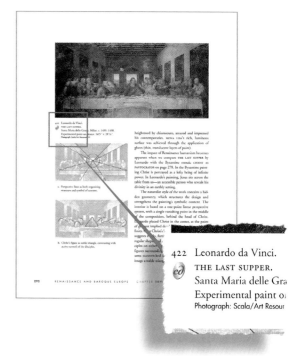

422 Leonardo da Vinci.
THE LAST SUPPER.
Santa Maria delle Gra
Experimental paint o
Photograph: Scala/Art Resour

This interactive CD-ROM is designed to help you get the most out of your art appreciation course and this textbook. Icons throughout the book point you to resources and activities contained on this CD-ROM *cd*. As you can see from the introductory screen, the program is divided into five main areas.

DISCOVERING ART
Introduction

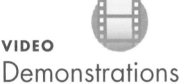

INTERACTIVE
Exercises

allow you to experiment with basic design concepts and principles and test yourself on elements of form, space, color, light, and design.

VIDEO
Demonstrations

show you works in progress as studio artists create art in different media. Watch printmaker Yugi Hiratsuka make an original woodblock print to demonstrate relief, or watch sculptor Tom Morandi make a plaster cast of a face to demonstrate modeling.

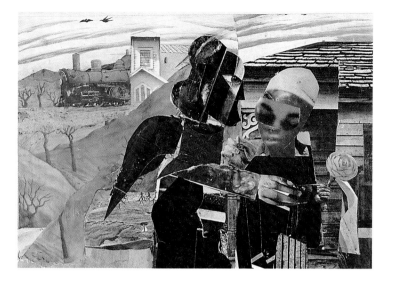

11 Romare Bearden.
 PREVALENCE OF RITUAL: TIDINGS. 1967.
 Photomontage. 36" × 48".
 © Romare Bearden Foundation/Licensed by VAGA, New York, NY.

empty dress seems to await a Korean occupant who will never put it back on. This sense of divided nationality is increasingly common among Americans, many of whom were born elsewhere.

Twentieth-century American artist Romare Bearden was fascinated by the pageant of daily life he witnessed in the rural South and in Harlem, New York. Bearden created memorable images of humanity by observing, distilling, then reconstructing the life he saw around him. In PREVALENCE OF RITUAL: TIDINGS an angel seems to console or embrace an introspective young woman. Borrowed picture fragments with a few muted colors make up an otherwise gray world. There is a mood of melancholy and longing. Does the train suggest departure from this world or escape to the lure of a better life in the North?

In ROCKET TO THE MOON, collage fragments build a scene of quiet despair and stoic perseverance. A barely visible rocket heads for the moon, while urban life remains punctuated by a red stoplight. The artist makes an ironic visual statement: Bearden placed America's accomplishments in space next to our inner cities' stalled social and economic progress.

Rembrandt and Bearden were concerned with the effectiveness of their communication to others, but equally important was their own inner need for expression. Within the broad range of the visual arts, there is a considerable difference in the amount and type of personal expression. Not all art is meant to express the personality of the maker; the designs of a coin or a telephone offer much less information about the personal concerns of the artist than do the designs of a painting or a piece of sculpture.

Yet an element of self-expression exists in all art, even when the art is produced cooperatively by many individuals, as in filmmaking and architecture. In each case, the intended purpose for the art affects the nature and degree of the personal expression.

12 Romare Bearden.
 ROCKET TO THE MOON. 1971.
 Collage on board. 13" × 9¼".
 © Romare Bearden Foundation/Licensed by VAGA, New York, NY.

ROMARE
Bearden
(1911–1988)

ROMARE BEARDEN paid tribute to the richness of his African-American experience through his art. He sought:

to paint the life of my people as I know it . . . because much of that life is gone and it had beauty.[4]

The child of educated, middle-class parents, Bearden spent his early childhood in rural North Carolina, then moved north with his family to Harlem, in New York City. He had a brief stint as a professional baseball player for the Boston club of the now-defunct Negro Leagues. He attended New York University, where he earned a degree in education and drew cartoons for the *NYU Medley*. He went on to draw humorous and political cartoons for magazines and a newspaper. During the Depression he attended the Art Students League in New York, where he was encouraged to say more in his drawings than he said in his cartoons. He held his first exhibition in a private studio in 1940—about the same time that he became a social worker in New York, a job he held on and off until 1966.

After serving in the army during World War II, Bearden used his G.I. Bill education grant to study at the Sorbonne in Paris. There he came to know a number of intellectuals and writers of African descent, including poet Leopold Senghor and novelist James Baldwin. Bearden was inspired to make the philosophical perspective of his ethnic heritage a cornerstone of his art. He said of his experience at the Sorbonne, "The biggest thing I learned was reaching into your consciousness of black experience and relating it to universals."[5]

Bearden was critical of programs that supported African-American artists by encouraging them to work in European academic traditions rather than those of their own lives. He believed that, just as African Americans had created their own musical forms such as jazz and blues, they should invent their own visual art. He urged fellow African-American artists to create art out of their own life experiences, as had jazz greats Ellington, Basie, Waller, and

Hines, who were among Bearden's friends. Bearden himself was a musician and songwriter who said he painted in the tradition of the blues.

He combined his stylistic search with institutional activism. In 1963, he founded the Spiral Group, an informal group of African-American artists that met in his studio. A year later, he became art director of the Harlem Cultural Council, a group devoted to recognizing and promoting the arts of Harlem residents.

His study of art history led Bearden to admire Cubist and Surrealist paintings and African sculpture, as well as work by earlier European masters. These works of art were among the many important influences on his creative development. Also important was the rapid-cut style of contemporary documentary filmmakers. Bearden worked in a variety of styles prior to the 1960s, when he arrived at the combined collage and painting style for which he is best known.

Although he learned from direct association with the previous generation of international artists, Bearden's focus remained the African-American

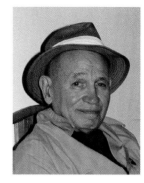

13 ROMARE BEARDEN.
Photograph: Bernard Brown and Associates.

experience. He kept a list of key events from his life on the wall of his studio. Often, Bearden drew upon memories of his childhood in rural North Carolina. The idea of homecoming fascinated him. He said, "You can come back to where you started from with added experience and you hope more understanding. You leave and then return to the homeland of your imagination."[6]

Despite his emphasis on his own experiences, Bearden cannot simply be labeled an African-American artist because his work has meaning both for and far beyond that community. He said, "What I try to do with art is amplify." If he had just painted a North Carolina farm woman, "it would have meaning to her and people there. But art amplifies itself to something universal."[7]

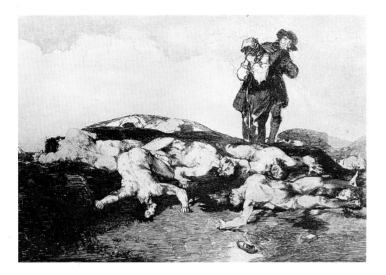

14 Francisco Goya.
THE DISASTERS OF WAR, NO. 18:
BURY THEM AND SAY NOTHING. 1818.
Etching and aquatint.
5⅞" × 8⅜".
S.P. Avery Collection, Miriam and Ira D.
Wallach Division of Art, Prints and Photographs.
The New York Public Library,
Astor, Lenox and Tilden Foundations.

Art for Social and Political Purposes

Artists in many societies have sought to criticize or influence values and public opinion through their work. Often the criticism is clear and direct, as with Francisco Goya's expression of outrage at the Napoleonic wars in his country. THE DISASTERS OF WAR vividly documents atrocities committed by Napoleon's troops as they invaded Spain in 1808. In a similar vein is the work of Cuban-American artist Félix González-Torres. In 1990, he printed large sheets with photographs and information on all of the victims of gunfire in the United States in a randomly selected week. UNTITLED (DEATH BY GUN) was reproduced in what the artist called "endless copies," which were then placed in a stack on the floor of the art gallery, free for the taking by viewers. González-Torres said of these pieces, "I need the public to complete the work. I ask the public to help me, to take responsibility, to become a part of my work, to join in."[8]

Sometimes the artist's social comment is less obvious, but still sincere. The Chinese painter Bada Shanren of the seventeenth century, deeply dissatisfied with the foreign rulers of his country, frequently painted melons as a political statement. Melons are a symbol in China of new birth and new beginnings. The seeds inside the melons symbolized the

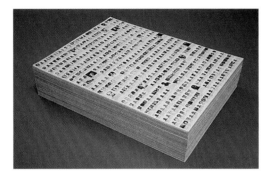

15 Félix González-Torres.
UNTITLED (DEATH BY GUN). 1990.
Offset print on paper. 44½" × 32½".
a. Installation view.
b. Single sheet.
The Museum of Modern Art, NY/Licensed by Scala-Art Resource, NY. Purchased in part with funds from Arthur Fleisher, Jr. and Linda Barth Goldstein.
Photographs: © 2002 The Museum of Modern Art, NY.

previous Chinese royal line to which the artist was still faithful. While not an outright protest, most educated persons understood the painter's intent.

Architecture, painting, and sculpture—and more recently film and television—have been used to project and glorify images of deities, political leaders, and now corporations. In seventeenth-century France, King Louis XIV built an enormous palace and formal garden at Versailles. His purpose was to symbolize the strength of his monarchy—to impress and intimidate the nobility with the Sun King's power (see Chapter 17).

Advertising designers often use the persuasive powers of art to present a version of the truth. We see their messages every day on television and in the print media. Not all persuasive art is commercial, however. Art can be an effective instrument for educating, directing popular values, molding public opinion, and gaining and holding political power.

For example, recent incidents of oppression caused one graphic designer to become politically active in a new way. When presidential elections were scheduled in Zimbabwe in 2002, the regime of Robert Mugabe took several steps to discourage voting, especially by persons who opposed the status quo. They failed to provide enough polling places in less friendly regions, forcing voters to travel long distances; they also harassed persons who attempted to register to vote. In the face of this threat, designer Chaz Maviyane-Davies began creating posters that denounced the situation, printing them on paper and distributing them free over the Internet. He established what he called a Portal of Truth web site and offered a new poster there each day in the month leading up to the elections.

One of these was OUR FEAR IS THEIR BEST WEAPON. Against a red background which symbolizes blood, we see a soldier staring back at us with the lower half of his face hidden, as if he were lurking in ambush. His eyes are the same red color as the background, so we might say that he has blood in his eyes. The upper portion shows slogans meant to encourage resistance, but the type is faded, giving it a tentative look. This and other posters did not lead to the downfall of the regime, but they did em-

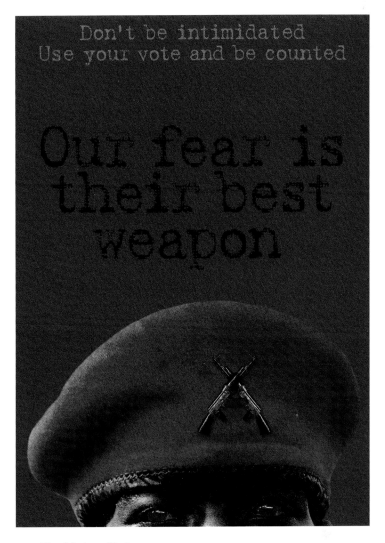

16 Chaz Maviyane-Davies.
 OUR FEAR IS THEIR BEST WEAPON. 2002
 Offset poster, graphic commentary #23b.
 Courtesy of the artist.

bolden the opposition to continue protests of various kinds. They also forced the designer into exile later that year.

The art of our culture reflects who we are and what our relationships are to our surroundings and to one another. Art can be pleasing and beautiful, but it can also shout us awake and inspire us to action. Today, when cross-cultural understanding, open-mindedness, and creative problem solving are urgently needed, art can elevate our consciousness and thus deepen our humanity.

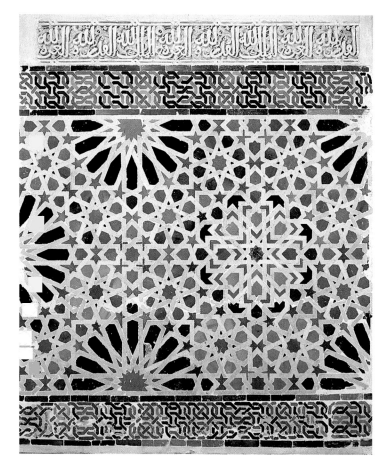

17 DECORATIVE PANEL FROM THE ALHAMBRA.
Granada. Nasrid Period, 14th Century.
Glazed mosaic tile. 60" × 50⅝".
Museo de la Alhambra. Photograph: Sheldan Collins.

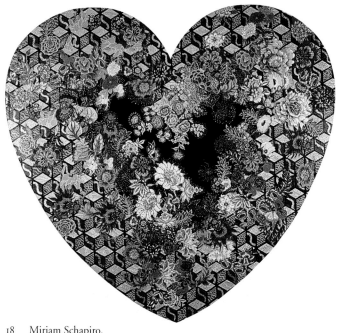

18 Miriam Schapiro.
HEARTLAND. 1985.
Acrylic, fabric, and glitter on canvas. 85" × 94".
Collection of Orlando Museum of Art, Orlando, Florida.
Gift of the Women for Special Acquisitions and the Council 101.87.1.

Art for Visual Delight

Many of us probably think of visual delight as the first function of art. Indeed, art can provide pleasure, enjoyment, amusement, diversion, and embellishment in our world. Art that is visually attractive and well crafted can "lift us above the stream of life," as a noted aesthetician once put it.[9] Absorbed in contemplating such works, we forget where we are for a moment.

Islamic art is particularly abundandant with lavish decorations of this sort. For example, the fourteenth-century DECORATIVE PANEL FROM THE ALHAMBRA is made of colored mosaic tile laid in dazzling patterns. Our eyes follow pathways that enclose geometric figures of many different shapes, sizes, and colors. These small polygons are elements in a larger rhythm of black starbursts between rows of geometric interlace. The piece shown here is only a small fragment of the lower portion of a wall enclosing a room in the Alhambra, a palace that reached its full glory under the Nasrid rulers of Granada in the fourteenth century.

Some contemporary artists have achieved decorative effects with very different materials. Miriam Schapiro's HEARTLAND depends partly on sheer size for its impact, since it measures nearly seven by eight feet. Here, a rich texture of mixed media calls to mind traditional art forms of quilting and flower arranging which were once considered the province of women. The piece actually combines paint, fabric, and glitter in a collage format whose feminine elements led Schapiro to coin the term "femmages" to describe them. The lush colors, bold patterns, and symbolic meanings of the shape of the work combine to create a garden of visual delight.

Art—like beauty, truth, and life itself—is larger than any single definition. One widely used dictionary defines art in this way:

art, *n. 1. the expression or application of creative skill and imagination, especially through a visual medium such as painting or sculpture.*[10]

As we have seen from the works illustrated in just this chapter, it is difficult to arrive at a definition that includes all the possible forms of art. Hence, we will spend the rest of the book exploring them.

AWARENESS, CREATIVITY, AND COMMUNICATION

There are as many ways to create as there are creative people. The creative process often begins when one is inspired by an idea or faced with a problem.

VISUAL THINKING

Much of our thinking is visual thinking. To visualize is to use imagination and visual memory to preview events or plans before they occur. Most of the things we make begin with a mental picture. This is true for a meal, a vacation, a painting, or a building. All artists use visualization. Some plan their works by mentally picturing them as completed images; others visualize each step as they go along, letting one idea lead to another.

Our experiences influence both inner visualization and outer seeing. For example, ten people painting the same subject—even working from the same vantage point—will make ten different images based on their experiences, values, and interests. An English botanist, a Peruvian developer, and a Japanese photographer each see the same landscape differently.

We may also have a variety of responses to a given subject over time. When we look at a picture of a house, for example, we see an enclosed volume. On an intellectual level we may assume it contains rooms, while our emotions may lead us to make associations with "home." In creative visual thinking, we see objects before us and know their names, but we also may associate them with feelings, and see them as shapes and colors, with relations to other remembered things. Thus, we draw from many levels of meaning, and integrate the complementary modes of rational and intuitive intelligence.

PERCEPTION AND AWARENESS

Of all our planet's resources, the most precious is human awareness.

DON FABUN[1]

Perception and awareness are closely related. To *perceive* is to become aware through the senses, particularly through sight or hearing. To be aware means to be conscious, to know something, and to understand through that awareness.

In the visual arts, we gain awareness through the sense of sight and through the development of visual thinking. Surprising as it may seem, much of our sensory awareness is learned. The eyes are blind to what the mind cannot see. The following story provides an unusually dramatic example.

Joey, a New York City boy with blind parents, was born with cerebral palsy. Because of his disabilities, as well as those of his parents, Joey was largely confined to his family's apartment. As he grew older, he learned to get around the apartment in a walker. His mother believed him to be of normal intelligence, yet clinical tests showed him to be blind and mentally retarded. At age five Joey was admitted to

a school for children with a variety of disabilities, and for the first time he had daily contact with people who could see. Although he bumped into things in his walker and felt for almost everything, as a blind person does, it soon became apparent that Joey was not really blind. *He simply had never learned to use his eyes.* The combined disabilities of Joey and his parents had prevented him from developing normal visual awareness. After working with specialists and playing with sighted children for a year, his visual responses were normal. Those who worked with him concluded that Joey was a bright and alert child.

To varying degrees, we are all guided—or limited, as Joey was—in the growth of our awareness by parents, teachers, the mass media, and others who influence us.

Even common words and concepts can sometimes limit our sensory impressions. When we look at an object only in terms of a label or a stereotype, we miss the thing itself; we tend to see a vague something called "tree" or "chair" rather than *this* tree, this *particular* chair, or this *unique* object or person. As artist Robert Irwin pointed out, "seeing is forgetting the name of the thing one sees."[2]

As we become more conscious of our own sensory experiences, we open up new levels of awareness. Ordinary things become extraordinary when seen without prejudgment. Is Edward Weston's photograph of a pepper meaningful to us because we like peppers so much? Probably not. To help us see anew, Weston created a memorable image on a flat surface with the help of a common pepper. A time exposure of over two hours gave PEPPER #30 a quality of glowing light—a living presence that resembles an embrace. Through his sensitivity to form, Weston revealed how this pepper appeared to him. Notes from his *Daybook* communicate his enthusiasm about this photograph:

August 8, 1930

I could wait no longer to print them—my new peppers, so I put aside several orders, and yesterday afternoon had an exciting time with seven new negatives.

First I printed my favorite, the one made last Saturday, August 2, just as the light was failing—quickly made, but with a week's previous effort back of my immediate, unhesitating decision. A week?—Yes, on this certain pepper,—but twenty-eight years of effort, starting with a youth on a farm in Michigan, armed with a No. 2 Bull's Eye [Kodak] 3½ × 3½, have gone into the making of this pepper, which I consider a peak of achievement.

It is a classic, completely satisfying—a pepper—but more than a pepper: abstract, in that it is completely outside subject matter . . . this new pepper takes one beyond the world we know in the conscious mind.[3]

Weston's photograph of a seemingly common object is a good example of the creative process at work. The artist was uniquely aware of something in his surroundings. He applied a great deal of creative effort in achieving the image he wanted. The photograph that resulted not only represents the object, but communicates a deep sense of wonder about the natural world and its processes. Thus, the work combines awareness, creativity, and communication.

LOOKING AND SEEING

Degrees of visual awareness can be distinguished by the verbs "look" and "see." Looking implies taking in what is before us in a purely mechanical way; seeing is a more active extension of looking. If we care only about function, we simply need to look quickly at a doorknob in order to grasp and turn it. But when we get excited about the shape and finish of a doorknob, or the bright clear quality of a winter day, we go beyond simple functional looking to a higher level of perception called "seeing."

The twentieth-century French artist Henri Matisse wrote about the effort it takes to move beyond stereotypes and to see fully:

To see is itself a creative operation, requiring an effort. Everything that we see in our daily life is more or less distorted by acquired habits, and this is perhaps more

19 Edward Weston.
PEPPER #30. 1930.
Photograph.
Collection Center for Creative Photography, The University of Arizona. © 1981, Arizona Board of Regents.

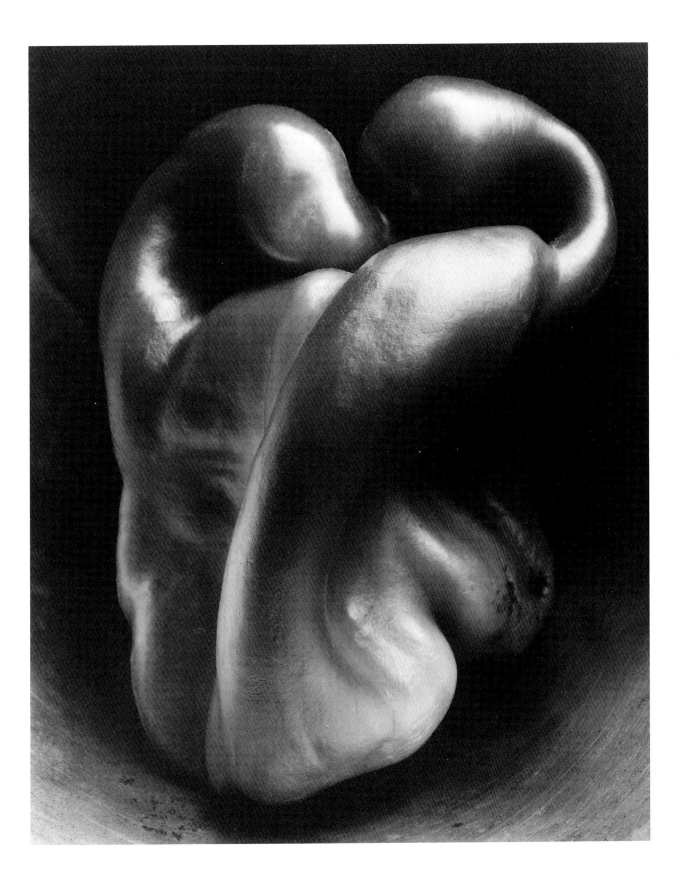

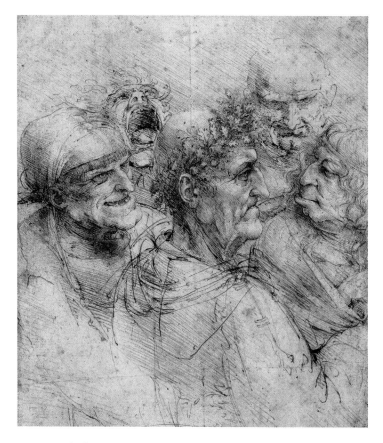

20 Leonardo da Vinci (1452–1519).

A MAN TRICKED BY GYPSIES. c. 1493.
Pen and brown ink. 10¼" × 8½".
The Royal Collection Windsor Castle. © 2004, Her Majesty Queen Elizabeth II.
Photo by EZM. RL 12495.

evident in an age like ours when cinema, posters, and magazines present us every day with a flood of ready-made images which are to the eye what prejudices are to the mind. The effort needed to see things without distortion takes something very like courage.[4]

AESTHETICS, ART, AND BEAUTY

Aesthetics refers to an awareness of beauty or to that quality in a work of art or other manmade or natural form which evokes a sense of elevated awareness in the viewer. Some people equate the word "aesthetic" with taste. Many artists and art critics oppose this view, maintaining that art has nothing to do with taste; they think that so-called good taste can actually limit an honest response. "Good taste" almost always refers to an already established way of seeing. Innovative artists, seeking new ways of seeing, often challenge the established conventions of taste.

Most cultures that have a definition of "beautiful" define it as something pleasing to the eye that is well-proportioned, harmonious, and often approximating an ideal of some sort. In the Western tradition works from Classical Greece or the Renaissance are most frequently described as beautiful. However, what is pleasing to the eye (and hence the sense of beauty) varies considerably across cultures.

Today we often use the word "beautiful" to refer to things that are simply pretty. "Pretty" means pleasant or attractive to the eye, whereas "beautiful" means having qualities of a high order, qualities that delight the eye, engage the intellectual or moral sense, or do all these things simultaneously. In the words of architect Louis Kahn, "Beautiful doesn't necessarily mean good-looking."[5]

Let us consider possibilities beyond the conventional or established standards of beauty and ugliness. If art's only function were to please the senses, ugliness would have no place in art. But since we don't expect all works of drama or literature to be pretty or pleasant, why should we have different

21 Otto Dix.
DER KRIEG (WOUNDED SOLDIER). 1924.
Etching. 7¾" × 5½".
Galerie der Stadt, Stuttgart. © 2002 Artists Rights Society (ARS),
NY/VG Bild-Kunst, Bonn.

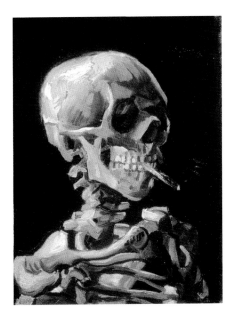

22 Vincent van Gogh.
SKULL WITH A BURNING CIGARETTE. 1885–1886.
Oil on canvas. 32" × 24½".
Van Gogh Museum (Vincent Van Gogh Foundation), Amsterdam.

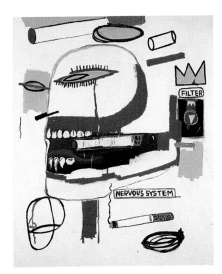

23 Jean-Michel Basquiat.
TOBACCO. 1984.
Acrylic and oil crayon on canvas. 86" × 68".
Courtesy Galerie Bruno Bischofberger, Zurich.
© 2002 Artists Rights Society (ARS), NY/ADAGP, Paris.

expectations of the visual arts? Leonardo da Vinci, Otto Dix, Vincent van Gogh, and Jean-Michel Basquiat—artists from different times and places—explored dimensions of "ugliness" in relation to their own concerns and personal modes of expression.

Street life fascinated Italian Renaissance artist Leonardo da Vinci. He was particularly interested in studying people of striking appearance, people either very beautiful or very ugly. Leonardo found ugliness to be as worthy of attention as beauty. In fact, he considered ugliness a variation of beauty, and this feeling can be seen in his A MAN TRICKED BY GYPSIES. In his *Treatise on Painting*, he advised others always to carry a pocket notebook in which to make quick drawings of what they observed. He also drew from memory, as described by sixteenth-century artist and biographer Giorgio Vasari:

Leonardo used to follow people whose extraordinary appearance took his fancy, sometimes throughout a whole day, until he could draw them as well by memory as though they stood before him.[6]

Unlike Leonardo's drawing, in which ugly people are gracefully drawn, every line in Otto Dix's etching carries the grotesque quality of the larger subject—the horror of war.

Dix, who served in the German army for four years during World War I, depicted the terrible an-

guish of war in his etching WOUNDED SOLDIER. In the economically and politically troubled 1920s, he criticized his society for its decadence. With unrelenting honesty, Dix documented the brutalities of gas and trench warfare. As his etching illustrates, even horrible events can provide the basis for constructive communication through art. Artists can help us to learn without our having to live through such horrors.

Vincent van Gogh's SKULL WITH A BURNING CIGARETTE presents another aspect of what we humans consider ugly: reminders of death, the skeleton. The skeleton seems eerily lit as it basks in an earthy brown glow before an overwhelmingly dark background.

In contrast to the careful brushwork of van Gogh is the intentionally blunt, bad-boy, street-painting style of Jean-Michel Basquiat. Basquiat's direct approach, as seen in TOBACCO, evolved from his early experience as a teenage graffiti artist.

I'd like to study the drawings of kids. That's where the truth is, without a doubt.

ANDRÉ DERAIN[10]

THE ARTS COME from inborn human needs to create and to communicate. They come from the desire to explore, confirm, and share special observations and insights—a fact readily apparent in nine-year-old Kojyu's SEARCHING FOR BUGS IN THE PARK. The arts are one of the most constructive ways to say "I did it. I made it. This is what I see and feel. I count. My art is me." Unfortunately, the great value of this discover-and-share, art-making process is only rarely affirmed in today's busy homes and schools.

We include art by children as the best way—other than actual hands-on art-making processes—to help you reexamine your relationship to your own creative powers and perhaps even to guide you as you prepare to become a parent, a teacher, or a caregiver for children.

Children use a universal visual language. All over the world, drawings by children ages two to six show similar stages of mental growth, from exploring with mark-making to inventing shapes to symbolizing things seen and imagined. Until they are about six years old, children usually depict the world in symbolic rather than realistic ways. Their images are more mental constructions than records of visual observations.

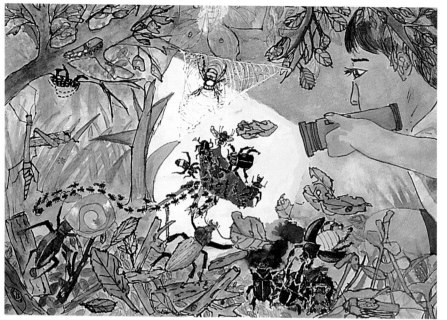

During the second year of life, children enjoy making marks, leaving traces of their movements. Sensitive exploration is visible in FIRST LINES, by a one-and-a-half-year-old child. After marking and scribbling, making circles and other shapes fascinates young children. The HOUSE shape is by a two-year-old. HAND WITH LINE AND SPOTS is by a three-year-old, as is the smiling portrait of GRANDMA in which self-assured lines symbolize a happy face, shoulders, arms, body, belly button, and legs.

Being the son of a saltwater fish collector, and watching an octopus, gave almost four-year-old Jason the idea for his drawing of a smiling MOTHER OCTOPUS WITH BABIES. The excitement of joyful play with friends on unicycles inspired eight-year-old Yuki's I CAN RIDE, I CAN RIDE MY UNICYCLE. Notice how she emphasized

24 Kojyu, age 9. SEARCHING FOR BUGS IN THE PARK.

25 FIRST LINES.

26 Alana, age 2. HOUSE.

27 Alana, age 3. GRANDMA.

28 Jeff, age 3. HAND WITH LINE AND SPOTS.
Photographs: Duane Preble.

29 Jason, almost 4.
MOTHER OCTOPUS
WITH BABIES.

30 Yuki, age 8.
I CAN RIDE,
I CAN RIDE MY
UNICYCLE.
Photographs: Duane Preble.

31 Anonymous Child. BIRDS.
a. This picture shows one child's drawing of a bird before exposure to coloring books.

b. Then the child colored a workbook illustration.

c. After coloring the workbook birds, the child lost creative sensitivity and self-reliance.
(a, b, and c) Creative Mental Growth
by Victor Lowenfeld, 1975, p 23. Reproduced by permission of Pearson Education, Upper Saddle River, NJ.

her own image by greatly exaggerating her size relative to others and how she included important information, such as her right leg seen through the spokes of the wheel.

Young children often demonstrate an intuitive sense of composition. Unfortunately, we lose much of this intuitive sense of balanced design as we begin to look at the world from a conceptual, self-conscious point of view. Most children who have been given coloring books, workbooks, and pre-drawn printed single sheets become overly dependent on such impersonal, stereotyped props. In this way, children often lose the urge to invent unique images based on their own experiences. A child's two drawings of BIRDS show this process: The child first interprets the bird in a personal, fresh way, but later adopts the trite forms of a conventional workbook. Without ongoing opportunities for personal expression, children lose self-confidence in their original creative impulses.

Children begin life as eager learners. If they are loved and cared for, they soon express enthusiasm for perceiving and exploring the world around them. Research shows that parents' ability to show interest in and empathy for their child's discoveries and feelings is crucial to the child's brain development. Before the age of one, and well before they talk, babies point tiny fingers at wonderful things they see. Bodies move in rhythm to music. Ask a group of four-year-olds "Can you dance?" "Can you sing?" "Can you draw?" and they all say, "Yes! Yes!" Ask twelve-year-olds the same questions, and they will too often say "No, we can't." Such an unnecessary loss has ominous implications for the spiritual, economic, social, and political health of society.

Most abilities observed in creative people are also characteristic of children during interactions with the world around them. What becomes of this extraordinary capacity? According to John Holt, author of *How Children Fail,*

We destroy this capacity above all by making them afraid—afraid of not doing what other people want, of not pleasing, or of making mistakes, of failing, of being wrong. Thus we make them afraid to gamble, afraid to experiment, afraid to try the difficult and unknown.[11]

ART AND EXPERIENCE

Art encourages us to experience our lives more vividly by urging us to reexamine our thoughts and renew our feelings. The essence of art is the spark of insight and the thrill of discovery—first experienced by the maker, then built into the work of art, and finally experienced by the viewer. A noted philosopher once described the process:

To evoke in oneself a feeling one has experienced, and having evoked it . . ., then by means of movement, line, color, sounds or forms expressed in words, so transmit that same feeling—this is the activity of art.[7]

As we live our lives, experiences flow past in a stream of what may seem like disconnected events and impressions. Art helps us to grasp the significance of the moment and the interrelationships of events—and thereby to experience life fully.

While animals seem keenly aware of their world through their senses, human beings have lost some of the ability to experience life intensely in the present moment. Caught up in thoughts and emotions, and often separated from direct experiences with nature, we risk adopting dulled, programmed responses to our environments.

The best art cuts through our tendency to prejudge our experience. Great art sharpens our perceptions by re-creating human experience in fresh forms, bringing a new sense of the significance and connectedness of life.

CREATIVITY

The source of all art, science, and technology—in fact, all of civilization—is human imagination, or creative thinking. As scientist Albert Einstein declared, "Imagination is more important than knowledge."[8]

What do we mean by this ability we call creativity? Psychologist Erich Fromm wrote:

In talking about creativity, let us first consider its two possible meanings: creativity in the sense of creating something new, something which can be seen or heard by others, such as a painting, a sculpture, a symphony, a poem, a novel, etc., or creativity as an attitude, which is the condition of any creation in the former sense but which can exist even though nothing new is created in the world of things. . . .

What is creativity? The best general answer I can give is that creativity is the ability to see (or to be aware) and to respond.[9]

Creativity is as fundamental to experiencing and appreciating a work of art as it is to making one. Insightful seeing is itself a creative act; it requires open receptivity—putting aside habitual modes of thought.

Studies of creativity have described traits of people who have maintained or rediscovered the creative attitude. These include the abilities to:

- wonder and be curious
- be open to new experience
- see the familiar from an unfamiliar point of view
- take advantage of accidental events
- make one thing out of another by shifting its function
- generalize from particulars in order to see broad applications
- synthesize, integrate, find order in disorder
- be in touch with one's unconscious, yet be intensely conscious
- be able to analyze and evaluate
- know oneself, have the courage to be oneself in the face of opposition
- be willing to take risks
- be persistent: to work for long periods—perhaps years—in pursuit of a goal

As Fromm said, creativity is an *attitude*. We all have the potential to be creative, yet most of us have not been encouraged to develop our creativity.

Though certain aspects of creativity seem very similar worldwide, each culture has specific ways of thinking about the subject. In Chinese painting, for example, the artist is not expected merely to copy the appearance of the subject of the work, but rather to *understand* it deeply and communicate that under-

standing. In that tradition, paintings of bamboo are fairly common; but an artist who masters the subject is one who can go beyond mere appearances and harmonize his or her spirit with that of the plant. The eleventh-century poet and painter Su Xi once described the creative process as an intuitive grasping of the subject, not a laborious copying of its every detail: "Painters of today draw joint after joint and pile up leaf on leaf. How can that become a bamboo? When you are going to paint a bamboo, you must first realize the thing completely in your mind."[12] He once praised the artist Yu Ko by saying that Yu was transformed into the bamboos that he painted.

Native American pottery painters of the Southwest offer another perspective on creativity. These artists decorate their earthenware vessels with symbolic forms that are meant to recall the natural surroundings. Each tribal group generally uses a basic set of commonly understood symbols, which the artists, who traditionally are women, may vary and combine at will. When an anthropologist interviewed several of these potters in the 1920s, most said that they first dreamed of the designs that they would paint on their pots. Each said that she fully conceived the design in her mind before painting it.

Wherever it happens, artistic creativity is an asset to society. Creativity developed through art experiences enhances problem solving and communication in other areas of life. For all of us, opportunities for creative expression develop our abilities to integrate experiences of the outside world with those of our inner selves.

UNTRAINED AND FOLK ARTISTS

The urge to create is universal; it has little to do with art training. We satisfy our artistic sensibilities every day in a variety of ways. Those with little or no formal art education who make objects commonly recognized as art are usually described as either *untrained* artists or *folk artists*.

Art by untrained artists, also called *naïve* or *outsider artists*, is made by people who are largely unaware of art history or the art trends of their time. Unlike folk art, which is made by people working within a tradition, art by untrained artists is personal expression created apart from any conventional practice or style.

Many untrained artists seem to develop their art spontaneously, without regard to art of the past or present. Anna Zemankova was a Czech housewife with no art training who at age fifty-two suddenly began making drawings. She would awaken each morning at about four o'clock and draw with colored pencil until seven. Seated at a special easel that her son designed, she seemed to work transfixed by some inner vision. All of her works are UNTITLED, but they seem to depict plant life. The imagery that she created resembles in some ways the local decorative arts of her region, such as embroideries or ceramic glazes, but the combination is completely her own. In later years she began embroidering on the drawings. She said that in her art she grew plants that did not grow elsewhere, and indeed they resemble no known species.

32 Anna Zemankova.
UNTITLED. ca, 1970s.
Pastel on paper, 24½" × 17¾" (61.6 cm × 45.1 cm).
Courtesy of the artist and Cavin-Morris Gallery, NY.

40 Nancy Graves.
FOOTSCRAY, from the AUSTRALIAN SERIES. 1985.
Oil, acrylic, and glitter on canvas with painted aluminum sculpture.
6'4½" × 14'5" × 12½" (diptych).
© Nancy Graves Foundation/Licensed by VAGA, NY.

Nonrepresentational Art

A great deal of the world's art was not meant to be representational at all. Amish quilts, many Navajo textiles, and most Islamic wood carvings consist primarily of flat patterns that give pleasure through mere variety of line, shape, and color. *Nonrepresentational* art (sometimes called *nonobjective* or *nonfigurative* art) presents visual forms with no specific references to anything outside themselves. Just as we can respond to the pure sound forms of music, so we can respond to the pure visual forms of nonrepresentational art.

While nonrepresentational art may at first seem more difficult to grasp than representational or abstract art, it can offer fresh ways of seeing. Absence of subject matter actually clarifies the way all visual form affects us. Once we learn how to "read" the language of vision, we can respond to art and the world with greater understanding and enjoyment.

Two widely different types of nonrepresentational art are pictured here. In FOOTSCRAY, the work of the American painter-sculptor Nancy Graves, oil paint on canvas combines with brightly colored aluminum elements that hover above the surface of the

41 TUKUTUKU PANELS.
Maori peoples, New Zealand. 1930s.
Dyed plaited flax strips over wood laths.
Dimensions variable.
Collection of the Museum of New Zealand,
Te Papa Tongarewa, Wellington, New Zealand, F236, F238.

work. The forms in the piece suggest organic, exuberant motion.

In New Zealand, Maori women working in pairs weave strips of dyed flax into geometric patterns called TUKUTUKU PANELS. These patterns are traditional in

Maori societies and they have names such as "sand flounder," "human ribs," and "albatross tears." The panels are woven in specific sizes to fit between the wooden uprights of meeting houses where religious ceremonies are held. A given meeting house may contain *tukutuku* panels of many different designs, giving the room a rich and varied visual texture.

Whereas the makers of the TUKUTUKU PANELS used naturally dyed flax to create elegantly rhythmic, yet strictly geometric, traditional designs, Graves employed manmade materials, bright synthetic colors, and a dynamic, irregular composition to create FOOTSCRAY. These contrasting works show that even in nonrepresentational art, an extremely wide variety of forms, compositions, moods, and messages are possible.

FORM AND CONTENT

Form is what we see; content is the meaning we get from what we see. In this book, *form* refers to the total effect of the combined visual qualities within a work, including such components as materials, color, shape, line, and design. *Content* refers to the message or meaning of the work of art—what the artist expresses or communicates to the viewer. Content determines form, but form expresses content; thus the two are inseparable. As form changes, content changes, and vice versa.

For example, the sign that represents the human heart is a symbol of love. If someone were to give you a huge, beautifully made red velvet valentine, so large it had to be pulled on a cart, you would probably be overwhelmed by the gesture. The content would be Love! But if you were to receive a faint photocopied outline of a heart on a cheap piece of paper, you might read the content as: *love*—sort of—a very impersonal kind. And if you were to receive a shriveled, greenish brown, slightly moldy image of a heart, you might read the content as *Ugh!*

One way to understand how art communicates experience is to compare works that have the same subject but differ greatly in form and content. THE KISS by Auguste Rodin and THE KISS by Constantin Brancusi show how two sculptors interpret an embrace. In Rodin's work, the life-size human figures represent Western ideals of the masculine and feminine: Rodin captured the sensual delight of that

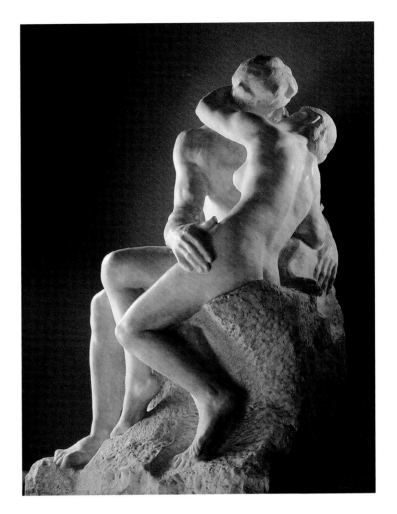

42 François Auguste René Rodin.
THE KISS. 1886.
Marble. Height 5'11¼".
Musée Rodin, Paris, France.
Photograph: Bruno Jarret.
© 2002 Artists Rights Society (ARS) NY/ADAPG, Paris.

43 Constantin Brancusi.
THE KISS. c. 1916.
Limestone.
23" × 13 " × 10".
Philadelphia Museum of Art.
The Louise and Walter Arensberg Collection.
Photograph: Graydon Wood, 1994.
© 2002 Artists Rights Society (ARS), NY/ADAGP, Paris.

highly charged moment when lovers embrace. Our emotions are engaged as we overlook the hardness of the marble out of which the illusion was carved. The implied natural softness of flesh is accentuated by the rough texture of the unfinished marble supporting the figures.

In contrast to Rodin's sensuous approach, Brancusi used the solid quality of a block of stone to express lasting love. Through minimal cutting of the block, Brancusi symbolized—rather than illustrated—the concept of two becoming one. He chose geometric abstraction rather than representational naturalism to express love. Rodin's work expresses the *feelings* of love while Brancusi's expresses the *idea* of love.

SEEING AND RESPONDING TO FORM

The creative act is not performed by the artist alone; the spectator brings the work in contact with the external world by deciphering and interpreting its inner qualifications and thus adds his contribution to the creative act.

MARCEL DUCHAMP[15]

Obviously, artists expend effort to produce a work of art. Less obvious is the fact that responding to a work

of art also requires effort. The artist is the source or sender; the work is the medium carrying the message. We viewers must receive and experience the work to make the communication complete. In this way, we become active participants in the creative process.

Whether we realize it or not, learning to respond to form is part of learning to live in the world. We guide our actions by "reading" the forms of people, things, and events that make up our environment. Even as infants, we have an amazing ability to remember visual forms such as faces, and all through life we interpret events based on our previous experiences with these forms. Every form can evoke some kind of response from each of us.

Subject matter can interfere with our perception of form. One way to learn to see form without subject is to look at pictures upside down. Inverting recognizable images frees the mind from the process of identifying and naming things. Familiar objects become unfamiliar. Art teachers have found that having students copy a picture placed upside down can dramatically improve seeing, and thereby

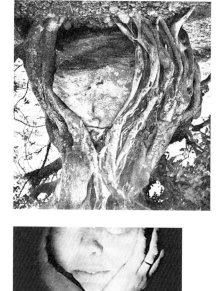

44 VISUAL METAPHOR.
Student Project.
Photographs: Duane Preble.

45 Elliott Erwitt.
FLORIDA. 1968.
Photograph.
Photograph: Magnum Photos Inc.

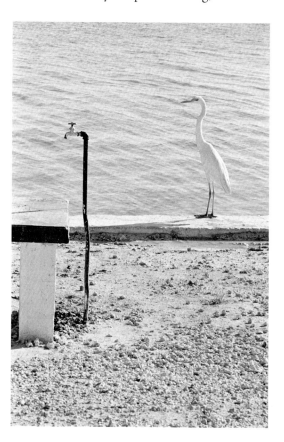

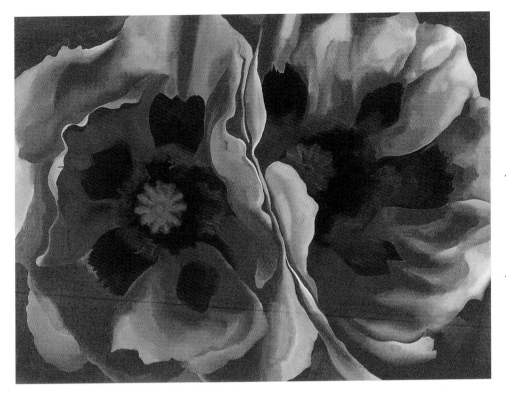

improve representational drawing skills, by encouraging concentration on spatial relationships rather than on preconceptions.

Another exercise in learning to see form is to search for images that are visually similar in form but dissimilar as nameable objects. For example, in VISUAL METAPHOR when we notice that the form of fingers supporting a head is similar to roots grasping a rock (in an inverted photograph), we are seeing beyond names to pure form. Such similarities can become visual metaphors, as in Elliott Erwitt's photograph, FLORIDA.

Georgia O'Keeffe responded to nature's forms in her own way. In paintings such as ORIENTAL POPPIES and JACK-IN-THE-PULPIT NO. V, she shared her awareness. She said of these paintings:

Everyone has many associations with a flower—the idea of flowers. Still—in a way—nobody sees a flower—really—it is so small—we haven't the time—and to see takes time, like to have a friend takes time. If I could paint the flower exactly as I see it no one would see what I see because I would paint it small like the flower is small.

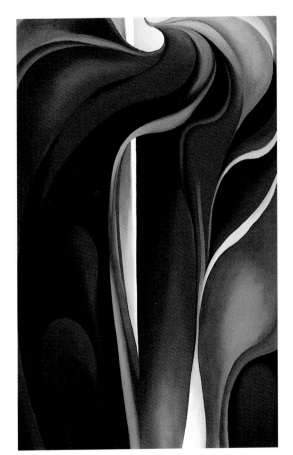

GEORGIA
O'Keeffe
(1887–1986)

48 Yousuf Karsh.
GEORGIA O'KEEFFE.
1956.
Photograph.
Woodfin Camp & Associates.
Photograph: Yousuf Karsh.

DURING HER LONG, productive life, Georgia O'Keeffe became nearly as well known as her distinctive paintings. She represented, to many people, the popular concept of the isolated, eccentric "artist." She lived a spare, often solitary life, and approached both her life and her art in her own unique way.

O'Keeffe was born in Sun Prairie, Wisconsin, and spent her childhood on her family's farm. While in high school, she had a memorable experience that gave her a new perspective on the art-making process. As she passed the door to the art room,

O'Keeffe stopped to watch as a teacher held up a jack-in-the-pulpit plant so that the students could appreciate its unusual shapes and subtle colors. Although O'Keeffe had enjoyed flowers in the marshes and meadows of Wisconsin, she had done all of her drawing and painting from plaster casts or had copied them from photographs or reproductions. This was the first time she realized that one could draw and paint from real life. Twenty-five years later she produced a powerful series of paintings based on flowers.

O'Keeffe studied at the Art Institute of Chicago, the Art Students League in New York, and Columbia University Teachers College. From Arthur Wesley Dow of Columbia she learned to appreciate Japanese design, to fill space in a beautiful way, and to balance light and dark. As a student she was also influenced by the first wave of European abstract paintings to reach the United States from Europe.

From 1912 to 1918, she spent four winters teaching school in the Texas Panhandle. The Southwest landscape left a strong impression on her and influenced her later decision to move to New Mexico—where the desert became her favorite subject.

O'Keeffe's first mature works, produced in 1915, consisted of abstract charcoal drawings suggesting natural forms and vivid

watercolor landscapes. A friend of O'Keeffe's showed those drawings to influential photographer and gallery owner Alfred Stieglitz, who exhibited them in his avant-garde Gallery 291 in New York. Thus began one of the best-known artistic and romantic liaisons of the twentieth century. O'Keeffe and Stieglitz were married in 1924, and O'Keeffe's work was exhibited annually in various galleries owned by Stieglitz until his death in 1946. They were strong supporters of one another's work.

Although associated with American modern artists, O'Keeffe developed her own style, which is both sensuous and austere. Her paintings of the 1920s include the series of greatly enlarged flowers, landscapes, and geometrically structured views of New York City. In her mature style, O'Keeffe rejected realism in favor of simplified flat patterns and color harmonies inspired by Japanese art.

From 1929 to 1949 O'Keeffe spent summers in Taos, New Mexico, surrounded by the desert she loved. After Stieglitz died she settled permanently on an isolated ranch near the village of Abiquiu, where she remained until her death in 1986 at age ninety-eight. In people's minds she lives on as a model of creative individuality and strength.

So I said to myself—I'll paint what I see—what the flower is to me but I'll paint it big and they will be surprised into taking time to look at it.[16]

Those who have seen O'Keeffe's paintings of flowers and the American Southwest often go on to see actual flowers and desert landscapes in new ways.

ICONOGRAPHY

As we have noted, form conveys content even when no nameable subject matter is represented. But when subject matter is present, meaning is often based on traditional interpretations.

Iconography is the symbolic meaning of signs, subjects, and images. Not all works of art contain iconography. In those that do, it is often the symbolism (rather than the obvious subject matter) that carries the deepest levels of meaning. The identification and specific significance of subjects, motifs, forms, colors, and positions are the central concern of iconographic interpretation.

Examples of iconography from different times and places reveal a wealth of cultural meanings. Today, the term iconography is usually associated with a religious or cultural area of study, such as Egyptian or Christian iconography.

The primary subject in Albrecht Dürer's THE KNIGHT, DEATH AND THE DEVIL is a man in armor on horseback; behind him are a corpselike figure and a horned monster. The meanings of this imagery would have been well understood by viewers in Dürer's time because they were familiar with Christian iconography: the knight in armor symbolizes the dutiful Christian who follows the right path undistracted by Death and the Devil.

The knight must ride through the darkness of the "valley of the shadow of death" to reach the City of God, seen in the background. An hourglass in the hand of Death symbolizes human mortality or the brevity of life. Serpents in Death's hair are ancient symbols of death and also Christian symbols of the Devil. The dog, a symbol of faithfulness in both religion and marriage, symbolizes the faith the knight

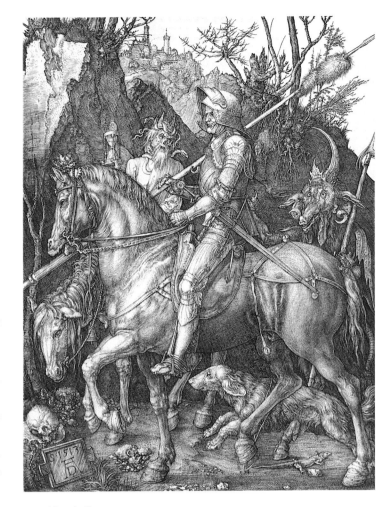

49 Albrecht Dürer.
 THE KNIGHT, DEATH AND THE DEVIL. 1513.
 Engraving. 9⅝" × 7½".
 The Brooklyn Museum of Art, New York.
 Gift of Mrs. Horace O. Havemeyer. 54.35.6.

must have if he is to reach his goal. A lizard, representing evil, scurries in the opposite direction. Dürer organized all these separate references in a way that leaves no doubt that the Christian knight will reach his goal. The idealized form and dominant central position of the knight and his powerful horse convey a sense of assurance.

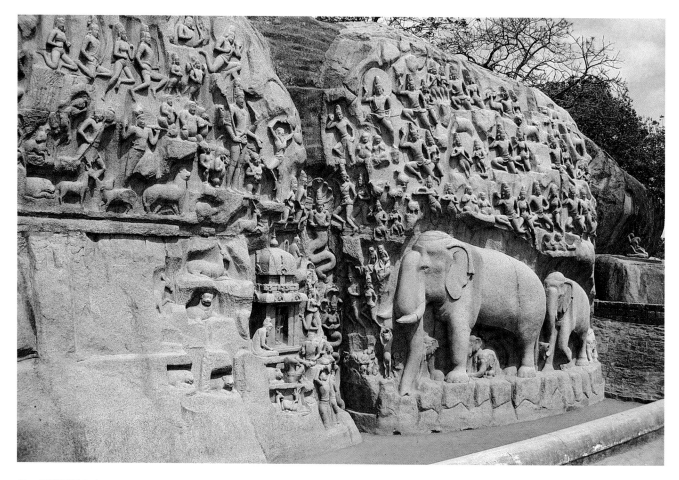

50 DESCENT OF THE GANGES.

Māmallapuram, India. 7th Century. Granite. Height approximately 30'.

a. Overview.

Dr. Jerome Feldman, Hawaii Pacific University.

An excellent example of Hindu iconography called DESCENT OF THE GANGES was carved in a huge granite outcropping in the town of Māmallapuram, in southern India. Included in the large composition are over a hundred human figures, deities, flying pairs of angels without wings, life-size elephants, and a variety of other animals, all converging at the Ganges River in an elaborate depiction of intertwining Hindu legends. As in Dürer's engraving, the composition is filled with symbolic subject matter.

The central gorge in the carving symbolizes the descent of the sacred Ganges from heaven to earth, making the land fertile. The cobra-like figures in the gorge are the King and Queen of the Nagas,

serpent deities that portray the great river. While these figures occupy the center of the relief, other legends are illustrated around them.

In front of the largest elephant is a comical depiction of a cat and mice. According to an old folk tale, a cat pretending to be an ascetic stood beside the Ganges with upraised paws and gazed at the sun. The cat convinced the mice that it was holy and thus worthy of worship. As the mice closed their eyes in reverence, the cat snatched them for dinner.

The whole sculpture relates to the annual miracle of the return of the life-giving waters of the river. Appropriately, the many figures appear to be emerging from the stone as if from flowing water.

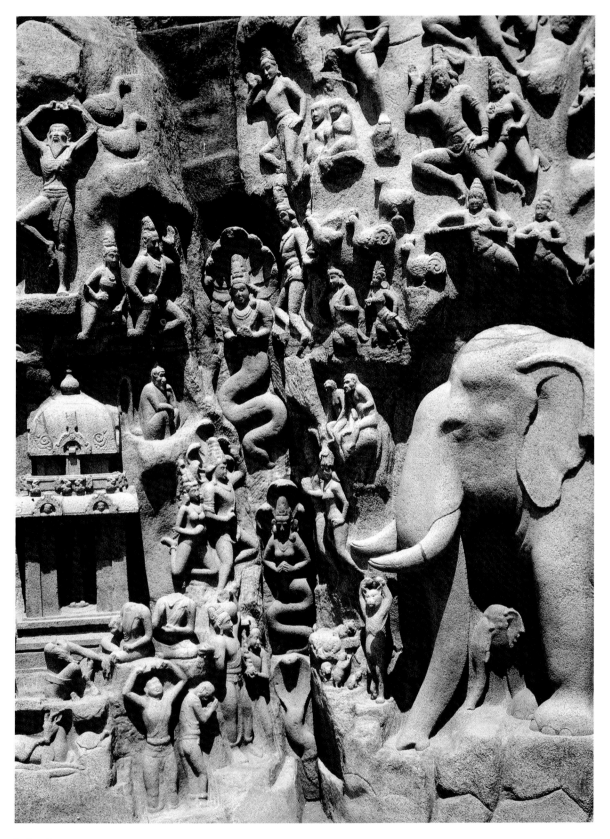

b. Detail.
Photograph: Duane Preble.

VISUAL ELEMENTS

Remember that a picture—before being a war horse, a nude woman, or some anecdote—is essentially a plane surface covered with colors assembled in a certain order.

MAURICE DENIS[1]

Painter Maurice Denis might have gone on to say that the *plane*, the two-dimensional picture surface, can also be covered with lines, shapes, textures, and other aspects of visual form (visual elements). Sculpture consists of these same elements organized and presented in three-dimensional space. Because of their overlapping qualities, it is impossible to draw rigid boundaries between the elements of visual form.

For example, a glance at Swiss artist Paul Klee's LANDSCAPE WITH YELLOW BIRDS reveals his playful interpretation of the subject. Fluid, curving *lines* define abstract *shapes*. Klee simplified and flattened the solid *masses* of natural plant and bird forms so that they read as flat shapes against a dark background *space*. Such abstraction emphasizes the fantastic, dreamlike quality of the subject. The whimsical positioning of the upside-down bird suggests a moment in *time* without *motion*. *Light* illuminates and enhances the yellow *color* of the birds and the unusual colors of the leaves. Surface *textures* provide further interest in each area of the painting.

This chapter introduces the visual elements identified in LANDSCAPE WITH YELLOW BIRDS: line, shape, mass, space, time, motion, light, color, and texture. Not all these elements are important, or even present, in every work of art; many works emphasize only a few elements. In order to understand their expressive possibilities, it is useful for us to examine—one at a time—some of the expressive qualities of each of the aspects of visual form.

53 Paul Klee.
LANDSCAPE WITH YELLOW BIRDS. 1923.
Watercolor, newspaper, black base. 14" × 17⅜".
Photograph: Hans Hinz/Artothek.
© 2002 Artists Rights Society (ARS), NY/VG Bild-Kunst, Bonn.

LINE

We write, draw, plan, and play with lines. Our individualities and feelings are expressed as we write our one-of-a-kind signatures or make other unmechanical lines. Line is our basic means for recording and symbolizing ideas, observations, and feelings; it is a primary means of visual communication. (An interactive exercise about line can be found on the *ed* *Discovering Art* CD.)

A line is an extension of a point. Our habit of making all kinds of lines obscures the fact that pure geometric line—line with only one dimension, length—is a mental concept. Such geometric lines, with no height or depth, do not exist in the three-dimensional physical world. Lines are actually linear forms in which length dominates over width. Wherever we see an edge, we can perceive the edge as a line—the place where one object or plane appears to end and another object or space begins. In a sense, we often "draw" with our eyes, converting edges to lines.

In art and in nature, we can consider *lines* as paths of action—records of the energy left by moving points. Many intersecting and contrasting linear paths form the composition in Ansel Adams' photograph RAILS AND JET TRAILS.

Characteristics of Line

Lines can be active or static, aggressive or passive, sensual or mechanical. Lines can indicate directions, define boundaries of shapes and spaces, imply volumes or solid masses, and suggest motion or emotion. Lines can also be grouped to depict light and shadow and to form patterns and textures. Note the line qualities in these LINE VARIATIONS.

54 Ansel Adams.
RAILS AND JET TRAILS, ROSEVILLE, CALIFORNIA. 1953.
Photograph.

55 LINE VARIATIONS.

a. Actual line.

b. Implied line.

c. Actual straight lines
and implied curved line.

d. Line created
by an edge.

e. Vertical line
(attitude of alert
attention); horizontal
line (attitude of rest).

f. Diagonal lines (slow
action, fast action).

g. Sharp, jagged line.

h. Dance of
curving lines.

i. Hard line, soft line.

j. Ragged, irregular line.

Consider the range of qualities expressed in Abby Leigh's simple WALLENOTE, in the vibrant energy of painted lines in Bridget Riley's CURRENT, and in the spontaneous dance of gestural line in Jackson Pollock's DRAWING. ACROBATS is one of many whimsical pieces of wire sculpture in which Alexander Calder took advantage of the descriptive and expressive potential of wire to draw in space.

Recording the outlines of three-dimensional shapes on a two-dimensional surface is a fundamental process of drawing—and one of the most important functions of line in art. In the descriptive drawing BLUE GINGER, contour lines depict the edges of leaves. Notice the contrasting ways contour lines are used to express lyric sensuality and brusque aggressiveness in the Japanese woodcut prints by Kiyonobu (WOMAN DANCER WITH FAN AND WAND) and Kiyotada (ACTOR IN A DANCE MOVEMENT).

56 Abby Leigh. WALLENOTE, 2002.
Linen on abaca on cotton, 30¾" × 30¾".
Paper made at Dieu Donne Papermill.
© Abby Leigh. Courtesy of the Betty Cuningham Gallery, NY.

58 Jackson Pollock.
DRAWING. 1950.
Duco on paper.
56.6 × 152.2 cm.
Staatsgalerie, Stuttgart. © 2002
The Pollock–Krasner Foundation/Artists
Rights Society (ARS), NY.

59 Alexander Calder.
TWO ACROBATS. 1928.
Brass wire.
Height with base 34".
Honolulu Academy of Arts, Gift of
Mrs. T.A. Cooke, Mrs. W.F.
Dillingham, and Mrs. P.E. Spalding,
1937. #4595. © 2002 Estate of
Alexander Calder/Artists Rights
Society (ARS), NY.

57 Bridget Riley.
CURRENT. 1964.
Synthetic polymer paint on composition board.
58⅜" × 58⅞".
The Museum of Modern Art, New York/Licensed by Scala-Art Resource, NY.
Philip Johnson Fund. Photograph © 2001 The Museum of Modern Art, NY.

60　Duane Preble.
BLUE GINGER. 1993.
Pencil. 13¾" × 11".

61　Attributed to Torii
Kiyonobu I.
WOMAN DANCER WITH
FAN AND WAND.
c. 1708.
Woodblock print.
21¾" × 11½".
The Metropolitan Museum of
Art, New York. Harris Brisbane
Dick Fund and Rogers Fund,
1949 (JP3098). Photograph:
© 1979 The Metropolitan
Museum of Art.

62　Torii Kiyotada.
AN ACTOR OF THE
ICHIKAWA CLAN IN A
DANCE MOVEMENT OF
VIOLENT MOTION.
c. 1715.
Hand-colored
woodcut. 11¼" × 6".
The Metropolitan Museum of
Art, New York. Harris Brisbane
Dick Fund and Rogers Fund,
1949 (JP3075). Photograph:
© 1979 The Metropolitan
Museum of Art.

63　John Sloan.
THE FLUTE PLAYER. 1905.
Etching. 3³⁄₁₆" × 2¾"; sheet 8" × 6".
Philadelphia Museum of Art: Purchased: Lessing J. Rosenwald gift and Katherine
Levin Farell Fund. 1956-35-61. Photo by Lynn Rosenthal, 2000.

Many kinds of prints are made up entirely of lines. Artists give these lines varying weights and functions, as we can see in the small etching THE FLUTE PLAYER. John Sloan used very light lines to suggest objects far away, as in the background at the upper left where lines indicate the edges of the lamppost. The lines are thicker and heavier where they describe nearer objects, such as the fire hydrant. Heavy lines close together help to emphasize the central figure of the flute player. In addition, Sloan deftly suggested the roundness of the figure by shading it from light to dark with parallel crossed lines called *crosshatching*. The density of the lines changes with the degree of shading on the subject. In the brightest areas, such as the flat street, there are no lines at all. Even a small work such as this—which is reproduced here near full size—shows sensitive use of line.

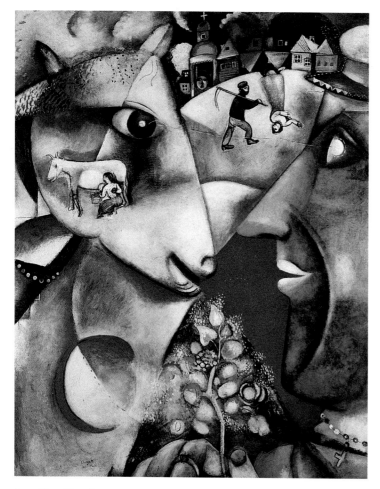

64 Marc Chagall.
I AND THE VILLAGE. 1911.
Oil on canvas. 75⅝" × 59⅝".
The Museum of Modern Art, NY/Licensed by Scala-Art Resource, NY. Mrs. Simon
Guggenheim Fund. Photograph ©2002 The Museum of Modern Art, New York.
© 2002 Artists Rights Society (ARS), NY/ADAGP, Paris.

64b Marc Chagall.
I AND THE VILLAGE. 1911.
Oil on canvas. 75⅝" × 59⅝".
The Museum of Modern Art, NY. Mrs. Simon Guggenheim Fund. Photograph
©2002 The Museum of Modern Art, New York. © 2002 Artists Rights Society
(ARS), NY/ADAGP, Paris.

Implied Line

Implied lines suggest visual connections. Implied lines that form geometric shapes can serve as an underlying organizational structure. In I AND THE VILLAGE, Marc Chagall used implied lines to create a circle that brings together scenes of Russian Jewish village life. Notice that he also drew in the implied sightline between man and animal.

SHAPE

The words shape, mass, and form are sometimes used interchangeably. Here *shape* is used to refer to the expanse within the outline of a two-dimensional area or within the outer boundaries of a three-dimensional object. When we see a three-dimensional object in natural light, we see that it has mass, or volume. If the same object is silhouetted against a sunset, we may see it only as a flat shape. Enclosing lines or changing color sets a shape or mass apart from its surroundings so that we recognize it. In BLUE GINGER (preceding page), lines define variations in similar leaf shapes.

We can group the infinite variety of shapes into two general categories: geometric and organic. *Geometric shapes*—such as circles, triangles, and squares—tend to be precise and regular. *Organic shapes* are irregular, often curving or rounded, and seem relaxed and more informal than geometric shapes. The most common shapes in the human-made world are geometric. Although some geometric shapes exist in nature—in such forms as crystals, honeycombs, and snowflakes—most shapes in nature are organic.

In I AND THE VILLAGE, Chagall used a geometric structure of circles and triangles to organize the organic shapes of people, animals, and plants. He softened the severity of geometric shapes to achieve a natural flow between the various parts of the painting. Conversely, he abstracted natural subjects toward geometric simplicity in order to strengthen visual impact and symbolic content. (An interactive exercise showing how shapes function in other artworks is on the *cd* *Discovering Art* CD.)

When a shape appears on a *picture plane* (the flat picture surface), it simultaneously creates a second shape out of the background area. The subject or dominant shapes are referred to as *figures* or *positive shapes*; background areas are *ground* or *negative shapes*. The figure-ground relationship is a fundamental aspect of perception; it allows us to sort out and interpret what we see. Because we are conditioned to see only objects, and not the spaces between and around them, it takes a shift in awareness to see the negative shapes in A SHAPE OF SPACE. An artist, however, must consider both positive and negative shapes simultaneously, and treat them as equally important to the total effectiveness of an image.

Interactions between figure shapes and ground shapes are heightened in some images. NIGHT LIFE can be seen as white shapes against black or as black shapes against white, or the figure-ground relationship can shift back and forth. In both this and M. C. Escher's woodcut SKY AND WATER, the shifting of figure and ground contributes to a similar content: the interrelatedness of all things.

In the upper half of Escher's print, we see dark geese on a white ground. As our eyes move down the page, the light upper background becomes fish against a black background. In the middle, however, fish and geese interlock so perfectly that we are not sure what is figure and what is ground. As our awareness shifts, fish shapes and bird shapes trade places, a phenomenon called *figure-ground reversal*.

66　Duane Preble.
NIGHT LIFE (figure-ground reversal).

65　A SHAPE OF SPACE.
(implied shape).

67　M. C. Escher.
SKY AND WATER I. 1938.
Woodcut. 17⅛" × 17¼".
© 2001 Cordon Art B.V., Baarn, Holland. All rights reserved.

MASS

Whereas a two-dimensional area is called a shape, a three-dimensional area is called a *mass*—the physical bulk of a solid body of material. When mass encloses space, the space is called *volume*. The word *form* is sometimes used instead of mass to refer to physical bulk.

Mass in Three Dimensions

Mass is often a major element in sculpture and architecture. Monumental mass was an important characteristic of ancient Egyptian architecture and sculpture. Egyptians sought this quality and perfected it because it expressed their desire to make art for eternity.

QENNEFER, STEWARD OF THE PALACE, was carved from hard black granite and retains the cubic, block-like appearance of the quarried stone. None of the limbs projects outward into the surrounding space.

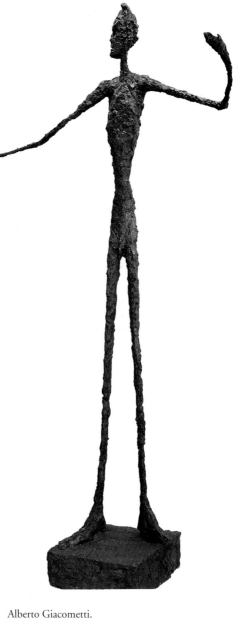

69 Alberto Giacometti.
MAN POINTING. 1947.
Bronze. 70½" × 40¾" × 16⅜".
The Museum of Modern Art, NY/Licensed by Scala-Art Resource, NY. Gift of Mrs. John D. Rockefeller III.
Photograph © 2002 The Museum of Modern Art, NY.
© 2002 Artists Rights Society (ARS), NY/ADAGP, Paris.

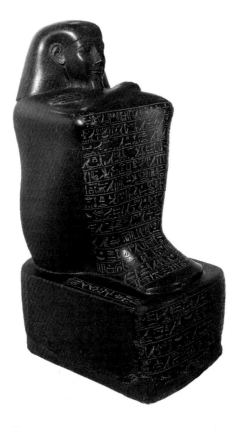

68 QENNEFER, STEWARD OF THE PALACE. C. 1450 B.C.E.
Black granite. Height 2'9",
The British Museum, Department of Egyptian Antiquities. © The British Museum.

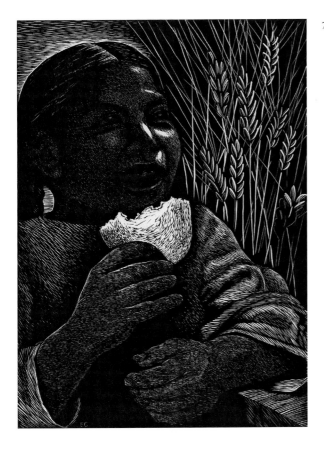

70 Elizabeth Catlett.
BREAD, 1962.
Linocut on paper.
Courtesy of Library of Congress, Prints and
Photographs Division.

The figure sits with knees drawn up and arms folded, the neck obscured by a ceremonial headdress. The body is abstracted and implied with minimal suggestion. This piece is a good example of *closed form*—form that does not openly interact with the space around it. Here, compact mass symbolizes permanence. Egyptian portrait sculpture acted as a symbolic container for the soul of an important person in order to insure eternal afterlife.

In contrast to the compact mass of the Egyptian portrait, modern sculptor Alberto Giacometti's MAN POINTING conveys a sense of fleeting presence rather than permanence. The tall, thin figure appears eroded by time and barely existing. Because Giacometti used little solid material to construct the figure, we are more aware of a linear form in space than of mass. The figure reaches out; its *open form* interacts with the surrounding space, which seems to overwhelm it, suggesting the fragile, impermanent nature of human existence.

Giacometti's art reveals an obsession with mortality that began when he was twenty, following the death of an older companion. Later, expressing the fleeting essence of human life became a major concern visible in his work. For Giacometti, both life and the making of art were continuous evolutions. He never felt that he succeeded in capturing the changing nature of what he saw, and therefore he considered all of his works unfinished.

Mass in Two Dimensions

With two-dimensional media, such as painting and drawing, mass must be implied. In BREAD, Catlett drew lines that seem to wrap around and define a girl

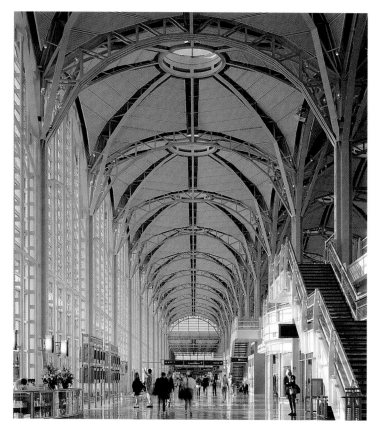

71 a. Cesar Pelli and Associates.
NORTH TERMINAL RONALD REAGAN WASHINGTON
NATIONAL AIRPORT. 1997.
Photographer: Jeff Goldberg/ Esto Photographics, Inc.

b. CLOSE-UP INTERIOR.
Photographer: Jeff Goldberg/ Esto Photographics, Inc.

in space, implying a solid mass. The work gives the appearance of mass because the lines both follow the curvature of the head and build up dark areas to suggest mass revealed by light. Her use of lines convinces us that we are seeing a fully rounded person. (Interactive exercises showing how artists imply mass in two dimensions are found on the *Discovering Art* CD.)

SPACE

Space is the indefinable, general receptacle of all things—the seemingly empty space around us. It is continuous, infinite, and ever present. The visual arts are sometimes referred to as *spatial* arts because most of these art forms are organized in space. In contrast, music is a *temporal* art because musical elements are organized primarily in time. In film, video, and dance, form is organized in both time and space.

Space in Three Dimensions

Of all the visual elements, space is the most difficult to convey in words and pictures. To experience three-dimensional space, we must be in it. We experience space beginning with our own positions in relation to other people, objects, surfaces, and voids at various distances from ourselves. Each of us has a sense of personal space—the area surrounding our bodies—that we like to protect, and the extent of this invisible boundary varies from person to person and from culture to culture.

Architects are especially concerned with the qualities of space. Imagine how you would feel in a small room with a very low ceiling. What if you raised the ceiling to fifteen feet? What if you added skylights? What if you replaced the walls with glass? In each case you would have changed the character of the space and, by doing so, would have radically changed your experience.

Whereas we experience the outside of a building as mass in space, we experience the inside as volume and as a sequence of enclosed spaces. Cesar Pelli's design for the NORTH TERMINAL at Ronald Reagan Washington National airport takes the passenger's experience of space into account. There are many large windows that offer views of the runways and

also of the Potomac River and the nearby Washington Monument. The interior is divided into many small domed modules: "The module has an important psychological value in that each one is like a very large living room in size," the architect said.[2] "It's a space that we experience in our daily life. . . . The domes make spaces designed on the scale of people, not on the scale of big machines."

Space in Two Dimensions

With three-dimensional objects and spaces, such as sculpture and architecture, we must move around to get the full experience. With two-dimensional works, such as drawing and painting, we see the space of the surface all at once. In drawings, prints, photographs, and paintings, the actual space of each picture's surface (*picture plane*) is defined by its edges—usually the two dimensions of height and width. Yet within these boundaries, a great variety of possible pictorial spaces can be implied, creating depth in the picture plane.

Paintings from ancient Egypt show little or no depth. Early Egyptian painters made their images clear by portraying objects from their most easily identifiable angles and by avoiding the visual confusion caused by overlap and the appearance of diminishing size. POND IN A GARDEN demonstrates this technique. The pond is shown from above while the trees, fish, and birds are all pictured from the side.

Implied Depth

Almost any mark on a picture plane begins to give the illusion of a third dimension: depth. Clues to seeing spatial depth are learned in early childhood. A few of the major ways of indicating space on a picture plane are shown in the diagrams of CLUES TO SPATIAL DEPTH.

When shapes overlap, we immediately assume from experience that one is in front of the other (diagram a). Overlapping is the most basic way to achieve the effect of depth on a flat surface. The effect of overlap is strengthened by *diminishing size*, which gives a sense of increasing distance between each of the shapes (diagram b). Our perception of distance depends on the observation that distant

72 POND IN A GARDEN.
 Wall painting from the tomb of Nebamun.
 Egypt. c. 1400 B.C.E.
 Paint on dry plaster.
 British Museum, London.
 Photograph: © The British Museum.

73 CLUES TO SPATIAL DEPTH.

a. Overlap.

b. Overlap and diminishing size.

c. Vertical placement.

d. Overlap, vertical placement, and diminishing size.

74 Mu Qi. SIX PERSIMMONS. C. 1269.
Pen and Ink on paper. width 36.2 cm.
Daitoku–ji Monastery, Kyoto, Japan. The Bridgeman Art Library International Ltd.

suggestion of depth in the overlap of two of the persimmons. By placing the smallest persimmon lowest on the picture plane, Mu Qi further minimized the illusion of depth; since we interpret the lower part of the picture as being closer to us, we might expect the persimmon there to be larger.

The persimmons appear against a pale background that works as both flat surface and infinite space. The shapes of the fruit punctuate the open space of the ground. Imagine what would happen to this painting if some of the space at the top were cut off. Space is far more than just leftovers; it is an integral part of the total visual design.

Linear Perspective. In general usage, the word perspective refers to point of view. In the visual arts, *perspective* refers to any means of representing three-dimensional objects in space on a two-dimensional surface. In this sense it is correct to speak of the perspective of Persian miniatures, Japanese prints, Chinese Song Dynasty paintings, or Egyptian paintings—although none of these styles is similar to the linear perspective system, which was developed during the Italian Renaissance. It is a difference in intention and tradition rather than mere skill that results in various ways of depicting depth.

In the West, we have become accustomed to *linear perspective* (also called simply *perspective*) to depict the way objects in space appear to the eye. This system was developed by Italian architects and painters in the fifteenth century, at the beginning of the Renaissance.

Linear perspective is based on the way we see. We have already noted that objects appear smaller when seen at a distance than when viewed close up. Because the spaces between objects also appear smaller when seen at a distance, parallel lines appear to converge as they recede into the distance, as shown in the first of the LINEAR PERSPECTIVE diagrams. Intellectually, we know that the edge lines of the road must be parallel, yet they seem to converge, meeting at last at what is called a *vanishing point* on the horizon—the place where land and sky appear to meet. On a picture surface, the horizon (or *horizon line*) also represents your eye level as you look at a scene.

objects appear smaller than near objects. A third method of achieving the illusion of depth is *vertical placement:* objects placed low on the picture plane (diagram c on the preceding page) appear to be closer to the viewer than objects placed high on the plane. This is the way we see most things in actual space. Creating illusions of depth on a flat surface usually involves one or more such devices (diagram d).

When we look at a picture, we may be conscious of both its actual flat surface and the illusion of depth that the picture contains. Artists can emphasize either the reality or the illusion—or strike a balance between these extremes. For centuries, Asian painters have paid careful attention to the relationship between the reality of the flat picture plane as well as the illusion of depth they wish to imply. Mu Qi's ink painting SIX PERSIMMONS has only a subtle

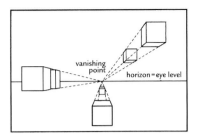

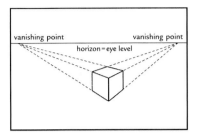

a. One-point linear perspective.

b. One-point linear perspective. Cubes above eye level, at eye level, and below eye level.

c. Two-point linear perspective.

Eye level is an imaginary plane, the height of the artist's eyes, parallel with the ground plane and extending to the horizon, where the eye level and ground plane appear to converge. In a finished picture, the artist's eye level becomes the eye level of anyone looking at the picture. Although the horizon is frequently blocked from view, it is necessary for an artist to establish a combined eye-level/horizon line to construct images using linear perspective.

With the LINEAR PERSPECTIVE system, an entire picture can be constructed from a single, fixed position called a *vantage point*, or *viewpoint*. Diagram a. shows one-point (one vanishing point) perspective, in which the parallel sides of the road appear to converge and trees in a row appear smaller as their distances from the vantage point increase.

Diagram b. shows cubes drawn in one-point linear perspective. The cubes at the left are at eye level; we can see neither their top nor their bottom surfaces. We might imagine them as buildings.

The cubes in the center are below eye level: We can look down on their tops. These cubes are drawn from a high vantage point, a viewing position above the subject. The horizon line is above these cubes and their perspective lines go up to it. We may imagine these as boxes on the floor.

The cubes at the right are above our eye level; we can look up at their bottom sides. These cubes are drawn from a low vantage point. The horizon line is below these cubes and their perspective lines go down to it. Imagine that these boxes are sitting on a glass shelf high above our heads.

In *one-point perspective*, all the major receding "lines" of the subject are actually parallel, yet visually they appear to converge at a single vanishing point on the horizon line. In *two-point perspective*, two sets of parallel lines appear to converge at two points on the horizon line, as in diagram c.

When a cube or any other rectilinear object is positioned so that a corner, instead of a side, is closest to us, we need two vanishing points to draw it. The parallel lines of the right side converge to the right; the parallel lines of the left side converge to the left. There can be as many vanishing points as there are sets and directions of parallel lines.

Horizontal parallel lines moving away from the viewer above eye level appear to go down to the horizon line; those below eye level appear to go up to the horizon line. (Linear perspective and spatial depth are explored on the *Discovering Art* CD.)

In THE SCHOOL OF ATHENS (on the following page), Raphael invented a grand architectural setting in the Renaissance style to provide an appropriate space for his depiction of the Greek philosophers Plato and Aristotle and other important thinkers. The size of each figure is drawn to scale according to its distance from the viewer; thus the entire group seems natural. Lines superimposed over the painting reveal the basic one-point perspective system used by Raphael. However, the cube in the foreground is not parallel to the picture plane or to the painted architecture and is in two-point perspective.

Raphael used perspective for emphasis. We infer that Plato and Aristotle are the most important

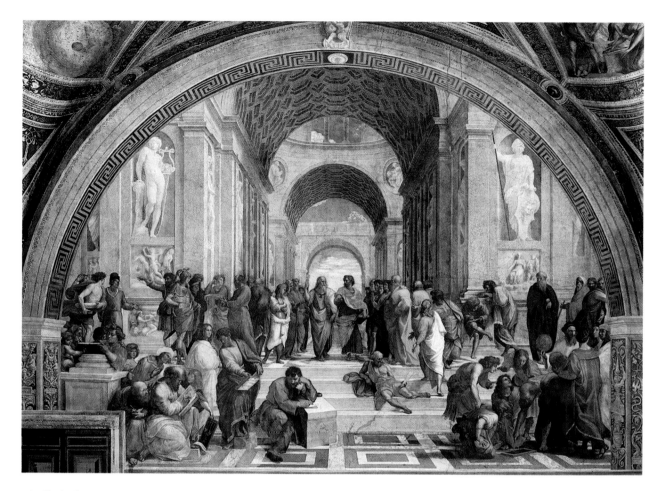

76 Raphael.

THE SCHOOL OF ATHENS. 1508. Fresco. Approximately 18' × 26'.
Stanza della Segnatura, Vatican Palace, Vatican State. © Erich Lessing/Art Resource, NY.

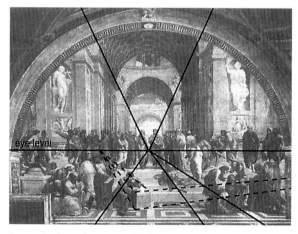

Perspective lines showing eye level, main vanishing point, and left
vanishing point for the stone block in the foreground.

76B Raphael.

THE SCHOOL OF ATHENS. 1508.
Stanza della Segnatura, Vatican Palace, Vatican State.
© Erich Lessing/Art Resource, NY.

77 Study of Raphael's THE SCHOOL OF ATHENS.

figures in this painting because of their placement at the center of receding archways in the zone of greatest implied depth.

If the figures are removed, as shown in the study of Raphael's THE SCHOOL OF ATHENS, our attention is pulled right through the painted setting into implied infinite space. Conversely, without their architectural background defined by perspective, Plato and Aristotle lose importance.

Atmospheric Perspective. *Atmospheric* or *aerial perspective* is a nonlinear means for giving an illusion of depth. The illusion of depth is created by changing color, value, and detail. In visual experience of the real world, as the distance increases between the viewer and faraway objects such as mountains, the increased quantity of air, moisture, and dust causes the distant objects to appear increasingly bluer and less distinct. Color intensity is diminished, and contrast between light and dark is reduced.

Asher Brown Durand used atmospheric perspective in his painting KINDRED SPIRITS to provide a sense of the vast distances in the North American wilderness. The illusion of infinite space is balanced by dramatically illuminated foreground details, by the figures of the men, and by Durand's lively portrayal of trees, rocks, and waterfalls. We identify with the figures of painter Thomas Cole and poet William Cullen Bryant as they enjoy the spectacular landscape. As in THE SCHOOL OF ATHENS, the implied deep space appears as an extension of the space we occupy.

Traditional Chinese landscape painters have differed from their European counterparts in their use of atmospheric perspective. In Shen Zhou's painting POET ON A MOUNTAIN TOP, near and distant mountains are suggested by washes of ink and color on white paper. The light gray of the farthest mountain implies space and atmosphere. Traditional Chinese landscape paintings present poetic symbols of landforms rather than realistic representations. Whereas KINDRED SPIRITS draws the viewer's eye into and through the suggested deep space, POET ON A MOUNTAIN TOP leads the eye across (rather than into) space.

78 Asher Brown Durand.
KINDRED SPIRITS. 1849.
Oil on canvas. 44" × 36".
Collection of the New York Public Library,
Astor, Lenox and Tilden Foundations.

A third system for suggesting depth is isometric perspective, which is employed by engineers and is often used by traditional Asian artists. In isometric perspective, parallel lines remain parallel; they do not converge as they recede. Instead, rectangular planes that turn away from the viewer are drawn as parallelograms. The illustration ISOMETRIC PERSPECTIVE shows a cube drawn in isometric perspective. Industrial designers and architects also find isometric perspective useful because it enables them to maintain accurate measurements in working drawings. The detail from the Chinese hanging scroll EIGHTEEN SCHOLARS (on the following page) shows furniture and another hanging scroll in isometric perspective.

白雲如帶東山腰石
磴飛空細路遙攬倚
枚藜舒眺望欲因鳴
澗谷吹簫沈周龍

79 Shen Zhou.
POET ON A MOUNTAIN TOP (CHANGI–LI YUAN–T'IAO).
Series: LANDSCAPE ALBUM: FIVE LEAVES by Shen Zhou, ONE LEAF
by Wen Cheng–Ming (Shen Shih–t'ien Wen Cheng-ming shan-shui-
ho-chuan). Ming Dynasty (1368–1644).
Album leaf mounted as a handscroll. Ink on paper.
15¼" × 23¾". Overall (38.73 × 60.32 cm).
The Nelson-Atkins Museum of Art, Kansas City, Missouri. (Purchase: Nelson Trust) 46–5½.

80 ISOMETRIC PERSPECTIVE.

81 Anonymous.
EIGHTEEN SCHOLARS. Detail.
Song Dynasty (960–1279).
Hanging scroll. Ink and color on silk.
67⅞" × 40¼".
National Palace Museum, Taipei, Taiwan.

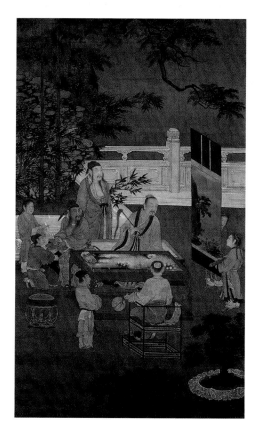

TIME AND MOTION

Time is the nonspatial continuum, the fourth dimension, in which events occur in succession. Because we live in an environment combining space and time, our experience of time often depends on our movement in space and vice versa. Although time itself is invisible, it can be made perceptible in art. Time and motion become major elements in visual media such as film, video, and kinetic (moving) sculpture.

Many traditional non-Western cultures teach that time is cyclic. The Aztecs of ancient Mexico, for example, held that the earth was subject to periodic destruction and recreation, and their calendar stone embodies this idea. At the center of the AZTEC CALENDAR STONE is a face of the sun god representing the present world, surrounded by four rectangular compartments that each represent one previous incarnation of the world. The whole stone is round, symbolizing the circular nature of time.

The Judeo-Christian tradition of Western culture teaches that time is linear—continually moving forward. The early Renaissance painter Sassetta implied the passage of linear time in his painted narration of THE MEETING OF SAINT ANTHONY AND SAINT PAUL. The painting depicts key moments during Saint Anthony's progression through time and space, including the start of his journey in the city, which is barely visible behind the trees. He first comes into view as he approaches the wilderness; we next see him encountering the centaur; finally, he emerges into the clearing in the foreground, where he meets Saint Paul. The road on which he travels implies continuous forward movement in time.

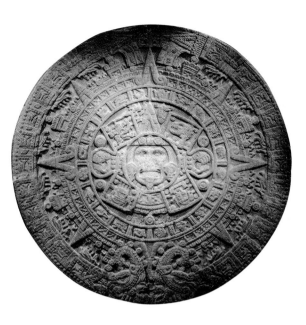

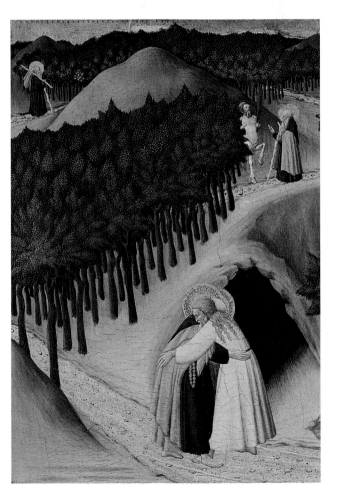

82 AZTEC CALENDAR STONE. 1479.
 National Museum of Anthropology, Mexico City.
 © Robert Frerck/Woodfin Camp and Associates.

83 Sassetta and Workshop of Sassetta.
 THE MEETING OF SAINT ANTHONY AND SAINT PAUL. c. 1440.
 Tempera on panel, .475 × .345 (18¾" × 13⅝");
 framed: .616 × 1.254 × .076 (24¼" × 49⅜" × 3").
 © 2001 Board of Trustees, The National Gallery of Art, Washington, D.C.
 Samuel H. Kress Collection. 1939.1.239.(404)/PA.

107 Vincent van Gogh.
Detail of STARRY NIGHT. 1889.
Oil on canvas. 29" × 36¼" (73.7 × 92.1 cm).
The Museum of Modern Art, NY/Licensed by Scala-Art Resource, NY.
Photograph: © 2002 The Museum of Modern Art, New York.

Incomplete mixing of the two left a mottled surface. Elsewhere in the body of the piece, the clay has loops and ridges that disclose the origin of the shape to be the leather flasks carried by horsemen. These varied textures make our experience of this object multisensory.

A painter may develop a rich tactile surface as well as an implied or simulated texture. We can see actual texture on a two-dimensional surface in the detail of van Gogh's STARRY NIGHT (the entire painting appears in Chapter 21 and in the interactive exercise on Texture and Pattern on the *Discovering Art* CD). With brush strokes of thick paint, called *impasto*, van Gogh invented textural rhythms that convey his intense feelings.

Five centuries earlier, painter Jan van Eyck used tiny brush strokes to show, in minute detail, the incredible richness of various materials. In his painting of GIOVANNI ARNOLFINI AND HIS BRIDE, van Eyck simulated a wide range of textural qualities. In the section of the painting reproduced here (close to actual size) we see the smooth textures of the mirror, amber beads, metal chandelier, a corner of a whisk broom, and the fur of the man's coat. Many other textures can be seen in the entire painting reproduced in Chapter 17.

We have explored some of the expressive powers of the visual elements. The ways in which the elements work together according to the principles of design are the focus of the next chapter.

108 Jan van Eyck. Detail of THE MARRIAGE OF GIOVANNI ARNOLFINI AND GIOVANNA CENAMI. 1434.
National Gallery, London.
Bridgeman Art Library, International, Ltd.

PRINCIPLES OF DESIGN

Organized perception is what art is all about.

ROY LICHTENSTEIN[1]

We are continually affecting and being affected by design—our own designs and the designs of others. Whenever we select clothing, place items on a plate, arrange furniture, or hang pictures, we are designing. The process of selecting and ordering the objects and events in our daily lives is related to the design process in art. Like all of us, artists and designers organize visual elements in order to create meaningful and interesting form. In two-dimensional arts, such as painting and photography, this organization is usually called *composition*, but a broader term that applies to the entire range of visual arts is *design*. The word *design* indicates both the process of organizing visual elements and the product of that process.

Design addresses of our basic need for meaningful order. Some designs are so well integrated that they have qualities beyond a mere sum of their parts. Such designs are said to be beautiful, interesting, absorbing, or surprising. Our desire to unify our experience of form is at the root of our appreciation for design.

There are no absolute rules for good design. However, there are principles and general guidelines for effective visual communication. We study them for the same reason artists do: to develop our innate design sense, to give ourselves a vocabulary for talking to one another about what we see, and to become more sensitive to the expressive and relational possibilities of form. In this chapter we look at seven key principles of design:

unity and variety
balance
emphasis and subordination
directional forces
contrast
repetition and rhythm
scale and proportion

Together, these terms provide an understanding not only of how artists work but also of how design affects us. The process at its best is a lively give-and-take between the intention and intuition of the designer and the character of the materials he or she uses.

UNITY AND VARIETY

Unity and variety are complementary concerns. *Unity* is the appearance or condition of oneness. In design, unity describes the feeling that all the elements in a work belong together and make up a coherent and harmonious whole. When a work of art has unity, we feel that any change would diminish its quality.

109 Jacob Lawrence.
GOING HOME. 1946.
Gouache.
21½" × 29½".
Private collection, courtesy of DC
Moore Gallery, NY. Artwork
copyright Gwendolyn Knight
Lawrence/Artists Rights Society
(ARS), NY.

Variety, on the other hand, provides diversity. Variety acts to counter unity. The sameness of too much unity is boring, and the diversity of uncontrolled variety is chaotic, but a balance between unity and variety creates life.

Artists select certain aspects of visual form in order to clarify and intensify the expressive character of their subjects or themes. In his painting GOING HOME, Jacob Lawrence balanced unity and variety. He established visual themes with the lines, shapes, and colors of the train seats, figures, and luggage, and then he repeated and varied those themes. Notice the varied repetition in the green chair seats and window shades. As a unifying element, the same red is used in a variety of shapes. The many figures and objects in the complex composition form a unified design through the artist's skillful use of abstraction, theme, and variation.

Lawrence was known for the lively harmony of his distinctive compositions. Although he worked in

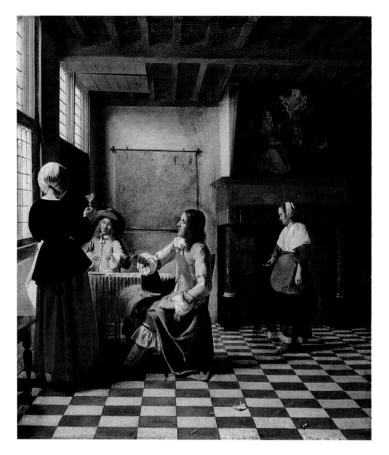

110 Pieter de Hooch.
 INTERIOR OF A DUTCH HOUSE. 1658.
 Oil on canvas. 29" × 35".
 © National Gallery, London.

a manner that may seem unsophisticated, he was always resolving his designs through adjustments of unity and diversity. Lawrence studied other artists' work, and he was influenced by painters who were design problem-solvers. He said, "I like to study the design to see how the artist solves his problems and brings his subjects to the public."[2]

The flat quality of GOING HOME contrasts with the illusion of depth in Pieter de Hooch's INTERIOR OF A DUTCH HOUSE. Each artist depicted daily life in a style relevant to his times. In both, the painter's depiction of space provides the unity in the composition. De Hooch "borrowed" the unity that architectural interior imposes in order to unify pictorial space and provide a cohesive setting for the interaction of figures.

Pattern refers to a repetitive ordering of design elements. In de Hooch's painting, the patterns of floor tiles and windows play off against the larger rectangles of map, painting, fireplace, and ceiling. These rectangular shapes provide a unifying structure. The nearly square picture plane itself forms the largest rectangle. He then created a whole family of related rectangles, as indicated in the accompanying diagram. In addition, the shapes and colors in the figures around the table relate to the shapes and colors of the figures in the painting above the fireplace—another use of theme and variation.

Alberto Giacometti's sculpture CHARIOT combines diverse elements—a standing female figure and two wheels. Unity is achieved through the thin lines and rough texture in the figure, wheels, and axle, as well as through the use of bronze for the entire piece. The unity of handling leads us to see the sculpture as a single mysterious entity. Our interest is held by the varied components and by the precariousness of the figure poised atop a two-legged table on two wheels. And these bring us to the principle called balance.

BALANCE

For sculptors such as Giacometti, balance is both a visual issue and a structural necessity. The interplay between the opposing forces of unity and variety is a common condition of life. The dynamic process of seeking balance is equally basic in art.

Balance is the achievement of equilibrium, in which acting influences are held in check by opposing forces. We strive for balance in life and in art, and we may lack peace of mind in its absence. In art, our instinct for physical balance finds its parallel in a desire for visual balance. A painting can depict an act of violence or imbalance—a frenzied battle or a fall from a tightrope; however, if the painting is unbalanced, it will lack the expressive power necessary to convince us that the battle was terrible, the fall disastrous. Instead, it will merely convince us that it is not a very good painting. (An interactive exercise on balance can be found on the *ed Discovering Art* CD.)

The two general types of balance are symmetrical (formal) and asymmetrical (informal).

Symmetrical Balance

Symmetrical balance is the near or exact matching of left and right sides of a three-dimensional form or a two-dimensional composition.

Architects often employ symmetrical balance to give unity and formal grandeur to a building's facade or front side. For example, in 1792 James Hoban won a competition for his DESIGN FOR THE PRESIDENT'S HOUSE, a drawing of a symmetrical, Georgian-style mansion. Today, two centuries and several additions later, we know it as the WHITE HOUSE.

Symmetrical design is useful in architecture because it is easier to comprehend than asymmetry. Symmetry imposes a balanced unity, making large complex buildings comprehensible in a glance. Symmetry connotes permanence and poise. We generally want our symbolically important buildings to seem motionless and stable. All the qualities that make symmetry desirable in architecture make it generally less desirable in sculpture and two-dimensional art. Too much symmetry can be boring. Although artists

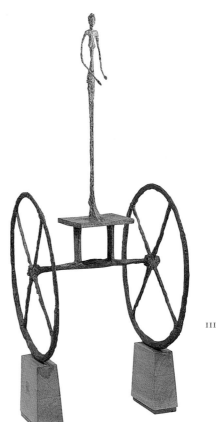

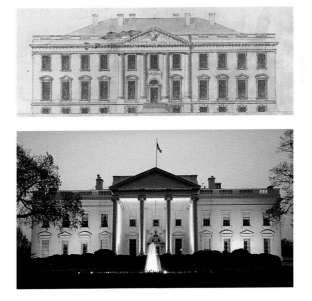

112 James Hoban.
ed A DESIGN FOR THE PRESIDENT'S HOUSE. 1792.
a. Elevation.
b. WHITE HOUSE.
Front view. 1997.

113 PORTRAIT OF THE HUNG-CHIH EMPEROR.
Ming Dynasty, 15th Century. Hanging Scroll. Ink and color on silk.
82" × 61".
National Palace Museum, Taipei, Taiwan, Republic of China.

admire symmetry for its formal qualities, they rarely employ it rigidly. Artists usually do not want their work to seem static.

Probably one of the most symmetrical paintings ever made is the PORTRAIT OF THE HUNG-CHIH EMPEROR, executed by an anonymous court artist in fifteenth-century China. The ruler sits stiffly facing us, hands concealed by his rich garments. Only a few asymmetrical dragons on the screen behind him and in the medallions on his cloak relieve the overall rigidity of the composition. Color in the painting is symmetrically placed, yet its richness also serves to lighten the air of formality and reserve. The emperor wanted to convey dignity, permanence, and majesty, and this artist's use of symmetry helps create those impressions.

Asymmetrical Balance

With *asymmetrical balance*, the left and right sides are not the same. Instead, various elements are balanced—according to their size and meaning—around a felt or implied center of gravity. For example, in THE EVENING GLOW OF THE ANDO, the composition as a whole seems balanced, but only because dramatic imbalances are held in check. The strong diagonal of the wall and floor is accented by the heads of the two subjects, one of whom is reading a poem. This diagonal provides the principal focus of the composition. The curves of the water in the upper left have no counterpart except for the curves of the figures at the center. The lightness of the water and the tree branches is balanced by the solidly anchored candle lamp that the other figure is adjusting. The horizontal lines of the alcove and floor mats give a rhythm to the composition which the principal diagonal often interrupts. The artist has engaged and balanced complex energies in a knowing and tasteful way typical of the best Japanese prints. Asymmetrical balance is difficult to achieve, but it is flexible, subtle, and dynamic.

What exactly are the visual weights of colors and forms, and how does an artist go about balancing them? As with design itself, there are no rules, only principles. Here are a few about visual balance:

- A large form is heavier, more attractive, or more attention-getting than a small form. Thus, two or more small forms can balance one large form.
- A form gathers visual weight as it nears the edge of a picture. In this way, a small form near an edge can balance a larger form near the center.
- A complex form is heavier than a simple form. Thus, a small complex form can balance a large simple form.

The introduction of color complicates these principles. Here are three color principles that overturn the three principles of form just given:

- Warm colors are heavier than cool colors. A single small yellow form can therefore balance a large dark blue form.
- Intense colors are heavier than weak or pale colors (tints and shades). Hence, a single small bright blue form near the center can balance a large pale blue form near an edge.
- The intensity, and therefore the weight, of any color increases as the background color approaches its complementary hue. Thus, on a green background, a small simple red form can balance a large complex blue form.

Although guidelines such as these are interesting to study and can be valuable to an artist if she or he gets "stuck," they are really "laboratory" examples. The truth is that most artists rely on a highly developed sensitivity to what "looks right" in order to arrive at a dynamic balance. Simply put, a picture is balanced when it feels balanced.

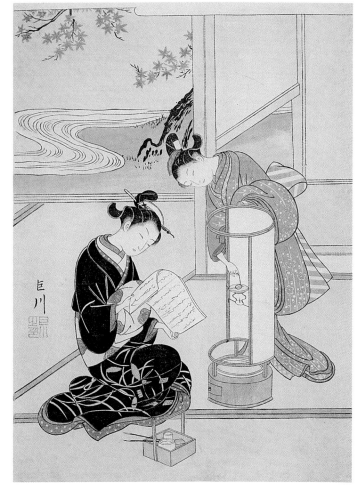

114 Suzuki Haranobu.
THE EVENING GLOW OF THE ANDO, from the series
EIGHT PARLOR VIEWS. Edo period. 1766.
Color woodblock print. 11¼" × 8½".
The Art Institute of Chicago. Clarence Buckingham Collection, 1928.900.
Photograph: © 1997, The Art Institute of Chicago. All rights reserved.

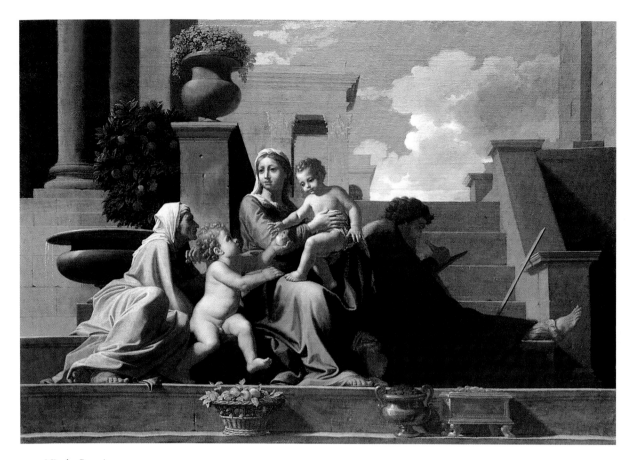

115 Nicolas Poussin.
THE HOLY FAMILY ON THE STEPS. 1648.
Oil on canvas. 28½" × 44" (72.4 × 111.7 cm).
© The Cleveland Museum of Art. 2001, Leonard C. Hanna Jr. Fund, 1981.18.

A classic example of balance in Western art is Nicolas Poussin's HOLY FAMILY ON THE STEPS. Poussin combined both asymmetrical and symmetrical elements in this complex composition. He grouped the figures in a stable, symmetrical pyramidal shape. The most important figure, the infant Jesus, is at the center of the picture, the strongest position. In case we don't see that right away, Poussin guided our attention by making the traditional red and blue of Mary's robes both light and bright, and by placing Jesus's head within a halolike architectural space.

But then Poussin offset the potential inertness of this symmetry with an ingenious asymmetrical color balance. He placed Joseph, the figure at the right, in deep shadow, undermining the clarity of the stable pyramid. He created a major center of interest at the far left of the picture by giving St. Elizabeth a bright

yellow robe. The interest created by the blue sky and clouds at the upper right counterbalances the figures of St. Elizabeth and the infant John the Baptist. But the final master stroke that brings complete balance is Joseph's foot, which Poussin bathed in light. The brightness of this small, isolated shape with the diagonal staff above it is enough to catch our eye and balance the color weights of the left half of the painting.

While the overall composition of HOLY FAMILY ON THE STEPS is balanced asymmetrically, the painting's center of gravity is still the central vertical axis. In JOCKEYS BEFORE THE RACE on the other hand, Edgar Degas located the center of gravity on the right. To reinforce it, he drew it in as a pole. At first glance, all our attention is drawn to our extreme right, to the nearest and largest horse. But the solitary

circle of the sun in the upper left exerts a strong fascination. The red cap, the pale pink jacket of the distant jockey, the subtle warm/cool color intersection at the horizon, and the decreasing sizes of the horses all help to move our eyes over to the left portion of the picture, where a barely discernible but very important vertical line directs our attention upward.

In JOCKEYS BEFORE THE RACE, a trail of visual cues moves our attention from right to left. If we are sensitive to them, we will perform the act of balancing the painting. If we are not, the painting will seem forever unbalanced. Degas, who was known for his adventurous compositions, relied on the fact that seeing is an active, creative process and not a passive one.

Notice that both Poussin and Degas used strong diagonals in their designs. In the Poussin, Elizabeth's robe at the lower left begins an implied diagonal line that continues up through the cloud at the upper right. In the Degas, the large horse in the lower right, our first center of attention, is counterbalanced by the sun in the upper left. Diagonal opposition is common in asymmetrical compositions, and looking for it can often help you find the key to the balance.

A good way to explore a picture's balance is to imagine it painted differently. Block out Joseph's light-bathed foot in the Poussin, then see how the lack of balance affects the picture. Cover the jockey's red cap in the Degas and you'll see a spark of life go out of the painting.

Asymmetrical balance in architecture is difficult to show in photographs. In Frank Lloyd Wright's FALLING WATER (Chapter 14), we can sense that the asymmetrically placed horizontal forms are firmly held, visually, by the implied gravity of the vertical tower. But what we cannot see is how the play of forms would shift constantly if we were to walk around the house, how the forms maintain a balance that we could see from every angle.

Besides the visual balance we seek in all art, works of sculpture and architecture need structural balance or they will not stand up. Feelings about visual balance are intimately connected to our experience with actual physical balance. It appears that

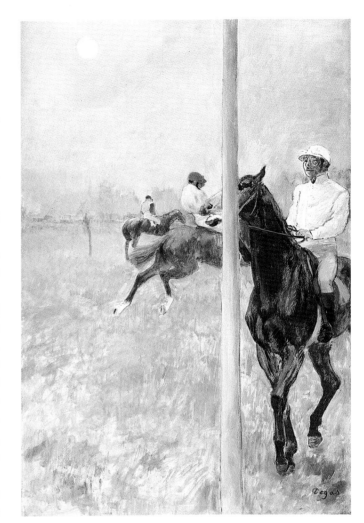

116 Edgar Degas.
JOCKEYS BEFORE THE RACE. c. 1878–1879.
Oil essence, gouache and pastel. 42½" × 29".
The Barber Institute of Fine Arts, The University of Birmingham/Bridgeman Art Library.

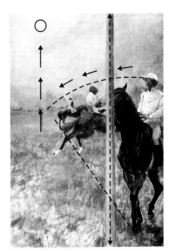

117 Beverly Pepper.
EXCALIBUR. 1975–1976.
San Diego Federal Courthouse.
Steel painted black. 35' × 45' × 45'.
Photograph: Courtesy of the Artist.
Beverly Pepper Studio.

Beverly Pepper designed her large sculpture EXCALIBUR to look somewhat unbalanced as a way of giving an intriguing tension to her soaring diagonal structures. We know the triangular forms are securely attached to the ground, yet they look precarious. If we view the work from this and other angles, the smaller piece seems to provide an anchor—a visual pull that acts as a counterweight to the larger form.

EMPHASIS AND SUBORDINATION

Emphasis is used to draw our attention to an area or areas. If that area is a specific spot or figure, it is called a *focal point*. Position, contrast, color intensity, and size can all be used to create emphasis.

Through *subordination*, an artist creates neutral areas of lesser interest that keep us from being distracted from the areas of emphasis. We have seen them at work in the two paintings we have just examined.

In HOLY FAMILY ON THE STEPS, Poussin placed the most important figure in the center, the strongest location in any visual field. In JOCKEYS BEFORE THE RACE, Degas took a different approach, using size, shape, placement, and color to create areas of emphasis *away* from the center. The sun is a separate focal point created through contrast (it is lighter than the surrounding sky area and the only circle in the painting) and through placement (it is the only shape in that part of the painting). Sky and grass

areas, however, are muted in color with almost no detail so that they would be subordinate to, and thus support, the areas of emphasis.

DIRECTIONAL FORCES

Like emphasis and subordination, directional forces influence the attention we pay to parts of an artwork. Directional forces are "paths" for the eye to follow provided by actual or implied lines. Implied directional lines may be suggested by a form's axis, by the imagined connection between similar or adjacent forms, or by the implied continuation of actual lines. Studying directional lines and forces often reveals a work of art's underlying energy and basic visual structure.

Looking at JOCKEYS BEFORE THE RACE, we find that our attention is pulled to a series of focal points: the horse and jockey at the extreme right, the vertical pole, the red cap, the pink jacket, and the blue-green at the horizon. The dominant directional forces in JOCKEYS are diagonal. The focal points mentioned above create an implied directional line. The face of the first jockey is included in this line.

The implied diagonal line created by the bodies of the three receding horses acts as a related directional force. As our eyes follow the recession, encouraged by the attraction of the focal points, we perform the act of balancing the composition by correcting our original attraction to the extreme right.

Just as our physical and visual feelings for balance correspond, so do our physical and visual feelings about directional lines and forces. The direction of lines produces sensations similar to standing still (|), being at rest (—), or being in motion (/). Therefore, a combination of vertical and horizontal lines provides stability. For example, columns and walls and horizontal steps provide a stable visual foundation for HOLY FAMILY ON THE STEPS. The vertical pole and horizon provide stability in Degas's JOCKEYS.

Francisco Goya's print BULLFIGHT provides a fascinating example of effective design based on a dramatic use of directional forces. To emphasize the drama of man and bull, Goya isolated them in the foreground as large, dark shapes against a light background. He created suspense by crowding the spectators into the upper left corner.

Goya evoked a sense of motion by placing the bullfighter exactly on the diagonal axis that runs from lower left to upper right (diagram a). He reinforced the feeling by placing the bull's hind legs along the same line.

Goya further emphasized two main features of the drama by placing the man's hands at the intersection of the image's most important horizontal and vertical lines. He also directed powerful diagonals from the bull's head and front legs to the pole's balancing point on the ground (a). The resulting sense of motion to the right is so powerful that everything in the rest of the etching is needed to balance it.

By placing the light source to the left, Goya extended the bull's shadow to the right, in order to create a relatively stable horizontal line. The man looks down at the shadow, creating a directional force that causes us also to look. When we do, we realize that the implied lines reveal the underlying structure to be a stable triangle (diagram b). Formally, the triangle serves as a balancing force; psychologically, its missing side serves to heighten the tension of the situation.

The dynamism of the man's diagonal axis is so strong that the composition needed additional balancing elements; thus Goya used light to create two

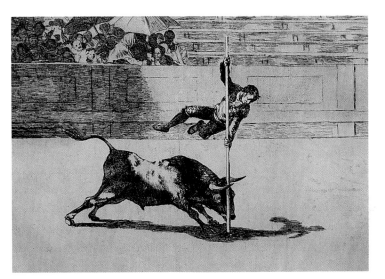

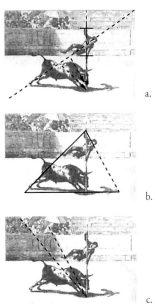

a.

b.

c.

118 Francisco Goya.
BULLFIGHT;
THE AGILITY AND DARING OF JUANITO APINANI.
Plate 20.
Ashmolean Museum, Oxford, England, U.K.

more diagonals in the opposite direction (diagram c). The area of shadow in the background completes the balance by adding visual weight and stability to the left.

It has taken many words and several diagrams to describe the visual dynamics that make the design of Goya's etching so effective. However, our eyes take it in instantly. Good design is efficient; it communicates its power immediately.

CHAPTER **six**

DRAWING

The desire to draw is as natural as the desire to talk. As children, we draw long before we learn to read and write. In fact, making letter forms is a kind of drawing—especially when we first learn to "write." Some of us continue to enjoy drawing; others return to drawing as adults. Those who no longer draw probably came to believe they did not draw well enough to suit themselves or others. Yet drawing is a learned process. It is a way of seeing and communicating, a way of paying attention.

In the most basic sense, to draw means to pull, push, or drag a marking tool across a surface to leave a line or mark. Most people working in the visual arts utilize drawing as a major tool for visual thinking—for recording and developing ideas.

Drawing is an immediate and accessible way to communicate through imagery. Through drawing we can share ideas, feelings, experiences, and imaginings. Sometimes a drawing does several of these things simultaneously.

The lines in Pamela Davis Kivelson's drawing of CAROL are lively and inventive, describing the way the subject appeared to Davis as she drew. She shaded the central area by smearing the felt-tip pen lines with wet fingers.

Many people find it valuable to keep a sketchbook handy to serve as a visual diary, a place to develop and maintain drawing skills and to note whatever catches the eye or imagination. From sketchbook drawings, some ideas may develop and

138 Pamela Davis Kivelson.
CAROL. 1973.
Felt-tip pen. 19⅓" × 17".
Courtesy of the artist.

reach maturity as finished drawings or compete works in other media. Leonardo da Vinci kept many of his exploratory drawings and writings in notebooks. He drew this study of THREE SEATED FIGURES next to idea sketches for some mechanical devices. Another study, DESIGNS FOR INVENTIONS, is the work

of Iris, age eight. These two sets of drawings made to aid visual thinking—one by a world-renowned artist, scientist, and engineer and one by an untrained child—underscore the essence of the thinking and drawing process.

A great deal of drawing is receptive; that is, we use it to attempt to capture the physical appearance of something before us. Many people use drawing in this way, as they take up a pencil or pen or chalk to render the fall of light on a jar, the leaves of a tree, arrangement of a landscape, the roundness of a body, or their own reflection in a mirror. This type of drawing can be a professional necessity for an artist, or recreation for the rest of us.

Other drawings, in contrast, are projective: We may draw something that already exists in our minds, either as a memory of something we have seen or a vision of something we imagine. Artists whose work is based on imagination often use this sort of drawing, as do architects when they plan new structures. The general tendency among today's artists in Europe and the United States seems to be toward projective types of drawing.

Drawing from direct observation is neither more nor less important than drawing from imagination or memory. However, the process of drawing from observation helps people learn to see more attentively and develops the ability to draw from either memory or imagination. In *The Zen of Seeing* medical doctor Frederick Franck describes drawing as a means to heighten visual awareness:

I have learned that what I have not drawn, I have never really seen, and that when I start drawing an ordinary thing I realize how extraordinary it is, sheer miracle: the branching of a tree, the structure of a dandelion's seed puff.[1]

139 Leonardo da Vinci.
THREE SEATED FIGURES AND STUDIES OF MACHINERY. c. 1490.
Silver-point on very pale pink, prepared surface.
Ashmolean Museum, Oxford, England, UK.

140 Iris Chamberlain, age 8.
DESIGNS FOR INVENTIONS. 1992.
Felt-tip pen. 8⅓" × 11".

141 Elizabeth Layton.
THE EYES OF THE LAW. 1985.
Crayon, colored pencil on paper.
Spencer Museum of Art: Gift of Don Lambert and the artist.

Learning to draw to your own satisfaction can transform your outlook on life. Elizabeth Layton was in her late sixties and had been suffering from depression for many years when she took a drawing course that "turned her around." She learned to create representational images with blind (or pure) contour drawing. This drawing method emphasizes the edge lines of a subject. After learning contour drawing, Layton drew with enthusiasm and gained wide recognition for the quality of her drawings.

Her most common subject was herself and her experiences, which she learned to depict with a keen and sometimes ironic visual sense. Her 1985 drawing THE EYES OF THE LAW is a humorous collection of the reflections in a crowd of policemen's mirrored sunglasses. In each lens we see a different view of her aged face.

Some artists, such as Picasso, demonstrated exceptional drawing ability as young children. Others, such as Paul Cézanne and Vincent van Gogh, did not show obvious drawing ability when they committed themselves to art. Their skills developed through diligent effort. In spite of early difficulties, they succeeded in teaching themselves to draw. Seeing and drawing are learned processes, not just inborn gifts.

Van Gogh learned a great deal, about both seeing and painting through his practice of drawing. He was just beginning his short career as an artist when he made the drawing of a CARPENTER. Although stiff, and clumsy in proportion, the drawing reveals van Gogh's careful observation and attention to detail. Yet he struggled to render the world with pencil and crayon, as his letters to his brother Theo show. In one of these notes, he recalled the difficulty and a breakthrough:

I remember quite well, now that you write about it, that at the time when you spoke of my becoming a painter, I thought it very impractical and would not hear of it. What made me stop doubting was reading a clear book on perspective . . . and a week later I drew the interior of a kitchen with stove, chair, table, and window—in their places and on their legs—whereas before it had seemed to me that getting depth and the right perspective into a drawing was witchcraft or pure chance. If only you drew one thing right, you would feel an irresistible longing to draw a thousand other things.[2]

OLD MAN WITH HIS HEAD IN HIS HANDS, made two years after CARPENTER, shows that van Gogh had learned a great deal about seeing and drawing in

those two years. By this time, van Gogh was able to portray the old man's grief as well as the solidity of the figure and to give a suggestion of his surroundings. The groups of parallel lines appear to have been drawn quickly, with sensitivity and self-assurance.

Good drawing may appear deceptively simple, yet it can take years of patient work to be able to draw easily and effectively. According to one account, a person viewing a portrait drawn by Matisse with only a few lines asked the artist with some disgust, "How long did it take you to do this?" "Forty years," replied Matisse (see his SELF-PORTRAIT on page 90).

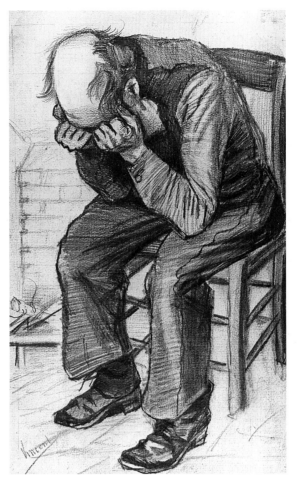

143 Vincent van Gogh.
OLD MAN WITH HIS HEAD IN HIS HANDS. 1882.
Pencil on paper. 19$\frac{11}{16}$" × 12$\frac{3}{16}$".
Vincent van Gogh Foundation/Van Gogh Museum, Amsterdam.

142 Vincent van Gogh.
CARPENTER. c. 1880.
Black crayon. 22" × 15".
Kröller-Müller, Otterlo, Netherlands.

VINCENT
van Gogh
(1853–1890)

144 Vincent van Gogh.
SELF PORTRAIT WITH GRAY HAT. 1887.
Oil on canvas. 17¼" × 14¾".
Vincent van Gogh Foundation/Van Gogh Museum,
Amsterdam.

TODAY THE ART of Vincent van Gogh is internationally known and admired. It is hard to believe that van Gogh worked as an artist for only ten years and that during his lifetime his art was known only to a few. In fact, he sold only one painting.

Van Gogh was born in the Netherlands. His father was a minister, his grandfather a famous preacher; three uncles, and later his brother, were art dealers—a background that paved the way for Vincent's lifelong concern with both art and religion.

From age sixteen, he worked for a firm of art dealers, first in The Hague and later in London and Paris. During this period he began what was to become his famous correspondence with his brother Theo. It is primarily

through these extraordinary letters (published in the book *Dear Theo*) that we have come to know van Gogh's short, intense, yet highly creative life.

After six years working for art dealers, he returned to the Netherlands to study theology. In 1878, at age twenty-five, he became a lay preacher among impoverished miners in Belgium. Although not successful at preaching, van Gogh was effective at nursing victims of mining disasters and disease. When his compassion spurred him to give most of his own clothes and other possessions to the poor, the missionary society that had hired him dismissed him for his literal interpretation of Christ's teachings.

Van Gogh remained in Belgium, living in acute poverty and spiritual turmoil until he decided to apply himself to becoming an artist. He made his commitment to art not because he possessed any obvious talent, but because he saw art as the means through which he could communicate with others. Although determined to be a painter, van Gogh believed that he had to master drawing before he allowed himself to use color. Miners and farm laborers were his first models. As he worked on developing his skill, Vincent—the name he used to sign his finished works—was supported by his brother Theo, who reg-

ularly sent money and provided encouragement through his letters.

Van Gogh studied briefly at the art academy in Antwerp, Belgium, but he was largely self-taught. In 1886 he joined his brother in Paris, where he met the leading French Impressionist and Post-Impressionist painters. Under their influence van Gogh's paintings, which had been limited to the somber tones of traditional Dutch painting, became much lighter and brighter in color (see his SELF-PORTRAIT WITH GRAY HAT).

In 1888 he moved to southern France, where—in less than two years—he produced most of the paintings for which he is known. There, armed with the Impressionists' bright, free color, and inspired by the intense semitropical light, van Gogh took color even further. He developed a revolutionary approach to color based on the way colors and color combinations symbolize ideas and emotional content. His new understanding of expressive color led him to write that "the painter of the future will be a colorist such as has never existed." [3]

Van Gogh's use of pure colors and his bold strokes of thick paint created images of emotional intensity that had a great impact on artists—especially Expressionist painters—of the twentieth century. Before van Gogh, most Western painters used color to describe the appearance of their subjects. After van Gogh, painters began to

realize that color could make visible feelings and states of mind.

From his teenage years, van Gogh's intense personality caused him to be rejected by the women with whom he fell in love, and later it drove away potential friends, such as Paul Gauguin. Such rejection contributed to several emotional breakdowns. Spells of fervent painting were interrupted by periods of illness arid depression. Increasing illness led him voluntarily to enter a mental hospital for several months. After leaving the hospital he returned to Paris, then settled in a nearby town under the watchful eye of a doctor known to be a friend of artists. There, in a frenzy of creative productivity, he completed about seventy paintings in sixty-five days—the last two months of his fife. Van Gogh's loneliness and despair drove him to suicide at age thirty-seven.

An emphasis on the tragic aspects of van Gogh's now legendary life has produced a popular view of the man that tends to obscure his great contribution to art. In spite of his difficulties, van Gogh produced almost two thousand works of art within a mere ten years. Although most of his contemporaries could not see the value of his art, his paintings and drawings are displayed today in major museums worldwide, and exhibitions of his works attract record crowds.

145 Michelangelo Buonarotti.
 Studies for the LIBYAN SIBYL on the
 Sistine Chapel ceiling. c. 1510.
 Red chalk on paper. 11⅜" × 8⅞".
 The Metropolitan Museum of Art, New York.
 Purchase (1924), (24.197.2). Joseph Pulitzer Bequest.
 Photograph: © 1995 The Metropolitan Museum of Art.

PURPOSES OF DRAWING

A drawing can function in three ways:

- as a notation, sketch, or record of something seen, remembered, or imagined
- as a study or preparation for another, usually larger and more complex work such as a sculpture, a building, a film, a painting—or another drawing
- as an end in itself, a complete work of art

Michelangelo made detailed studies of the LIBYAN SIBYL for his finished painting of the figure on the ceiling of the Sistine Chapel.

This magnificent drawing of a mythical female figure was drawn from a male model. The studies are a record of search and discovery as Michelangelo carefully drew what he observed. His knowledge of anatomy helped him to define each muscle. The flow between the head, shoulders, and arms of the figure is based on Michelangelo's feeling for visual

146 Pablo Picasso.
FIRST COMPOSITION STUDY FOR GUERNICA. May 1, 1937.
Pencil on blue paper. 8¼" × 10⅝".
Museo Nacional Centro de Arte Reina Sofia.
© 2002 Estate of Pablo Picasso/Artists Rights Society (ARS), NY.

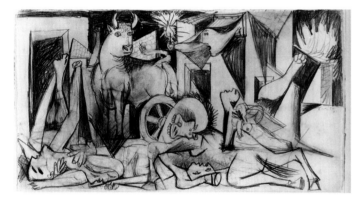

147 Pablo Picasso.
COMPOSITION STUDY FOR GUERNICA. May 9, 1937.
Pencil on white paper. 9½" × 17⅞".
Museo Nacional Centro de Arte Reina Sofia.
© 2002 Estate of Pablo Picasso/Artists Rights Society (ARS), NY.

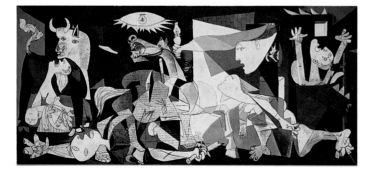

continuity as well as his attention to detail. The parts of the figure that he felt needed further study he drew repeatedly. To achieve the dark reds, Michelangelo evidently licked the point of the chalk.

A simple, tiny sketch, quickly done, can be the starting point for a far larger and more complex work. In such drawings an artist can work out problems of overall design or concentrate on small details. Picasso did many studies in preparation for a major painting, GUERNICA—a huge work measuring more than 11 feet high by 25 feet long (a larger reproduction appears in Chapter 23). Forty-five of Picasso's studies are preserved; nearly all are dated.

The first drawing for GUERNICA shows what can be identified in later stages as a woman with a lamp, apparently an important symbol to Picasso. The woman leans out of a house in the upper right. On the left appears a bull with a bird on its back. Both the bull and the woman with the lamp are major elements in the final painting. The first drawing was probably completed in a few seconds, yet its quick gestural lines contain the essence of the large, complex painting.

Although artists do not generally consider their preliminary sketches as finished pieces, studies by leading artists are often treasured both for their intrinsic beauty and for what they reveal about the creative process. Picasso recognized the importance of documenting the creative process from initial idea to finished painting:

It would be very interesting to preserve photographically, not the stages, but the metamorphoses of a picture. Possibly one might then discover the path followed by the brain in materializing a dream. But there is one very odd thing to notice, that basically a picture doesn't change, that the first "vision" remains almost intact, in spite of appearances.[4]

148 Pablo Picasso.
GUERNICA. 1937.
Oil on canvas. 11'5½" × 25'5¼".
Museo National Centro de Arte Reina Sofia, Madrid.
© John Bigelow Taylor/Art Resource NY.
© 2002 Estate of Pablo Picasso/Artists Rights Society (ARS), NY.

149 TYPES OF HATCHING.

a. Hatching.

b. Cross-hatching.

c. Contour hatching.

Another type of preparatory drawing is the cartoon. The original meaning of cartoon, still used by art professionals, is a full-sized drawing made as a guide for a large work in another medium, particularly a fresco painting, mosaic, or tapestry.

In today's common usage, the word *cartoon* refers to a narrative drawing emphasizing humorous or satirical content. Cartoons and comics are among the most widely enjoyed drawings. Young people fond of drawing cartoons often go on to develop their drawing skills in other ways.

Each drawing tool and each type of paper has its own characteristics. The interaction between these materials and the technique of the artist determines the nature of the resulting drawing. The illustration DRAWING TOOLS shows the different qualities of marks made by common drawing tools.

TYPES OF HATCHING shows how values can be built up with parallel lines, called *hatching*, or with *cross-hatching* of various types. Charles White used cross-hatched ink lines in PREACHER to build up the figure's mass and gesture in a forceful manner. Through the use of *contour hatching*, White gave the figure a feeling of sculptural mass. The foreshortened right hand and forearm add to the drawing's dramatic impact.

150 Charles White.
PREACHER. 1952.
Ink on cardboard.
21⅜" × 29⅜".
Collection of Whitney Museum of American Art, New York.
Purchase. 52.25.
Photograph: Geoffrey Clements, NY.
© 2001: Whitney Museum of American Art.

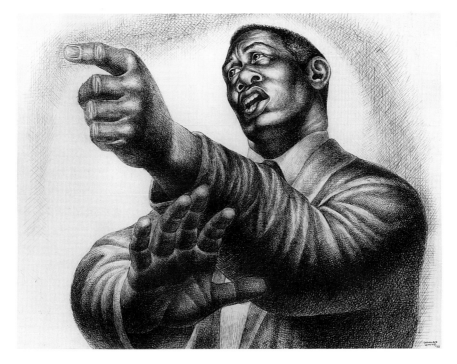

151 DRAWING TOOLS AND THEIR CHARACTERISTIC LINES.

DRY MEDIA

Dry drawing media include pencil, charcoal, conté crayon, and pastel. Drawing pencils include those made of graphite varying from soft (dark) to hard (light) and high-quality colored pencils in a wide range of colors.

Darkness and line quality are determined both by the degree of hardness of the pencil and by the texture of the surface to which it is applied. Paper with some *tooth* or surface grain receives pencil marks more readily than paper that is smooth. Pencil lines can vary in width or length, can be made by using the side of the pencil point in broad strokes, and can be repeated as hatching. A considerable range of values can be produced by varying the pressure on a medium-soft drawing pencil.

A rich variety of values and inventive shapes made with light and dark grades of drawing pencils fills Judith Murray's drawing OBSIDIAN.

The sticks of charcoal used today are similar to those used by prehistoric peoples to draw on cave walls. With charcoal, dark passages can be drawn quickly. The various hard-to-soft grades now available provide a flexible medium for both beginning and advanced artists. Because not all charcoal particles bind to the surface of the paper, charcoal is easy to smudge, blur, or erase. This quality is both an advantage and a drawback: it enables quick changes, but finished works can easily smear. A completed charcoal drawing may be set or "fixed" with a thin varnish called *fixative*, which is sprayed over it to help bind the charcoal to the paper. Charcoal produces a wide range of light to dark values from soft grays to deep velvety blacks.

Georgia O'Keeffe took full advantage of charcoal in her drawing of a BANANA FLOWER. The potential for showing gradations of shade in charcoal provided her with the means to draw with powerful precision. Here she dramatized the structure of her subject as a monumental sculptural mass. Although O'Keeffe is best known for her colorful paintings of enlarged close-up views of flowers (see page 33), in

152 Judith Murray.
OBSIDIAN. 1988.
Pencil on arches paper. 17½" × 19¼".
Courtesy of the artist. Collection of Howard and Terry S. Walters, Summit, NJ.

153 Georgia O'Keeffe.
BANANA FLOWER. 1933.
Charcoal and black chalk on paper. 21¾" × 14¾".
The Museum of Modern Art, NY/Licensed by Scala-Art Resource, NY. Given
anonymously (by exchange). Photograph © 2002 Museum of Modern Art, NY.
© 2002 The Georgia O'Keefe Foundation/Artists Rights Society (ARS), NY.

154 Georges Pierre Seurat.
L'ECHO, STUDY FOR UNE BAIGNADE, ASNIERES.
1882–1891.
Black conté crayon. 12¹⁵⁄₁₆" × 9⁷⁄₁₆".
Yale University Art Gallery, New Haven. Bequest of Edith Malvina K. Wetmore.
1966.80.11.

this drawing she achieved a comparable impact with just black and white.

Conté crayon is a semi-hard chalk with enough oil in the binder to cause it to adhere to smooth paper. It can produce varied lines or broad strokes that are relatively resistant to smudging. Wax-based crayons, such as those given to children, are avoided by serious artists; they lack flexibility, and most fade over time. Because the strokes do not blend easily, it is difficult to obtain bright color mixtures with wax crayons.

Georges Seurat used conté crayon to build up the illusion of three-dimensional form through value gradations (*chiaroscuro*) in his drawing L'ECHO. Seurat actually drew a multitude of lines; yet in the final drawing the individual lines are obscured by the total effect of finely textured light and dark areas. He selected conté crayon on rough paper as a means of concentrating on basic forms and on the interplay of light and shadow.

Natural chalks of red, white, and black have been used for drawing since ancient times. Pastes, produced since the seventeenth century, have characteristics similar to those of natural chalk. They have a freshness and purity of color because they are comprised mostly of pigment, with very little binding material. Because no drying is needed, there is no change in color, as occurs in some paints when they dry; Soft pastels do not allow for much detail—they force the user to work boldly. Blending of strokes with fingers or a paper stump made for the purpose produces a soft blur that lightly mixes the colors. Pastels yield the most exciting results when not overworked.

Venetian portraitist Rosalba Carriera made dozens of works with pastels in the early eighteenth century. Her ALLEGORY OF PAINTING depicts one of her favorite students at work. The hard, fine-grained pastels in common use at that time give the finished work a smooth surface that makes possible fine color shadings. Because of the artist's light, deft touch with short strokes of the pastel, the work resembles an oil painting in its appearance, an effect promoted by the very smooth paper. Carriera was in demand to make pastel portraits throughout Germany, France, and North Italy until poor eyesight forced her retirement in 1746.

French artist Edgar Degas shifted from oil painting to pastels in his later years, and occasionally he combined the two. He took advantage of the rich strokes of color and subtle blends possible with pastel. Although carefully constructed, his compositions look like casual, fleeting glimpses of everyday life. In LE PETIT DEJEUNER APRES LE BAIN, bold contours give a sense of movement to the whole design.

155 Rosalba Carriera.
ALLEGORY OF PAINTING. c. 1720.
Pastel on paper. 17¾" × 13¾".
Samuel H. Kress Collection. Photograph © 2001 Board of Trustees, National Gallery of Art, Washington, D.C. 1939.1.136.(247)/DR

156 Edgar Degas.
LE PETIT DEJEUNER APRES LE BAIN (JEUNE FEMMME S'ESSUYANT). c. 1894.
Pastel on paper. 99.7 × 59.7 cm.
© 2002. Courtesy Christie's Images Limited, NY.

157 Vincent van Gogh.
THE FOUNTAIN IN THE
HOSPITAL GARDEN. 1889.
Pen and ink. 18⅞" × 17¾".
Vincent van Gogh Foundation/
Van Gogh Museum, Amsterdam.

LIQUID MEDIA

Black or colored inks are the mast common drawing liquids. Some brush drawings are made with *washes* of ink thinned with water. Such ink drawings are similar to watercolor paintings. Felt- and fiber-tipped pens are widely used recent additions to the traditional pen-and-ink media.

In THE FOUNTAIN IN THE HOSPITAL GARDEN, van Gogh used a Japanese bamboo pen and ink for his vigorous lines, varying the darkness of lines by using both full strength and diluted ink. Rhythmic line groups suggest the play of light and shadow on the various surfaces.

Nineteenth-century Japanese artist Hokusai, a skilled and prolific draftsman, is said to have created about 13,000 prints and drawings during his lifetime. His good-humored statement about the development of his artistic ability should encourage all artists to persevere:

I have been in love with painting ever since I became conscious of it at the age of six. I drew some pictures which I thought fairly good when I was fifty, but really nothing I did before the age of seventy was of any value at all. At seventy-three I have at last caught every aspect of nature—birds, fish, animals, insects, trees, grasses, all.

When I am eighty I shall have developed still further and will really master the secrets of art at ninety. When I reach one hundred my art will be truly sublime, and my final goal will be attained around the age of one hundred and ten, when every line and dot I draw will be imbued with life.

(signed) HOKUSAI
The art-crazy old man[5]

In TUNING THE SAMISEN, the expressive elegance of Hokusai's lines was made possible by his control of the responsive brush. In Asia, the same brushes are used for traditional writing and drawing. These brushes are ideal for making calligraphic lines because they hold a substantial amount of ink and readily produce lines thick and thin. Hokusai played the uniformly thin lines of head, hands, and instrument against the bold spontaneous strokes indicating the folds of the kimono. As the woman tuned the strings of her samisen, he captured a moment of concentration with humor and insight.

Rembrandt also used brush and ink, plus wash (gray water color), for the drawing of his wife, SASKIA ASLEEP. The result is at once bold and subtle, representational and abstract, finished and unfinished. Rembrandt's spontaneous technique here bears comparison to Asian brush-painting technique seen in the works of Hokusai. While Rembrandt used shading to give the illusion of three-dimensional form, Hokusai suggested the mass of the figure with line alone.

158 Hokusai.
 TUNING THE SAMISEN. c. 1820–1825.
 Brush drawing. 9¾" × 8¼".
 Courtesy of Freer Gallery of Art, Smithsonian Institution, Washington, D.C.
 (F1904.241).

159 Rembrandt van Rijn.
 SASKIA ASLEEP. c. 1642.
 Brush and wash. 9½" × 8".
 Copyright The British Museum.

CONTEMPORARY APPROACHES

Today's artists have considerably expanded the definitions and uses of drawing. Many use it in combination with other media in finished works. Others use it as a tool to free the imagination by giving tangible form to ideas. Some artists use drawing as an aid to understanding drawings from the past, such as sketches by the masters or comics strips. A few artists create works in new ways using new media, and label them drawings because no other name quite describes what they do. Julie Mehretu, for example, uses media from both drawing and painting in the same large works. Her BACK TO GONDWANALAND piece from 2000 includes colored swatches of cut paper along with drawn ink lines. She makes abstract drawings, but the shapes she uses generally suggest the impersonal public spaces of today's mass-produced world: offices, classrooms, airports, and stadiums. If drawing has been traditionally an organic process, her works do not look entirely hand-made. Rather, they exist in a gap between the natural and the manufactured.

Christine Hiebert makes lines directly on walls with the blue tape that painters use to mask negative spaces. In works that she creates specifically for each exhibition, her lines affect our perception of the space. In her UNTITLED work (on the following page) from 2004, for example, she interrupted the clean horizontals and verticals of a gallery with diagonals of varying thickness. Her lines resemble drawn lines, but in fact she has "drawn" the tape across the walls. When the show is over, the tape comes off without leaving a trace.

Often a drawing is a predecessor to a painting, but John Currin frequently reverses the process. His 1999 painting HOBO (on the following page) is a chillingly exact depiction of an imaginary, strangely half-clothed hiker. He later rethought the image in a set of drawings in which he changed the pose slightly and added other props. The 2001 HOBO illustrated on the following page shows the figure carrying a marshmallow on a stick and wearing a wacky headdress with a fanny pack. These accoutrements make the figure seem more ridiculous, but the pose borrows some of the pedigree of a Renaissance painting by Sandro Botticelli, THE BIRTH OF VENUS (pictured in Chapter 16). Currin thus "reclothed" a historical image in a way that seems contemporary in its freewheeling use of imagination.

160 Julie Mehretu.
BACK TO GONDWANALAND.
Ink and acrylic on canvas, 8' × 10'.
Courtesy of the Project–New York and Los Angeles.

161 Christine Hiebert, UNTITLED, 2004.
Installation at Margarete Roeder Gallery, New York, 2004.
Blue adhesive tape on wall; full drawing: running wall length 36'7", wall height 11'6".
Courtesy of the artist.

162 John Currin.
HOBO. 1999.
Oil on canvas. 40" × 32".
© John Currin. Courtesy of the Gagosian Gallery, NY.

163 John Currin.
HOBO. 2001.
Pencil on paper. 11⁷⁄₁₆" × 9".
© John Currin. Courtesy of the Gagosian Gallery, NY.

PAINTING

For many people in the Western world, the word art means painting. The long, rich history of painting, the strong appeal of color, and the endless image-making possibilities explain painting's popularity.

Drawing and painting are related, overlapping processes. Paintings tend to be larger, more formal, more colorful, and usually take more time to complete than drawings—but there are many exceptions. There is no distinct separation between painting and drawing.

Painting is often drawing with paint. In Gerhard Richter's ABSTRACT PAINTING (on the following page), the medium, paint, and the process of its application are a major part of the message. Richter's invented landscape suggests rugged forms in the foreground and an open, distant sky. Large brush strokes of thickly applied oil paint contrast with the smooth gradations of paint in the sky area.

The people who made the earliest cave paintings used natural pigments obtained from plants and nearby deposits of minerals and clays. Pigments used in cave paintings at Pont d'Arc, France—including blacks from charred woods and earth colors—have lasted more than 30,000 years.

By Rembrandt's time, the seventeenth century, painters or their assistants mixed finely ground pigments with oil by hand until the paint reached a desirable fineness and consistency. Today high-quality paints are conveniently packaged in tubes or jars, ready for immediate use.

Paints consist of three components: pigment, binder (or medium), and vehicle. The pigment provides color; the binder mixes with the pigment to hold the pigment particles together and to attach the pigment to the surface; and the vehicle spreads the pigment. With oil paints, linseed oil is the binder and turpentine (or its substitute) is the vehicle. With traditional tempera, egg yolk is the binder and water is the vehicle.

Powdered coloring agents called pigments have long been derived from plant, animal, and mineral sources. In the nineteenth and twentieth centuries, major advances in the chemical industry made it possible to produce synthetic pigments that extend the available range of colors. Since then, the durability of both natural and synthetic pigments has also been improved. Most of the same pigments are used in manufacturing both the various paint media and the dry drawing media, such as colored pencils and pastels.

In the broad context of the visual arts, medium means both a material and its accompanying technique. In the context of painting, the word medium can also refer to the vehicle in which pigment is suspended in order to apply it.

Paints are usually applied to a flat support, such as stretched canvas for oils or paper for watercolors.

164　Gerhard Richter.
ABSTRACT PAINTING (551-4). 1984.
Oil on canvas. 17" × 23⅝".
© Gerhard Richter.

To achieve a ground (the prepared surface to which the paint is applied), the surface of the support (usually canvas) is prepared by sizing or priming, or both. Because supports are often too absorbent to permit controlled application of paint, a size, or sealer, is usually applied to lessen absorbency and fill in the pores of the material. For oil painting in particular, sizing is needed on canvas and paper to protect them from disintegrating from the drying action of linseed oil in oil paint. To complete the surface preparation for painting, an opaque primer, or ground, usually white, is often applied after or instead of sizing. Sizing and priming are unnecessary for watercolors; a paper surface provides both the support and the ground.

A student or beginning artist will want to experiment with the various types of paint available, learning firsthand the possibilities of each paint medium. Watercolor, tempera, oils, and synthetic or acrylic paints are among today's choices, but for the last five hundred years, oil paint has been the favorite medium of most Western painters. In recent years artists have begun to use synthetic (usually acrylic) paints for spraying, pouring, dripping, and other innovative methods of application. Each type of paint has its own unique advantages and disadvantages.

WATERCOLOR

Watercolor paintings are made by applying pigments suspended in a solution of water and gum arabic (a resin from the acacia tree) to white paper. Rag paper (made from cotton rag) is the preferred support because of its superior absorbency and long-lasting

165 Winslow Homer.
SLOOP, NASSAU. 1899.
Watercolor and graphite on off-white wove paper. 14⅞" × 21⁷⁄₁₆".
The Metropolitan Museum of Art. Amelia B. Lazarus Fund, 1910 (10.228.3).
Photograph: © 1989 The Metropolitan Museum of Art.

qualities. Blocks of paint available in metal or plastic boxes are modern versions of the dried blocks of watercolor used for thousands of years. Professional artists use high-quality pigments sold in tubes.

Watercolor is basically a staining technique. The paint is applied in thin, translucent washes that allow light to pass through the layers of color and to reflect back from the white paper. Highlights are obtained by leaving areas of white paper unpainted. Opaque (nontranslucent) watercolor is sometimes added for detail. Watercolors are well suited to spontaneous as well as carefully planned applications. Despite the simple materials involved, watercolor is a demanding medium because it does not permit easy changes or corrections. If you overwork a watercolor, you lose its characteristic freshness.

Watercolor's fluid spontaneity makes it a favorite medium for painters who want to catch quick impressions outdoors. The translucent quality of watercolor washes particularly suits depictions of water, atmosphere, light, and weather.

American artist and illustrator Winslow Homer was one of the best watercolorists. In SLOOP, NASSAU, Homer used the bright whiteness of the bare paper to form the highlights of ocean waves, boat, and sails. From light pencil lines to finished painting, his whole process is visible. Homer captured the mood of weather—in this case, the particular qualities of light and color in the calm just before a storm. For Homer, a keen observer of nature, a quick impression made with watercolor was visually stronger than a painting filled with carefully rendered details.

166 Qi Baishi.
LANDSCAPE. 1924.
Hanging scroll, ink and colors on paper. 40⅜" × 15⅜".
China National Art Gallery, Beijing, China/China Stock.

Homer's spontaneous technique was well suited to watercolor; because it dries so quickly, watercolor does not allow for easy changes if the artist makes a mistake or decides to alter the composition.

Opaque watercolor (also called gouache) has been widely used for centuries. It was common in book illustration during the European Middle Ages, and also in traditional Persian art (see Chapter 19 for an example). Gouache is like watercolor except that the medium includes small amounts of chalk powder. It is popular in our times with designers and illustrators because of its ease of use and low cost. Jacob Lawrence used gouache to good advantage in his work GOING HOME (see page 73). Here we see the typical opaque appearance of the colors. The speed of application of gouache also helps to suggest the rapid movements of the figures in the work.

In traditional Chinese watercolor technique, the artist employs water-based black ink as well as color, and often uses the ink without color. The Chinese regard painting as descended from the art of calligraphy, which is also done with black ink. In Asia, black ink painting is a fully developed art form, accorded at least as much honor as painting with color.

We see excellent use of ink in LANDSCAPE by Qi Baishi. The artist used a variety of techniques. At the top of the mountain is a spot of dark black. The rest of this landmass is composed of brush strokes of varying density. Some strokes show a brush laden with dark ink; in others, the brush is relatively dry. At the base of the mountain, a layer of mist is suggested with lateral strokes of very light wash. The grasses below are also suggested with deftly varying strokes of ink. The artist included a little green color in both the grasses and the mountain, and he finished the work with two lines of calligraphy in different writing styles. Despite the obvious level of skill and care in the composition, the painting shows great freshness, as if it were painted in a single brief sitting. This work demonstrates mastery of a variety of brushstrokes and control of ink in a wide range of tones, qualities admired in traditional Chinese painting.

TEMPERA

Tempera was used by the ancient Egyptians, Greeks, and Romans. It was highly developed during the Middle Ages, when it was used for small paintings made on wood panels. Since ancient times the principal tempera medium has been egg tempera, in which egg yolk, or occasionally egg white, is the binder. Today the word tempera is sometimes used for the water-based paints such as poster paints or paints with binders of glue or casein.

Egg tempera has a luminous, slightly matte (not shiny) surface when dry. Its clear, brilliant quality results from painting on a ground of very white gesso. Gesso, a preparation of chalk or plaster of Paris and glue, is applied to a support as a ground for tempera and oil paintings.

Egg tempera is good for achieving sharp lines and precise details, and it does not darken with age. However, its colors change during drying, and blending and reworking are difficult because tempera dries rapidly. Traditional tempera painting requires complete preliminary drawing and pale underpainting because of its translucency and the difficulty in making changes. Overpainting consists of applying layers of translucent paint in small, careful strokes. Because tempera lacks flexibility, movement of the support may cause the gesso and pigment to crack. A rigid support, such as a wood panel, is required.

In MADONNA AND CHILD, Fra Filippo Lippi methodically built up thin layers of color, creating a smooth, almost luminous surface. Tempera is well suited for depicting translucencies such as those created by Lippi in the halo and the sheer neck scarf. His naturalistic yet poetic portrayal brought a worldly dimension to religious subject matter.

OIL

In Western art, oil paint has been a favorite medium for five centuries. Pigments mixed with various vegetable oils, such as linseed, walnut, and poppyseed, were used in the Middle Ages for decorative purposes, but not until the fifteenth century did Flemish painters fully develop the use of paint made with

167 Fra Filippo Lippi.
MADONNA AND CHILD. c. 1440–1445.
Tempera on wood. 31⅜" × 20⅛";
framed 46⅛" × 33⅝" × 3¾".
Samuel H. Kress Collection.
Photograph © 2001 Board of Trustees, National Gallery of Art, Washington.
1939.1.290.(401)/PA.

linseed oil pressed from the seeds of the flax plant. In this early period, artists applied oil paint to wood panels covered with smooth layers of gesso, as in the older tradition of tempera painting. (The *Discovering Art* CD demonstrates how oil paint is made by mixing pigment, binder, and medium.)

The van Eyck brothers, Hubert and Jan, are credited with developing oil painting techniques and bringing them to their first perfection. They achieved glowing, jewel-like surfaces that remain

168 Jan van Eyck.
MADONNA AND CHILD WITH THE
CHANCELLOR ROLIN. c. 1433–1434.
Oil and tempera on panel. 26" × 24⅜".
Musée du Louvre, Paris.
Photograph: Erich Lessing/Art Resource, NY.

amazingly fresh to the present day. Jan van Eyck's MADONNA AND CHILD WITH THE CHANCELLOR ROLIN is an example of his early mastery of the oil technique.

MADONNA AND CHILD WITH THE CHANCELLOR ROLIN was painted on a small gesso-covered wood panel. After beginning with a brush drawing in tempera, van Eyck proceeded with thin layers of oil paint, moving from light to dark and from opaque to translucent colors. The luminous quality of the surface is the result of successive oil glazes. A glaze is a very thin, transparent film of color applied over a previously painted surface. To produce glazes, oil colors selected for their transparency are diluted with glazing medium—usually a mixture of oil, thinner, and varnish. Glazes give depth to painted surfaces by allowing light to pass through and reflect from lower paint layers.

Here the sparkling jewels, the textiles, and the furs are each given their own refined textures. Within the context of the religious subject, van Eyck demonstrated his enthusiasm for the delights of the visible world. Veils of glazes in the sky area provide atmospheric perspective and thus contribute to the illusion of deep space in the enticing view beyond the open window. The evolution in the new oil painting technique made such realism possible.

Oil has many advantages not found in other traditional media. Compared to tempera, oil paint can provide both increased opacity—which yields better covering power—and, when thinned, greater transparency. Its slow drying time, first considered a

169 Rembrandt van Rijn.
 Detail of SELF-PORTRAIT. 1663.
 Oil on canvas. Full painting 45" × 38".
 Kenwood House/English Heritage Photo Library.

170 Frank Auerbach.
 HEAD OF MICHAEL PODRO. 1981.
 Oil on board. 13" × 11".
 Photograph: Marlborough Fine Art Ltd., London.

drawback, soon proved to be a distinct advantage, permitting strokes of color to be blended and repeated changes to be made during the painting process. Unlike pigment in tempera, gouache, and acrylics, pigment colors in oil change little when drying; however, oil medium (primarily linseed oil) has a tendency to darken and yellow slightly with age. Because of the flexibility of dried oil film, sixteenth-century Venetian painters who wished to paint large pictures could replace heavy wood panels with canvas stretched on wood frames. A painted canvas not only is light in weight, but also can be unstretched and rolled (if the paint layer is not too thick) for transporting. Canvas continues to be the preferred support for oil paintings.

Oil can be applied thickly or thinly, wet into wet or wet onto dry. When applied thickly, it is called impasto. When a work is painted wet into wet and completed at one sitting, the process is called the direct painting method.

Rembrandt used this method in his SELF-PORTRAIT. The detail here shows how the impasto of light and dark paint both defines a solid-looking head and presents the incredible richness of Rembrandt's brushwork.

In Rembrandt's SELF-PORTRAIT and in Frank Auerbach's HEAD OF MICHAEL PODRO, the artists' responsiveness to both the reality of their subjects and the physical nature of paint and painting is clearly visible. Because the thick, paste-like quality of oil paint is celebrated rather than hidden, viewers participate in the process of conjuring up images when viewing Rembrandt's rough strokes and Auerbach's smears and globs of paint. Both paintings project strong images when seen at a distance and show rich tactile surfaces when viewed close up.

171 Joan Mitchell.
 BORDER. 1989.
 Oil on canvas. 45½" × 35".
 Courtesy Robert Miller Gallery. © The Estate of Joan Mitchell.

The wide range of approaches possible with oil paint becomes apparent when we compare van Eyck's subtly glazed colors with the impasto surfaces of Rembrandt and Auerbach.

In one sense, the story of painting is about the visual magic that people around the world have been able to conjure up with various paint media.

Joan Mitchell used oil paint to spontaneously re-create emotional states in abstract visual form. BORDER is painted very loosely in a complex mix of rich, sensuous colors. The composition is subtly symmetrical (note the light vertical green stripe near the top center), and colors are applied with a combination of care and abandon. To arrive at the bright and lush yellows, blues, greens, and reds, the artist avoided overmixing her colors. The varying textures of the work show spontaneous, expressive execution. She made the yellow strokes with a dry brush; she allowed some of the blues to run; reds give accents at carefully selected points. We can actually follow the creation of this work, layer by layer and color by color, as we look at this embodiment of a warm—even exciting—mood.

Some contemporary artists use oil in ways that show the influence of digital arts and animation. Inka Essenhigh's 2003 work ESCAPE POD, for example, resembles a still from an animated science-fiction film. The work's title refers to the small craft that space travelers use in case of disaster, and some kind of accident seems to have happened here. The slick surfaces and subtle gradations of tone in this work make good use of the characteristics of oil paint.

172 Inka Essenhigh.
 ESCAPE POD, 2003.
 Oil on canvas. 50" × 50".
 Courtesy 303 Gallery, NY.

ACRYLIC

Foremost among the synthetic painting media currently in wide use are acrylics. Pigments are suspended in acrylic polymer medium, which provides a fast-drying, flexible film. These relatively permanent paints can be applied to a wider variety of surfaces than traditional painting media. Most acrylics are water-thinned yet water-resistant when dry. Because acrylic resin medium is highly transparent, colors can maintain a high degree of intensity. Unlike oils, acrylics rarely darken or yellow with age. Their rapid drying time restricts blending and reworking possibilities, but it greatly reduces the time involved in layering processes such as glazing.

Acrylics work well when paint is applied quickly with little blending—witness the splash in David Hockney's A BIGGER SPLASH—or when it is brushed on in flat areas as in the rest of the painting. The strong contrast between the dramatic freedom of the paint application of the splash and the thinly painted, geometric shapes of house, chair, pool rim, and diving board gives lively energy to the suburban scene.

In recent years many painters have used airbrushes to apply acrylics and other types of paint. An airbrush is a small-scale paint sprayer capable of projecting a fine, controlled mist of paint. It provides an even paint application without the personal touch of individual brush strokes, and it is therefore well suited to the subtle gradations of color values found in many paintings of the 1960s and 1970s, such as Audrey Flack's WHEEL OF FORTUNE. Graffiti artists, of course, also favor spray guns because of the quickness of execution.

ENCAUSTIC

In the ancient medium of encaustic, pigments are suspended in hot beeswax, resulting in lustrous surfaces that bring out the full richness of colors. The Egyptian city of Fayum was a center of encaustic painting during the second century. Fayum portraits,

173 David Hockney.
A BIGGER SPLASH. 1967.
Acrylic on canvas. 96" × 96".
The Tate Gallery, London/Art Resource, NY.

174 Audrey Flack.
WHEEL OF FORTUNE. 1977–1978.
Oil over acrylic on canvas. 96" × 96".
Photograph courtesy of Louis K. Meisel Gallery, New York.

175 PORTRAIT OF A BOY.
From Fayum, Lower
Egypt. c. 50–100 C.E.
Encaustic on
limewood.
15⅜" × 7½".
The Metropolitan Museum of
Art, New York. Gift of Edward
S. Harkness, 1918. (18.9.2).
Photograph: © 1998 The
Metropolitan Museum of Art.

such as the PORTRAIT OF A BOY, were memorials to the deceased, painted directly on their wooden coffins. In these portraits, the sense of lifelike individuality remains strong, and colors have retained their intensity after almost two thousand years.

Early practitioners found it difficult to keep the wax binder of encaustic at the right temperature for proper handling; with modern electrical heating devices, it is easier to maintain workable temperatures. Nevertheless, encaustic is used by only a few painters today. One of the best-known proponents of encaustic painting is Jasper Johns, whose TARGET WITH FOUR FACES is pictured in Chapter 23.

FRESCO

True fresco, or buon fresco, is an ancient wallpainting technique in which very finely ground pigments suspended in water are applied to a damp lime-plaster surface. Generally, a full-size drawing called a cartoon is completed first, then transferred to the freshly laid plaster wall before painting. Because the plaster dries quickly, only the portion of the wall that can be painted in one day is prepared; joints are usually arranged along the edges of major shapes in the composition.

The painter works quickly in a rapid staining process similar to watercolor. Lime, in contact with air, forms transparent calcium crystals that chemically bind the pigment to the moist lime-plaster wall. The lime in the plaster thus becomes the binder, creating a smooth, extremely durable surface. Once the surface has dried, the painting is part of the wall. Notice the texture of the plaster in the detail from Diego Rivera's DETROIT INDUSTRY. Completion of the chemical reaction occurs slowly, deepening and enriching the colors as the fresco ages. Colors reach their greatest intensity fifty to one hundred years after a fresco is painted, yet the hues always have a muted quality.

The artist must have the design completely worked out before painting, because no changes can be made after the paint is applied to the fresh plaster. It may take twelve to fourteen straight hours of work just to complete two square yards of a fresco painting. Fresco technique does not permit the delicate manipulation of transitional tones; but the luminous color, fine surface, and permanent color make it an ideal medium for large murals. (A mural is any wall-sized painting; fresco is one possible medium for such a work.)

Secco fresco (dry fresco), another ancient wall-painting method, is done on finished, dried lime-plaster walls. With this technique, tempera paint is applied to a clean, dry surface or over an already dried buon fresco to achieve greater color intensity than is possible with buon fresco alone.

Fresco has been used in Asian and Western cultures for at least four thousand years. In Renaissance Italy it was the favored medium for painting on church walls. Probably the best known fresco paintings are those by Michelangelo on the Sistine Chapel ceiling in the Vatican in Rome, Italy. After the

Renaissance and Baroque periods, fresco became less popular, eclipsed by the more flexible oil medium. However, a revival of the fresco technique began in Mexico in the 1920s, encouraged by the new revolutionary government's support for public murals.

By leading the revival in fresco mural painting for public buildings, Diego Rivera broke away from the limited studio and gallery audience and made art a part of the life of the people. His style blends European and native art traditions with contemporary subject matter. He created DETROIT INDUSTRY in the lobby of the Detroit Institute of Arts.

176 Diego Rivera. Detail from
 DETROIT INDUSTRY. 1932–1933.
 Fresco.
 Detroit Institute of Arts. Gift of Edsel B. Ford/
 Bridgeman Art Library.

177 Diego Rivera.
 DETROIT INDUSTRY, 1932–1933.
 Fresco.
 Detroit Institute of Arts. Gift of Edsel B. Ford/
 Bridgeman Art Library.

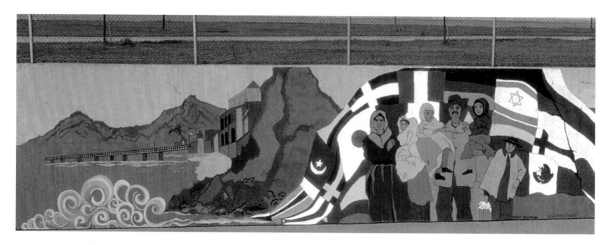

178 Judy Baca, director; Isabel Castro, designer.
GREAT WALL OF LOS ANGELES, IMMIGRANT CALIFORNIA. 1976–1983.
Tujunga Wash, Studio City, CA.
Photograph: Social and Public Art Resource Center (SPARC), Venice, CA.

THE WORLD'S largest painting is fourteen feet high and stretches for a half mile along the side wall of a drainage ditch in the San Fernando Valley. Not able to take it in all at once, viewers must contemplate it from a bike path or through the windows of their passing cars. This colossal project is the brainchild of Judy Baca, who for twenty years has combined art with community activism.

She was inspired by the mural paintings of Mexican artists of the 1920s and 1930s, who decorated public buildings with scenes of their country's history and life. They showed through their work how art could become, rather than a luxurious private possession, a vehicle of community awareness and empowerment. Baca recalls recruiting over four hundred teenagers and young adults to help make

THE GREAT WALL OF LOS ANGELES over a period of several summers beginning in 1976.

Baca recalls how the idea was born:

When I first saw the wall, I envisioned a long narrative of another history of California: one which included ethnic peoples, women, and minorities who were so invisible in conventional textbook accounts. The discovery of California's multicultured peoples was a revelation to me.[1]

THE GREAT WALL presents a sweeping panorama of the history of California. Beginning with the Native American cultures of the area, it continues with the Roman Catholic missions and moves on to the Anglicization of the state when it became part of the United States with the Treaty of Guadalupe Hidalgo in

1848. The twentieth-century section includes the Dust Bowl migrants of the 1930s, the dawn of the movie and aviation industries, and the impact of World War II.

Many parts of the mural highlight histories that are often left untold. One panel tells graphically how the building of Dodger Stadium in 1962 dislodged a Mexican-American neighborhood. Another depicts the forced incarceration of Japanese Americans in "relocation" camps after the Pearl Harbor attack that started World War II in the Pacific. A third deals with the blacklisting of dozens of Hollywood writers for suspected Communist affiliations during the height of the Cold War. THE GREAT WALL's size parallels its expansive, inclusive vision of the history of California.

Getting it done was a monumental task. Baca paid all

of the workers, to help both the pocketbooks and the pride of the young people she recruited. Many of the Mural Makers were former gang members, juvenile delinquents, or ex-offenders on parole; painting the mural was their first job. She organized the workers into crews, taking care that each unit was multi-ethnic.

The mural's impact on the lives of those who painted it is well documented. Many disadvantaged youths got needed job skills. Social service referrals to counseling or drug treatment were readily available. For the first time, hundreds learned of their history and how it related to the state as a whole. One participant recalled, "After my first year on the mural, I left with a sense of who I was and what I could do that was unlike anything I'd ever felt before."[2]

PRINTMAKING

The term *printmaking* describes a variety of techniques developed to create multiple copies of a single image. So much in our society is printed—newspapers, books, posters, magazines, greeting cards, billboards—that it is hard to imagine a time in which all illustrations were produced by hand, one at a time. Before 1415, every book and manuscript in Europe was hand-lettered and hand-illustrated. In contrast, hundreds of copies of *Artforms* are printed in a few hours by a mechanical printing method called *offset lithography*.

The technologies for both printing and paper making came to Europe from China. By the ninth century, the Chinese were printing pictures; by the eleventh century, they had invented (but seldom used) movable type. Printmaking was developed in Europe during the fifteenth century—first to meet the demand for inexpensive religious icons and playing cards, then to illustrate books printed with the new European movable type. Since the fifteenth century, the art of printmaking has remained closely associated with the illustration of books.

As recently as the late nineteenth century, printmakers were still needed to copy drawings, paintings, and even early photographs by making plates to be used, along with movable type, for illustrating newspapers and books. However, as photomechanical methods of reproduction were developed in the late nineteenth century, handwork played a decreasing role in the printing process. Artists, however, have continued to use the old handcrafted printmaking processes to take advantage of their uniquely expressive properties. By designing and printing multiple originals, today's printmakers can sell their works for much less than one-of-a-kind paintings. Such works, conceived as *original prints*, are not to be confused with reproductions (see the discussion at the end of this chapter).

Nearly all original prints are numbered to indicate the total number of prints *pulled*, or printed, in the edition, and to give the number of each print in the sequence. The figure 6/50 on a print, for example, would indicate that the edition totaled fifty prints and that this was the sixth print pulled.

As part of the printmaking process, artists make prints called progressive proofs at various stages to see how the image on the block, plate, stone, or screen is developing. When a satisfactory stage is reached, the artist makes a few prints for his or her record and personal use. These are marked AP, meaning *artist's proof*.

Printmaking methods range from simple to complex. Traditionally, these methods are divided into four basic categories: relief, intaglio, planographic

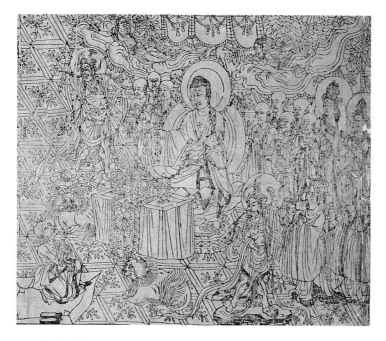

179 Section of THE DIAMOND SUTRA.
Chinese Buddhist text, 868.
Scroll, woodblock print on paper.
Length of entire scroll 18'.
By permission of The British Library. OR.8210f2.

(lithography), and stencil (screenprinting). (The *Discovering Art* CD provides live examples of these methods.)

RELIEF

In a *relief* process, the printmaker cuts away all parts of the printing surface not meant to carry the ink, leaving the design to be printed "in relief" at the level of the original surface (see the Relief diagram on page 130). The surface is then inked, and the ink is transferred to paper with pressure. Relief processes include *woodcut* (or *woodblock*), *wood engraving*, and *linoleum cut* (or *linocut*). Marks made by rubber stamps, fingerprints, and wet tires are examples of relief-printed marks in the everyday world.

The traditional woodcut process lends itself to designs with bold black-and-white contrast. The image-bearing block of wood, usually a soft wood, is a plank cut along the grain. Because the woodcut medium does not easily yield shades of color, artists who use it are generally drawn by the challenge of

working in black and white only. Others use woodcut because they enjoy the feel of carving a fresh block of wood. Color can be printed with single or multiple blocks. As with most printmaking techniques, when more than one color is used, individually inked blocks—one for each color—are carefully *registered* (lined up) to ensure that colors will be exactly placed in the final print.

Block printing from woodcuts originated in China, where the desire to spread the Buddhist religion greatly influenced the type of prints produced. THE DIAMOND SUTRA is one of the world's oldest surviving books. It opens with a woodblock print of the Buddha, surrounded by attendants and guardians, preaching to an old man seen in the lower left. (The swastika on the Buddha's chest is an ancient symbol of his enlightenment.) An inscription states that it was made in 868 for free distribution, an apparent act of religious goodwill. The hard wood of this early print makes possible the many fine lines in the design, which is similar in style to stone carvings from the same time period. This scroll is in excellent condition despite its age, because it was hidden in a cave for many centuries.

Woodblock printing became a highly developed art in Japan in the seventeenth through the nineteenth centuries. Japanese woodblock prints were made through a complex process that used multiple blocks to achieve subtle and highly integrated color effects. Since they were much cheaper than paintings, these prints were the preferred art form for middle-class people who lived in the capital city of Edo (now known as Tokyo). Their subject matter included famous theater actors, night life, landscapes, and even erotic pictures. Japanese prints were among the first objects of Asian art to be appreciated by European artists, and many Impressionist and Post-Impressionist painters were strongly influenced by them.

Japanese artist Hokusai's color woodcut prints have become well known around the world. Hokusai worked in close collaboration with highly skilled craftsmen to realize the final prints. For each of his woodcuts, specialists transferred Hokusai's watercolor brush painting to as many as twenty blocks,

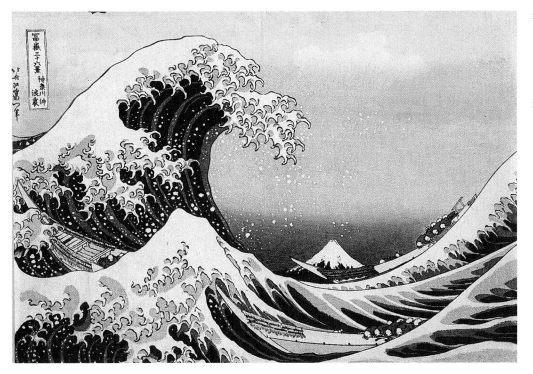

180 Katsushika Hokusai.
THE WAVE. c. 1830.
Color woodblock print.
10¼" × 15⅛".
Private Collection.
© Art Resource, NY.

181 Emil Nolde.
PROPHET. 1912.
Woodcut.
Image 12½" × 8¹³⁄₁₆".
Rosenwald Collection.
Photograph © Board of Trustees,
National Gallery of Art,
Washington, D.C. Rosenwald
Collection. 1943.36698.
(B-9059)/PR. Stiftung Seebull Ada
and Emil Nolde.

then cut the blocks. In Hokusai's print THE WAVE, a clawing mountain of water threatens tiny fishermen in their boats. The rhythmic curves of the churning sea even dwarf Mt. Fuji, which nonetheless stands firm in the distance. This imaginative rendering capturines the awesome power of the sea. This print is one of Hokusai's thirty-six views of Mount Fuji seen from various locations.

The detail in Hokusai's print is quite different from the roughness of the woodcut PROPHET by German artist Emil Nolde. Each cut in the block is expressive of an old man's face and reveals the character of the wood and the wood-cutting process. The simplified light-and-dark pattern of the features gives emotional intensity to the image. Nolde's direct approach is part of the long tradition of German printmaking that includes the prints of Albrecht Dürer.

The linoleum cut is a modern development in relief printing. The artist starts with the rubbery, synthetic surface of linoleum, and just as in woodcut, gouges out the areas not intended to take ink. The material is softer than wood, has no grain, and can be cut with equal ease in any direction.

182 Elizabeth Catlett.
SHARECROPPER. 1970.
Color linocut on cream Japanese paper. 15⅓" × 10⅛".

An example of a linoleum cut (or linocut) is SHARECROPPER by Elizabeth Catlett, in which the even, white gouges betray the soft material. This work also typifies Catlett's lifelong devotion to creating dignified images of African Americans.

INTAGLIO

Intaglio printing is the opposite of relief: areas below the surface hold the ink. *Intaglio* comes from the Italian *intagliare*, "to cut into." The image to be printed is either cut or scratched into a metal surface by steel- or diamond-tip tools, or etched into the surface by acid. To make a print, the printmaker first daubs the plate with viscous printer's ink, then wipes the surface clean, leaving ink only in the etched or grooved portions. Damp paper is then placed on the inked plate, which then passes beneath the press roller. A print is made when the dampened paper picks up the ink in the grooves. The pressure of the roller creates a characteristic plate mark around the edges of the print. Intaglio printing was traditionally done from polished copper plates, but now zinc, steel, aluminum, and even plastic are often used. Engraving, drypoint, and etching are intaglio processes.

Engraving

In *engravings*, lines are cut into the polished surface of the plate with a *burin*, or engraving tool. This exacting process takes strength and control. Lines are made by pushing the burin through the metal to carve a groove, removing a narrow strip of metal in the process. Engraving grew out of the inscription and decoration of jewelry. A clean line is desired; thus, any rough edges of the groove must be smoothed down with a scraper. Engraved lines cannot be as freely drawn as etched lines because of the pressure needed to cut the grooves. The precise, smooth curves and parallel lines typical of engravings are obvious in the engraved portraits that appear on the paper currency we use.

We can see the complex richness of engraved lines in Albrecht Dürer's engraving THE KNIGHT, DEATH AND THE DEVIL, reproduced here close to its

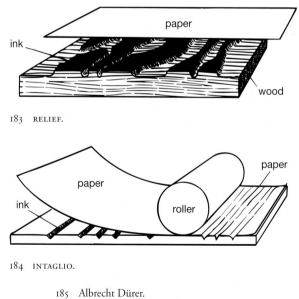

183 RELIEF.

184 INTAGLIO.

185 Albrecht Dürer.
THE KNIGHT, DEATH AND THE DEVIL. 1513.
Engraving, Page: 10" × 7⅞", Plate: 9⅝" × 7½".
Brooklyn Museum of Art, New York.
Gift of Mrs. Horace O. Havemeyer. 54.35.6.

187 DRYPOINT PLATE.

actual size. Thousands of fine lines define the shapes, masses, spaces, values, and textures of the depicted objects. The precision of Dürer's lines seems appropriate to the subject—an image of the noble Christian knight moving with resolute commitment, unswayed by the forces of chaos, evil, and death that surround him (a discussion of the print's iconography appears on page 35).

Drypoint

Drypoint is similar to line engraving. Using a thin, pencil-like, pointed tool with a steel or diamond tip, the artist digs lines into a soft copper or zinc plate. The displaced metal leaves a *burr*, or rough edge, similar to the row of earth left by a plow. The burr catches the ink and, when printed, leaves a slightly blurred line. Because the burr is fragile and deteriorates rapidly from the pressure of the printing press rollers as prints are made, drypoint editions are by necessity small. Skillful draftsmanship is required, for drypoint lines are difficult to execute and almost impossible to correct. UNTITLED (WEB 3) by Vija Celmins shows the delicate lines that drypoint makes possible.

Etching

The process of making an *etching* begins with the preparation of a metal plate with a *ground*—a protective coating of acid-resistant material that covers the copper or zinc. The printmaker then draws easily through the ground with a pointed tool, exposing the metal. Finally, the plate is immersed in acid. Acid "bites" into the plate where the drawing has exposed the metal, making a groove that varies in depth according to the strength of the acid and the length of time the plate is in the acid bath.

Because they are more easily produced, etched lines are generally more relaxed or irregular than engraved lines. We can see the difference in line quality

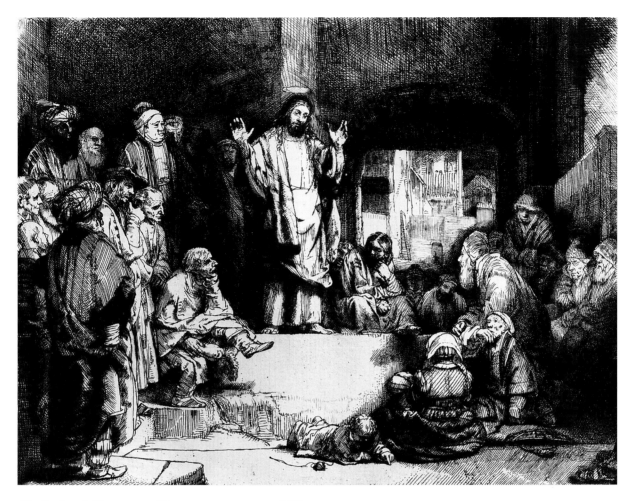

188 Rembrandt Harmensz van Rijn. CHRIST PREACHING. c. 1652.
 Etching. 61¼" × 8⅛".
 The Metropolitan Museum of Art.
 Bequest of Mrs. H.O. Havemeyer Collection, 1929. The H.O. Havemeyer Collection (29.107.18).

between an etching and an engraving—the freedom versus the precision—by comparing the lines in Rembrandt's etching CHRIST PREACHING with the lines in Dürer's engraving THE KNIGHT, DEATH AND THE DEVIL.

In CHRIST PREACHING, Rembrandt's personal understanding of Christ's compassion harmonizes with the decisive yet relaxed quality of the artist's etched lines. This etching shows Rembrandt's typical use of a wide range of values, achieved with drypoint as well as etching. Skillful use of light and shadow draws attention to the figure of Christ and gives clarity and interest to the whole image. In a composition in which each figure is similar in size,

Rembrandt identifies Jesus as the key figure by setting him off with a light area below, a light vertical band above, and implied lines of attention leading to him from the faces of his listeners.

Aquatint is an etching process used to obtain shaded areas in black-and-white or color prints. Contemporary aquatints are prepared with acid-resistant spray paints. When the plate is placed in acid, the exposed areas between the paint particles are eaten away to produce a rough surface capable of holding ink. Values thus produced can vary from light to dark, depending on how long the plate is in the acid. Because aquatint is not suited to making thin lines, it is usually combined with a

196 SCREENPRINTING.

197 Andy Warhol.
LITTLE RACE RIOT. 1964.
Synthetic polymer paint
and silkscreen ink on
canvas. 30" × 33".
Art Resource, NY. © 2002 Andy
Warhol Foundation for the
Visual Arts/Artists Rights Society
(ARS), NY.

198 Elizabeth Murray.
EXILE, 1993.
Screenprint with collage,
30" × 23" × 2½".
Edition of 38.
© 1993 Elizabeth Murray and
Gemini G.E.L. LLC.

stretched across a frame (synthetic fabric is used today). With a rubber-edged tool (called a *squeegee*), ink is then pushed through the fabric in the open areas of the stencil to make an image of the stencil on the material being printed. Because silk was the traditional material used for the screen, the process is also known as *silkscreen* or *serigraphy* (*seri* is Latin for silk).

Screenprinting is well suited to the production of images with areas of uniform color. Each separate color requires a different screen, but registering and printing are relatively simple. There is no reversal of the image in screenprinting—in contrast to relief, intaglio, and lithographic processes in which the image on the plate is "flopped" in the printing process. The medium also allows the production of large, nearly mass-produced editions without loss of quality.

The latest development in screenprinting is the photographic stencil, or *photo screen*, achieved by attaching light-sensitive gelatin to the screen fabric.

Capitalizing on the impersonal, mass-media look provided by this technique, Andy Warhol popularized photo-screenprinting. LITTLE RACE RIOT is a work derived from a news photograph of a 1964 civil rights demonstration. Warhol enlarged the photograph and transferred it to a silkscreen, thus magnifying its flat, impersonal character.

Elizabeth Murray's EXILE takes screenprinting to the limit. The base is a piece of irregular shaped yellow board embossed with a pattern and screenprinted with a design based on newspaper pages. Above this she laid a jagged and perforated blue sheet, which was also silkscreened and lithographed with colors. Finally she cut a large piece of red paper, screenprinted and lithographed on it, and then set it above the other two layers. All the layers show hand-drawn crayon and pencil marks along with the printed colors. The artist describes EXILE as a "twenty-three color lithograph and screenprint construction with collage and pastel."

CURRENT DIRECTIONS

Experimental printmaking in recent years has taken two general directions: use of experimental printing plates, and use of digital technology. Each has altered the boundaries of the medium.

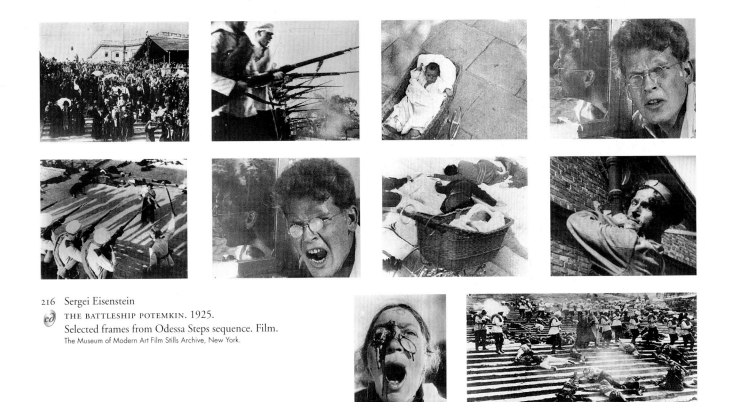

216 Sergei Eisenstein
THE BATTLESHIP POTEMKIN. 1925.
Selected frames from Odessa Steps sequence. Film.
The Museum of Modern Art Film Stills Archive, New York.

An International Language

When films were silent, movies could be produced in many countries for an international audience, without concern for language barriers. Following the Russian Revolution in 1917, Sergei Eisenstein emerged as a major film artist, honored as much in the West as in the Soviet Union. Eisenstein greatly admired Griffith's film techniques; after careful study, he developed them further, becoming one of the first filmmakers to produce epic films of high quality.

One of Eisenstein's major contributions was his skilled use of montage to heighten dramatic intensity. *Montage*, introduced by Griffith in 1916, is the editing technique of combining a number of very brief shots, representing distinct but related subject matter, in order to create new relationships, build strong emotion, or indicate the passage of time. With the use of montage, a great deal seems to happen simultaneously, in a short time.

In his film THE BATTLESHIP POTEMKIN, Eisenstein created one of the most powerful sequences in film history: the terrible climax of a failed revolt. The montage of brief shots, edited into a sequence of no more than a few minutes, effectively portrays the tragedy of the historic event. Rather than shoot the entire scene with a wide-angle lens from a spectator's perspective, Eisenstein intermixed many close-ups to give viewers the sensation of being caught as participants in the middle of the violence. The juxtaposition of close-ups and longshots gives audiences a powerful sense of the fear and tragedy that took place.

Charlie Chaplin came to prominence about 1915, when pressure from audiences and industry competition caused "stars" to be created and publicized. After starting his career as a member of a pantomime troupe, he became not only the leading comedian of his time, but also a director, producer, writer, and even composer. He built a team consisting

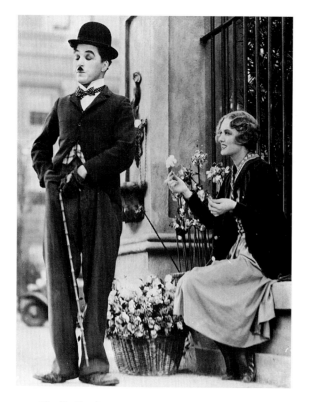

217 Charlie Chaplin
CITY LIGHTS. 1931.
Film.
The Museum of Modern Art Film Stills Archive, New York.

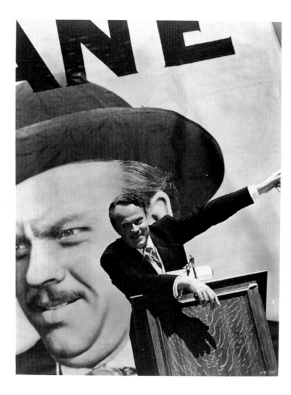

of cameraman, leading lady, and comic actors, who worked with him for many years. A perfectionist, he reshot particular scenes dozens, even hundreds of times. Chaplin chose to stay with the silent tradition in CITY LIGHTS (except for music and sound effects), even though "talkies" were then being made by all other Hollywood filmmakers.

The arrival of sound in 1927 added a new dimension to film, but it did not change the medium's fundamental visual grammar. Color was introduced in the 1930s; the wide screen and three-dimensional images in the 1950s; 360-degree projection was first seen by the public in the 1960s. Most of these techniques, however, had been conceived of and researched by 1910.

After World War I, Hollywood became the film capital of the world. In the 1930s, most Hollywood films simply repeated plot formulas already proven successful at the box office. During that decade, the major studios all adhered voluntarily to the Motion Picture Production Code, which attempted to regulate the moral content of films. The Code forbade profanity in the script, as well as depictions of nudity, sexual activity, drug use, interracial romance, and ridicule of the clergy. It also prohibited the glamorization of crime, so that all gangsters had to be arrested or killed in the end. Studios submitted scripts to the Code authorities prior to shooting, and any film that lacked a Code seal of approval had no chance of wide distribution. At times, Code strictures were relaxed somewhat: Clark Gable's famous farewell to Vivien Leigh in *Gone With the Wind* ("Frankly, my dear, I don't give a damn.") remained in the film, but the producer paid a fine of $5,000 for it. The Code's authority declined in succeeding decades, but remained in effect until 1968, when the Motion Picture Association of America introduced the Ratings system which is still in force.

In 1941, at age twenty-five, Orson Welles made his film debut with CITIZEN KANE, an international landmark in filmmaking. Welles coauthored the script,

218 Orson Welles
CITIZEN KANE. 1941.
Film.
The Museum of Modern Art Film Stills Archive, New York.

219 Federico Fellini
LA DOLCE VITA. 1961.
Film.
Everette Collection, Inc.

directed, and played the leading role in the thinly disguised account of the life of newspaper tycoon William Randolph Hearst. Because of its outstanding aesthetic quality and meaningful social message, CITIZEN KANE immediately set new standards for filmmaking. Welles and his cinematographer, Gregg Toland, pioneered the use of extreme camera angles. The low angle camera presents Kane (Welles) as a towering presence; another such angle is the tilt, shown here, which emphasizes Kane's crooked politics.

Italian director Federico Fellini's 1961 film LA DOLCE VITA (The Sweet Life) foreshadows many of today's critiques of the mass media. Marcello Mastroianni played the lead character, a tabloid journalist also named Marcello who makes his career reporting on sensations, scandals, and celebrities.

The protagonist follows the lifestyles of the rich and famous, dutifully attending spectacles of all kinds, from the exploits of American movie stars to decadent parties to religious visions. He frolics in a fountain at 4 A.M. with Anita Ekberg. He joins the media circus as thousands throng to a small town where two children say they saw the Virgin Mary. One of these fellow travelers is a photographer friend named Paparazzo, and ever since this film's release intrusive photographers throughout the world have been called *paparazzi*.

Questioned about his tendency to exaggerate all he reports on, Marcello replies defensively, "The public demands exaggeration; but reasonably, when permitted, I can report events without exaggeration." At a party where the discussion has turned to art, Marcello announces that the art he prefers is "a living art; a clear, honest style, without rhetoric and without subterfuge." In fact, he devotes his life to rhetoric and subterfuge, as he later tells a friend, "I am just wasting my days, uselessly." In the end, Marcello proves unable to resist the temptations of the "Sweet Life," as he plunges headlong into the world he reported on.

220 Walt Disney
FANTASIA. 1940.
The Sorcerer's Apprentice.
Photograph: © The Walt Disney Studios/Photofest.

221 George Lucas
Still from STAR WARS, 1977.
Lucasfilms.
Picture Desk, Inc.
Kobal Collection.

Animation and Special Effects

Beginning with the development of FANTASIA in the late 1930s, Disney animators have meticulously explored the possibilities of animation. With FANTASIA, released in 1940, Disney created a new form of film that integrated classical music, painting, dance, and drama with a mix of human and cartoon characters as the stars.

The group effort began with a story conference in which artists and musicians brainstormed ways to realize Walt Disney's initial concept. Ideas were portrayed on storyboards outlining the story from which the director choreographed the action. A *storyboard*, a series of drawings or paintings arranged in a sequence like a comic strip, was used to visualize the major shots in the film. Layout artists made the story come alive as the spatial relationships were worked out. Animators dramatized individual characters in each action sequence. Disney's goal was always to create characters who gave the illusion—at twenty-four frames per second—that they were not just moving, but thinking and feeling. Inkers traced the drawings onto cels (clear plastic sheets) for each frame and painters painted the reverse side. Each cel was then photographed, often using Disney's innovative multiplane camera for heightening the illusion of depth.

In recent years, some of the biggest box office successes have employed special effects made possible by a merging of old techniques and new technology. Teams of artists and technicians work with producer-directors such as George Lucas, creator of the STAR WARS trilogy, to provide working sketches, models, animation, and sets that are fantastic yet believable.

Industrial Light and Magic (ILM), the special effects division of George Lucas's company, Lucasfilm Ltd., was the leading special effects studio of the late 1970s and 1980s. The ILM team took ideas from script to storyboard to models to film. ILM spent at least a week on a sequence that lasts less than two seconds in the finished film. Only with computers can the complex alignment of all the elements of camera, light, model, and background be achieved.

Some of the best animated films in recent years have been made in Japan, where meaningful characters combine with epic story lines in visually stun-

ning productions. One of the best of these was PRINCESS MONONOKE, a saga in which a warrior overcomes a curse as he defeats the evil effects of technology.

A new kind of film that shows today's more global society is the international co-production. Companies from several countries may collaborate on these films as they avoid some of the stereotypes of Hollywood. A recent example was JU DOU, by the Chinese director Zhang Yimou. Set in the 1920s in China, it paints a vivid picture of a family plagued by the seemingly modern problems of exploitation, incest, and child abuse. The family's ownership of a cloth dying mill adds vivid color to the visual style of the film's sensational plot lines. Though based on a Chinese short story, the film owes some of its melodrama to Latin American soap operas, which are very popular on Asian television. When the Chinese government attempted to keep JU DOU from an Academy Award nomination, several international directors protested.

Today, most major Hollywood film studios are owned by large international corporations, and they have discovered that they can draw audience interest around the world with movies that employ luxurious special effects with a fast story line. To aid international receipts, these "blockbusters" generally do not rely on character development or social comment for their success, and they are promoted together with merchandise such as clothing or toys derived from the film, to aid their appeal to younger audiences. In this way a movie such as I, ROBOT can earn millions

222 Still from PRINCESS MONONOKE. 1997.
 Film. Miramax.
 Picture Desk, Inc./The Kobal Collection.

223 Still from JU DOU. 1990. Film. Miramax.
 Picture Desk Inc./The Kobal Collection.

224 Still from I, ROBOT. 2004. Film. 20th Century Fox.
 ZUMA Press Inc./Keystone Press Agency.

in the United States, and then go on to attract large crowds in places as diverse as Moscow, Hong Kong, and Rio de Janeiro. Such international success is often required if the producer is to recoup the original expense of production and promotion, which often exceeds $100 million.

TELEVISION AND VIDEO

Television, literally "vision from afar," is the electronic transmission of still or moving images and sound by means of cable or wireless broadcast. Television is primarily a distribution system for advertising, news, and entertainment. Video is the medium for television, it can also be an art form.

Video Art

The Sony corporation set the stage for the beginning of video art in 1965 when it introduced the first portable video recording camera, the Portapak. Though it was cumbersome, some artists were drawn to the new medium because of its unique characteristics: The instant feedback of video does away with development times necessary for film. Video works can be stored on inexpensive cassettes that can be erased and re-recorded. In addition, because a video

225 Nam June Paik and John Godfrey.
GLOBAL GROOVE. Video.
Courtesy of Electronic Arts Intermix, New York.

signal can be sent to more than one monitor, it allows flexibility of presentation.

Early videos by artists were relatively simple, consisting mainly of recordings of the artists themselves performing, or of dramatic scenes staged with only a few actors or props. Since no editing was possible, and the black-and-white image was incompatible with the color resolution of television broadcasts of the time, the medium was most suited to private screenings for small groups. In 1972, the compatibility issue was resolved with the introduction of standardized ¾-inch tape; this allowed artists to work with television production equipment, and even to broadcast the results of their labors. The 1980s brought vast improvements in video technology in the form of lighter cameras, color, and computerized editing.

In the short history of video art, some artists have consistently tried to expand the limits of the medium's technical capacities. A leader in this movement is the Korean-born artist Nam June Paik. With the help of foundation grants, he worked in partnership with public television labs in Boston to develop the first video synthesizer. This machine generated brilliant color patterns that could be programmed to develop from black-and-white input. Using it, he created GLOBAL GROOVE, a 1987 program that was broadcast over a public station in New York City.

Other video artists have used the medium to create and tell stories using themselves as actors. In her VOLCANO SAGA, Joan Jonas tells a story of a memorable trip to Iceland. Caught in a fierce windstorm, she was blown off the road and lost consciousness. Awakened by a local woman who offers help, the artist is magically transported back to ancient times in the company of Gundrun, a woman from Icelandic mythology who tells her dreams. The artist sympathizes with Gundrun's struggles in her ancient society, and returns to her New York home feeling kinship with women of the past. In the video, images move back and forth between past and present with the aid of overlays and an evocative musical score.

Today's video artists often use the medium as an element in three-dimensional installations. Dara

Birnbaum's HOSTAGE uses five monitors arranged in an ascending arc together with target figures. The screens display borrowed images from a 1977 television news broadcast of a German hostage explaining his captors' demands. These are interrupted with cuts to American news reports of various other hostage-takings. The gallery environment is activated with sensors, so that viewers, by moving about, cause the cuts from one scene to another, and are thus held "hostage" themselves by being implicated in how the story unfolds on the screens.

DIGITAL ART FORMS

The artmaking capacity of computer-linked equipment ranges from producing finished art, such as color prints, film, and videos, to generating ideas for works that are ultimately made in another medium. Computers are also used to solve design problems by facilitating the visualization of alternative solutions. The computer's capacity to store images-in-progress enables the user to save unfinished images while exploring ways of solving problems in the original. Thus sculptors, photographers, filmmakers, designers, and architects can take advantage of the tools created by programmers of computer software.

The multipurpose characteristics of the computer have accelerated the breakdown of boundaries between media specializations. A traditional painter working with a computer can easily employ photo imaging or even add movement and sound to a work. A photographer can retouch, montage, change values, "paint over," or color black-and-white images. Digital technology facilitates the writing, design, and printing of books such as *Artforms*.

Early computer art looks dull by today's standards. The first exhibition of computer-generated digital imagery took place in a private art gallery in 1965; few claimed that it was art. Most of the earliest digital artists used computers to make drawings with a plotter, a small ink-bearing, wheeled device that moves over a piece of paper drawing a line in one color according to programmed instructions. With the help of technicians, Vera Molnar made some of the most visually interesting of these early

226 Joan Jonas.
VOLCANO SAGA. 1987.
Performance still. Performing Garage, NY.
Pat Hearn Gallery, NYC.

227 Dara Birnbaum.
HOSTAGE. 1994.
Six-channel video and interactive laser installation with Peerless ceiling and wall mounts, and designed ceiling mounts and plexiglass shields.
Dimensions site specific.
Photograph: Geoffrey Clements, Installation: Paula Cooper Gallery, NY. Courtesy of Paula Cooper Gallery.

228 Vera Molnar. PARCOURS: (MAQUETTE FOR AN ARCHITECTURAL ENVIRONMENT). 1976. Computer drawing. Courtesy of the artist.

229 Joseph Nechvatal
THE INFORMED MAN. 1986. Computer/robotic. Acrylic on canvas. 82" × 116". Collection Dannheisser Foundation. Photograph courtesy of the artist.

efforts, such as her 1976 PARCOURS: (MAQUETTE FOR AN ARCHITECTURAL ENVIRONMENT). The computer was programmed to make variations on a basic set of plotter movements, yielding a work that resembles a drawing quickly done by hand. In many of these early types of computer art, the plotter's motions were not entirely predictable, a fact that added to the attractiveness of the images. The expense and complexity of computer technology in those years, however, kept all but a few pioneer artists away from the medium.

The advent of faster computers, color printers, and interactive graphics changed the scenario in the middle 1980s; as the computer's abilities grew, more artists began to take interest. Joseph Nechvatal was close to the "cutting edge" at that time with his work THE INFORMED MAN. To make this work, he first created an original image on a small transparency by chaotically combining a myriad of illegible information patterns in a photo editing program. He then enlarged the transparency to mural size by using computer-guided airbrushes attached to a device called a Scanamural. The resulting large work resembles a very expressive painting with a human figure at its center.

Camilla Benolirao Griggers used video editing in her work ALIENATIONS OF THE MOTHER TONGUE. She began with a fashion photograph and introduced incremental changes in the subject's face, bit by bit, until by the last frame we have a horrifying image of destruction. She combined all the stages of the frame's evolution into a five-minute video that evolves from something glamorous and desirable into a cry of pain.

Both of these works show how digital technology has undercut the traditional truth value of photography. If images are so easy to manipulate, then the camera, if it is digital, can indeed be made to lie. Seeing is no longer believing, in the traditional sense of the term.

Digital artist William Latham moves even farther from reality in his digital works. With the aid of a mathematician, he writes programs that generate eerie digital beings. Latham said that his CR3Z72 grew and evolved in his computer, a digital plant grown in fertile binary soil under the care of the artist-gardener.

The digital artists considered so far use the computer to create art for the wall or the video screen; in that sense they are more traditional than the ones we consider next. This is because the digital revolution, besides generating new ways of making art, has also given rise to new ways of presenting it.

Some artists now create digital works for distribution on CD-ROMs, compact disks capable of storing and retrieving hundreds of megabytes of data. Artists' CD-ROM works usually include images, text, and video clips; since the amount of information is so voluminous, viewers at their terminals are usually free to exercise certain choices about how they navigate through the contents. This makes the presentation of the work interactive, that is, not entirely under the artist's control in the way that a movie or video is. Indeed, the same viewer examining the same CD on different days may get an entirely different order of output. So far, artists who create for CD-ROMs tend to make works of two general types: either they tell a story that the viewer can unfold in different ways by their interactive choices, or they archive works and information related to a theme that viewers can click through according to their interest.

For example, FANTASTIC PRAYERS (on the following page) is an interactive CD-ROM that contains eight environments. One of these is a graveyard, another is a pile of refuse, another is an abandoned building, another simulates a game show, etc. Each environment first appears as a still image that has several hot spots embedded in it. These hot spots are not immediately apparent, so that experiencing FANTASTIC PRAYERS entails a great deal of exploration. Clicking on any hot spot will show new content which can take almost any form. Entering the abandoned building, we see that it was once a natatorium. Clicking anywhere in this environment will cause randomly

230 Camilla Benolirao Griggers.
ALIENATIONS OF THE MOTHER TONGUE.
1996.
Video with digital graphics and animation.
5 minutes.
Photo courtesy of the artist.

231 William Latham. CR3Z72. 1992.
Photographic print. 5' × 5'.
© 2000 William Latham. Computer Artworks Ltd.

232 Constance de Jong, Tony Oursler,
Stephen Vitiello.
Screenshot from
FANTASTIC PRAYERS, 2000.
Multimedia CD-ROM. Produced
by Dia Center for the Arts, NY.
© 2000 Dia Center for the Arts, NY.

selected photographs to gradually grow and engulf the screen. In the corner of each environment is a navigation spot that can take us at any moment to the next or the preceding environment. We may go next to the pile of refuse, for example, which represents the imaginary "place where lost items all end up." Clicking in the pile shows video clips, sound, or music related to the idea of loss. Viewers who purchase the CD thus have the original work of art on their screens, and they can navigate it at will, constructing a new pathway through the environments each time they access it. The work has so many layers that seeing all the content requires many visits.

The newest digital medium is the World Wide Web, and many artists take advantage of its free universal distribution to create works expressly for viewing there. Some create works for posting to their own web pages; in addition there are several sites that specialize in exhibiting web works and thus function like interactive galleries. A few museums have added collections of web works to their sites as well. Like other branches of digital art, web works have evolved rapidly since the first examples came out in the middle 1990s, in accordance with the increasing capabilities of web browsers and plug-in programs.

The degree of sophistication of a web-based work is no indicator of its quality, however. As in other media, artists who are best at organizing meaningful visual information create the best web works.

Near the edge of the envelope in web works is Annette Weintraub, whose 2001 piece THE MIRROR THAT CHANGES joins high-tech execution with social awareness. The title comes from a quote by Leonardo da Vinci: "Water is the mirror that changes with the color of its subject." On opening the work, we see nine vertical bars, each a portion of a photograph of water. A soundtrack of flowing liquid is a constant background. Clicking on one of the bars enlarges it and presents its related content, which may include video, sound, layered images, voice tracks, or scrolling text. The words that pass and the voices we hear may inform us about past wars fought over water, delight us with poetic quotes from literature about water, or wake us up to current crises that involve water ("We will never have more water on earth than we have right now"). The work's wealth of information, presented

233 Annette Weintraub, Screenshot from THE MIRROR THAT CHANGES. 2003.
Interactive WWW work.
http://www.virtualthemeworld.com/mirror/flashindex.html. Courtesy of the artist.

in easily accessible layers with elegant presentation, make it a standout.

In short, digital art has evolved as quickly as computers themselves. Many artists today include digital technology in their works in one way or another. The need for a separate category "digital art" is subject to further debate. Whether it remains a medium with its own properties, or becomes integrated into others, is a decision best left for the future. For the present, the art world as a whole has been quick to adopt many aspects of digital technology, as the essay on the following page shows.

CRITERION	HERESY
MOODY	LICENSE
REGRET	INTRUDE
PERSERVERE	DANGER

234 James Johnson. ONE THOUSAND WORDS. 1998.
Interactive www work. Screen shot from 1KWORDS, 1998.
WWW work, 7½" × 9".
© James Johnson. http://spot.colorado.edu/~johnsoja/1kWords.html

JAMES Johnson

James Johnson, who began his digital art career working with a plotter, makes web works whose complexity is not apparent to the casual user. His interactive work ONE THOUSAND WORDS presents the viewer with an array. Clicking on any word will change it to another by selecting randomly from a large store. In this way, meanings and their combinations shift at random at a speed that the user determines. The work generates a welter of meanings, all presented in a unique type font that the artist himself invented.

One of the many ways in which web works differ from other kinds is that copyright protection is severely weakened, because viewers can download and print in unlimited quantities any phase of a web work. This does not worry Johnson, who says that art should be a gift. See the *Artforms* Web site for more of this interview.

THE IMPACT of digital technology on the creation of art works has been important, but the impact has been greater in other areas connected to art. Computers are now integral to the analysis, preservation, and sale of art works. Indeed, the new technology has taken root in these areas sooner than it has in artists' studios.

There are several on-line art magazines, where Internet surfers can go to find out where art shows are held and read reviews of current exhibitions in many parts of the world. Critical issues surrounding art are discussed, and scholars present new findings. Because the quality of images visible on a computer screen is below that of a printed page, digital magazines are far from replacing hard copy; for now they function as a supplement to paper-based art criticism and analysis.

Museum Web sites become more sophisticated with each passing year. Most museums have them, and usually they contain information about current special exhibitions, as well as on-line viewing of art works from their collections. Some museums create education modules on their sites so that the Inter-

net public can learn in depth about the art on display. The most advanced museum Web sites have pioneered new methods of digital browsing of art works, placing more and more of the collection on-line and allowing for close-up, high-resolution views of selected parts of works. In this way they have narrowed the quality gap between screen images and printed photographs.

Likewise, the new technology has had an important impact on conservation of artworks. From small pottery fragments dug up at an archaeological site, for example, computer programs can digitally reconstruct an entire piece. New three-dimensional laser scanners can track every square millimeter of sculptural works from several angles at once, making exact recordings of every surface possible. Painting conservators use computer-assisted mass spectrometers to analyze the chemical content of paint surfaces in order to aid in their cleaning and restoration.

On a more mundane level, there are several Web sites that track and post information on stolen art works. Dealers and auction houses make frequent recourse to such sites, to check on the legal status of works that they may buy or sell.

Increasingly, the Internet is an important venue for the sale of artworks as well. Many galleries and dealers have Web sites that post works for sale, saving art collectors a great deal of browsing time. On-line auctions are another fast-growing trend. Only a small portion of these will last, partly because it is difficult to assess the quality, much less the authenticity, of a work posted on line. In addition, deceptive practices such as price collusion and false bids are easy to bring about and difficult to trace. For these reasons, most of the high-value works will continue to sell at live auctions and in dealers' galleries. But there is little doubt that on-line auctions of art works are here to stay because of the ease with which they bring in a wider public. On-line auctions are a highly visible phenomenon, widely reported in the media. But they represent only one facet of the continuing impact that computer technology is having on the art world.

There is one area that is still relatively untouched by digital technology: the study of art works. Only a tiny fraction of documents relating to the history of art have been placed on line. Thus, most art research still requires much more time in the library than at the computer screen. More important, no digital experience can quite take the place of standing before an actual work, or of meeting the person who created it face to face.

GRAPHIC DESIGN AND ILLUSTRATION

Every manufactured object, printed image, and constructed space has been designed by someone. From clothing to airplanes, from homes to public buildings and community spaces, design is a necessity, not an afterthought.

DESIGN DISCIPLINES

Professional designers can enhance living by including aesthetics as well as utility in the design of the human-made world. Their designs shape and express our cultural values. Some designers see themselves as artists, while others think of themselves as creative problem solvers. The design concepts introduced in Chapter four provide a basis for understanding how designers enhance the visual, informational, and mechanical qualities of our material environment.

As consumers, we discover that some things are well designed and some are not. When the form and function of an object do not complement each other, the object is poorly designed. Good design solves problems; bad design creates problems.

Design disciplines include, but are not limited to, graphic design, industrial design, textile design, clothing design, interior design, architecture, and environmental design. In this chapter, the focus is on graphic design and illustration.

Of all the arts, we encounter graphic design most frequently in our daily life. We interact with graphic design on an almost constant basis; most designers have chosen it as their profession because they relish that close interaction with people in all situations. Our encounters with graphic design are usually casual and unintended; we do not seek out graphic design the way we might seek other art forms in a gallery or museum. This fact gives designers an unequalled opportunity to attract, inform, persuade, delight, bore, offend, or repel us.

Text dominates Russian designer Alexander Rodchenko's sketch for a 1923 sign. GIVE ME SUN AT NIGHT! exclaims the text in the upper left. "Where do we find this?" reads the inscription just below. "Buy it at GUM," is the answer, referring to Moscow's largest department store. In the lower right, a slogan

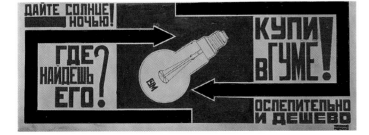

235 Aleksandr Rodchenko and Vladimir Maiakovskii. GIVE ME SUN AT NIGHT. Design for Poster, 1923. Gouache, ink, pencil, gelatin silver print. 4⅜" × 18".
Merrill C. Berman Collection. Photograph by Jim Frank.
© Estate of Aleksandr Rodchenko/Licensed by VAGA, New York, NY.

236 Cassandre (Adolpe Jean-Marie Noreau).
L'ATLANTIQUE. 1932.
Lithograph, 39½" × 24½".
Merrill C. Berman Collection. Photograph by Jim Frank.
© 2002 Artists Rights Society (ARS), NY.

237 Eric Rodenbeck.
THE EMPTY CITY. 2000.
Screenshot from web self-promotion piece for stamen.com.
Courtesy of the artist.

hammers the point home: "Blinding and cheap." In the center, surrounded by arrows, is the light bulb that will illuminate everyone at night. The designers had the task of convincing people to buy a product that was not widely used at the time, so the tone is emphatic.

Graphic design often has the goal of getting us to do something. The French designer Cassandre designed the poster L'ATLANTIQUE in 1932 in order to promote travel by ship. The text of the poster merely informs viewers that the ship weighs forty thousand tons, and frequently goes to South America under the auspices of the Sud-Atlantique Steamship Company. The designer lets the image do most of the persuading in this poster, and it dominates the composition. The angle of view is from below, as if we were bobbing on the ocean surface as the ship looms majestically above. The implication is that if we travel by ship, we participate in something larger than life.

By far the most profound current influence on design in all areas—from print media to car design and architecture—is the digital revolution, comparable in its impact on human life to the Industrial Revolution. The Internet and digital graphics are changing not only design processes, but also the character of form and imagery.

Today's designers for the Internet use photo editing programs, browser plug-ins, and animation to create the next wave in graphic design. Eric Rodenbeck's THE EMPTY CITY is a slowly shifting array of words and phrases, most of them clickable links.

GRAPHIC DESIGN

The term *graphic design* refers to the process of working with words and pictures to create solutions to problems of visual communication. Much of graphic design involves designing materials to be printed, including books, magazines, brochures, packages, posters, and imagery for electronic media. Such design ranges in scale and complexity from postage stamps and trademarks to billboards, film, video, and web pages.

Graphic design is a creative process employing art and technology to communicate ideas. With

control of symbols, type, color, and illustration, the graphic designer produces visual compositions meant to attract, inform, and persuade a given audience. Under the skilled guidance of a graphic designer, a message becomes visual, transcending words alone.

Signs and Symbols

Often the name, product, or purpose of a company or organization is given a distinctive and memorable appearance by a graphic designer. An identifying mark, or trademark, based on letter forms is known as a *logo* (short for *logotype*). An identifying mark based on pictorial (rather than typographic) sources is called a *symbol*.

The ALTRIA LOGO uses a carefully selected symbol and type to represent a complex multinational company. The colors in the symbol come from the labels that make up the various parts of the firm; their square array suggests close coordination between them. The company name in the logo comes from the Latin word for "high" (*altus*) and from "altruism," concern for others. A logo such as this not only informs the viewer about the company's goals, it also may divert attention from more sensitive topics. The company was formerly known as Philip Morris, one of the tobacco firms that had to pay billions in court settlements to smokers who had become ill.

An organization's logo may change over time, reflecting a different cultural climate, a different set of goals, or new management. When the National Aeronautics and Space Administration (NASA) was founded in the late 1950s, the first of the NASA LETTERHEAD used a celestial globe with the Earth, the

238 Landor Associates.
ALTRIA LOGO, 2003.
Altria Group, Inc.

239 NASA LETTERHEAD STATIONERY.
Cooper Hewitt, National Design Museum. Smithsonian Institution. Gift of NASA.

a. 1959. Logo designer James Modarelli.

b. 1974. Designers Danne & Blackburn, NYC. 1973

c. 1992. Logo designer James Modarelli.

Moon, and a stylized arrow symbolizing space flight (a). In 1973, with space travel more commonplace, the logo was changed to the stylized initials in red (b). The letters "A" symbolize rocket nose cones in this second NASA logo.

In the early 1990s, in the aftermath of federal budget cuts and with a demoralized atmosphere caused by the explosion of the space shuttle *Challenger*, the logo was redesigned. NASA decided to return to a version of its previous logo, which administrators thought better exemplified an optimistic and exploratory mood (c). This time they used the color blue to symbolize the heavens.

Typography

Letter forms are art forms. *Typography* is the art and technique of composing printed material from letter forms (*typefaces* or *fonts*). Designers, hired to meet clients' communication needs, frequently create designs that relate nonverbal images and printed words in complementary ways.

Just a few decades ago, when people committed words to paper, their efforts were handwritten or typewritten—and nearly all typewriters had the same typeface, the name of which was unknown to most users. Now anyone who uses a computer can select fonts and can create documents that look typeset, producing desktop publications such as newsletters and brochures. But computer programs, like pencils, paintbrushes, and cameras, are simply tools: They can facilitate artistic aims if their operator has artistic sensibilities.

MOTHER &CHILD

240 Herb Lubalin, assisted by Alan Peckolick and Tom Carnase.
MOTHER & CHILD, logo for a magazine (never produced). 1965.
By permission of Herb Lubalin, Study Center of Design and Typography.

Nobel
Armada
Garage Gothic

241 Tobias Frere-Jones.
THREE TYPEFACES: NOBEL™, ARMADA™, GARAGE
GOTHIC™.1992–1994.
The Font Bureau, Boston.

Since the Chinese invention of printing in the eleventh century, thousands of typefaces have been created—helped recently by digital technology. For the text of *Artforms*, Adobe Garamond was selected for its elegance and readability.

Many European-style typefaces are based on the capital letters carved in stone by early Romans. **Roman** letters are made with thick and thin strokes, ending in *serifs*—short lines with pointed ends, at an angle to the main strokes. In typesetting, the term "roman" is used to mean "not italic." **Sans serif** (without serifs) typefaces have a modern look due to their association with modernist designs. They are actually ancient in origin. **Black letter** typefaces are based on Northern medieval manuscripts and are rarely used today.

Graphic designer Herb Lubalin first gained an international reputation for his elegant typographic designs. In his most innovative work, form and content are inseparably united, as in his logo design intended for a magazine devoted to parenting, to be called MOTHER & CHILD. The magazine was never produced, but the logo—an apt symbol of the mother-and-child relationship—is now well known to designers and students of design.

Today, many type designers are redesigning and updating old fonts, keeping in mind readability and contemporary preferences. Tobias Frere-Jones reworked the NOBEL font, updating a style invented in 1929 in Holland. He developed the font ARMADA to refer to the arches of nineteenth-century urban warehouses; his GARAGE GOTHIC is meant to recall the printing on parking garage tickets.

Heidi Cody took a more ironic stance with her 2000 work AMERICAN ALPHABET. She found all twenty-six letters in the initials of corporate logos. She said, "I try to get viewers to consciously acknowledge how indoctrinated, or 'branded' they are." [1]

Posters, Advertisements, and Other Graphics

A poster is a concise visual announcement that provides information through the integrated design of typographic and pictorial imagery. In a flash, an effective poster attracts attention and conveys its message. The creativity of a poster designer is directed toward a specific purpose, which may be to advertise or to persuade.

The concept of the modern poster is more than a hundred years old, but it wasn't until the 1920s and 1930s that advances in printing methods made possible high-quality mass production. Since the 1950s, radio, television, and print advertising have over-

242 Heidi Cody.
AMERICAN ALPHABET, 2000.
Lightbox installation.
Roebling Hall Gallery, Brooklyn, NY.
© 2000 Heidi Cody, www.heidicody.com.

243 SILENCE=DEATH. 1986.
Poster. Offset lithograph. Designed
and published by the Silence=Death
Project, New York.
© Avram Finkelstein, Brian Howard, Oliver Johnston,
Charles Kreloff, Christopher Lione, Jorge Soccoras.

244 Chaz Maviyane-Davies.
RIGHTS, ARTICLE 15. 1996. Offset Poster.
Courtesy of the artist.

shadowed posters. While they now play a lesser role than they once did, well-designed posters can still fulfill needs for instant communication.

For example, the AIDS crisis presented a new set of social issues in many American cities during the 1980s. The SILENCE=DEATH poster was produced as advocacy by a group of six gay men who founded the Silence=Death Project in 1986. The composition as a whole is meant to resemble a corporate logo. The purple triangle is an inverted version of the insignia homosexuals were forced to wear in Nazi concentration camps. The slogan suggests that the causes, treatment, and prevention of AIDS need to be discussed openly. It is not until the viewer comes close enough to read the inscription at the bottom of the poster that the epidemic is mentioned at all. This emblem became the logo of the movement known as ACT UP (AIDS Coalition to Unleash Power), and is still used on posters, T-shirts, bumper stickers, billboards, and handbills.

Some posters remind us of our rights rather than urge us to change our behavior. Chaz Maviyane-Davies in 1996 based a set of posters on the United Nations Universal Declaration of Human Rights. His poster RIGHTS, ARTICLE 15 includes text that

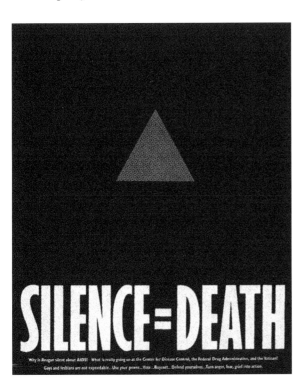

CHAZ
Maviyane-Davies

245 Chaz Maviyane-Davies.
ABSOLUTE POWER. Offset poster. 2002.
Courtesy of the artist.

CHAZ MAVIYANE-DAVIES grew up in Zimbabwe when it was still a British colony. His first jobs were low-paying drafting tasks for a telecommunications company. He recalled, "discrimination was the order of the day so very few opportunities existed for me pursue anything outside of the life that a racist government had planned for me."[2] He went to London and earned an M.A. degree at the Central School of Art and Design. While he was away, Zimbabwe became independent under the leadership of the Patriotic Front party headed by Robert Mugabe. He estab-lished a graphic design firm called the Maviyane Project in the capital, Harare. Most of his clients were charities, public service agencies, and nongovernmental organizations.

As years passed, the Mugabe regime became more and more suspicious and repressive of alternate viewpoints. Maviyane-Davies tried to remain apart from the growing fray, but found it difficult. He recalled, "Designers can choose to be active or passive in what they do, regardless of their ideology—but if they think they are neutral they should be careful whose interests they really serve." By trying to remain neutral, he grew to believe that he was only giving support to the regime.

His work took a step toward militancy when the Mugabe government began restricting participation in the 2000 legislative elections. Suddenly opposition parties had trouble getting candidates on the ballot, and voters were prevented from registering in many areas. Maviyane-Davies created dozens of posters for free distribution encouraging people to keep democracy alive (See OUR FEAR IS THEIR BEST WEAPON on page 13).

The Mugabe regime began using many of the same procedures during the 2002 presidential campaigns, even imprisoning the leading candidate for treason. Maviyane-Davies again swung into action, making posters for free distribution on paper and over the internet. One of these is ABSOLUTE POWER, a simple design based on a popular drink advertisement in which the designer changed the original beverage into blood.

This graphic agitation must have been effective: The government forced Maviyane-Davies to leave the country in 2003. He now teaches graphic design and continues his public service work. One of his best-known projects was a set based on the United Nations Universal Declaration of Human Rights. He said the series "grew out of the indignation I have always felt in the way that Africans are constantly portrayed. For many, 'Africa' conjures up images of a continent torn apart by hatred and brutality, corpses and corruption. Ignore these images and the continent has no other identity. And yes, as an African I've experienced life on a continent where in many parts, fundamental human rights are obliterated with blood and sadness, as conflict and turmoil leave only despair and hopelessness in their wake." Hence the series gives prominence to black persons.

His advice for aspiring designers: "I'd just say believe in yourself, really believe in yourself; research, work as hard as you can at the process and not the ends, strive to realize your vision, listen with your eyes and ears and use your soul."

246 Chaz Maviyane-Davies.
Courtesy of Chaz Maviyane-Davies.

guarantees the right to a nationality. He used the face of a black man who watches hopefully between the stripes of a flag, because a great many images of Africans that we see in the media are associated with disaster or famine. Maviyane-Davies has also made more urgent graphic appeals, as the accompanying essay shows.

Humor has great appeal. Maira Kalman's NEW YORKER COVER gently mocks the boisterous subcultures of Manhattan and environs with exotic-sounding names. Some of these are Botoxia, Hiphopabad, Trumpistan, and al-Zeimers. Published in December 2001, the design allowed New Yorkers to laugh at themselves again after the tragedy of September 11. English graphic designer Jonathan Barnbrook took a more sarcastic tone with his TOMAHAWK FONT, which is based on the script found on missiles that the military uses to strike suspected terrorist camps.

Subcultures often have their own unique design styles. For example, when the Globe Poster company promoted NORTH AMERICAN TOUR '94, it used a brightly colored and highly readable style that its designers had pioneered a generation before. Globe set the standard for promotional design on behalf of soul, gospel, and blues performers, and the "Globe Style" is still the norm in many areas of

247 Maira Kalman. NEWYORKISTAN.
 NEW YORKER COVER, December 10, 2001.
 The Conde Nast Publications, Inc.

248 Jonathan Barnbrook. TOMAHAWK FONT SAMPLE. 2003.
 Courtesy of the artist.

249 NORTH AMERICAN TOUR '94. Poster. 1994.
 Globe Poster Printing Corporation, Francis Cicero.
 Silkscreen and offset lithography. 33¾" × 22¹⁄₁₆".
 Cooper-Hewitt National Design Museum. Smithsonian Institution. Gift of Globe
 Poster Printing Corp., 1997-54-2.

>>TOMAHAWK
FOR ALL YOUR
GRAPHIC
PRE-EMP+IVE
S+RIKES

the United States for such functions, giving almost instant recognizability.

The subculture of punk music developed its own design style, which does not look designed at all. The Sex Pistols released their first single, GOD SAVE THE QUEEN, to coincide with the Silver Jubilee celebrations of the twenty-fifth year of the reign of Queen Elizabeth. The song was so controversial that it was banned from the airways, yet it became the number one selling song. Twenty-five years later, the book *100 Best Record Covers of All Time* judged Jamie Reid's cover the best record cover ever produced.

David Carson came from the world of hardcore and grunge music. His rough and expressive designs have enlivened compact disk cases, T-shirts, concert promotions, and independent magazines, or "zines." The PAGES FROM RAY GUN MAGAZINE is an example of his work at its most raw, where legibility is nearly sacrificed for expressiveness. The magazine completely avoids the slick look of most publications. This layout is the visual equivalent of the music it extols. Columns of text are unequal in size and look slapped on. Different fonts are combined in the heading, with the last word crossing a page break. The accompanying photograph is purposely out of focus and off-center.

In advertising, the arts frequently work together. Television advertising is a kind of operatic art form that calls on writers, musicians, and actors as well as directors, camera operators, and graphic designers. In printed advertising, a writer, a designer, and often an illustrator or photographer work as a team.

250 Jamie Reid.
GOD SAVE THE QUEEN. 1977.
Album cover.
Virgin Records. Arcova Publishing Ltd.

251 David Carson.
PAGES FROM RAY GUN MAGAZINE. 1993.
Offset lithograph. Ray Gun Publishing, Santa Monica, CA.
Ray Gun Magazine.

ILLUSTRATION

An *illustration* is a picture or decoration created to enhance the appearance of written material or to clarify its meaning. Illustrators create images for books, magazines, reports, CD cases, greeting cards, and advertisements.

Some of the most elaborate and sumptuous illustrations ever made were hand painted; however, modern illustration has evolved in conjunction with the development of printing processes. Nineteenth-century illustration usually required the insertion of a plate into the blocks of raised type (letters) that served as text. The plate, prepared by lithography, engraving, or etching, was inked and printed. The resulting page was then bound with the other pages of the text. Honoré Daumier was among the first to use lithography for illustration.

One of the great illustrators of all time was José Guadalupe Posada, a printmaker who worked in

252 José Guadalupe Posada.
LAS BRAVÍSIMAS CALAVERAS GUATEMALTECAS DE MORA
DE MORALES. 1907.
Published by Antonio Vanegas Arroyo, Mexico City. Zinc
etching, type-metal, and letterpress, printed on blue, thin-
wove paper. Sheet: 15⅞" × 11¾".
The Metropolitan Museum of Art. The Elisha Whittlesey Collection, The Elisha
Whittlesey Fund, 1946. (46.46.290).
Photograph: © 1990 The Metropolitan Museum of Art.

Mexico City in the years surrounding 1900. His il-
lustrations were metal plates that his publisher
mounted on a wood frame together with raised type
to make flyers, single sheets that sold for one cen-
tavo. These sheets told stories of disasters, robberies,
murders, and miracles: whatever would be of inter-
est to the working classes of that time. LAS BRAVÍSI-
MAS CALAVERAS GUATEMALTECAS deals with the case
of two Guatemalans who were executed for carrying
out a political assassination in 1907. As we see in the
sheet, Posada's style was full of humor and energy.
The criminals dance through a field of skulls as the
general public flees in alarm. The skeleton has an-
cient roots in Mexico as a symbol of the dead, but
here death is mocked in a high-spirited fashion.

The distinction between illustrations and art
displayed in galleries and museums has to do with

the purpose the work is intended to serve, rather
than the medium in which the work is made, since
both illustrations and gallery art can be drawings,
paintings, or photographs.

American illustrator Norman Rockwell was best
known for the many *Saturday Evening Post* magazine
covers he created between 1916 and 1963. He spe-
cialized in humorous, often sentimental scenes of
everyday small-town life, drawn with an eye for
meaningful detail. His 1946 illustration MUSEUM
WORKER is a quaintly humorous picture of a museum
worker carrying a frame in a portrait gallery who has
become a momentary work of art himself. The three
figures in the paintings the custodian passes seem to
look in his direction, as if surprised to see him join
their number. The implied lines of their glances help
to focus the composition. The worker's legs are

253 Norman Rockwell.
MUSEUM WORKER.
Cover for *Saturday Evening Post*, March 2, 1946.
Curtis Publishing Company. Printed by permission of the Norman Rockwell Family
Agency LLC. © 1946 the Norman Rockwell Family Agency LLC.

READING IS FUN!
INTERNATIONAL YEAR OF THE CHILD 1979

254 Maurice Sendak.
READING IS FUN.
Poster.
© 1979 by Reading is Fundamental, Inc. Reprinted with permission.

echoed in the small piece of sculpture at the left. The wire dangling at the center suggests wayward but graceful right-to-left motion. After these close observations, it is not really surprising that a worker can be a work of art; surely this was part of Rockwell's egalitarian message.

Maurice Sendak's name has become synonymous with children's book illustration. Though he has illustrated many books by other authors, he is best known for those he wrote himself. His style varies from quite simple line drawings, with little or no indication of background, to elaborate cross-hatched and textured drawings in which every inch of the composition is filled.

Sendak's make-believe creatures delight adults as well as children. His READING IS FUN poster uses animals from his book *Where the Wild Things Are*. Sendak rejects the notion that illustrations for children's books must be devoid of anything frightening; his playfully menacing creatures provide children with a healthy way to confront some of their fears of the unknown. Sendak's work has had a strong influence on other illustrators.

Recent photomechanical reproduction processes have enabled illustrators to employ drawing, painting, and photographic techniques—with computers further extending the capabilities of illustrators. Although most illustration is now done with photography, some areas—notably children's books, fashion illustration, and greeting cards—continue to rely on drawn or painted images.

SCULPTURE

Sculpture exists in space, as we do. The total experience of a sculpture is the sum of its surfaces and profiles. Even when touching is not permitted, perceiving its tactile quality is an important part of the way we experience sculpture.

FREESTANDING AND RELIEF SCULPTURE

Sculpture meant to be seen from all sides is called *in-the-round* or *freestanding.* As we move around it, our experience of a sculpture is the sum of its surfaces and profiles. No one had to suggest moving around Calder's OBUS to the little girl in our photograph. A single photograph shows only one view of a sculpture under one kind of light; thus, unless we can see many photographs or, better yet, a video, or best of all, view the piece firsthand, we receive only a limited impression of the sculpture.

A sculpture that is not freestanding but projects from a background surface is in relief. In *low-relief* (or *bas-relief*) sculpture, the projection from the surrounding surface is slight. As a result, shadows are minimal. Coins, for example, are works of low-relief sculpture stamped from molds. A high point in the art of coin design was reached on the island of Sicily during the classical period of ancient Greece. The APOLLO coin, shown here slightly larger than actual size, has a strong presence in spite of being in low relief and very small.

255 Alexander Calder.
OBUS. 1972.
Painted sheet metal. 142½" × 152" × 89⅝".
Mr. & Mrs. Paul Mellon Collection. Photograph © 2001 Board of Trustees, National Gallery of Art, Washington, D.C. 1983.1.49.(A–1859)/SC. © 2002 Estate of Alexander Calder/Artists Rights Society (ARS), NY. Photograph: Duane Preble.

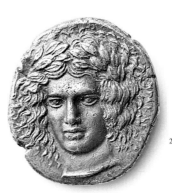

256 APOLLO. C. 415 B.C.E.
Greek silver coin.
Diameter 1⅛".
Photograph: Hirmer Fotoarchiv, Munich Germany.

257 ARMY ON THE MARCH.
Angkor Wat, c. 1150, Cambodia. 1100–1150.
Sandstone.
Eliot Elisofon, LIFE Magizine © TimePix.

258 Robert Longo.
Middle portion, CORPORATE WARS: WALL OF INFLUENCE. 1982.
Cast aluminum 7' × 9'.
Photograph: Courtesy of Metro Pictures.

Some of the world's best and most varied low-relief sculptures are found at the temple of Angkor Wat in Cambodia. This vast temple complex was the center of the Khmer empire in the twelfth century. It was here that Khmer kings sponsored an extensive program of sculpture and architecture. Within the chambers of the complex, carvings are in such delicate low relief that they seem more like paintings than sculpture. One scene depicting an ARMY ON THE MARCH is a king's army commanded by a prince. The rhythmic pattern of the spear-carrying soldiers contrasts with the curving patterns of the jungle foliage in the background. The soldiers and background provide a setting for the prince, who stands with bow and arrow poised in his carriage on the elephant's back. Intricate detail covers entire surfaces of the stone walls.

In *high-relief* sculpture, more than half of the natural circumference of the modeled form projects from the surrounding surface, and figures are often substantially undercut.

This is the case with Robert Longo's CORPORATE WARS: WALL OF INFLUENCE, where male and female figures convulse in painful conflict. Much of the composition is high-relief; in only a few areas are limbs and garments barely raised above the background surface. Dynamic gestures and the diagonal placement of torsos and limbs make the sculpture very active. The emotional charge of the piece suggests that Longo is horrified by the dog-eat-dog competition of corporate life.

METHODS AND MATERIALS

Traditionally, sculpture has been made by modeling, casting, carving, constructing, and assembling, or a combination of these processes. (The techniques of modeling, casting, and carving can be seen on the *Discovering Art* CD.)

Modeling

Modeling is a *manipulative* and often *additive* process. Pliable material such as clay, wax, or plaster is built up, removed, and pushed into a final form.

Tool marks and fingerprint impressions are visible on the surface as evidence of the modeling

259 DOUBLE FIGURE, MALE AND FEMALE.
Maya. C. 700 C.E. Terracotta and paint. 10½" × 5¾" × 3⅜".
Honolulu Academy of Arts. Purchase 1973 (4184.1).

technique employed to make DOUBLE FIGURE. Body volume, natural gesture, and costume detail are clearly defined. The ancient Maya, who lived in what are now parts of Mexico, Guatemala, and Honduras, used clay to create fine ceramic vessels and lively naturalistic sculpture.

The working consistencies of wax, clay, and plaster are soft. To prevent sagging, sculptors usually start all but very small pieces with a rigid inner support called an *armature*. When clay is modeled to form large sculptures, the total piece can be built in relatively small, separately fired, structurally self-sufficient sections, thereby eliminating the need for an armature.

This was the case when Robert Arneson employed the modeling process for building his clay work CALIFORNIA ARTIST. Arneson considered all art self-portraiture. He made this piece in response to an attack on his work by a New York critic, who said

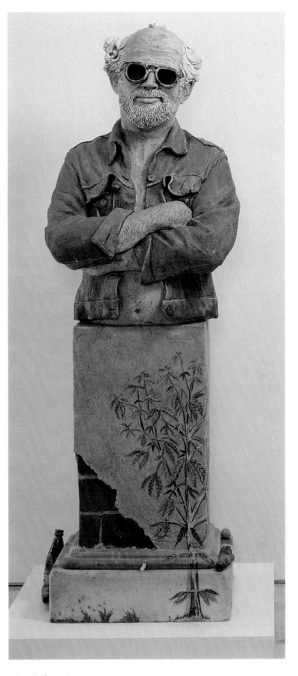

260 Robert Arneson.
CALIFORNIA ARTIST. 1982.
Stoneware with glazes. 68¼" × 27½" × 20¼".
San Francisco Museum of Modern Art. Gift of the Art Council.
© Estate of Robert Arneson/Licensed by VAGA, NY.

Scott Chamberlin

Scott Chamberlin would prefer that this work be untitled, because a title "just tells you what to think about." He said; "You might just look at the label and walk away." He gave this piece the title AHYRE, a word that makes no sense to most viewers. The work is abstract, a term that the artist defined: "you might know that it has some basis in the real world but you don't know what that basis is." Hence this work suggests subjects rather than depicting them; it is intended to stimulate imagination. And what could this work suggest? Body parts, physical being, or eroticism. The work is modeled from terra cotta; the exterior walls are thin and the interior is hollow in order to facilitate firing. Chamberlin discusses eroticism, abstraction, and audience response on the interview at the *Artforms* companion Web site.

261 Scott Chamberlin.
AHYRE. 1998.
Terra Cotta. 24" high.
Photograph by John Bobath. Courtesy of the artist.

that, because of California's spiritual and cultural impoverishment, Arneson's work could have no serious depth or meaning.

Arneson created a life-sized ceramic figure with empty holes in place of eyes, revealing an empty head, depicted himself as a combination biker and aging hippie—complete with the appropriate visual cliches on and around the base. Those who think that clay is only for making bricks and dinnerware were acknowledged by Arneson, who put his name on the bricks, as any other brickmaker would. The artist stated his point of view:

I like art that has humor, with irony and playfulness. I want to make "high" art that is outrageous, while revealing the human condition which is not always high.[1]

Casting

Casting processes make it possible to execute a work in an easily handled medium (such as clay) and then to reproduce the results in a more permanent material (such as bronze). Because most *casting* involves the substitution of one material for another, casting is also called the *substitution* or *replacement* process. The process of bronze casting was highly developed in ancient China, Greece, Rome, and parts of Africa. It has been used extensively in the West from the Renaissance to modern times.

Casting is a sequence of several steps. First, a *mold* is taken from the original work (also called the *pattern*). The process of making the mold varies, depending on the material of the original and the material used in the casting. Materials that can be poured and will harden can be used to cast: clay diluted with water, molten metal, concrete, or liquid plastic. Second, the original sculpture is removed from the mold and the casting liquid is poured into the resulting hollow cavity. Finally, when the casting liquid has hardened, the mold is removed.

Some casting processes employ molds or flexible materials that allow many casts to be made from the same mold; with other processes, such as the

262 Duane Hanson.
MUSEUM GUARD. 1975.
Polyester, fiberglass, oil, and vinyl. 69" × 21" × 13".
Nelson-Atkins Museum of Art, Kansas City, MO. Gift of the Friends of Art.
Photograph by Robert Newcombe © 1995 The Nelson Gallery Foundation.
All Reproduction Rights Reserved. © Estate of Duane Hanson/Licensed by
VAGA, New York, NY.

263 Charles Ray.
SELF-PORTRAIT. 1990.
Mixed media. 75" × 26" × 20".
Collection of the Orange County Museum of Art, Museum purchase.

lost wax process, the mold is destroyed to remove the hardened cast, thus permitting only a single cast to be made.

Castings can be solid or hollow, depending on the casting method. The cost and the weight of the material often help determine which casting method will be used for a specific work.

The process of casting a large object like Giacometti's MAN POINTING (page 46) is extremely complicated. Except for small pieces that can be cast solid, most artists turn their originals over to foundry experts, who make the molds and do the casting. Most of our monuments in public parks were cast in bronze from artists' clay or wax models.

In recent years, many sculptors have turned to modern synthetic media such as plastics, which can be cast and painted to look like a variety of other materials. Cast polyvinyl resin can be made to resemble human flesh, and some artists have exploited this property to create sculptures of unbelievable realism by adding clothing. Viewers might be forgiven for approaching and conversing with Duane Hanson's GUARD, for example. It is difficult to tell whether it is a work of art or is protecting other works. Its presence in the gallery probably does help protect other works. Charles Ray's SELF-PORTRAIT is a little more witty, if that is possible. He made the statue taller than he actually is—wouldn't we all like to be taller—and put a mannequin stand at the bottom. Both works play an elaborate game between human-made image and reality, but Ray's work adds a third possibility: Is it real, is it art, or something in between, such as a dummy? Is it dummy art?

Sculptors who attempt to fool our eyes with statues that resemble real people are working in an ancient Western tradition that values realism as

264 Rachel Whiteread.
PUBLIC ART FUND WATERTOWER PROJECT. 1997.
12' high, 9' diameter.
Courtesy of the artist and Luhring Augustine.

Sculpture made with materials such as polyvinyl or epoxy resin is often formed in separate pieces in plaster molds, then assembled and unified with the addition of more layers of plastic. Although molds are used, the initial pouring process differs from conventional casting because forms are built up in layers inside mold sections rather than being made out of material poured into a single mold all at once.

English artist Rachel Whiteread has used these new materials in fascinating cast pieces that turn empty spaces into solid volumes. She made her 1997 PUBLIC ART FUND WATERTOWER PROJECT by pouring 9,000 pounds of clear urethane into a mold made from an actual tower. The piece looks as though the wooden container vanished, leaving only the water.

Carving

Carving away unwanted material to form a sculpture is a *subtractive* process. Michelangelo preferred this method. Close observation of his chisel marks on the surfaces of the unfinished AWAKENING SLAVE reveals the steps he took toward increasingly refined cutting—even before he had roughed out the figure from all sides. Because Michelangelo left this piece in an unfinished state, it seems as though we are looking over his shoulder midway through the carving process. For him, the act of making sculpture was a process of releasing the form from within the block of stone. This is one of four figures, later called "Slaves," that Michelangelo abandoned in various stages of completion.

Carving is the most challenging of the three basic sculptural methods because it is a one-way technique that provides little or no opportunity to correct errors. Before beginning to cut, the sculptor must visualize the finished form from every angle within the original block of material. Another example of Michelangelo's carving is his PIETÀ on page 86.

The various types of stone with their different characteristics greatly influence the type of carving that can be done with them. The marble that Michelangelo and many sculptors in the European tradition prefer is typically soft and workable enough that it can be cut with a chisel. Final polishing with a light abrasive yields a smooth and creamy surface

evidence of artistic skill. According to myth, the Classical Greek artist Zeuxis once painted a man holding a bowl of grapes so realistically that a bird flew down and tried to eat the fruit. Zeuxis was unsatisfied with the work, however, because, he reasoned, if he had painted the man with equal skill, the bird would have been frightened off by the painted figure. Unfortunately, none of his works survive. The belief that the greatest artists are the best at capturing a likeness still holds much sway in our society, and artists such as Hanson and Ray make charming allusion to it in their works.

265 Michelangelo Buonarroti.
AWAKENING SLAVE. 1530–1534.
Marble. Height 9'.
Academy Gallery, Florence. © Nimatallah/Art Resource, NY.

266 MASSIVE STONE HEAD.
12th–10th centuries B.C.E.
Olmec. Basalt. Height 65".
© Werner Forman/Art Resource, NY.

not unlike human skin. Marble has been a preferred material in the West for outdoor sculpture for centuries, but modern air pollution and acid rain harm the stone, making it far less desirable today. Granite avoids these pitfalls, and thus is often used for outdoor monuments such as tombstones, but granite is so hard that carving in detail is difficult. Sandstone and limestone are sedimentary materials that have also found wide use in many parts of the world. The Cambodian creators of ARMY ON THE MARCH, for example (see page 176), took advantage of the qualities of sandstone. Sedimentary stones are relatively soft, allowing much detail, and can be polished to a high gloss, though weather reduces this over time.

The ancient Egyptians used schist, a dense stone similar to slate. The jade that the Chinese favored is so hard and brittle that it can only be ground down by abrasion or filing; hence it is suitable only for small pieces. The Olmecs of ancient Mexico used basalt, common in their area of the Gulf Coast. We can see its coarse-grained character in the MASSIVE STONE HEAD. Even though the sculptor achieved an intense facial expression, there is little detail. The relative hardness of the stone forced the sculptors to keep most of its original boulder-like shape. The coarseness of basalt is even more obvious when we consider that this piece is nearly five and a half feet tall and weighs several tons.

267 Elizabeth Catlett.
MOTHER AND CHILD #2. 1971.
Walnut. Height 38".
Photograph by Samella Lewis. © 2002 Elizabeth Catlett/Licensed by VAGA, NY.

In wood carving, sculptors prefer walnut and cypress because of their strength and ease of working. The gesture of the mother in Elizabeth Catlett's carved MOTHER AND CHILD suggests anguish, perhaps over the struggles all mothers know each child will face. Both figures have been abstracted in a composition of bold sweeping curves and essential shapes. Solidity of the mass is relieved by the open space between the uplifted chin and raised elbow and by the convex and concave surfaces. An engraved line indicating the mother's right hand accents the surface of the form. The highly polished smooth wood invites the viewer to touch.

Carving from a single block of wood is risky because the outside of a piece of wood dries much more readily than the inside, and the resulting difference in rates of shrinkage causes splits and cracks.

The Chinese, who have traditionally excelled at wood carving, solved this problem many centuries ago by developing the technique called joined-block construction. Here, different parts of a sculpture are carved separately and fitted together. The whole piece is then hollowed out. If the work is done well, as it is in BODHISATTVA GUAN YIN, the joints between the pieces of wood are not noticeable except to experts. This work was finished with paint.

Constructing and Assembling

For most of recorded history, the major sculpting techniques in the Western world were modeling, carving, and casting. Early in the twentieth century, *assembling* methods became popular. Such works are called *constructions*.

In the late 1920s, Spaniard Julio González pioneered the use of the welding torch for cutting and welding metal sculpture. The invention of oxyacetylene welding in 1895 had provided the necessary tool for welded metal sculpture, but it took three decades for artists to utilize the new tool's potential. González had learned welding while working briefly in an automobile factory. After several decades—and limited success—as a painter, González began assisting Picasso with the construction of metal sculpture. Subsequently González committed himself to sculpture and began to create his strongest, most original work. In 1932 he wrote:

The Age of Iron began many centuries ago by producing very beautiful objects, unfortunately mostly weapons. Today it makes possible bridges and railroads as well. It is time that this material cease to be a murderer and the simple instrument of an overly mechanical science. The door is wide open, at last! for this material to be forged and hammered by the peaceful hands of artists.[2]

González welded iron rods to construct his linear abstraction MATERNITY. It is airy and playful. In contrast, THE MONTSERRAT, created a few years later, is a representational figure. The figure, named for Catalonia's holy mountain, is a symbol of Spanish will and resistance to Nazi aggression.

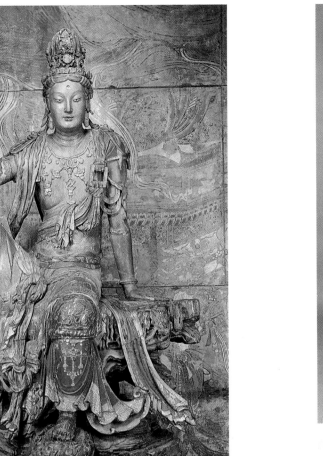

268 BODHISATTVA GUAN YIN.
 11th–12th century. Northern Song (960–1127) or Liao Dynasty (916–1125).
 Chinese, Shanxi Provice.
 Wood with paint. 95" × 65" (241.3 × 165.1 cm).
 Nelson-Atkins Museum of Art, Kansas City, MO, Purchase: Nelson Trust. Photograph by Robert Newcombe.
 © 1993. The Nelson Gallery Foundation. All Rights Reserved.

269 Julio González.
 MATERNITY. 1934.
 Welded iron. Height 49⅞".
 © Tate Gallery, London/Art Resource, NY.
 © 2002 Artists Rights Society (ARS), New York.

270 Julio González.
 THE MONTSERRAT. 1936–1937.
 Sheet iron. Height 5'5".
 Stedelijk Museum, Amsterdam, © 2002 Artists Rights Society (ARS), New York.

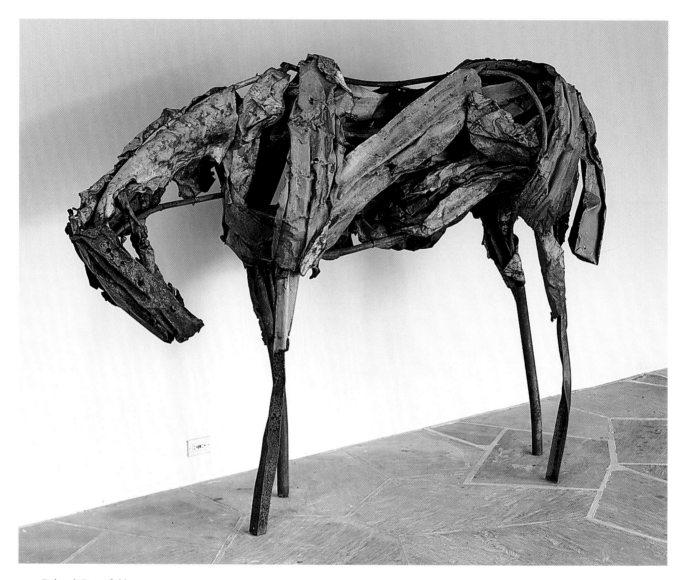

271 Deborah Butterfield.
NAHELE. 1986.
Scrap metal. 72" × 102" × 39".
Courtesy the Contemporary Museum, Honolulu.
Gift of the Honolulu Advertiser Collection at Persis Corporation.

Since the 1970s, Deborah Butterfield has created figures of horses from found materials such as sticks and scrap metal. Much of Butterfield's time is spent on ranches in Montana and Hawaii where she trains and rides horses and makes sculpture. Painted, crumpled, rusted pieces of metal certainly seem an unlikely choice for expressing a light-footed animal, yet Butterfield's NAHELE and other abstract horses have a surprisingly lifelike presence. The artist intends her sculpture to *feel* like horses rather than simply look like them. The old car bodies she has used for many of her welded and wired metal horses add a note of irony: the scrapped autos take on a new life as a horse.

Some sculptors assemble found objects in ways that radically change the way we see familiar things, yet the artists maintain enough of the objects' original characteristics and identities to invite us to participate in their transformation. Such work requires

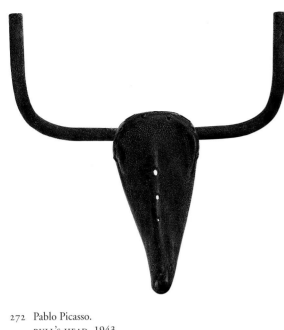

272 Pablo Picasso.
BULL'S HEAD. 1943.
Bronze. Height 16⅛". Seat and handles of a bicycle.
Photo by Bernice Hatala. Musée Picasso, Paris, France.
© Reunion des Musées Nationaux/Art Resource, NY.
© 2002 Estate of Pablo Picasso/Artists Rights Society (ARS), NY.

metaphorical visual thinking by both artists and viewers. This type of constructed sculpture is called *assemblage*.

Picasso found a wealth of ready-made ingredients from salvaged fragments of daily life. For his assemblage BULL'S HEAD he cut the creative process to a single leap of awareness. Describing how it happened, Picasso said:

One day I found in a pile of jumble an old bicycle saddle next to some rusted handle bars . . . In a flash they were associated in my mind . . . The idea of this BULL'S HEAD came without my thinking of it . . . I had only to solder them together . . .[3]

Some assemblages gather meaning from the juxtaposition of real objects. Roberto Visani brought a tripod stand, a rifle, and a crutch together in his installation YOU SEE THE HUT YET YOU ASK "WHERE SHALL I GO FOR SHELTER." The phrase Tribal War inscribed across the top of the crutch indicates the recent events in African that partly inspired the work. Yet the assemblage was also influenced by music:

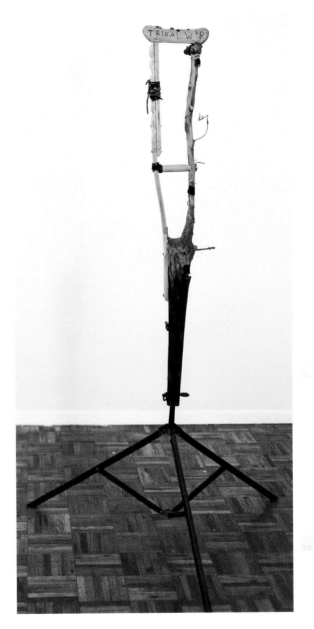

273 Roberto Visani. TRIBAL WAR.
YOU SEE THE HUT YET YOU ASK "WHERE SHALL I GO FOR SHELTER." 2000–2003.
61" × 35" × 34".
Detail from mixed-media installation. Dimensions variable.
Courtesy of the artist.

The artist heard a concert by Afro beat artist and political activist Fela Kuti while traveling in Ghana, and was inspired by a line in one of Kuti's songs: "Tell the man with the gun that the people who teach our people fear, render the whole country defenseless."

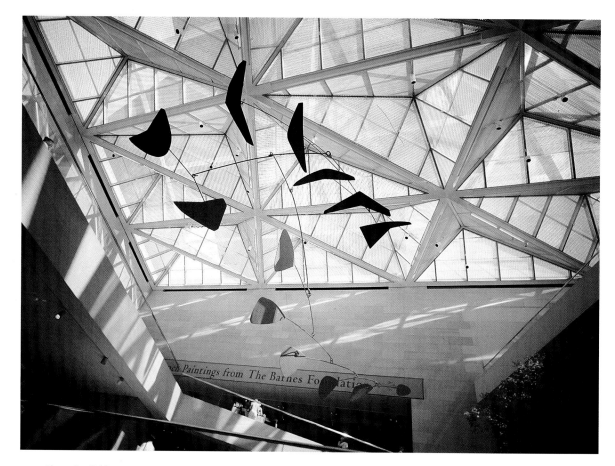

274 Alexander Calder.
UNTITLED. 1976.
Painted aluminum and tempered steel. 29'10½" × 76'.

KINETIC SCULPTURE

Alexander Calder was among the first to explore the possibilities of *kinetic sculpture,* or sculpture that moves. Marcel Duchamp named Calder's kinetic sculptures *mobiles*—a word Duchamp had coined for his own work in 1914. Sculptors' traditional emphasis on mass is replaced in Calder's work by a focus on shape, space, and movement. By 1928, he was designing inventive wire and sheet-metal constructions (see page 42). Calder's huge UNTITLED mobile is the centerpiece of the contemporary wing of the National Gallery of Art in Washington, D.C.; its slow, graceful movement is caused by air currents within the building.

MIXED MEDIA

Today's artists frequently use a variety of media in a single work. Rather than being presented as a long list of materials, such combinations are often identified only as *mixed media.* The media may be two-dimensional, three-dimensional, or a mixture of the two. Often, the choice of media expresses some cultural or symbolic meaning.

Cai Guo Qiang retold an ancient Chinese war story in his large work BORROWING YOUR ENEMY'S ARROWS: A crafty general dared the enemy to shoot at his boats as he floated by; the enemy obliged with such enthusiasm that the arrows helped the general's laden boats float higher.

Traditional art training in European cultures encouraged mastery of one medium, such as sculpture or painting or ceramics, but in many other cultures mixing media is the norm. This is most true in African and Native American cultures, where sculptures are frequently painted and clothing may be decorated with beads or stones or pigments.

Contemporary African artist Ouattara used paint, hinges, and record album covers in his two-dimensional mixed-media work HIP-HOP, JAZZ, MAKOUSSA. The title refers to styles of music popular in Africa in the 1990s, and this work includes covers from Bob Marley, LL Cool J, Fela Kuti, John Coltrane, and Salif Keita, among others. Makoussa was a musical movement begun in the 1960s by Cameroonean musician Manu Dibango. Ouattara once told an interviewer that few African artists make work in only one medium; mixing media has been the norm for generations.

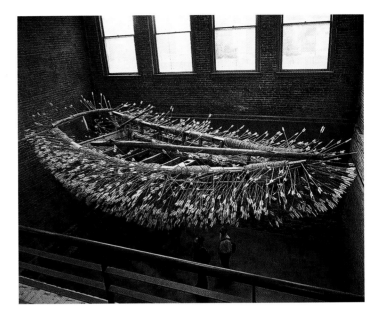

275 Cai Guo Qiang.
BORROWING YOUR ENEMY'S ARROWS. 1998.
Wooden boat, straw, bamboo, arrows, flags, and fan. 32½' long.
Photo: Hiro Ihara. Courtesy of the artist.

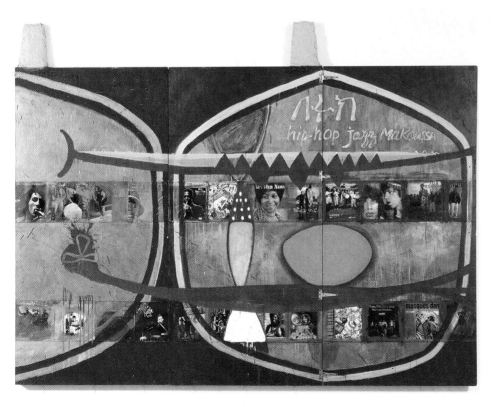

276 Ouattara.
HIP-HOP, JAZZ, MAKOUSSA, 1994.
Mixed media on wood,
109" × 144".
Courtesy the artist and Tracy Williams Ltd., NY.

277 Marisol.
WOMEN AND DOG. 1964.
Wood, plaster, synthetic polymer, taxidermed dog head, and mixed media.
Whitney Museum of American Art, New York. Purchase, with funds from the Friends of the Whitney Museum of American Art. 64.17a–g. Photograph by Robert E. Mates © 1999: Whitney Museum of American Art, NY.
© Marisol/Licensed by VAGA, New York, NY.

Marisol, a Venezuelan who uses only one name, makes assembled wood sculpture in a more geometric style. WOMEN AND DOG incorporates drawing and painting on the life-sized, boxy figures, along with a stuffed dog's head. Her work usually has a satirical edge to it, as the rigidity and multiple blank faces of the figures show. She most often lampoons political leaders and upper-class persons, a rather ironic fact since the artist herself comes from these social levels.

For almost four decades, Korean-born Nam June Paik has been the artist most identified with the fusion of art and technology. In Chapter 9, Paik was introduced as among the first to use video as an art medium. Here, we consider him as a major mixed-media artist.

From the beginning of his career, Paik has refused to conform to the demands of only one creative medium. He began by studying musical composition before moving on to visual art. In the 1960s he achieved art-world notoriety for creating a cello made from television monitors. He composed several works for his "TV cello." For a 1978 installation, he recorded videotapes of green landscapes, and played them on monitors placed in a bed of live plants. A more recent installation included video monitors, sounds, projected imagery, and brightly colored laser beams.

In 1974 Paik envisioned a totally new kind of super highway made up of interactive technologies that would enable a new level of communication around the world. His 1997–1998 traveling instal-

278 Nam June Paik.
INTERNET DWELLER: WOL.FIVE.YDPB. 1994.
Two Panasonic 10" televisions, six KTV 5" televisions, six
vintage television cabinets, projector, lantern, glass
insulators, neon, one laser disc player, one original Paik
laser disc.
Courtesy Carl Solway Gallery, Cincinnati, Ohio.
Photographers: Chris Gomien and Tom Allison.

279 Ilya Kabakov.
THE MAN WHO FLEW INTO SPACE FROM HIS APARTMENT.
1981–1988. Mixed-media installation.
© Ilya Kabakov. Courtesy Barbara Gladstone. © 2002 Artists Rights Society
(ARS), NY.

lation exhibit, the *Electronic Super Highway,* filled
with his recent assemblages, incorporates over 650
working television monitors. He calls it "Cyber-
town." What could be more "mixed" than the in-
gredients of Paik's humorous INTERNET DWELLER:
WOL.FIVE.YDPB listed in the caption of the piece
shown here?

INSTALLATIONS

Many artists now use the three-dimensional medium
of *installation* in an effort to tell a story visually. An
installation artist transforms a space by bringing
into it items of symbolic significance. This medium

is most similar to constructed sculpture, but the
artist constructs an entire environment within the
gallery. A leader in this trend has been the Russian
émigré artist Ilya Kabakov, whose work THE MAN
WHO FLEW INTO SPACE FROM HIS APARTMENT was
first exhibited in 1989, a year after he left the Soviet
Union. It represents a cramped tenement apartment
of the sort typical of the Russian middle classes, ex-
cept that the walls are covered with Communist
posters and drawings by the room's imagined in-
habitant. Looking at the piece, viewers can guess at
the story line: The hero, feeling dejected and op-
pressed by life as he found it, literally blasted himself

280 James Turrell
MEETING. 1980–1986.
Installation at P.S.1, Long Island City, NY.
Courtesy Barbara Gladstone Gallery and P.S. 1
Museum of Contemporary Art, NY.

out of his cubicle, leaving behind a gaping hole in the ceiling directly above his abandoned shoes. Kabakov is committed to the installation style, because, he says, "it may unite—on equal terms, without recognition of supremacy—anything at all . . . Here, politics may be combined with the kitchen, objects of everyday use with scientific objects, garbage with sentimental effusions."[4]

A very different installation from Kabakov's was created by James Turrell within P.S.1, an old public school in Long Island City that had been renovated to provide studio and exhibition spaces. MEETING, a site-specific permanent installation, is in a small square room on an upper floor. This work is one of

a series of installations Turrell calls Skyspaces. The space is visited by appointment only, in dry weather, in late afternoon to early evening hours. It consists of a white room without windows or furniture except for a high-backed continuous bench built into the base of the four walls. Visitors slowly realize that most of the ceiling is not ceiling, but open sky. As evening comes, the natural light defining the space gradually fades to reveal a previously unseen warm light gently emerging from behind the high-backed seating. For many visitors, MEETING is a wonderful visual experience, a meditative spiritual renewal. It is a place where nature and human ingenuity conspire to transform one's sense of self and place.

CHAPTER **twelve**

CLAY, GLASS, METAL, WOOD, FIBER

Ever since the Renaissance, we in the West have tended to rank the "crafts" a little below the "arts." We have generally considered craft objects to be useful things, such as dishes, blankets, or jewelry, while art (painting and sculpture) is meant to be only looked at and thought about, in a gallery or on a wall in someone's home. Crafts are made with different media (clay, glass, wood, fiber) from those of art (paint, marble, bronze). Craft objects tend to be decorative, while art generally makes a personal statement.

Artists and craft workers have tried to break down this barrier at various times. For example, in the 1870s William Morris in England urged artists to turn away from the "fine arts" and devote their skills to making everyday objects. Most works of art in the West are unique and very expensive things; only the wealthy can afford them, while the rest of us visit them in museums or look at copies in books. Morris thought that if artists devoted their skills and taste to the creation of things for common use, then everyone's life would be enriched. (His belief was influenced by the Socialist politics that he also practiced.) Hence the artists in his workshop made dishes, wallpaper, furniture, and fabrics, all by hand like craft workers of the middle ages. Unfortunately, the shop could never get its prices low enough to please either the founder or the public.

A similar idea led to the creation of the Bauhaus in Germany in 1919, though it had a more modern approach. The school was the union of an art academy and a craft workshop, and there too, students and teachers cultivated the "fine arts" side by side with the "applied arts" of furniture-making, graphic design, typography, and even architecture. The emphasis here was on modern mass-production rather than hand crafting, as the artists' designs were destined to be made in factories. The goal was similar to that of the Morris workshop: to bring craft and art together and let artists use their skills to enrich objects we use every day. But because Adolph Hitler disliked modern art, the school was subject to Nazi harassment in the early 1930s and forced to close.

The most recent push against this separation began in the 1970s, when many artists began making unique objects for gallery exhibition out of craft media. Viewers at that time increasingly appreciated the high level of skill, taste, and labor that go into the best craft work such as quilts, dishes, and stained glass. Industry and mass production reduced the demand for handmade things for daily use. Craft and art thus began to draw together, and the barrier between them began to break down.

This change in attitude brought Western thought in line with that of other cultures around the world and throughout history, who have not separated art and craft. Most of the world's cultures have always regarded an excellent piece of pottery as highly as a painting, and a book illustration as equal in merit to a piece of sculpture; Western society is

Nampeyo

(1857?–1942)

NAMPEYO WAS BORN into the Snake Clan in the village of Hano, on land that the Hopis called First Mesa. Her name means "Snake That Does Not Bite." There were no paved roads leading to the village, and the nearest city—Winslow, Arizona—was three days' journey away. Her family responded to her early artistic interests by sending here to a neighboring village to learn pottery making from her grandmother, one of the few who still made pots.

Nampeyo began picking up broken shards of pottery from the nearby site of an ancient Hopi village called Sikyatki. This village had been abandoned before the Spanish Conquest. She was fascinated by the ancient designs and began to incorporate them into her own pots.

In 1895, the anthropologist Jesse Walter Fewkes arrived to dig and study to ruins of Sikyatki. Nampeyo's husband helped Fewkes with the digging and told what he knew about the Hopi peoples. Fewkes and his assistants unearthed hundreds of burials, findings many ancient Hopi pots in excellent condition. Among these were many seed jars, low pots with a narrow open-

284 NAMPEYO DECORATING POTTERY. 1901.
Displaying pottery: ollas, dippers, bowls, vases.
Courtesy of the Southwest Museum, Los Angeles. Photograph: Adam Clark Vroman. N42363.

ing and abstract designs in brown or black over a rich yellow body.

Nampeyo studied and copied these pots, invigorated by the work of her ancestors, and she mastered the shape of the traditional seed jar. Once she learned the vocabulary of symbols, she found that she could freely adapt and combine them, rather than merely copy ancient models. She told an anthropologist, "When I first began to paint, I used to go to the ancient village and pick up pieces of pottery and copy the design. That is how I learned to paint. But now I just close my eyes and see designs and I paint them."[2] She discovered that there was a ready

market for pottery with the ancient designs. In this effort she was a pioneer. The relatively rare ancient pottery had always found buyers among a few select collectors; however, when Nampeyo began making pots in that style, to her delight she found that she could easily sell her entire production. She used the new income to support her entire extended family, and alleviate some of the poverty on First Mesa.

Her success became a pattern that other Indian artists would follow. In the Pueblo of San Ildefonso, María Martínez and her

husband, in collaboration with anthropologist Edgar Hewitt, soon reintroduced ancient black pottery from that Pueblo. Lucy Lewis of Ácoma was similarly inspired by ancient designs. The revival of Pueblo and Hopi pottery contributed to the creation, in 1932, of the American Indian Arts and Crafts Board, the first government attempt to encourage Native creators to practice their traditional art forms.

Nampeyo continued to produce work until she began to lose her eyesight in the 1920s. Her husband painted some of her designs until his death in 1932. Today, her great-granddaughters continue the tradition.

porcelain BELL-FLOWER-SHAPED BOWL, delicate and fragile looking, was probably fired a total of three times: once with the raw white clay, once with a transparent glaze, and finally, at a lower temperature, to set the colored glazes. Porcelain is made with a fine-grained, translucent clay body. Both pieces are outstanding traditional examples, yet express greatly contrasting approaches within the same society.

Some present-day potters use ancient methods, firing their pots in open fires that reach only low and generally varied temperatures. A pioneer in the rediscovery of past techniques was the Hopi potter Nampeyo. Working in the 1890s in collaboration with anthropologists and archaeologists who were digging ancient ruins near her village, she learned the long-forgotten symbolic vocabulary of ancient wares, and in the process revitalized her own work and that of many other potters, as the accompanying essay shows.

In the mid-1950s, Peter Voulkos brought ceramic tradition together with modern art expression, and thus extended the horizons for both art and craft. He and a group of his students led the California sculpture movement that broke through preconceptions about the limits of clay as a medium for sculpture. With his rebellious spirit, Voulkos revitalized ceramic art and helped touch off new directions in other craft media. If most movements to unite art and craft involved artists moving toward craft, Voulkos reversed the process. He was trained as a potter, and had a studio that sold dishes in upscale stores until the middle 1950s. Then he began to explore abstract art, and he found ways to incorporate some of its techniques into his ceramic work. At first he took a fresh approach to plates: He flexed them out of shape and scratched their surface as if they were paintings, thereby rendering them useless in the traditional sense. His first exhibition of these works in 1959 caused a great deal of controversy, because most people did not think of stoneware as an art medium. Yet none could deny the boldness of his inventions. His monumental GALLAS ROCK brings the emotional energy of Abstract Expressionist paint-

285 Peter Voulkos.
GALLAS ROCK. 1960.
Glazed ceramic. Height 6'.
University of California at Los Angeles.
Photograph: Duane Preble.

ing (see Chapter 23) to three-dimensional form. He said that the basis of this work is "the core cylinder inside, with other cylinders going in different directions to take the weight of the slabs. . . . Outside and inside grew together." While working on it, he had to "relate everything at the same time and still keep the spontaneity."[3]

286 Toshiko Takaezu.
MAKAHA BLUE II, 2002.
Stoneware, 18½" × 48".
Courtesy of the artist and Charles Cowles Gallery, New York.

Both Peter Voulkos and Toshiko Takaezu were influenced by the earthiness and spontaneity of some traditional Japanese ceramics, such as the TEA BOWL on page 193, as well as by expressionist painting, yet they have taken very different directions. Voulkos's pieces are rough and aggressively dynamic, while Takaezu's MAKAHA BLUE II offers subtle, restrained strength. By closing the top of container forms, Takaezu shifted attention to sculptural form, and thus provided surfaces for rich paintings of glaze and oxide. She reflects on her love of the clay medium:

When working with clay I take pleasure from the process as well as from the finished piece. Every once in a while I am in tune with the clay, and I hear music, and it's like poetry. Those are the moments that make pottery truly beautiful for me.[4]

Ceramic processes evolved very slowly until the twentieth century, when new formulations and even synthetic clays became available. Other changes have included more accurate methods of firing and improved techniques and equipment. The most significant change of all has come in the use of clay as a conceptual and sculptural art form.

GLASS

Glass has been used for at least four thousand years as a material for practical containers of all shapes and sizes. During the Middle Ages, stained glass was used extensively in Gothic churches and cathedrals (see page 5). Elaborate, blown-glass pieces have been made in Venice since the Renaissance. Glass is also a fine medium for decorative inlays in a variety of objects—including jewelry.

Glass is an exotic and enticing art medium. One art critic wrote, "Among sculptural materials, nothing equals the sheer eloquence of glass. It can assume any form, take many textures, dance with color, bask in clear crystallinity, make lyrics of light."[5]

Chemically, glass is closely related to ceramic glaze. As a medium, however, it offers a wide range of unique possibilities. Hot or molten glass is a sensitive, amorphous material that is shaped by blowing, casting, or pressing into molds. As it cools, glass solidifies from its molten state without crystallizing. After it is blown or cast, glass may be cut, etched, fused, laminated, layered, leaded, painted, polished, sandblasted, or slumped (softened for a controlled sag). The fluid nature of glass produces qualities of mass flowing into line as well as translucent volumes of airy thinness.

Although it is said that the character of any material determines the character of the expression, this statement is particularly true of glass. Molten glass requires considerable speed and skill in handling. The glassblower combines the centering skills of a potter, the agility and stamina of an athlete, and the grace of a dancer to bring qualities of breath and movement into crystalline form.

The person most responsible for making glass into an art form was Harvey Littleton. Formerly a ceramic artist, he started a glassblowing studio on the

grounds of the Toledo Museum of Art in Ohio in 1962 and began experimenting with artistic glass-making. With help from industrial technicians, he soon settled at the University of Wisconsin, where he began the first instructional studio. A generation of glass workers studied with him, and they fanned out to start over fifty other university glass studios within ten years.

The fluid and translucent qualities of glass are used to the fullest in Dale Chihuly's SEAFORM SERIES. Chihuly, a Littleton student, produces such pieces with a team of glass artists working under his direction. In this series, he arranges groups of pieces and carefully directs the lighting to create suggestions of delicate undersea environments.

METAL

Metal's primary characteristics are strength and forma-bility. The various types of metal most often used for crafts and sculpture can be hammered, cut, drawn out, welded, joined with rivets, or cast. Early metalsmiths created tools, vessels, armor, and weapons.

A high point of metalwork production was reached in the Islamic cultures of the Middle East in the thirteenth and fourteenth centuries, when techniques of shaping and inlaying were practiced with unparalleled sophistication. The D'ARENBERG BASIN, named after a French collector who owned it for many years, was made for the last ruler of the Ayyubid Dynasty in Syria in the mid-thirteenth century. The body of the basin was first cast in brass; its extremely intricate design included lowered areas into which precisely cut pieces of silver were placed. Although most of the silver pieces are only a fraction of an inch in size, they enliven a carefully patterned design that occupies several finely proportioned horizontal bands. The lowest band is a decorative pattern based on repeated plant shapes. Above is a row of real and imaginary animals that decorates a relatively narrow band. The next band depicts a scene of princely pleasure, as well-attired people play polo. The uppermost contains more plant shapes between the uprights of highly stylized Arabic script that expresses good wishes to the owner of the piece. A central panel in this upper row depicts a scene from

287 Dale Chihuly.
MAUVE SEAFORM SET WITH BLACK LIP WRAPS from the "SEAFORMS" SERIES. 1985.
Blown glass.
Courtesy of Dale Chihuly. Photograph: Dick Busher.

288 D'ARENBERG BASIN.
Syria. Mid-13th century.
Brass with silver inlay. 9" × 20".
Freer Gallery of Art, Smithsonian Institution, Washington, D.C. F1955.10.

289 Albert Raymond Paley.
PORTAL GATES. 1974.
Forged steel, brass, copper, and bronze. 90¾" × 72" × 4".
© National Museum of American Art, Smithsonian, Washington, D.C./Art Resource, NY. Commissioned for the Renwick Gallery (1975.117.1).

ating larger pieces such as the GATES, commissioned for the entrance of the Renwick Gallery museum shop. Few artists today possess the technical skill required to forge red-hot iron. Paley enjoys handling a material that physically resists him. Whether he is working on small pieces or large ones, Paley employs a variety of metals, woven together in harmonious interplay. A lively relationship between lines and spaces creates the high energy of his ornamental gates. The curves have the sensual fluidity of hot pliable metal, while the center verticals recall the rigid strength of iron and steel. Bundles of straight lines unify and solidify the composition. The twelve-hundred-pound Renwick PORTAL GATES took Paley and his assistant seven months to complete.

WOOD

The living spirit of wood is given a second life in handmade objects. Growth characteristics of individual trees remain visible in the grain of wood long after trees are cut, giving wood a vitality not found in other materials. Its abundance, versatility, and warm tactile qualities have made wood a favored material for human use and for art pieces.

Virginia Dotson makes elegant works that straddle the boundary between useful things and objects just for contemplation. Her bowl CROSS WINDS includes two kinds of wood that have been inlaid, laminated, and turned on a lathe. While devoted to wood as a medium, she favors interaction with other types of artists. She said, "I love to look at work in other media and talk about common concerns with weavers, quilters, metal, and glass artists. This type of interaction has provided many insights for the personal involvement I have with my work."[6]

Most furniture purchased today is produced by industrial mass-production methods. However, those with the skill to make their own—or enough money to buy custom pieces—can enjoy living with hand-crafted furniture.

Sam Maloof makes unique pieces of furniture and also repeats some designs he finds particularly satisfying. His DOUBLE ROCKING CHAIR and other designs show his thorough understanding of wood and

the life of Christ, who is regarded as an important figure in the Muslim religion.

Perhaps the largest number of craft artists using metal today are those who make jewelry. Contemporary jewelry often includes unusual materials, as well as the more traditional metals and precious stones. The best examples can be appreciated as miniature sculpture that involves the crafts of metalworking, enameling, and precise stone-cutting (lapidary).

Albert Paley's large, heavy, hand-wrought and forged PORTAL GATES appear delicate when seen in a small reproduction. Paley began his metalworking career making jewelry and gradually shifted to cre-

290 Virginia Dotson.
CROSS WINDS. 1989.
Wenge and maple, laminated and turned.
5¾" × 13⅛" × 13⅛".
Ronald C. Wornick Collection.

291 Sam Maloof.
DOUBLE ROCKING CHAIR. 1992.
Fiddleback maple and ebony.
42⅝" × 42" × 44½".
Courtesy of the artist.

of the hand processes he uses to shape wood into furniture. Flowing curves result from his sensitive melding of form and function. Although he employs assistants who help him duplicate his best designs, he limits quantity. Because he enjoys knowing that each piece is cut, assembled, and finished according to his own high standards, Maloof has rejected offers from manufacturers who want to mass-produce his designs. He prefers to retain quality control and the special characteristics that are inevitably lost when even the best designs are factory-produced rather than handmade. Many pieces of furniture are pleasing to look at, and many are comfortable to use, but relatively few fulfill both functions so successfully.

FIBER

Fiber art includes such processes as weaving (both loom and nonloom techniques), stitching, basketmaking, surface design (dyed and printed textiles), wearable art, and handmade papermaking. These fiber processes use natural and synthetic fibers in both traditional and innovative ways. Artists working with fiber (as with artists working in any medium) draw on the heritage of traditional practices and also explore new avenues of expression.

All weaving is based on the interlacing of lengthwise fibers, *warp,* and cross fibers, *weft* (also called *woof*). Weavers create patterns by changing the numbers and placements of interwoven threads, and they can choose from a variety of looms and techniques. Simple hand looms can produce very sophisticated, complex weaves. A large tapestry loom,

installed them on the floor of a gallery. The resulting work resembles a quilt, a carpet, and a luxurious bed of flower petals.

Colombian artist Olga de Amaral draws on traditional sources closer to her own ethnic roots: goldsmithing and textiles of the native peoples of Andean South America. To make GOLD MOUNTAIN, she began with a loose network of fibers. Into this array she wove pieces of parchment covered with gold leaf. Because of their size (five to six feet on a side), she calls her works from this period "woven walls." The visual effect of GOLD MOUNTAIN is like a plush tapestry of shimmering texture.

Faith Ringgold's paintings, quilts, and soft sculptures speak eloquently of her life and ideas. Happy memories of her childhood in Harlem in the 1930s provide much of her subject matter. MRS. JONES AND FAMILY represents Ringgold's own family. Commitments to women, the family, and cross-cultural consciousness are at the heart of Ringgold's work. With playful exuberance and insight, she draws on history, recent events, and her o vn experiences for her depictions and narratives of class, power, race, and gender. Her sophisticated use of naiveté gives her work the appeal of the best folk art, but her work has also dealt with more urgent themes such as unemployment and race discrimination. See the biographical essay at the end of this chapter.

296 Olga de Amaral.
GOLD MOUNTAIN. 1992.
Fiber, parchment, and gold leaf. 61" × 61".
Private Collection. Courtesy of Bellas Artes, Santa Fe, New Mexico.

297 Faith Ringgold.
MRS. JONES AND FAMILY. 1973.
Soft sculpture, mixed media. 74" × 69".
Artist's collection. © 1973 Faith Ringgold.

298 Magdalena Abakanowicz.
BACKS (IN LANDSCAPE). 1976–1982.
80 pieces, burlap and glue.
Photograph: © 1982 Dirk Bakker.
© Magdalena Abakanowicz.
Courtesy Marlborough Gallery, NY.

Innovations in off-loom fiber work have taken the fiber arts into the realm of sculpture in a variety of ways. Magdalena Abakanowicz has been at the leading edge of nontraditional uses of fiber since the 1960s. Her powerful series called BACKS has an unforgettable quality—at once personal and universal. The earthy color and textures of the formed burlap suggest the capacity to endure dire hardships and to survive with strength. Her forms have what she feels all art must have: mysterious, bewitching power. The artist spoke of her motives:

I want the viewer to penetrate the inside of my forms. For I want him to have the most intimate contact with them, the same contact one can have with clothes, animal skins, or grass.[8]

keystone

306 ROUND ARCH.

308 GROIN VAULT.

307 BARREL VAULT.

309 ARCADE.

310 PONT DU GARD.
Nimes, France. 15 C.E.
Limestone. Height 161', length 902'.
Photograph: Duane Preble.

Round Arch, Vault, and Dome. (View these basic elements of architecture using the interactive exercises on the *Discovering Art* CD.) Both Egyptian and Greek builders had to place their columns relatively close together because stone is weak under the load-bearing stresses inherent in a beam. A structural invention had to be made before this physical limitation of short spans could be overcome and new architectural forms created. That invention was the semicircular or ROUND ARCH, which when extended in depth creates a tunnel-like structure called a BARREL VAULT. Roman builders perfected the round arch and developed the GROIN VAULT, formed by the intersection of two barrel vaults.

A *vault* is a curving ceiling or roof structure, traditionally made of bricks or blocks of stone tightly fitted to form a unified shell. In recent times, vaults have been constructed of materials such as cast reinforced concrete.

Early civilizations of western Asia and the Mediterranean area built arches and vaults of brick, chiefly for underground drains and tomb chambers. But it was the Romans who first used the arch extensively in above-ground structures. They learned the technique of stone arch and vault construction from the Etruscans, who occupied central Italy between 750 and 200 B.C.E.

A round stone arch can span a longer distance and support a heavier load than a stone beam because the arch transfers the load more efficiently. The Roman arch is a semicircle made from wedge-shaped stones fitted together with joints at right angles to the curve. During construction, temporary wooden supports carry the weight of the stones. The final stone that is set in place at the top is called the *keystone.* When the keystone is placed, a continuous arch with load-bearing capacity is created and the wood support may be removed. A series of such arches supported by columns forms an ARCADE.

As master builders, the Romans created cities, roads, and aqueducts throughout their vast empire in most of Europe, the Near East, and North Africa. The aqueduct called PONT DU GARD, near Nimes, France, is one of the finest remaining examples of the functional beauty of Roman engineering. The combined height of the three levels of arches is 161 feet. Dry masonry blocks, weighing up to two tons each, make up the large arches of the two lower tiers. Water was once carried in a conduit at the top, with the first level serving as a bridge for traffic. That the aqueduct is still standing after two thousand years attests to the excellence of its design and construction.

311 DOME.
a. Dome (arch rotated 180°).

b. Dome on a cylinder.

c. Dome on pendentives.

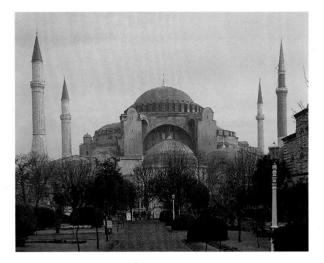

312 HAGIA SOPHIA. 532–535.
Istanbul, Turkey.
a. Exterior.

Roman architects borrowed Greek column design and combined it with the arch, enabling them to greatly increase the variety and size of their architectural spaces. The Romans also introduced concrete as a material for architecture. Cheap, stonelike, versatile, and strong, concrete allowed the Romans to cut costs, speed construction, and build on a grand scale.

An arch rotated 180 degrees on its vertical axis creates a DOME. Domes may be hemispherical, semihemispherical, or pointed. In general usage the word *dome* refers to a hemispherical vault built up from a circular or polygonal base. The weight of a dome pushes downward and outward all around its circumference. Therefore, the simplest support is a cylinder with walls thick enough to resist the downward and outward thrust.

One of the most magnificent domes in the world was designed for the Byzantine cathedral of HAGIA SOPHIA (Holy Wisdom) in Istanbul, Turkey. It was built in the sixth century as the central sanctuary of the Eastern Orthodox Christian Church. After the Islamic conquest of 1453, *minarets* (towers) were added and it was used as a mosque. It is now a museum. In contrast to the PANTHEON's dome on a cylinder, the dome of HAGIA SOPHIA rests on a square base.

HAGIA SOPHIA's distinctive dome appears to float on a halo of light—an effect produced by the row of

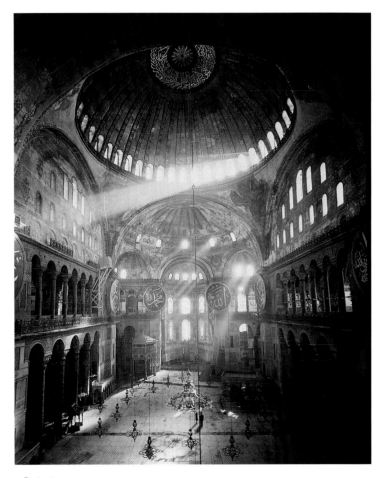

b. Interior.
Photographs: Erich Lessing/Art Resource, NY.

348 EARTHENWARE BEAKER. Susa, Iran. c. 4000 B.C.E.
Painted terra cotta. Height 11¼".
Musée du Louvre, Paris.
Reunion de Musée Nationaux/Art Resource/NY

designs used to enhance articles of daily use. The motifs, or dominant themes, used on clay pots were often derived from plant and animal forms.

The painted EARTHENWARE BEAKER is from Susa, the first developed city on the Iranian plateau. Solid bands define areas of compact decoration. The upper zone consists of a row of highly abstract long-necked birds, below which appears to be a band of dogs running in the opposite direction. The dominant image is an ibex or goat abstracted into triangular and circular shapes. The significant difference between the naturalism of Paleolithic animal art and the abstraction of Neolithic art becomes clear when we compare this goat with the naturalistic bulls of Lascaux.

We can see how Neolithic abstract designs were derived from representational images in AN EVOLUTION OF ABSTRACTION, the series of drawings copied from pieces of pottery found in Shensi Province in China. As the decorative designs evolved over generations, the clearly recognizable bird image became more and more abstract, and eventually it formed the basis for the nonrepresentational band around the pot shown in the drawing. Such playing with figure-ground reversal is also found in modern painting and design.

Some of the finest Neolithic pottery was made in China. The well-preserved BURIAL URN from Kansu Province is decorated with a bold interlocking design, which may have been abstracted from spirals observed in nature. The design in the center of the spirals is probably derived from the bottoms of cowrie shells.

It is quite possible that nonrepresentational signs often found in Paleolithic caves along with naturalistic images of animals were meant to communicate specific information. Many of the world's writing systems grew out of a search for visual equivalents for speech and were preceded by various types of PICTOGRAPHS, or "picture writing." The pictographic origin of some characters in modern Chinese writing is well known. Less well known is that some letters of the Roman alphabet used in English came from pictographs that stood for objects or ideas.

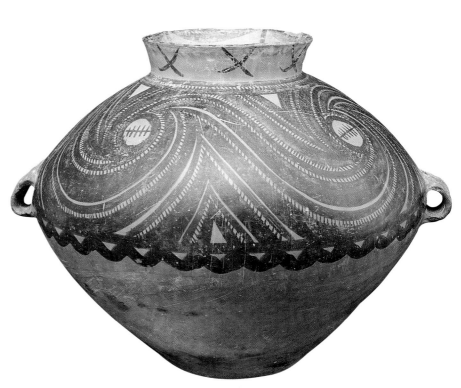

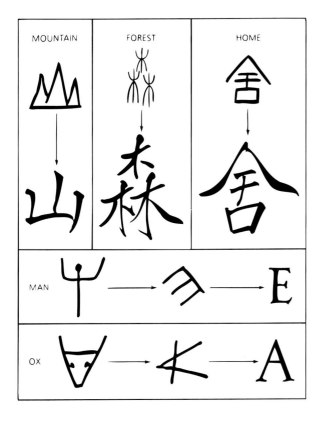

349 AN EVOLUTION OF ABSTRACTION.
From Neolithic pottery,
Shensi Province, China.
Courtesy of Charles Weber.

350 BURIAL URN.
Kansu type. Chinese, Neolithic period.
c. 2200 B.C.E.
Pottery with painted decoration.
Height 14⅛".
The Seattle Art Museum. Eugene Fuller Memorial Collection (51.194).
Photograph: Paul Macapia.

351 PICTOGRAPHS TO WRITING, ASIAN AND WESTERN.

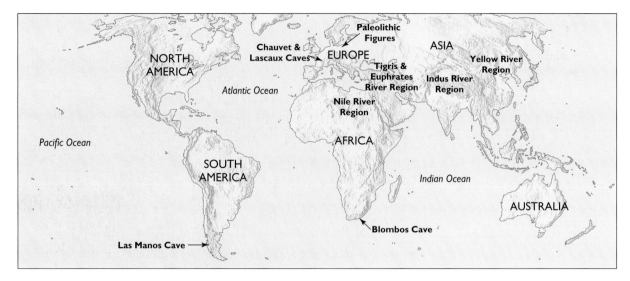

352　EARLIEST CENTERS OF CIVILIZATION, 3500–1500 B.C.E.

THE BEGINNINGS OF CIVILIZATION

Artifacts indicate that early civilizations emerged independently, at different times, in many parts of the world. We use the term *civilization* to distinguish cultures, or composites of cultures, that have fairly complex social orders and relatively high degrees of technical development. Key elements are food production through agriculture and animal husbandry, occupational specialization, writing, and production of bronze by smelting lead and tin. All of these developments were made possible by the move to cooperative living in urban as well as agricultural communities.

Among the earliest major civilizations were those in four fertile river valleys: the Tigris and Euphrates Rivers in Iraq, the Nile River in Egypt, the Indus River in west Pakistan and India, and the Yellow River in northern China.

The ancient civilizations of Mesopotamia and Egypt were almost parallel in time, arising in the fourth millennium B.C.E. and lasting some three thousand years. Yet they were quite different from each other. Urban civilization developed earlier in Mesopotamia than it did in Egypt. The Nile Valley of Egypt was protected by formidable deserts, making it possible for the Egyptians to enjoy thousands of years of relatively unbroken self-rule. The Tigris–Euphrates Valley of Mesopotamia, however, was vulnerable to repeated invasion; the area was ruled by a succession of different peoples. Each civilization therefore developed its own distinctive art forms.

MESOPOTAMIA

It was the Greeks who named the broad plain between the Tigris and Euphrates Rivers Mesopotamia, "the land between the rivers." Today, this plain is part of Iraq. The first Mesopotamian civilization arose in the southernmost part of the plain in an area called Sumer. The Sumerian people developed the world's first writing, the wheel, and the plow.

In the city-states of Sumer, religion and government were one; authority rested with priests who claimed divine sanction. The Sumerians worshiped a hierarchy of nature gods in temples set on huge platforms called *ziggurats,* which stood at the center of each city-state. Ruins of many early Mesopotamian cities are still dominated by eroding ziggurats, such as the ZIGGURAT OF UR-NAMMU. The biblical Tower of Babel was probably a ziggurat.

Ziggurats symbolized the concept of the "sacred mountain" that links heaven and earth. They were filled with sun-baked bricks and faced with fired bricks often glazed in different colors. Two or more successively smaller platforms stood on the solid base, with a shrine on the uppermost platform. On these

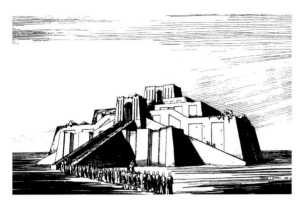

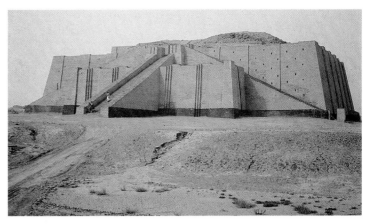

353 ZIGGURAT OF UR-NAMMU. Iraq. c. 2100 B.C.E.
a. Reconstruction drawing.
University of Pennsylvania Museum of Archaeology and Anthropology,
Philadelphia #S8-55876.

b. Incomplete restoration.
Photograph: Superstock.

354 Reconstructed LYRE. From "The King's Grave" tomb RT
789, Ur. c. 2650–2550 B.C.E. Reconstructed. Wood with
gold, lapis lazuli, shell, and silver.
University of Pennsylvania Museum of Archaeology and Anthropology,
Philadelphia (B 17694T4-29C), (#T4–109C3).

a. Soundbox.
b. Front plaque.

heights, close to heaven, the city's deities might dwell, and there the ruling priests and priestesses had their sanctuaries. A lack of stone led to the use of brick and wood for building, and consequently very little Mesopotamian architecture remains.

We can imagine the splendor of Sumerian court life by studying the reconstruction of the elegant royal LYRE found in the king's tomb in the ancient city of Ur. The narrative panel on the front and the bull's head are original. The bearded bull's head is a symbol of royalty often seen in Mesopotamian art. In contrast, the bulls and other imaginary animals

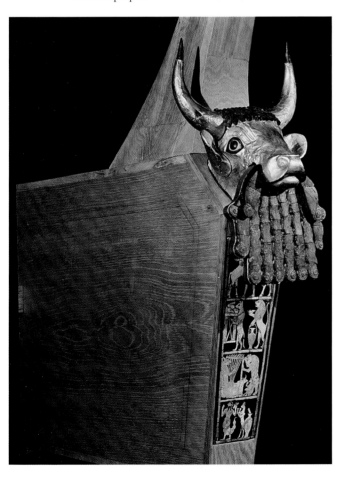

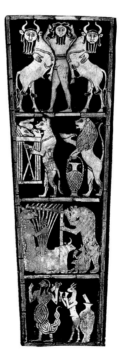

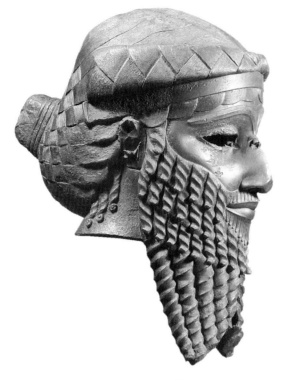

355 HEAD OF AN AKKADIAN RULER. Nineveh.
c. 2300–2200 B.C.E. Bronze. Height 12"
Photograph: Himer Fotoarchiv, Munich, Germany.

inlaid on the harp's soundbox are depicted in a simplified narrative style. They take on human roles, as do the animals in the later Greek fables of Aesop. The upper panel, which shows a man embracing two bearded bulls, is a type of heraldic design developed by the Sumerians that was to influence the art of many later cultures. Both the upper panel and the panel at the bottom—a goat attending a scorpion-man—are believed to be scenes from the great classic of Sumerian literature, the *Epic of Gilgamesh.*

The region of Mesopotamia north of Sumer was called Akkadia. By about 2300 B.C.E., the scattered city-states of Sumer had come under the authority of a single Akkadian king. The magnificent HEAD OF AN AKKADIAN RULER portrays such an absolute monarch. Clearly, this highly sophisticated work evolved from a long tradition. The elaborate hairstyle and rhythmic patterning show the influence of Sumerian stylization. The handsome face expresses calm inner strength. Such superb blending of formal design with carefully observed naturalism is

a characteristic of both later Mesopotamian and Egyptian art.

Mesopotamia was an area of continual local rivalries, foreign invasions, and the rise and fall of military powers, yet this disorder did not prevent the development and continuity of cultural traditions.

EGYPT

Deserts on both sides of the Nile diminished outside influences and enabled Egypt to develop distinctive styles of architecture, painting, and sculpture that remained relatively unchanged for 2500 years— longer than the time from the birth of Christ to today. In our age of rapid cultural and technological change, it is difficult to imagine such artistic stability.

Among the most impressive and memorable works of Egyptian civilization are THE GREAT PYRAMIDS, gigantic mountain-like structures built as burial vaults for pharaohs—rulers who were considered god-kings. Legions of workers cut huge stone blocks, moved them to the site, and stacked them, without mortar, to form the final pyramidal structure. The interiors are mostly solid, with narrow passageways leading to small burial chambers.

Egyptian religious belief was distinguished by its emphasis on life after death. Preservation of the body and care for the dead were considered essential for extending life beyond the grave. Upon death, bodies of royalty and nobility were embalmed; together with accompanying artifacts, tools, and furniture, they were then buried in pyramids or in hidden underground tombs. Architects put great effort into preventing access to these funerary structures. As a result, most of what we know about ancient Egypt comes from such tombs.

Names of many Egyptian architects are known in association with their buildings. A striking and well-preserved example is the FUNERARY TEMPLE OF QUEEN HATSHEPSUT, designed by Senmut, the queen's chancellor and architect. Complementing the majestic cliffs of the site, the ramps and colonnades provide an elegant setting for ritual pageantry.

Egyptian sculpture is characterized by compact, solidly structured figures that embody qualities of strength and geometric clarity found in Egyptian

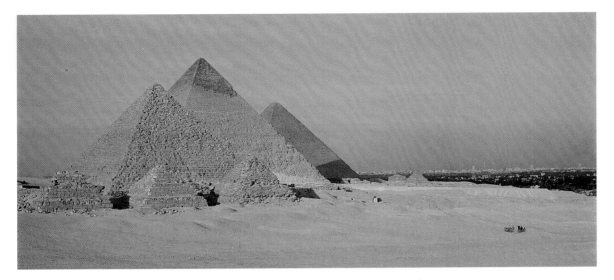

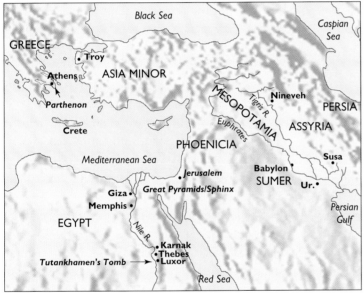

356 THE GREAT PYRAMIDS. Giza, Egypt.
Pyramid of Mycerinus, c. 2500 B.C.E.;
Pyramid of Chefren, 2650 B.C.E.;
Pyramid of Cheops, c. 2570 B.C.E.
© SEF/Art Resource, NY.

357 THE ANCIENT MIDDLE EAST.

358 FUNERARY TEMPLE OF QUEEN
HATSHEPSUT.
Deir el-Bahari. c. 1490–1460 B.C.E.
Tom Till Photography. © Tom Till.

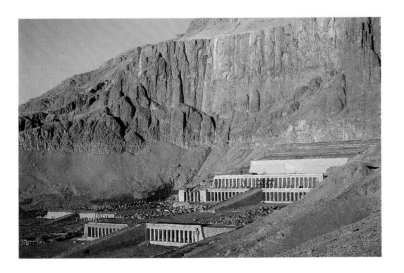

architecture. The final form of a piece of sculpture was determined by an underlying geometric plan that was first sketched on the surface of the stone block. The sculptor of KING MYCERINUS AND QUEEN KHAMERERNEBTY paid considerable attention to human anatomy yet stayed within the traditionally prescribed geometric scheme. The strength, clarity, and lasting stability expressed by the figures result from this union of naturalism and abstraction. With formal austerity, the couple stands in the frontal pose (straight forward, not turning) that had been established for royal portraits. Even so, the figures express warmth and vitality; the queen touches Mycerinus in a sympathetic, loving way. Typical of sculpture of this era are the formal pose with left foot forward, the false ceremonial beard, and figures that remain attached to the block of stone from which they were carved.

Tutankhamen ("King Tut"), who died at age eighteen, is the best-known Egyptian pharaoh because his was the only Egyptian royal tomb discovered in modern times with most of its contents intact. The volume and value of the objects in the small tomb make it clear why grave robbers have been active in Egypt since the days of the first pharaohs. Tutankhamen's inlaid gold MASK FROM MUMMY CASE is but one of hundreds of extraordinary artifacts from the tomb. Its formal blend of naturalism and abstract idealism is distinctly Egyptian.

A feature of Egyptian painting, relief carving, and even sculpture in the round is the presentation of the human figure either in a completely frontal

359 KING MYCERINUS AND A QUEEN. KHAMERERNEBTY.
Egypt, Giza, Old Kingdom, Dynasty 4, reign of Mycerinus, 2532–2510 B.C.E. Schist. 56" × 22½" × 21¾".
Harvard University–MFA Expedition, 1911.11.1738. Courtesy, Museum of Fine Arts, Boston. Reproduced with permission. © 2004 Museum of Fine Arts, Boston. All rights reserved.

360 MASK FROM MUMMY CASE.
Tutankhamen. c. 1340 B.C.E. Gold inlaid with enamel and semiprecious stones.
Height 21¼".
Egyptian Museum, Cairo.
Photograph: Superstock, Inc.

361 WALL PAINTING FROM THE TOMB OF NEBAMUN.
Thebes, Egypt. c. 1450 B.C.E.
Paint on dry plaster.
© British Museum, London.

position or in profile. Egyptian artists portrayed each object and each part of the human body from what they identified as its most characteristic angle, thus avoiding the ambiguity caused by random or chance angles of view (see also page 49).

In the WALL PAINTING FROM THE TOMB OF NEBAMUN, the painter of the hunting scene presents a wealth of specific information without making the painting confusing. Flat shapes portray basic elements of each subject in the clearest, most identifiable way. The head, hips, legs, and feet of the nobleman who dominates this painting are shown from the side, while his eye and shoulders are shown from the front. Sizes of human figures are determined by social rank, a system known as *hierarchic*

scale; the nobleman is the largest figure, his wife is smaller, his daughter smaller still.

The family stands on a boat made of papyrus reeds; plants grow on the left at the shore. The entire painting is teeming with life, and the artist has even taken great care to show life below the water's surface. Attention to accurate detail lets us identify species of insects, birds, and fish. The hieroglyphics—the picture writing of ancient Egyptian priesthood—can be seen behind the figures.

Egyptian art greatly influenced that of early Greece, and the Greeks later developed one of the most important styles in Western in art. To this period we now turn.

THE CLASSICAL AND MEDIEVAL WEST

The Classical cultures of Greece and Rome dominated Western civilization from the fifth century B.C.E. until the decline of Rome in the fifth century C.E. The later periods of Roman rule of Europe also saw the rise of Christianity, a faith that brought a wealth of new subjects to Western art. The period between the fall of Rome and the beginning of the Renaissance is referred to as the Middle Ages or Medieval Period, a term that does little justice to the creativity of that era. Meanwhile, Eastern Europe was dominated by the Byzantine Empire, headquartered in Constantinople (today's Istanbul). Byzantine Christianity is today known as the Orthodox Church. Hence, Christianity of one form or another was a major force in the art of both Eastern and Western Europe for a thousand years.

GREECE

The Greeks distinguished themselves from other peoples of Europe and Asia by their attitude toward being human. They came to regard humankind as the highest creation of nature—the closest thing to perfection in physical form, coupled with the power to reason. Greek deities had human weaknesses, and Greek mortals had godlike strengths.

With this attitude came a new concept of the importance of the individual. The Greek focus on human potential and achievement led to the development of democracy and to the perfection of naturalistic images of the human figure in art. The philosopher Plato taught that behind the imperfections of transitory reality was the permanent, ideal form. Thus, to create the ideal individual (the supreme work of nature) became the goal of Greek artists.

Greek civilization passed through three broad stages: the Archaic period, the Classical period, and the Hellenistic period. In the art of the Archaic period (from the late seventh to the early fifth centuries B.C.E.), the Greeks assimilated influences from Egypt and the Near East. Greek writers of the time tell us that Greek painters were often better known than Greek sculptors. Yet what we now see of Greek painting appears only on pottery because very few wall paintings survive. The elegant GREEK VASE shown here suggests the level of achievement of Greek pot-

362 Exekias. GREEK VASE.
Achilles and Ajax
playing draughts.
c. 540 B.C.E.
Black-figured style.
Height 24".
Vatican Museums, Rome, Italy.

ters as well as painters. It is in the Archaic, "black-figured" style and shows Achilles and Ajax, two heroes from Homer's epic poetry, playing draughts, what we now call checkers. Although their eyes are still shown from the front in the Egyptian manner, there is a new liveliness in the bodies.

Numerous life-size nude male and clothed female figures were carved in stone or cast in bronze during this era. The Archaic-style KOUROS, carved at about the same time the vase was painted, has a rigid frontal position that is an adaptation from Egyptian sculpture. (*Kouros* is Greek for male youth; *kore* is the word for female youth.) The Egyptian figure of MYCERINUS (page 240) and the KOUROS both stand with arms held straight at the sides, fingers drawn up, and left leg forward with the weight evenly distributed on both feet.

In spite of the similarity of stance, however, the character of Greek sculpture is already quite different from that of Egyptian. The KOUROS is freestanding, and it honors an individual who was not a supernatural ruler.

Within one hundred years after the making of the KOUROS figure, Greek civilization entered its Classical phase (480–323 B.C.E.). Greek aesthetic principles from this period provide the basis for the concept of classicism. *Classical* art emphasizes rational simplicity, order, and restrained emotion. The rigid poses of Egyptian and early Greek figures gave way to a greater interest in anatomy and more relaxed poses. Sculpture became increasingly naturalistic as well as idealized and began to show the body as alive and capable of movement.

The statue known as the SPEAR BEARER is an excellent example of Greek Classicism. The sculptor Polykleitos wrote a treatise on the perfect proportions of the human form and created this statue as an example. Neither the book nor the statue survives, but both are known from documents and later copies. Polykleitos envisioned the human body as a harmonious set of divinely inspired ratios. By studying numerous models, he arrived at what he thought were the ideal proportions of the human body. Hence, the SPEAR BEARER combines actual observations with mathematical calculation.

363 KOUROS. Statue of a youth. c. 610–600 B.C.E.
 Marble. Height 76".
 The Metropolitan Museum of Art, New York. Fletcher Fund, 1932.
 (32.11.1). Photograph: © The Metropolitan Museum of Art.

364 Polykleitos.
 SPEAR BEARER (DORYPHOROS).
 Roman copy after Greek original bronze of
 450–440 B.C.E. Marble, height 6'6".
 Museo Acheologico Nazionale, Naples.
 Scala/Art Resource, NY.

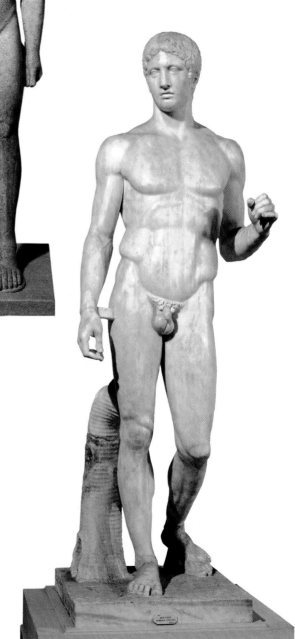

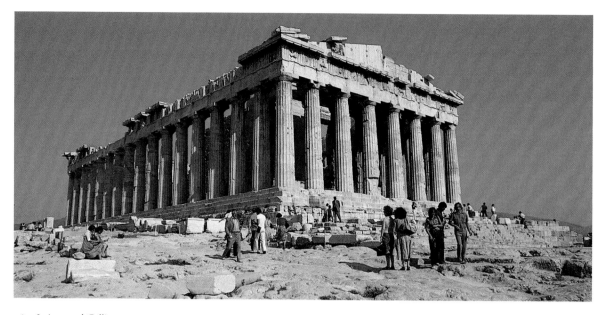

365 Ictinus and Callicrates.
PARTHENON. Acropolis, Athens. 448–432 B.C.E.
a. View from the northwest.

b. View from the southwest.
Photographs: Duane Preble.

The statue depicts an athlete who once held a spear on his left shoulder. Typical of Classical art, the figure is in the prime of life, and blemish-free. It is not a portrait of an individual but rather a vision of the ideal. He bears most of his weight on one leg in a pose known as *contrapposto,* meaning counterpoised. The Greeks and then the Romans used this pose to give a lifelike quality to figures at rest. Cen-

turies later, their sculpture would inspire Renaissance artists to use the same technique.

The city-state of Athens was the artistic and philosophical center of Classical Greek civilization. Above the city, on a large rock outcropping called the Acropolis, the Athenians constructed one of the world's most admired structures, the PARTHENON. Today, even in its ruined state, the PARTHENON continues to express the ideals of the people who created it.

The largest of several sacred buildings on the Acropolis, the PARTHENON was designed and built as a gift to Athena Parthenos, goddess of wisdom, arts, industries, and prudent warfare, and protector of the Athenian navy.

When Ictinus and Callicrates designed the PARTHENON, they were following Egyptian tradition in temple design based on the post-and-beam system of construction (see page 209). In the PARTHENON, the Greek temple concept reached its highest form of development. The structure was located so that it could be seen against the sky, the mountains, or the sea from vantage points around the city, and it was

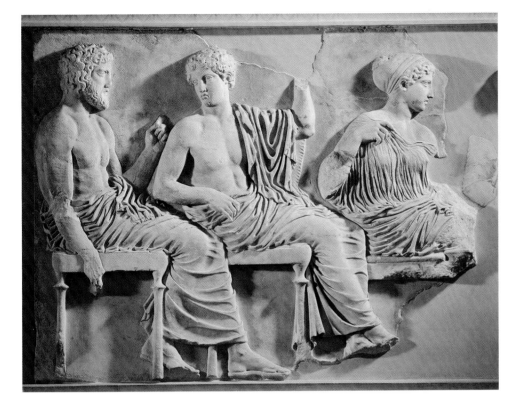

C. PARTHENON FRIEZE.
Poseidon, Apollo, and Artemis.
Acropolis Museum, Athens, Greece.
Photograph: Erich Lessing/Art Resource, NY.

the focal point for processions and large outdoor religious ceremonies. Rites were performed on altars placed in front of the eastern entrance. The interior space was designed to house a forty-foot statue of Athena. The axis of the building was carefully calculated so that on Athena's birthday the rising sun coming through the huge east doorway would fully illuminate the towering gold-covered statue.

In its original form, the PARTHENON exhibited the refined clarity, harmony, and vigor that are the basis of the Greek tradition. The proportions of the PARTHENON are based on harmonious ratios. The ratio of the height to the widths of the east and west ends is approximately 4 to 9. The ratio of the width to the length of the building is also 4 to 9. The diameter of the columns relates to the space between the columns at a ratio of 4 to 9, and so on.

None of the major lines of the building is perfectly straight. Many experts believe that the subtle deviations were designed to correct optical illusions. The columns have an almost imperceptible bulge (called *entasis*) above the center, which causes them to appear straighter than if they were in fact straight-sided, and this gives the entire structure a tangible grace. Even the steps and tops of doorways rise slightly in perfect curves. Corner columns, seen against the light, are somewhat larger in diameter to counteract the diminishing effect of strong light in the background. The axis lines of the columns lean in a little at the top. If extended into space, these lines would converge 5,856 feet above the building. These unexpected variations are not consciously seen, but they are felt, and they help make the building visually appealing.

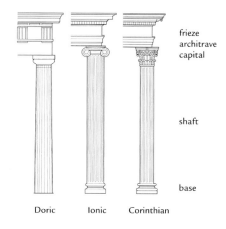

frieze
architrave
capital

shaft

base

Doric Ionic Corinthian

366 ARCHITECTURAL ORDERS.

367 VENUS DE MEDICI. 3rd century B.C.E.
Marble. Height 5'.
Uffizi Gallery, Florence. Photograph: Scala/Art Resource, NY.

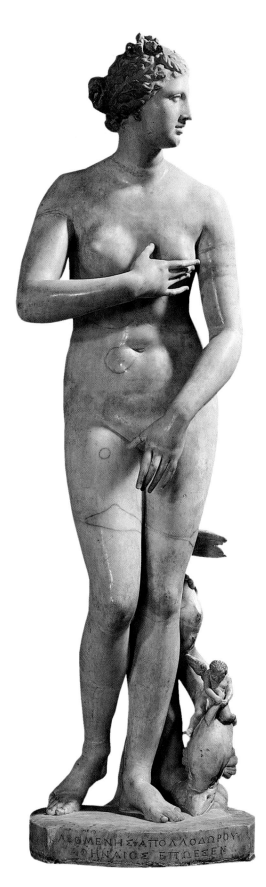

The Greeks developed three ARCHITECTURAL ORDERS: Doric, Ionic, and Corinthian. Each order comprises a set of architectural elements and proportions. The most telling details for identification of the orders are the three types of *capitals* used at the tops of columns. Doric, which came first, is simple, geometric, and sturdy; Ionic is taller and more dynamic than Doric; Corinthian is complex and organic. (See the *Discovering Art* CD for an interactive exercise and a video demonstration of Classical Architecture.)

Although today we see Greek temples as white stone structures, some of the upper portions of exterior surfaces were once brightly painted. Parts of sculpture were also painted.

Some of the finest Greek sculpture was made for the upper areas of the PARTHENON. Running along the exterior wall of the inner temple was a 524-foot-long relief sculpture of a procession in honor of Athena. As with the other figures on the FRIEZE (on the preceding page), the gods Poseidon, Apollo, and Artemis are depicted in ideal human form—noble and perfect.

VENUS DE MEDICI is a third-century B.C.E. Roman copy of a fourth-century B.C.E. Greek original. (Aphrodite, the Greek goddess of love and beauty, was known to the Romans as Venus.) This

copy was inspired by an Aphrodite by Praxitiles, one of the most famous sculptors of the Classical period. Because it was made to symbolize a goddess rather than to portray a real woman, the figure is more ideal than natural. Its refined profile is one of the most obvious features of the Greek idealization of human figures. But we can sense the emerging Hellenistic sensibility in the figure's sensuality—a mortal element foreign to Classical ideals.

After the decline of the Greek city-states at the end of the fourth century B.C.E., the art of the Mediterranean changed. Though it continued to be strongly influenced by earlier Greek art, and was often executed by Greek artists, it was produced for, and according to the preferences of, non-Greek patrons. Mediterranean art during this era is called *Hellenistic*, meaning Greek-like. The transition from Classical to Hellenistic coincided with the decline of Athens as a city-state after it fought a useless war with the neighboring city of Sparta, and with the rise of an absolute monarchy in Macedonia which soon took over the entire peninsula. Artists turned from the idealized restraint Classical period to the subjective and imperfect aspects of life and humanity.

In the Hellenistic period, Greek art became more dynamic and less idealized. Everyday activities, historical subjects, myths, and portraiture became more common subjects for art. Late, or Hellenistic, Greek art contrasts with Classical Greek art in that it is more expressive and frequently shows exaggerated movement.

THE LAOCOÖN GROUP is a Roman copy of a late Hellenistic work. In Greek mythology, Laocoön was the Trojan priest who warned against bringing the wooden horse into Troy during the Trojan War. Subsequently, he and his sons were attacked by serpents, an act the Trojans interpreted as a sign of the gods' disapproval of Laocoön's prophecy. Laocoön is shown in hierarchic proportion to his sons.

The rationalism, clarity, and restraint of Classical sculpture have given way to writhing movement, tortured facial expressions, and strained muscles expressing emotional and physical anguish. When this sculpture was unearthed in Italy in 1506, it had an immediate influence on the young Michelangelo.

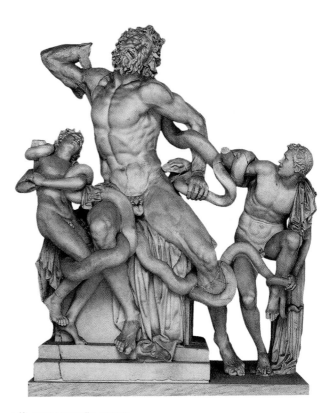

368 THE LAOCOÖN GROUP.
Roman copy of a 1st- or 2nd-century B.C.E. Greek original, perhaps after Agesander, Athenodorus, and Polydorus of Rhodes.
c. 1st century C.E. Marble.
Height 95¼".
Vatican Museum, Vatican State. Rome.
Photograph: Giraudon/Art Resource, NY.

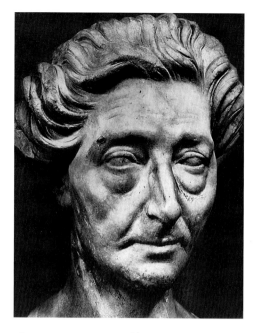

369 FEMALE PORTRAIT. C. 54–117 C.E.
Marble. Life-size.
Vatican Museum, Rome.

ROME

The Hellenistic era saw the rise of Rome, a formidable new force in the Mediterranean. By the second century B.C.E., Rome had become the major power in the Western world. At its height, the Roman Empire would include western Europe, North Africa, and the Near East as well as the shores of the Mediterranean. The governance of a multitude of unique peoples and cultures was a prime example of the Roman genius for order and practical politics. Roman culture has affected our lives in many areas: our systems of law and government, our calendar, festivals, religions, and languages. We also inherited from the Romans the concept that art is worthy of historical study and critical appreciation.

The Romans were a practical, materialistic people, and their art reflects these characteristics. They made few changes in the general style of Greek art, which they admired, collected, and copied. But not all Roman art was imitative. Roman portraiture of the Republican period, such as the FEMALE PORTRAIT, achieved a high degree of individuality rarely found in Greek sculpture. The representationally accurate style probably grew out of the Roman cus-

tom of making wax death masks of ancestors for the family shrine or altar. Later, these images were recreated in marble to make them more durable. Roman sculptors observed and carefully recorded those physical details and imperfections that give character to each person's face.

The Romans' greatest artistic achievements were in civil engineering, town planning, and architecture. They created utilitarian and religious structures of impressive beauty and grandeur that were to have a major influence on subsequent Western architecture. As we saw in Chapter 13, the outstanding feature of Roman architecture was the semicircular arch, which the Romans utilized and refined in the construction of arcades, barrel vaults, and domes (see the diagrams on pages 210–11).

By developing the structural use of concrete combined with semicircular arch and vault construction, the Romans were able to enclose large indoor spaces. Although a type of concrete was commonly used in Roman construction, the quality of cement (the chemically active ingredient in concrete) declined during the Middle Ages, and concrete was not widely used again until it was redeveloped in the nineteenth century.

As shown in THE INTERIOR OF THE PANTHEON, in the PANTHEON, a major temple dedicated to all the gods, Roman builders created a domed interior space of immense scale. The building is essentially a cylinder, capped by a hemispherical dome, with a single entrance framed by a Greek porch, or *portico*.

Whereas Greek temples such as the PARTHENON were designed both as inner sanctuaries for priests and as focal points for outdoor religious ceremonies, the PANTHEON was built as a magnificent, awe-inspiring interior space that complemented its once opulent exterior. To meet their preference for spacious interiors, the Romans developed many other great domed and vaulted buildings.

The PANTHEON's circular walls, which support the huge dome, are stone and concrete masonry, twenty feet thick and faced with brick. The dome diminishes in thickness toward the crown, and it is patterned on the interior surface with recessed squares called *coffers*, which both lighten and strengthen the

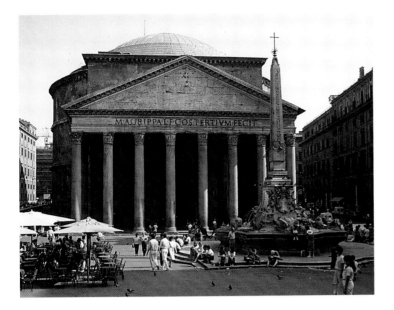

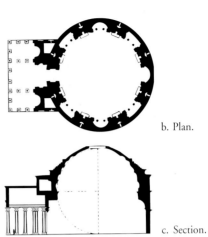

370 PANTHEON. Rome. 118–125 C.E.
a. View of the entrance.
Photograph: Duane Preble.

b. Plan.

c. Section.

371 Giovanni Paolo Panini.
THE INTERIOR OF THE PANTHEON,
ROME. c. 1734.
Oil on canvas. 50½" × 39".

372 EUROPE FROM 117 TO 1400.

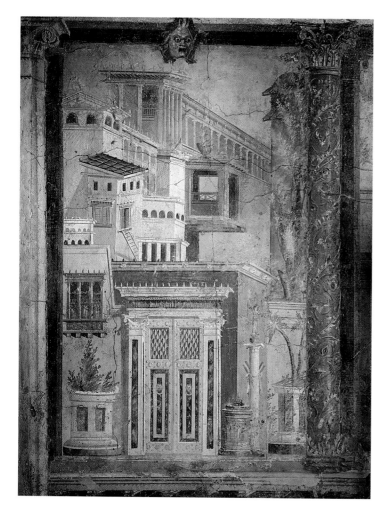

373 ROMAN PAINTING.
Detail of west wall in a villa at Boscoreale. 1st century B.C.E.
Fresco on lime plaster. Height: 8'.
The Metropolitan Museum of Art, New York. Rogers Fund, 1903. (03.14.13).
Photograph: © 1986 The Metropolitan Museum of Art.

structure. Originally covered with gold, the coffered ceiling symbolizes the dome of heaven. It was designed so that the distance from the summit to the floor is equal to the 143-foot diameter—making it a virtual globe of space. At the dome's crown, an opening called an *oculus,* or eye, thirty feet in diameter, provides daylight and ventilation to the interior. Neither verbal description nor views of the exterior and interior can evoke the awe one experiences upon entering the PANTHEON.

Wall paintings are among the most interesting art produced during the period of the Roman Empire. The majority known to us come from Pompeii, Herculaneum, or other towns buried—and thus preserved—by the eruption of Mt. Vesuvius in 79 C.E. In the first century, Roman artists continued the late Greek tradition of portraying depth in paintings of landscapes and urban views. The ROMAN PAINTING from a villa near Naples presents a complex urban scene painted with an unsystematic form of perspective. As is typical of Roman painting, the receding lines are not systematically related to one another to create a sense of common space, nor is there controlled use of the effect of diminishing size relative to distance. Perhaps the artist intended viewers simply to enjoy the pleasing interwoven shapes, patterns, colors, and varied scale rather than to "enter" the illusory space. After the collapse of the Roman Empire, even such suggestions of space were no longer applied, and the knowledge was forgotten until it was rediscovered and developed as a scientific system during the Renaissance, more than one thousand years later.

EARLY CHRISTIAN AND BYZANTINE ART

The Romans first regarded Christianity as a strange cult and suppressed it through law. Since it was illegal to be Christian, the followers of Christ were forced to worship and hide their art in underground burial chambers called *catacombs.* The earliest Christian art was a simplified interpretation of Greco-Roman figure painting. The emphasis was on storytelling through images of Christ and other biblical figures as well as through Christian symbols. In contrast to

major changes in the size relationships between figures (*hierarchical scale*) in later Byzantine art, CHRIST TEACHING HIS DISCIPLES shows Christ only slightly larger than the faithful who surround him.

By the time Emperor Constantine acknowledged Christianity in 312, Roman attitudes had changed considerably. The grandeur of Rome was rapidly declining. As confidence in the material world fell, people turned inward to more spiritual values. The new orientation was reflected in art such as the colossal marble HEAD OF CONSTANTINE, once part of an immense figure. The superhuman head is an image of imperial majesty, yet the large eyes and stiff features express an inner spiritual life. The late Roman style of the facial features, particularly the eyes, is very different from the naturalism of earlier Roman portraits.

In 330, Constantine moved the capital of the Roman Empire east from Rome to the city of Byzantium, which he renamed Constantinople (present-day Istanbul). Although he could not have known it, the move would effectively split the empire in two. In 395, the Roman Empire was officially divided, with one emperor in Rome and another in Constantinople—the center of what became known as Byzantium or the Byzantine empire. Over the course of the next century, the entire empire was repeatedly attacked by nomadic Germanic tribes. They placed one of their own on the Imperial throne in 476.

Byzantium successfully repelled its invaders; Rome was not so fortunate. Under relentless attack from the Germanic tribes, and weakened from within by military rebellions and civil wars, the political unity of the Western Roman Empire decayed, ushering in the era in Europe known as the Middle Ages.

The eastern portion of the empire, however, did not collapse. Indeed, the Byzantine Empire survived well into the fifteenth century. Founded as a Christian continuation of the Roman Empire, Byzantium developed a rich and distinctive artistic style that continues today in the mosaics, paintings, and architecture of the Orthodox church of Eastern Europe.

Not only did Constantine grant Christianity official recognition, he also sponsored an extensive

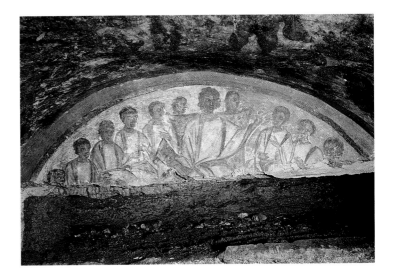

374 CHRIST TEACHING HIS DISCIPLES.
Catacomb of Domitilla, Rome. Mid-4th century C.E.
Photograph: Scala/Art Resource, NY.

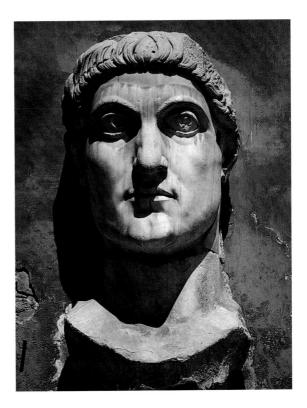

375 HEAD OF CONSTANTINE.
c. 312 C.E.
Marble. Height 8'.
Museo dei Conservatori, Rome.
Photograph: Duane Preble.

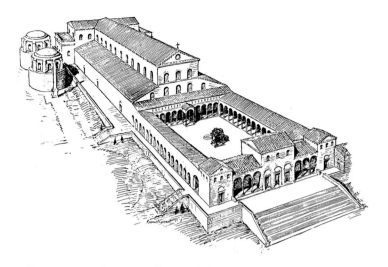

376 OLD ST. PETER'S BASILICA. Rome. c. 320–335.
a. Reconstruction drawing.
Restoration study by Kenneth J. Conant.
Courtesy of the Francis Loeb Library, Graduate School of Design, Harvard University.

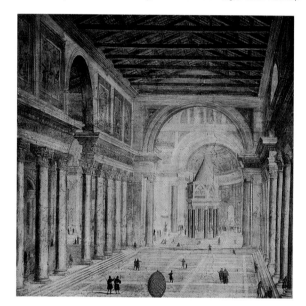

b. Interior view of basilica of Old Saint Peter's.
Fresco. S. Martino ai Monti, Rome, Italy.
Photograph: Scala/Art Resource, NY.

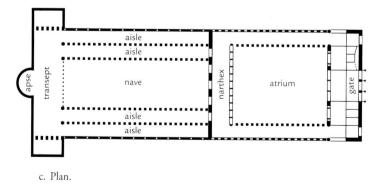

c. Plan.

building program. Thus, in the late Roman and early Byzantine empires, we find the first flowering of Christian art and architecture. For example, Christians adapted the Roman *basilica,* or assembly hall, for use in public worship. For the Romans, a basilica was a long hall flanked by columns with a semicircular *apse* at each end where government bodies and law courts met. One of the earliest Christian churches was OLD ST. PETER'S BASILICA in Rome. Its long central aisle, now called the *nave,* ends in an apse, as in a Roman building. Here, Christians placed an altar.

Round or polygonal buildings crowned with domes had been used in earlier buildings such as Roman baths, and later in the PANTHEON. Beginning in the fourth century, such buildings were built for Christian services and took on Christian meaning. Domed, central-plan churches have dominated the architecture of Eastern Orthodox Christianity ever since.

In contrast to the external grandeur of Greek and Roman temples, early Christian churches were built with an inward focus. Their plain exteriors gave no hint of the light and beauty that lay inside.

The rapid construction of many large churches created a need for large paintings or other decorations to fill their walls. Mosaic technique (used by the Sumerians in the third millennium B.C.E. and later by the Greeks and Romans) was perfected and widely used in Early Christian churches. While other cultures knew of the art of attaching pieces of colored glass and marble (tesserae) to walls and floors, early Christians used smaller tesserae, with a greater proportion of glass, in a wider range of colors. Thus they achieved a new level of brilliance and opulence.

Ravenna, Italy, was briefly the capital of the Western Roman Empire (402–476), and was then recovered by Justinian for the Byzantine Empire (540–751). The many mosaics created in Ravenna in the fifth and sixth centuries show the transition from Early Christian to Byzantine style.

The most important sixth-century church is SAN VITALE in Ravenna. The glittering mosaic compositions that cover most of the interior surfaces depict

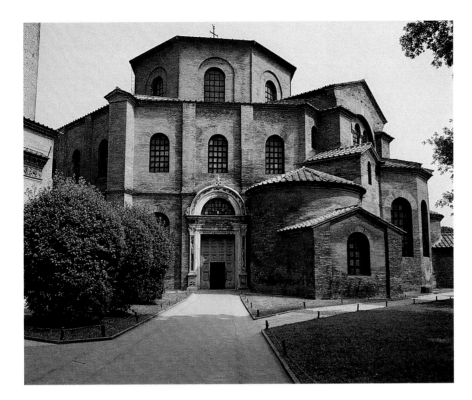

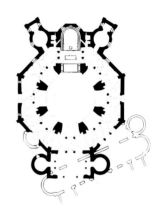

377 SAN VITALE.
Ravenna, Italy. 526–547.
a. Exterior.
Photograph: Guglielmo Mairani/Garzla Neri.

b. Plan.

the figures of Emperor Justinian and EMPRESS THEODORA in addition to religious figures and events. In a blending of religious and political authority, Justinian and Theodora are shown with halos, analogous to Christ and Mary, yet both are royally attired and bejeweled.

The elongated, abstracted figures provide symbolic rather than naturalistic depictions of the Christian and royal figures. Emphasis on the eyes is a Byzantine refinement of the stylized focus seen in the HEAD OF CONSTANTINE (page 251). Figures are depicted with heavy outline and stylized shading. The only suggestion of space has been made by overlap. Background and figures retain a flat, decorative richness typical of Byzantine art.

The arts of the Early Christian period were affected by an ongoing controversy between those who sought to follow the biblical prohibition against the making of images and those who wanted pictures to help tell the sacred stories. The Byzantine style developed as a way of inspiring the illiterate while keeping the biblical commandment that forbids the making of graven images. The Byzantine theory was

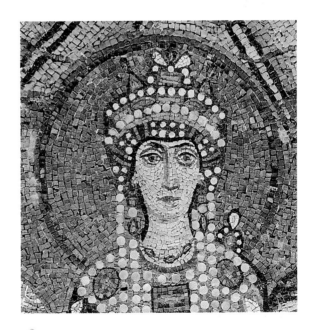

c. EMPRESS THEODORA.
Mosaic detail.
Photograph: Scala/Art Resource, NY.

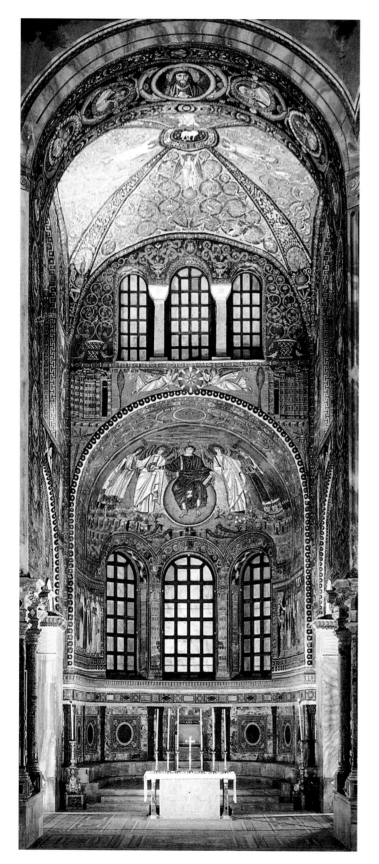

that highly stylized (abstract) and decorative images could never be confused with a real person (as a naturalistic work might be). As a result, the naturalism and sense of depth found in Roman painting gradually gave way to Byzantine stylization.

The apse mosaic in the interior of SAN VITALE (pictured at the left) shows Christ dressed in royal purple and seated on an orb that symbolizes the universe. He is beardless, in the fashion of Classical gods. With his right hand, he passes a crown to San Vitale, who stands in a depiction of the Biblical paradise along with other saints and angels. The appearance of all of these figures owes something to Roman art, but in keeping with Byzantine style, they stand motionless and stare straight ahead. In their heavenly majesty, they seem to soar above human concerns. At the highest point in the aisle, where the groin vaults come together, we see a lamb which symbolizes Christ and his self-sacrifice.

Between the sixth century and the twelfth, when CHRIST PANTOCRATOR was created, the Byzantine empire was wracked by the Iconoclastic Controversy, a debate over religious images which at times turned violent. In 726, Byzantine Emperor Leo III ordered the destruction of all images of Christ, Mary, the saints, and the angels. He and his party believed that such images encouraged idolatry, or worship of the image rather than the divine being. They were soon termed Iconoclasts, or image-breakers, and they punished persons who owned images by flogging or blinding them. (The Iconoclasts did not resist all decoration: they permitted jewelled crosses and pictures of leafy paradises, for example.) Those who favored images (the Iconophiles) argued that just as Christ was both god and human, an image of Christ combines the spiritual and the physical.

Although the Emperor's decree was not uniformly enforced, the controversy lasted for over a hundred years, and it contributed to the split between the Western (Roman) and Eastern (Orthodox)

d. Interior.
Photograph: Scala/Art Resource, NY.

churches. There was a political struggle as well: The Iconoclasts favored the Emperor's power over that of local monasteries, which were wealthy with sumptuous images. The dispute finally came to and end in 843, when Empress Theodora officially overturned Leo's decree.

As the controversy subsided, the inside of the dome of Hagia Sophia (see page 211) was adorned with a new kind of image, Christ as ruler of the universe—Christ as Pantocrator. This mosaic (now destroyed) became the inspiration for similar portrayals in smaller Byzantine churches such as the Cathedral of Monreale, Sicily, where the mosaic of CHRIST AS PANTOCRATOR WITH MARY AND SAINTS shows typical Byzantine style employing hierarchic scale to express the greater magnitude of Christ relative to Mary, the saints, and angels portrayed in rows below him.

By the tenth and eleventh centuries, Byzantine artists had created a distinct style that expressed Eastern Orthodox Christianity and also met the needs of a lavish court. The style had its roots in the Early Christian art of the late Roman Empire, as we have seen. But it also absorbed Eastern influences, particularly the flat patterns and nonrepresentational designs of Islam. Eastern influence continued with the hierarchical sizing and placement of subject matter in Byzantine church decoration.

The Byzantine style is still followed by painters and others working within the tradition of the Eastern Orthodox church. Clergy closely supervise the iconography and permit little room for individual interpretation. Artists of the Eastern Orthodox faith seek to portray the symbolic or mystical aspects of religious figures rather than their physical qualities. The figures are painted in conformity to a precise formula. Small paintings, referred to as *icons* (from the Greek *eikon,* meaning image), are holy images that inspire devotion but are not worshiped in themselves. The making of portable icon paintings grew out of mosaic and fresco traditions.

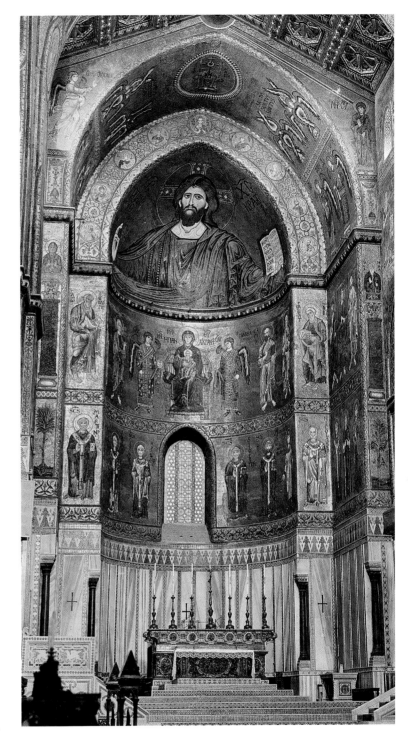

378 CHRIST AS PANTOCRATOR WITH MARY AND SAINTS.
Apse mosaic. Cathedral of Monreale, Sicily.
Late 12th century.
Photograph: Scala/Art Resource, NY.

379 Andrei Rublev.
OLD TESTAMENT TRINITY. c. 1410–1420.
Tempera on panel. 55½" × 44½".
Tretyakov Gallery, Moscow.
Photograph: Scala/Art Resource, NY.

380 Byzantine School.
MADONNA AND CHILD ON A CURVED THRONE.
Byzantine, 13th century.
Tempera on panel.
32⅛" × 19⅜"; framed 35¾" × 22¹⁵⁄₁₆" × 3".
Photograph © 2001 Board of Trustees, National Gallery of Art, Washington, D.C.
Andrew W. Mellon Collection. 1937.1.1.(1)/PA.

Even within the relatively tight stylistic confines of the Orthodox style, occasionally an artist is able to make icons that not only have the required easy readability but also communicate powerful feeling. Such an artist was Andrei Rublev, one of the most highly regarded painters in Russian history. His OLD TESTAMENT TRINITY depicts a story in which Jewish patriarch Abraham entertained three strangers who later turned out to be angels: Christians have seen this story as foreshadowing their doctrine of the trinity. Rublev was able to give the scene a sweetness and tenderness through subtle facial expressions and elongation of bodies. The bright colors add intensity to the work, even in its present poor state.

The design of the icon painting MADONNA AND CHILD ON A CURVED THRONE is based on circular shapes and linear patterns. Mary's head repeats the circular shape of her halo; circles of similar size enclose angels, echoing the larger circle of the throne. The lines and shapes used in the draped robes that cover the figures give scarcely a hint of the bodies beneath. Divine light is symbolized by the gold background that surrounds the throne in which the Virgin Mary sits. The large architectural throne symbolizes Mary's position as Queen of the City of Heaven. Christ appears as a wise little man, supported on the lap of a heavenly, supernatural mother.

In order that they be worthy of dedication to God, icons are usually made of precious materials. Gold leaf was used here for the background and costly lapis lazuli for the Virgin's robe.

THE MIDDLE AGES IN EUROPE

The one thousand years that followed the fall of the Western Roman Empire have been called the medieval period, or the Middle Ages, because they came between the time of ancient Greek and Roman civilizations and the rebirth, or renaissance, of Greco-Roman ideas in the fifteenth century.

Early Medieval Art

The art of the early Middle Ages took shape as Early Christian art absorbed a new influence: the art of the invaders. Many nomadic peoples traveled across the Eurasian grasslands called the Steppes, which extend from the Danube River in Europe to the borders of China. Their migrations occurred over a long period that began in the second millennium B.C.E. and lasted well into the Middle Ages. The Greeks called these nomads (and other non-Greeks) "barbarians." What little we know about them is derived from artifacts and records of literate cultures of the Mediterranean, Near East, and China, to whom the nomads were a menace. The Great Wall of China and Hadrian's Wall in Britain were built to keep out such invaders.

A long-lasting, varied, but interrelated art, known as the *animal style,* was developed by the Eurasian nomads. Because of their migrant way of life, their art consisted of small, easily portable objects such as items for personal adornment, weapons, and ornamental horse fittings for saddles, bridles, and harnesses. The style is characterized by active, intertwining shapes. The art of the animal style rarely depicts human beings; when it does, they play subordinate roles to animals.

Nomadic metalwork often exhibits exceptional skill. Because of frequent migrations and the durability and value of the art objects, the style was diffused over large geographic areas. Among the best-known works of nomadic art are small gold and bronze ornaments like the SCYTHIAN ANIMAL shown here, produced by the Scythians, whose culture flourished between the eighth and fourth centuries B.C.E. Their abstracted animal forms appear to have been adopted by groups in the British Isles, Scandinavia, and China. In the art of medieval Eu-

381 SCYTHIAN ANIMAL. (BRIDLE PLAQUE WITH A BEAST OF PREY CURVED ROUND).
5th century B.C.E. Bronze. 10.5 × 97 cm.
Kulakovsky Barrow No. 2; Crimea.
The State Hermitage Museum, St. Petersburg, Russia.

382 PURSE COVER.
From the Sutton Hoo Ship Burial, Suffolk, England.
Before 655. Gold and enamel. Length 7½".
© British Museum, London. Reproduced courtesy of the Trustees of the British Museum.

rope, similar animal forms appear later in wood-carving, stonecarving, and manuscript illumination, as well as in metal.

The gold and enamel PURSE COVER found in a grave at Sutton Hoo belonged to a seventh-century East Anglian king. The distinct variations of its motifs indicate that they are derived from several

383 CHI-RHO MONOGRAM (XP).
Page from the BOOK OF KELLS. Late 8th century.
The Board of Trinity College Library, Dublin, Ireland.
Reproduced courtesy of the Board of Trinity College Library.

sources. The motif of a man standing between confronting animals appeared first in Sumerian art over three thousand years earlier (see page 237).

The meeting of decorative nomadic styles with Christianity can be seen most clearly in the illuminated holy books created in Ireland. The Irish had never been part of the Roman Empire, and in the fifth century they were Christianized without first becoming Romanized. During the chaotic centuries that followed the fall of Rome, Irish monasteries be-

came the major centers of learning and the arts in Europe, and they produced numerous hand-lettered copies of religious manuscripts.

The initial letters in these manuscripts were embellished over time, moving first into the margin and then onto a separate page. This splendid initial page is the opening of St. Matthew's account of the Nativity in the BOOK OF KELLS, which contains the Latin Gospels. It is known as the CHI-RHO MONOGRAM because it is composed of the first two letters of Christ in Greek (XP) and is used to represent Christ or Christianity. Except for XP and two Latin words beginning the story of Christ's birth, most of the page is filled with a rich complexity of spirals and tiny interlacings. If we look closely at the knots and scrolls we see angels to the left of the X, a man's head in the P, and cats and mice at the base.

Romanesque

The stylistic term *Romanesque* was first used to designate European Christian architecture of the mid-eleventh to the mid-twelfth centuries, which revived Roman principles of stone construction, especially the round arch and the barrel vault. This term is now applied to all medieval art of western Europe during that period.

Byzantine art traditions continued in southeastern Europe, while Romanesque art developed in a western Europe dominated by feudalism and monasticism. Feudalism involved a complex system of obligations to provide services through personal agreements among local leaders of varying ranks. In addition to accommodating religious practices, monasteries provided shelter from a hostile world and served as the main sources of education.

Religious crusades and pilgrimages brought large groups of Christians to remote places, creating a need for larger churches. Romanesque builders increased the sizes of churches by doubling the length of the nave (the central space), doubling the side aisles, and building galleries above side aisles.

Churches continued to have wooden roofs, but stone vaults largely replaced fire-prone wooden ceil-

ings, giving the new structures a close resemblance to Roman interiors. Consistent throughout the variety of regional styles was a common feeling of security provided by massive, fortresslike walls.

Romanesque churches feature imaginative stone carvings that are an integral part of the architecture. Subjects and models came from miniature paintings in illuminated texts, but sculptors gradually added a degree of naturalism not found in earlier medieval work. In addition to stylized and at times naive figures from biblical stories, relief carvings include strange beasts and decorative plant forms. The largest and most elaborate figures were placed over the central doorways of churches. Such figures were the first large sculpture since Roman times.

Deviation from standard human proportions enabled sculptors to give appropriately symbolic form to figures such as CHRIST OF THE PENTECOST. The mystical energy and compassion of Christ are expressed in this relief carving above the doorway of Saint Madeleine Cathedral at Vézelay, France. As worshippers enter the sanctuary, the image above them depicts Christ at the time he asked the Apostles and all Christians to take his message to the world. The image of Christ is larger in scale than the other figures, showing his relative importance. The sculptor achieved a monumental quality by making the head smaller than normal and by elongating the entire figure. Swirling folds of drapery are indicated with precise curves and spirals that show the continuing influence of the linear energy of the animal style and the CHI-RHO MONOGRAM. In abstract terms, the spiraling motion suggests Christ's cosmic power. (See the *Discovering Art* CD for a video demonstration of medieval architecture of the Romanesque and succeeding Gothic periods.)

Gothic

The restless energy of Europeans can be seen in the frequent changes in attitude that resulted in the changing styles of Western art. The Romanesque style had lasted barely a hundred years when the Gothic style began to replace it in about 1145.

384 Detail of CHRIST OF THE PENTECOST.
Saint Madeleine Cathedral, Vézelay, France. 1125–1150.
Stone. Height of the tympanum 35½".
Photograph: Dagli Orti. Picture Desk, Inc./Kobal Collection.

The shift is seen most clearly in architecture, as the Romanesque round arch was superseded by the pointed Gothic arch, developed in the mid-twelfth century (discussed on page 212).

Gothic cathedrals were expressions of a new age of faith that grew out of medieval Christian theology and mysticism. The light-filled, upward-reaching structures symbolize the triumph of the spirit over the bonds of earthly life, evoking a sense of joyous spiritual elation. Inside, the faithful must have felt they had actually arrived at the visionary Heavenly City.

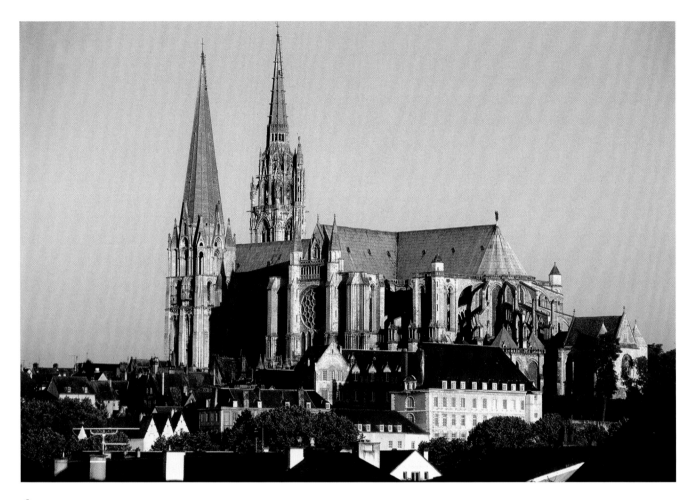

385 NOTRE DAME DE CHARTRES.
Chartres, France. 1145–1513.
Cathedral length 427'; facade height 157'; south tower height 344'; north tower height 377'.
a. View from the southeast.
© John Elk III.

Gothic cathedrals such as NOTRE DAME DE CHARTRES (Our Lady of Chartres) were the center of community life. In many cases, they were the only indoor space that could hold all the townspeople at once; thus, they were used for meetings, concerts, and religious plays. But most of all, they were places of worship. Above the town of Chartres, the cathedral rises, its spires visible for miles around.

The entire community cooperated in the building of NOTRE DAME DE CHARTRES, although those who began its construction never saw it in its final form. The cathedral continued to grow and change in major ways for over three hundred years. Although the basic plan is symmetrical and logically organized, the architecture of chartres has a rich, enigmatic complexity that is quite different from the easily grasped totality of the classical PARTHENON.

Chartres was partially destroyed by fire in 1194 and then rebuilt in the High Gothic style. One of the first cathedrals based on the full Gothic system, it helped set the standard for Gothic architecture in Europe. In its WEST FRONT, Chartres reveals the transition between the early and late phases of Gothic architecture. The massive lower walls and

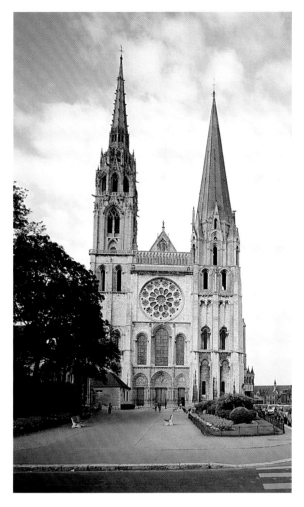

b. WEST FRONT.
Photograph: Duane Preble.

c. "ROSE DE FRANCE" WINDOW. c. 1233.
Photograph: Duane Preble.

round arch portals were built in the mid-twelfth century. The north tower (on the left as one approaches the facade) was rebuilt with the intricate flamelike or *flamboyant* curves of the late Gothic style early in the sixteenth century, after the original tower collapsed in 1506.

Magnificent stained-glass windows of this period are so well integrated with the architecture that one is inconceivable without the other. The scriptures are told in imagery that transforms the sanctuary with showers of color, changing hour by hour. At Chartres, the brilliant north rose window, known as the ROSE DE FRANCE, is dedicated to the Virgin Mary, who sits in majesty, surrounded by doves, angels, and royal figures of the celestial hierarchy. See also the interior photo on page 212.

The statues of the OLD TESTAMENT PROPHET, KINGS, AND QUEEN (on the following page) to the right of the central doorway at the west entrance of CHARTRES are among the most impressive remaining examples of early Gothic sculpture. The kings and queen suggest Christ's royal heritage and also honor French monarchs of the time. The prophet on the left depicts Christ's mission as an apostle of God.

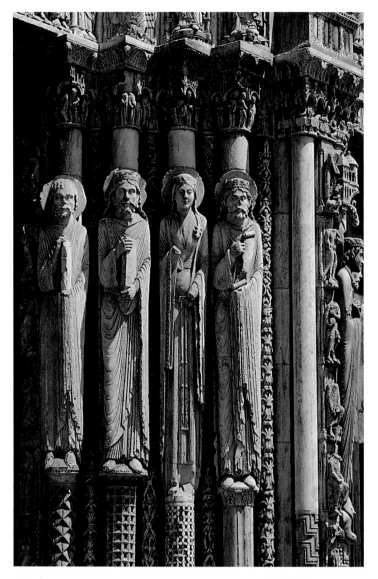

In contrast to active, emotional Romanesque sculpture, the figures are passive and serene. Their elongated forms allow them to blend readily with the vertical emphasis of the architecture.

Although they are part of the total scheme, the figures stand out from the columns behind them. Their draped bodies, and especially their heads, reveal a developing interest in portraying human features. Such interest eventually led again to full portraiture and freestanding figures.

The cathedral relates to an idea expressed by Abbot Suger, the man credited with starting the Gothic era. At the Abbey church of St. Denis, where Suger began the Gothic style, he had an inscription placed on the entrance door stating his idea of the church's spiritual purpose:

Whoever you may be, if you are minded to praise this door,
Wonder not at the gold, nor at the cost, but at the work.
The work shines in its nobility; by shining nobly,
May it illumine the spirit, so that, through its trusty lights,
The spirit may reach the true Light in which Christ is the Door.
The golden door proclaims the nature of the Inward:
Through sensible things, the heavy spirit is raised to the truth;
From the depths, it rises to the light.[1]

d. OLD TESTAMENT PROPHET, KINGS, AND QUEEN. c. 1145–1170.
Doorjamb statues from West (or Royal) Portal.
Photograph: Duane Preble.

0 150 feet

0 50 meters

e. Plan based on Latin cross.

RENAISSANCE AND BAROQUE EUROPE

A shift in attitude occurred in Europe as the religious fervor of the Middle Ages was increasingly challenged by logical thought and the new philosophical, literary, and artistic movement called *humanism*. Leading humanist scholars did not discard theological concerns, yet they supported the secular dimensions of life, pursued intellectual and scientific inquiry, and rediscovered the classical literature and art of Greece and Rome. The focus gradually shifted from God and the hereafter to humankind and the here and now.

THE RENAISSANCE

For many Europeans, the Renaissance was a period of achievement and worldwide exploration—a time of discovery and rediscovery of the world and of the seemingly limitless potential of individual human beings. The period began to take shape in the fourteenth century, reached its clear beginning in the early fifteenth century, and came to an end in the early seventeenth century. However, Renaissance thinking continues to influence our lives today, not only in Western countries but in all parts of the world where individualism, modern science, and technology influence the way people live. In art, new and more scientific approaches were brought to the quest for representational accuracy. The resulting naturalism dominated Western art for more than four hundred years.

The intellectuals of the time were the first in European history to give their own era an identifying name. They named their period the *Renaissance*—literally, Rebirth—an apt description for the period of revived interest in the art and ideas of classical Greece and Rome. Fifteenth-century Italians believed they were responsible for the rebirth of "the glory of ancient Greece," which they considered the high point of Western civilization. Yet Greco-Roman culture was not really reborn, because this "classical" heritage had never disappeared from the medieval West where Muslim scholars in Spain and Constantinople succeeded in keeping it alive. In essence, the Renaissance was a period of new and renewed understanding that transformed the medieval world, and laid the foundation for modern society.

In art, we can trace the beginnings of this new attitude to the fourteenth century. While Gothic and Byzantine painters continued to employ relatively flat symbolic styles, Gothic sculptors were moving from stylized abstraction toward greater naturalism and individuality in their figures.

The humanist enthusiasm for classical antiquity and a growing secularism led to revolutionary thinking in many areas. The first writer to reveal evidence of Renaissance thinking was the Italian poet Dante Alighieri, who lived during the thirteenth and fourteenth centuries and belonged primarily to the Middle Ages. The last major writer of the Renaissance was William Shakespeare, who lived three centuries later.

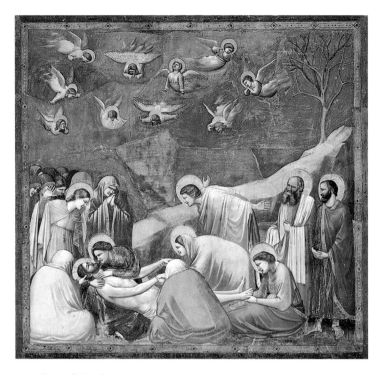

386 Giotto di Bondone. LAMENTATION.
Scrovegni Chapel, Padua, Italy. c. 1305.
Fresco. 72" × 78".
Photograph: Alinari/Art Resource, NY.

New values combined with technological advances brought forth an abundance of major artworks. Painting and sculpture were liberated from their medieval roles as supplements to architecture. Artists, who had been viewed as anonymous workers in the Middle Ages, came to be seen as individuals of creative genius.

The art of the Renaissance evolved in different ways in northern and southern Europe because the people of the two regions had different backgrounds, attitudes, and experiences. The Gothic style reached its high point in the north while Byzantine and Greco-Roman influences remained strong in the south. Italian Renaissance art grew from classical Mediterranean traditions that were human-centered and often emphasized monumentality and the ideal. In contrast, the art of the northern Renaissance evolved out of pre-Christian, nature-centered religions that became God-centered through conversion to Christianity.

New directions in the course of human history are often begun by a small group or a single person of genius who seizes the opportunity that changing circumstances present. Such a person was Italian painter and architect Giotto di Bondone, known as Giotto. He departed from the abstract Byzantine style by portraying the feelings and physical nature of human beings. His innovative depictions of light, space, and mass gave a new sense of realism to painting. In LAMENTATION, Giotto depicted physical as well as spiritual reality. His figures are shown as individuals within a shallow, stagelike space, and their expressions portray personal feelings of grief not often seen in medieval art.

In retrospect, Giotto is considered not only a precursor of the Renaissance, but also the reinventor of naturalistic painting, which had not been seen in Europe since the decline of Rome a thousand years earlier. This "realism" is still an important current in Western painting.

The ancient Greeks had been concerned with idealized physical form; Roman artists had emphasized physical accuracy; and artists of the Middle Ages had focused on spiritual concerns rather than physical existence. In the Renaissance, as attention shifted from heaven to earth, artists portrayed Christian subjects in human terms. Italian leaders expressed a desire to equal or surpass the glory of ancient Greece and Rome and to imbue their achievements with the light of Christian understanding.

Italy was the principal homeland of the Renaissance. In time the movement spread northward, but it did not flourish everywhere in Europe; it came late to Spain and Portugal, and it barely touched Scandinavia.

The Renaissance in Italy

Artistic and intellectual developments in the Italian city-states were aided by a flourishing economy set against a divided and chaotic political background. The great wealth of Italian merchants enabled them to compete with one another, and with church officials and nobility, for the recognition and power that came with art patronage.

Italian architects, sculptors, and painters sought to integrate Christian spiritual traditions with the

rational ordering of physical life in earthly space. Artists began an intense study of anatomy and light, and they applied geometry to the logical construction of implied space through the use of linear perspective (see page 50). In turn, the careful observation of nature initiated by Renaissance artists aided the growth of science.

About one hundred years after Giotto, Masaccio became the first major painter of the Italian Renaissance. In his fresco THE HOLY TRINITY, the composition is centered on an open chapel in which is seen the Trinity: God the father, Christ the son, and between their heads a white dove symbolizing the Holy Spirit. Within the niche, Mary the mother of Jesus stands, gesturing to Christ; opposite her is St. John. Kneeling outside are the donors who paid for the painting, a husband and wife who headed a powerful banking family of that time. He is wearing the red robe that marks him as a member of the Florence city council. Below, a skeleton is lying on a sarcophagus beneath the inscription, "I was what you are, and what I am you shall become." If we view the painting from top to bottom, we move from spiritual reality to temporal reality.

THE HOLY TRINITY was the first painting based on the systematic use of linear perspective. Although perspective was known to the Romans in a limited way, it did not become a consistent science until architect Filippo Brunelleschi rediscovered and developed it in Florence early in the fifteenth century. Masaccio used perspective to construct an illusion of figures in three-dimensional space. The single vanishing point is below the base of the cross, about five feet above ground, at the viewer's eye level. Masaccio's perspective is so precise that we can see the interior of the illusionary chapel as a believable extension of the space we occupy. The setting also reveals Masaccio's knowledge of the new Renaissance architecture developed by Brunelleschi, which he based on Roman prototypes.

The figures in THE HOLY TRINITY have a physical presence that shows what Masaccio learned from the work of Giotto. In Giotto's work, however, body and drapery still appear as one; Masaccio's figures are clothed nudes, with garments draped like real fabric.

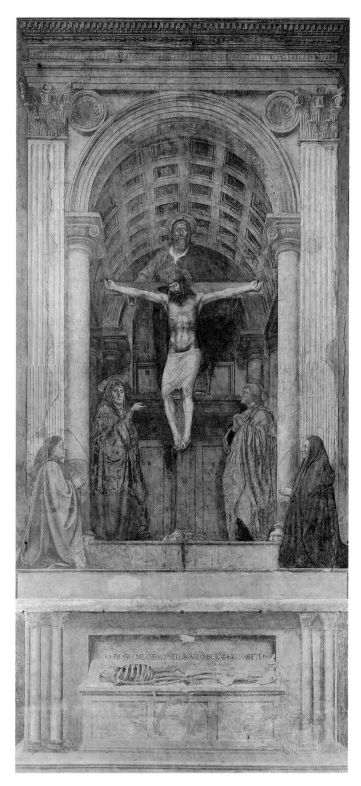

387 Masaccio.
THE HOLY TRINITY.
Santa Maria Novella, Florence. 1425.
Fresco. 21'10½" × 10'5".
Photograph: Scala/Art Resource, NY.

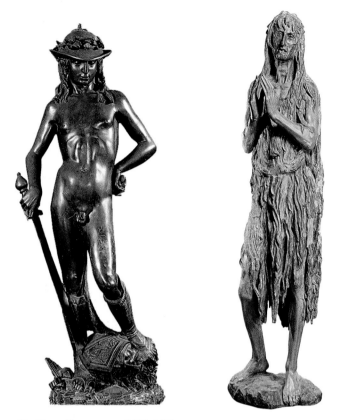

388 Donatello. DAVID. c. 1425–1430.
cd Bronze. Height 62¼".
Museo Nazionale del Bargello, Florence. Photograph: Scala/Art Resource, NY.

389 Donatello. MARY MAGDALEN. c. 1455.
cd Wood, partially gilded. Height 74".
Museo dell'Opera del Duomo, Florence. Photograph: Scala/Art Resource, NY.

During the Italian Renaissance, the nude became a major subject for art, as it had been in Greece and Rome. Unclothed subjects are rare in medieval art (Adam and Eve, sinners in hell) and appear awkward, their bodies graceless. In contrast, sculpted and painted figures by Italian Renaissance artists appear as strong and natural as the Greek and Roman nudes that inspired them.

The great range and vitality of work by sculptor Donatello had a lasting influence on subsequent Renaissance sculpture and on European sculpture and painting for four centuries. Donatello brought the Greek ideal of what it means to be human into the Christian context. As a young adult he made two trips to Rome, where he studied medieval (Byzantine, Romanesque, and Gothic) as well as classical Greek and Roman art.

Donatello shows himself as a well-developed artist even in his early work. His bronze figure of DAVID was the first life-size, freestanding nude statue since Roman times. In it Donatello went beyond the classical ideal by including the dimension of personal expressiveness.

Although he was greatly attracted to the classical ideal in art, Donatello's sculpture was less idealized and more naturalistic than that of ancient Greece. He chose to portray the biblical shepherd, David—slayer of the giant Goliath and later to be king of the Jews—as an adolescent youth rather than as a robust young man. The sculptor celebrated the sensuality of the boy's body by clothing him only in hat and boots. It is not so much the face, but every shift in the figure's weight and angle that is expressive. The youth's position is derived from classical contrapposto. The few nudes that appeared in medieval art showed little sensual appeal and often portrayed shame and lust. Under the influence of humanist scholars who sought to surpass the Greeks and Romans in the nobility of form, the nude became a symbol of human worth and divine perfection, a representation of the "immortal soul."

During the Renaissance, artists received growing support from the new class of wealthy merchants and bankers, such as the Medici family, who, with great political skill, dominated the life of Florence and Tuscany. It is likely that Donatello created his bronze DAVID as a private commission for Cosimo de Medici, for the courtyard of the Medici palace.

A major influence on Donatello and other Renaissance artists was the renewal of Neoplatonist philosophy, embraced by the Medici family and their circle of philosophers, artists, historians, and humanists. These intellectuals believed that all sources of inspiration or revelation, whether from the Bible or classical mythology, are a means of ascending from earthly existence to mystical union with "the One." In this context, Donatello's DAVID was intended to be a symbol of divine beauty.

Donatello's work displayed a wide range of expression, from lyric joy to tragedy to extremes of religious passion. In contrast to the youthful and somewhat brash DAVID, Donatello's MARY MAGDALEN

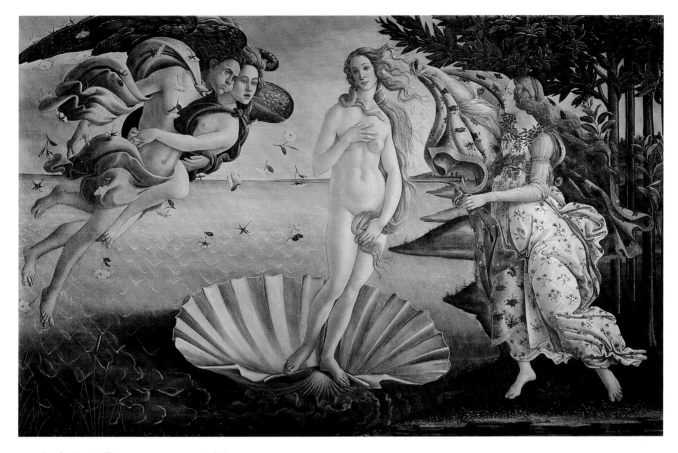

390 Sandro Botticelli. BIRTH OF VENUS. c. 1480.
 Tempera on canvas. 5'8⅞" × 9'1⅞".
 Uffizi Gallery, Florence.
 Photograph: Scala/Art Resource, NY.

is haggard and withdrawn—a forcefully expressive figure of old age and repentance. For this late work, Donatello chose painted wood, the favorite medium of northern Gothic sculptors.

Another Medici commission is Sandro Botticelli's BIRTH OF VENUS, one of the first paintings of an almost life-size nude since antiquity. The large painting, completed about 1480, depicts the Roman goddess of love just after she was born from the sea. She is being blown to shore by a couple symbolizing the wind. As she arrives, Venus is greeted by a young woman who represents Spring. The lyric grace of Botticelli's lines shows Byzantine influence. The background is decorative and flat, giving almost no illusion of deep space. The figures appear to be in relief, not fully three-dimensional.

The posture and gestures of modesty were probably inspired by a third-century B.C.E. Greco-Roman sculpture of Venus that Botticelli must have seen in the Medici family collection (see page 246). In her posture of introspection and repose, Botticelli's Venus combines the classical Greek idealized human figure with a Renaissance concern for thought and feeling.

It was revolutionary for an artist working within the context of a Christian society to place a nude "pagan" goddess at the center of a large painting, in a position previously reserved for the Virgin Mary. Botticelli's focus on classical mythology was—like Donatello's—based on Neoplatonist philosophy. Botticelli's ethereal Venus was intended to portray divine love—a celestial Venus.

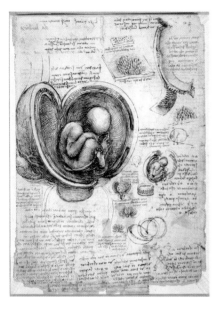

391 Leonardo da Vinci.
THE INFANT IN THE
WOMB. c. 1510.
Pen and ink. 11⅞" × 8⅜".
The Royal Collection
© 2004 Her Majesty Queen
Elizabeth II.
Photograph: EZM. RL19102r.

392 Leonardo da Vinci.
MONA LISA.
c. 1503–1506.
Oil on wood.
30¼" × 21".
Musée du Louvre, Paris.
Photograph: Scala/Art Resource, NY.

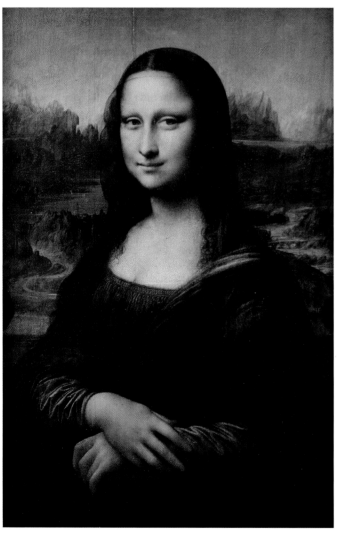

The High Renaissance

Between about 1490 and 1530—the period known as the High Renaissance—Italian art reached a peak of accomplishment in the cities of Florence, Rome, and Venice. The three artists who epitomized the period were Leonardo, Michelangelo, and Raphael. They developed a style of art that was calm, balanced, and idealized, reconciling Christian theology with Greek philosophy and the science of the day.

Leonardo da Vinci was motivated by an insatiable curiosity and an optimistic belief in the human ability to understand the fascinating phenomena of the physical world. He believed that art and science are two means to the same end: knowledge.

Leonardo's investigative and creative mind is revealed in his journals, in which he documented his research in notes and drawings (see also pages 18 and 101). His notebooks are filled with studies of anatomy and ideas for mechanical devices, explorations that put him in the forefront of the scientific development of his time. His study of THE INFANT IN THE WOMB has a few errors, yet much of the drawing is so accurate that it could serve as an example in one of today's medical textbooks.

Leonardo was one of the first to give a clear description of the *camera obscura* (see page 142), an optical device that captures light images in much the same way as the human eye. The concept of photography began with the Renaissance desire to create an equivalent to our visual perception of reality.

So frequently has Leonardo's world-famous portrait of MONA LISA been reproduced that it has become a cliché and the source of innumerable spoofs. Despite this overexposure, it is worthy of careful attention. It was one of Leonardo's favorite paintings. We can still be intrigued by the mysterious mood evoked by the faint smile and the strange, otherworldly landscape. The ambiguity is heightened by the hazy light quality that gives an amazing sense of atmosphere around the figure. This soft blurring of the edges—in Leonardo's words, "without lines or borders in the manner of smoke"—achieved through subtle value gradations, is called *sfumato* and was invented by Leonardo.[1] The effect, heightened by chiaroscuro, amazed and impressed his contemporaries.

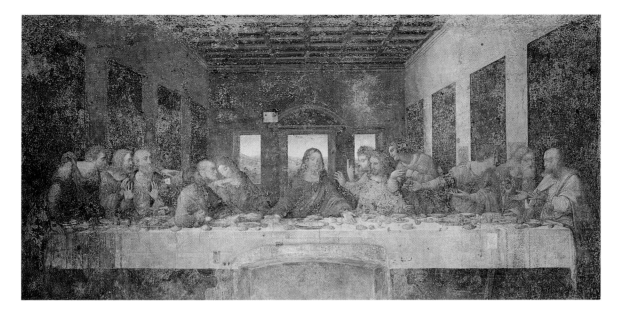

393 Leonardo da Vinci. THE LAST SUPPER.
Santa Maria delle Grazie, Milan. c. 1495–1498. Experimental paint on plaster. 14'5" × 28'¼".
Photograph: Scala/Art Resource, NY.

a. Perspective lines as both organizing structure and symbol of content.

b. Christ's figure as stable triangle, contrasting with active turmoil of the disciples.

MONA LISA's rich, luminous surface was achieved through the application of glazes (thin, translucent layers of paint).

The impact of Renaissance humanism becomes apparent when we compare THE LAST SUPPER by Leonardo with the Byzantine mosaic CHRIST AS PANTOCRATOR on page 255. In the Byzantine painting, Christ is portrayed as a lofty being of infinite power. In Leonardo's painting, Jesus sits across the table from us—an accessible person who reveals his divinity in an earthly setting.

The naturalist style of the work contains a hidden geometry, which structures the design and strengthens the painting's symbolic content. The interior is based on a one-point linear perspective system, with a single vanishing point in the middle of the composition, behind the head of Christ. Leonardo placed Christ in the center, at the point of greatest implied depth, associating him with infinity. Over Christ's head an architectural pediment suggests a halo, further setting him off from the irregular shapes and movements of the surprised disciples on either side. In contrast to the anguished figures surrounding him, Christ is shown with his arms outstretched in a gesture of acceptance, his image a stable triangle.

LEONARDO
da Vinci

THE ARTIST AS SCIENTIST

(1452–1519)

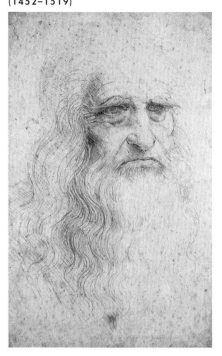

394 Leonardo da Vinci.
SELF-PORTRAIT. c. 1512.
Chalk on paper.
13" × 8¼".
Biblioteca Reale, Turin, Italy.
Photograph: Scala/Art Resource, NY.

LEONARDO DA VINCI— painter, sculptor, architect, town planner, writer, musician, scientist, engineer, and inventor—is the prototypical "Renaissance man," an extremely versatile individual with a record of high achievement in many fields.

Leonardo was the son of a young notary, Piero da Vinci, and a peasant girl of whom nothing is known. He grew up an only child in his father's household. In his mid-teens, he was apprenticed to Andrea del Verrochio, a leading artist in nearby Florence. Botticelli was one of his fellow apprentices.

Leonardo grew into a magnetic young man—tall, handsome, strong, graceful, charming, and enormously talented. He played the lute, sang beautifully, and made fascinating conversation. People loved to be near him, yet he remained essentially solitary. He formed few friendships over the course of his life, and he never married.

At age thirty he began seventeen years in the service of the Duke of Milan, primarily as a military engineer and secondarily as a court painter, sculptor, and architect. He also entertained the court as a musician and satirist and designed scenery and costumes for pageants. During this period he painted several important works, including THE LAST SUPPER.

It was also in Milan that he started to keep notebooks. Along with his few paintings, Leonardo's notebooks are his great legacy. They contain a lifetime of observations, inventions, and plans, all drawn in meticulous detail and annotated in secretive mirror writing. In his research drawings, he anticipated the development of such twentieth-century technology as the airplane, the parachute, and the armored tank. His range of subjects was enormous: Mathematics, anatomy, architecture, astronomy, optics, botany, geology, cartography, aeronautics, mechanics, civil engineering, urban planning, hydraulics, and weaponry all captured Leonardo's interest and benefited from his research.

Milan fell to French invaders in 1499 and Leonardo fled to Venice, where he was again employed as a military engineer. From there he went to Florence and worked on a portrait of an obscure merchant's third wife, the MONA LISA. The French called him back to Milan in 1506. He stayed until they were driven out six years later; then, hoping the Pope would have use for him, he journeyed to Rome.

Now in his sixties, Leonardo was increasingly haunted by a sense of futility. No building or invention of his had ever been built, no sculpture cast. Patrons had used his endless skills in frivolous or ignoble ways. Bored with what he could already do exquisitely well, he had left many paintings unfinished and ruined others with technical experiments. "Tell me if anything at all was done," he wrote over and over in his last notebooks. "Tell me if anything at all . . ."[2]

Yet what little he had finished was so spectacular that his fame was well established. In 1516, the new King of France, Francis I, offered Leonardo a house, a stipend, and the title of First Painter and Engineer and Architect to the King. The title was a formality; Francis expected nothing in return but the honor of the great man's presence and the pleasure of his conversation. Leonardo died in Cloux, near Amboise, France, in 1519.

MICHELANGELO BUONARROTI was so greatly admired by his contemporaries that the poet Aristo referred to him as "Michael, more than human, Angel divine." Two biographies of Michelangelo were published in his lifetime. His noble, if irascible, character and his mistrust of human nature—including his own—make his life one of the most interesting known to us from the sixteenth century.

Michelangelo's father was a member of the minor nobility of Florence, a lazy, mean-spirited man who merely lived off the remains of the family fortune. Michelangelo's mother was unable to nurse him, so the infant was sent to stay with a wet nurse. The nurse's husband was a quarry worker in an area where stonecutting was a way of life. Michelangelo returned to his parents only for visits because his mother continued to suffer poor health. She died when Michelangelo was six years old. For four more years he continued to live as the son of the stonecutter and his wife, visiting his father only occasionally. He could neither read nor write, but he learned to use hammer and chisel.

When he was ten his father remarried, and Michelangelo returned home and was enrolled in school for the first time.

In three years he learned to read and write in Italian but absorbed little else. Michelangelo drew whenever he could and neglected his other studies. He decided to leave school to become an artist, starting as an apprentice to the painter Ghirlandaio. His father and uncles looked down on artists and thought it a disgrace to have one in the house. Michelangelo's father never realized the importance of the arts, even when Michelangelo gained fame and fortune.

After a year, Michelangelo transferred to the school in the Medici gardens, where he was inspired by the beauty of the Medici collection of contemporary Italian, ancient Greek, and Roman art. He studied there for several years, in the company of the leading artists and scholars of the time. During the turmoil following the death of his patron, Lorenzo de Medici, Michelangelo left Florence for Rome. In Rome he completed the first of his major sculptures, including the PIETÀ, at the age of twenty-four (see page 86). His handling of the difficult subject and the beautiful finish of the work established his reputation and led to important commissions, including DAVID, when he returned to Florence. For the rest of his life, he went back and forth between Florence and Rome.

Although he considered himself primarily a sculptor, Michelangelo's painting on THE SISTINE CHAPEL ceiling is one of the world's most acclaimed works of art. The project was made enormous by Michelangelo himself; although the original plan called for twelve figures, Michelangelo included over three hundred.

No other artist has left such masterful accomplishments in four major art forms: sculpture, painting, architecture—and poetry. If he had not been a supreme architect, sculptor, and painter, Michelangelo might have been known to us as a writer. Perhaps the most revealing writings are his poems, which express his innermost feelings about his mind and soul as well as his art.

In his later years, in addition to architectural commissions—including the rebuilding of St. Peter's in Rome—Michelangelo worked as a city planner, completed some of his most important sculpture, and wrote many of his finest sonnets.

Michelangelo was very different from Leonardo, who was twenty-three years older. Michelangelo saw human beings as unique, almost godlike, while Leonardo saw them as one part of nature, which he viewed as a scientist as well as an artist. Michelan-

395 Daniele da Volterra.
MICHELANGELO BUONARROTI. 1565.
Detail of bronze bust.
Height of entire work 32".
Accademia, Florence.
Photograph: Alinari/Art Resource, NY.

gelo believed that in an artist's hands, "life" could be created through inspiration from God. For Michelangelo, sculpture and the process of its creation reflected people's struggle with their imperfect selves—souls in turmoil, bound in their bodies.

Michelangelo's life spanned nearly a century. From the time he was apprenticed at age thirteen until six days before his death at eighty-nine, he worked continuously. His last words were, "I regret that I have not done enough for the salvation of my soul and that I am dying just as I am beginning to learn the alphabet of my profession."[3]

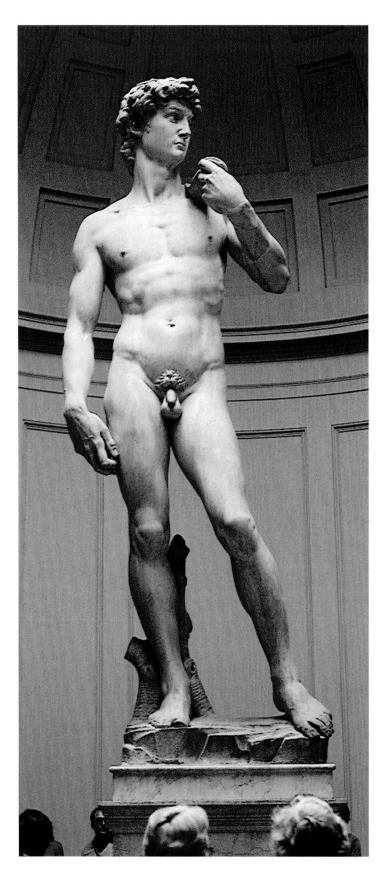

In 1501, when he was twenty-six years old, Michelangelo obtained a commission from the city of Florence to carve a figure of David from an eighteen-foot block of marble that had been badly cut and then abandoned by another sculptor. The biblical hero David was an important symbol of freedom from tyranny for Florence, which had just become a republic. Other Renaissance artists such as Donatello had already given the city images of the young David, but it was Michelangelo's figure that gave the most powerful expression to the idea of David as hero, the defender of a just cause.

Michelangelo took DAVID's stance, with the weight of the body on one foot, from Greek sculpture. But the positions of the hands and tense frown indicate anxiety and readiness for conflict. Through changes in proportion and the depiction of inner feeling, Michelangelo humanized, then made monumental, the classical Greek athlete.

396 Michelangelo Buonarroti.
ed a. DAVID. 1501–1504.
Marble. Height of figure 14'3".
Accademia, Florence.
Photograph: Duane Preble.
b. DAVID. Close-up of head.
Accademia, Florence. Alinari/Art Resource, NY.

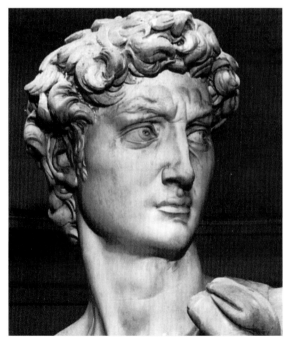

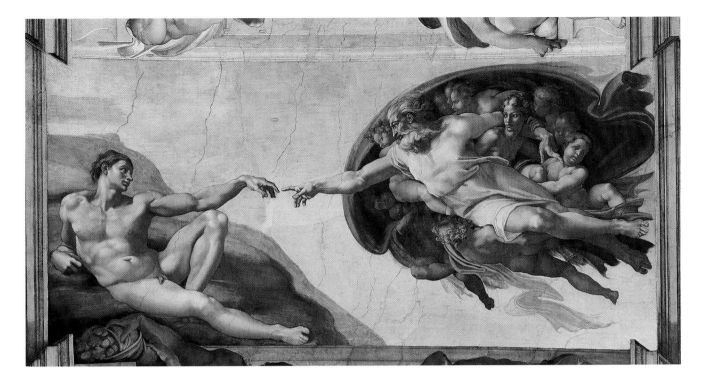

Michelangelo worked for three years on this sculpture. When it was finished and placed in the town square, the citizens of Florence were filled with admiration for the work and its creator. With this achievement, Michelangelo became known as the greatest sculptor since the Greeks.

Equally praised as a painter, Michelangelo had just begun work on what he thought would be his main sculptural commission, the tomb of Pope Julius II, when the Pope ordered him to accept a commission to paint THE SISTINE CHAPEL in the Vatican. Michelangelo began work on the ceiling in 1508 and finished it four years later. The surface is divided into three zones. In the highest are nine panels of scenes from Genesis, including THE CREATION OF ADAM. The next level contains prophets and sibyls (female prophets). The lowest level consists of groups of figures, some of which have been identified as Christ's biblical ancestors. *The Last Judgment,* painted later, fills the end wall above the altar.

The most-admired composition on the ceiling is the majestic portrayal of THE CREATION OF ADAM, in which God reaches out to give life to the first man. Eve, not yet mortal, stares at Adam from behind God's left arm.

397 Michelangelo Buonarroti.
Frescoes on the ceiling and walls of THE
SISTINE CHAPEL.
Vatican, Rome. 1508–1512.
a. THE CREATION OF ADAM, Fresco of the
Sistine Chapel after restoration.
Vatican Museums, Rome, Italy.
b. THE SISTINE CHAPEL after restoration.
Vatican Museums, Rome, Italy. © Reuters NewMedia
Inc./Corbis.

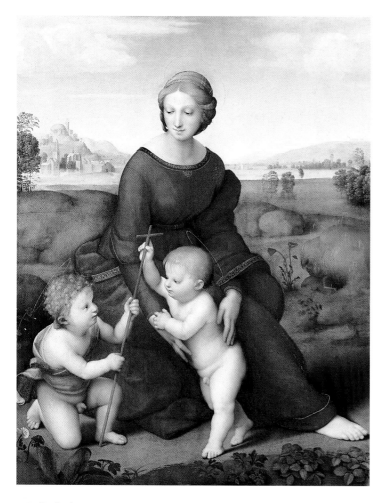

398 Raphael.
MADONNA OF THE MEADOWS. 1505.
Oil on panel. 3'8½" × 2'10¼".
Kunsthistorisches Museum, Vienna.

The work powerfully expresses the Renaissance humanist concept of God: an idealized, rational man who actively tends every aspect of creation and has a special interest in humans. Michelangelo invented this powerful image, which does not exist in the Bible, to tell the story of the relationship between God and people from a Renaissance point of view.

Raphael Sanzio's warmth and gentleness were in sharp contrast to Leonardo's solitary, intellectual nature and Michelangelo's formidable moodiness. Of these three major creators of the High Renaissance, Raphael was the youngest and, in his life and art, the most expressive of the untroubled grace and radiance that marked the art of the period. His paintings present his awareness of the divine in human beings, the insight that was the driving enthusiasm of Italian Renaissance. For him life was an art form. It was as if he were saying, "Life is beautiful; human possibilities are limitless because we are one with God."

Among the most beloved of Raphael's many depictions of Mary and the infant Jesus are the superbly designed MADONNA OF THE CHAIR (page 83) and MADONNA OF THE MEADOWS altarpiece. Of much greater size and complexity is his mural painting THE SCHOOL OF ATHENS (page 52). Together, these paintings reveal Raphael's own harmonious resolution of the Renaissance desire to reconcile Christianity with the ideals of classical Greece and Rome.

Raphael was honored for centuries as Europe's greatest painter, yet he was also an accomplished archaeologist and architect. In addition to being principal artist for the Vatican, he was art director and city planner for Rome and made it his mission to restore the classic grandeur of the ancient capital city.

As the Early Renaissance was unfolding in Italy, a parallel new interest in realism arose in northern Europe, where artists were even more concerned than the Italians with depicting life in the real world. Yet lingering medieval attitudes made the fifteenth-century art of the north as much a late phase of Gothic style as an early Renaissance style.

The Renaissance in Northern Europe

Jan van Eyck was a leading painter in Flanders, the region of present-day Belgium and adjacent parts of France and The Netherlands. He was one of the first to use linseed oil as a paint medium (see also pages 119–20). The fine consistency and flexibility of the new oil medium made it possible to achieve a brilliance and transparency of color that were previously unattainable. His oil paintings remain in almost perfect condition, attesting to his skill and knowledge of materials. Italian artists admired and

were influenced by the innovations of van Eyck and other Flemish and Dutch artists.

On the same type of small wooden panels previously used for tempera painting, van Eyck painted in minute detail, achieving an illusion of depth, directional light, mass, rich implied textures, and the physical likenesses of particular people. Human figures and their interior settings took on a new, believable presence.

In spite of van Eyck's realistic detail, THE MARRIAGE OF GIOVANNI ARNOLFINI AND GIOVANNA CENAMI has a Gothic quality in its traditional symbolism, formality, and vertical emphasis of the figures. At the time the portrait of the Arnolfini wedding was commissioned, the Church did not always require the presence of clergy for a valid marriage contract, and thus it was easy to deny that a marriage had taken place. Van Eyck's painting is thought to be a testament to the oath of marriage between the two of them. As witness to the event, Jan van Eyck placed his signature and the date, 1434, directly above the mirror—and he himself appears to be reflected in the mirror (see detail on page 71).

Today the painting's Christian iconography, well understood in the fifteenth century, needs explanation. Many of the ordinary objects portrayed with great care have sacred significance. The single lighted candle in the chandelier symbolizes the presence of Christ; the amber beads and the sunlight shining through them are symbols of purity; the dog indicates marital fidelity. The bride's holding up her skirt suggestively in front of her stomach may indicate her willingness to bear children. Green, a symbol of fertility, was often worn at weddings.

In the early sixteenth century in Germany, Northern Renaissance master Albrecht Dürer further developed the practice of presenting instructive symbolism through detailed realism. His engraving THE KNIGHT, DEATH AND THE DEVIL (page 132) combines Christian symbols with familiar subjects in the Flemish tradition of van Eyck.

Pieter Bruegel was an independent thinker of far-reaching vision. As a young man he traveled ex-

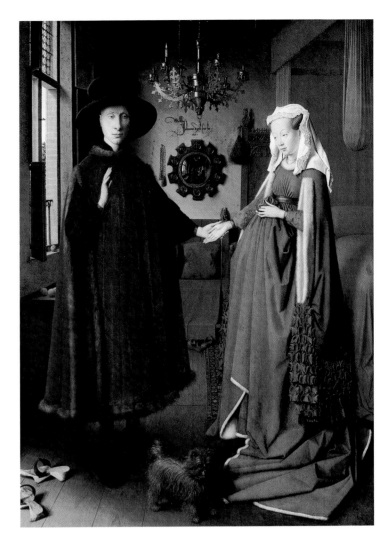

399 Jan van Eyck.
THE MARRIAGE OF GIOVANNI ARNOLFINI AND GIOVANNA CENAMI. 1434.
Oil on oak panel. 33½" × 23½".
National Gallery, London, UK.
Photograph: Bridgeman Art Library, New York.

tensively in France and Italy. Under the influence of Italian Renaissance painting, Bruegel developed a grand sense of composition and spatial depth. The focus of Bruegel's paintings was the lives and surroundings of common people, and toward the end of his life he did a series of paintings representing the activities of the twelve months of the year.

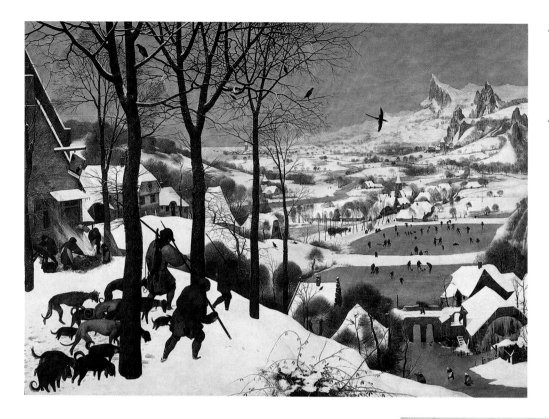

400 Pieter Bruegel.
THE RETURN OF THE
HUNTERS. 1565.
Oil on panel.
46½" × 63¾".
Kunsthistorisches Museum, Vienna.

401 The Limbourg Brothers.
FEBRUARY, from LES TRÈS
RICHES HEURES DU DUC
DE BERRY.
1413–1416.
8⅞" × 5⅜".
Musée Condé, Chantilly, France.
Photograph: Giraudon/Art
Resource, NY.

One of the most beloved of the series is his painting for January, THE RETURN OF THE HUNTERS. Following the precedent set by manuscript painters (illuminators) of medieval calendars, who depicted each month according to the agricultural labor appropriate to it, Bruegel shows peasants augmenting their winter diet by hunting. New here is the emphasis on nature's winter mood rather than on human activity. The illusion of deep space, so important to this image, came from the innovations of the Italians and was also inspired by Bruegel's journey over the Alps. Views from high vantage points are often seen in his work.

Compare Bruegel's painting with an illuminated page for FEBRUARY from a late Gothic book of hours painted by the Limbourg brothers in the early fifteenth century, before the Renaissance influence reached the North. Notice how far landscape painting evolved in just one hundred fifty years. Although there is a huge difference in the way space is depicted, in both paintings there is attention to nature and the details of everyday life. Bruegel achieved greater naturalism by portraying what he might see

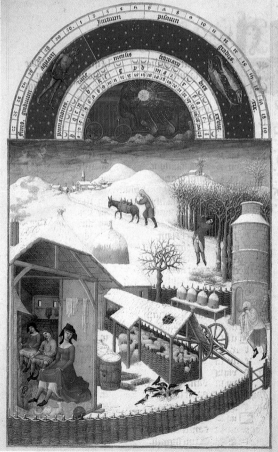

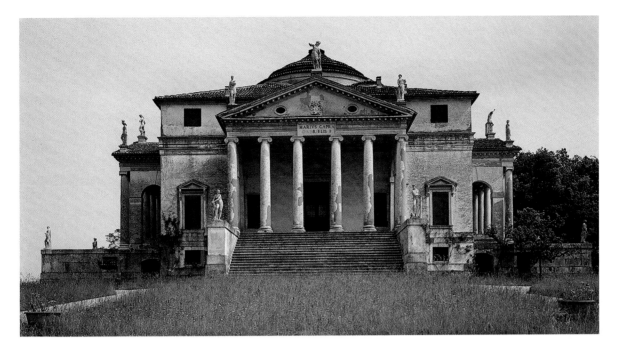

402 Andrea Palladio.
VILLA ROTONDA.
Vicenza, Italy. 1567–1570.
Photograph: Scala/Art Resource, NY.

from one vantage point at a particular time; the Limbourg brothers implied various moments in time by creating an imaginary composite view.

Late Renaissance in Italy

The High Renaissance was followed by a period of turmoil, revolution, and new expectations. In the early sixteenth century, religious questioning spawned the Protestant Reformation—a movement to reform the Western Christian Church that resulted in a split into Protestant and Catholic churches. The tensions brought on by these social changes were apparent in major changes in art.

In the fifteenth century, Renaissance architects, sculptors, and painters had gone to great lengths to acquire knowledge of Greek and Roman ideas and to employ these ideas, along with contemporary concepts, in the creation of architecture they considered more beautiful than any done by their predecessors.

During the sixteenth century, architects made a deliberate effort to rethink and extend classical rules even as they used classical forms. The most learned and influential architect was Andrea Palladio. His fa-

mous VILLA ROTONDA is a free reinterpretation of the Roman Pantheon (see page 249). It has four identical sides, complete with porches resembling ancient temple façades, built around a central domed hall. The villa's design hardly satisfies the architectural goal of livability, but it was not intended for family living; it was designed for a retired monsignor as a kind of open summer house for social occasions. From its hilltop site, visitors standing in the central rotunda could enjoy four different views of the countryside.

Palladio's designs were published in books that were widely circulated throughout the Western world. For the next two centuries, architects and builders from Russia to London to Pennsylvania often used motifs that he developed, and his designs have even reappeared on Postmodern buildings in the last twenty-five years.

By the mid-sixteenth century, it had become increasingly difficult for artists to surpass the examples of Leonardo, Michelangelo, and Raphael. While the ideas of the Renaissance spread north, Mediterranean artists also faced change. Mannerism, the key trend in southern Europe, dominated painting,

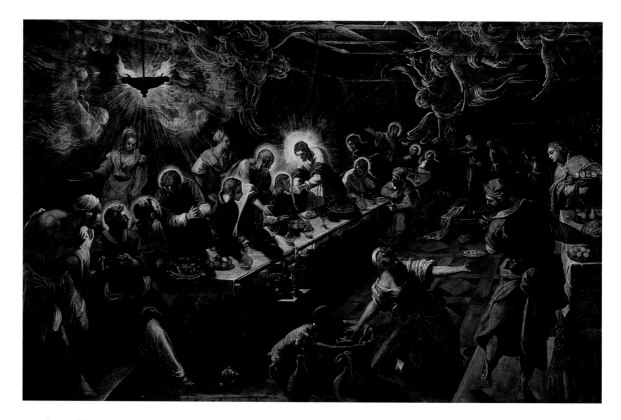

403 Jacopo Tintoretto.
THE LAST SUPPER. 1592–1594.
Oil on canvas. 12' × 18'8".
S. Giorgio Maggiore, Venice.
Photograph: Scala/Art Resource, NY.

sculpture, and architecture. Mannerist painters of the sixteenth century admired the drama and emotion found in the late work of Michelangelo and Raphael. The younger generation exaggerated these qualities, sometimes in contrived or mannered ways, to achieve their own unique expression. *Mannerism* is characterized by distortions of perspective, scale, and proportion; exaggerated color; and increased value contrast—all aimed at provoking a sense of mystery and heightened emotion. The result was often ambiguous and disquieting, unlike the classical confidence inspired by High Renaissance art. Mannerism led from the High Renaissance of the early sixteenth century into Baroque art of the seventeenth century.

Paintings of Jacopo Tintoretto exhibit Mannerist qualities. His version of THE LAST SUPPER,

completed when the artist was in his seventies, is a radical departure from Leonardo's calm, classical interpretation painted one hundred years earlier (page 269). After a lifetime working with the subject, Tintoretto transformed the earthly event into a supernatural vision. Christ seems farther away, distinguished only by a brilliant halo of light. The table, seen from a higher angle, is turned away from the picture plane in exaggerated perspective, creating a strong feeling of movement through diagonal forces. Angels appear overhead in the light and smoke of a blazing oil lamp. Disciples and attendants are caught at a moment of emotional intensity. Such vivid exaggerations of light, movement, spatial tension, and theatrical gesture became major storytelling devices for seventeenth-century artists.

BAROQUE

The era known as the Baroque period includes the seventeenth and most of the eighteenth centuries in Europe. Although Baroque generally refers to a period, the term is also used to describe the art that arose in Italy around 1600 and spread through much of Europe during the next two hundred years.

The Baroque period had far more varied styles than the Renaissance, yet much of the art shows great energy and feeling, and a dramatic use of light, scale, and balance. The goal of balanced harmony achieved by Renaissance artists such as Raphael in his SCHOOL OF ATHENS (page 52) and Michelangelo in his DAVID was set aside first by Mannerists and later by Baroque artists as they explored more innovative uses of space and more intense ranges of light and shadow. Their art, with its frequent use of curves and countercurves, often appeals to the mind by way of the heart. Also, we can see a new degree of vivid realism in compositions employing sharp diagonals and extreme foreshortening.

The Counter Reformation developed in the late sixteenth and early seventeenth centuries as the Catholic Church's response to the Protestant Reformation and the growing impact of science. Many of the characteristics of the Baroque style were spawned and promoted by the Catholic Counter Reformation.

Michelangelo Merisi da Caravaggio's down-to-earth realism and dramatic use of light broke from Renaissance idealism and became the leading influences on other Baroque painters, north and south. Caravaggio created the most vivid and dramatic paintings of his time, using directed light and strong contrasts to guide the attention of the viewer and intensify the subject matter.

Emotional realism and theatrical use of chiaroscuro, especially in Caravaggio's night effects (called *tenebrism*), influenced later Baroque painters such as Rubens and Rembrandt. Displayed in a dark chapel, Caravaggio's paintings take on a vivid, lifelike quality intended to heighten the religious experience.

In THE CONVERSION OF SAINT PAUL, Caravaggio used light to imply a blinding flash, symbolizing the evangelist's conversion: "And suddenly there shined around him a light from heaven: and he fell

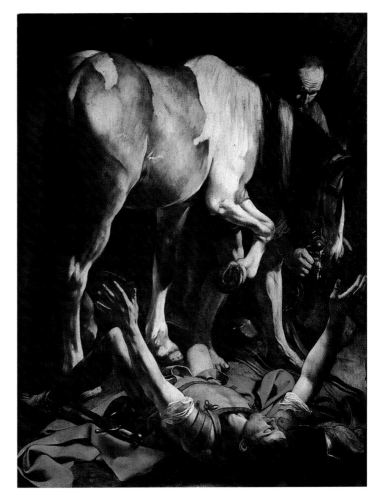

404 Michelangelo Merisi da Caravaggio.
THE CONVERSION OF SAINT PAUL. 1600–1601.
Oil on canvas. 100½" × 69".
Santa Maria del Popolo, Rome.
Photograph: Scala/Art Resource, NY.

to the earth" (Acts 9:3). The figure of Paul, in Roman dress, is foreshortened and pushed into the foreground, presenting such a close view that we feel we are right there. In keeping with the supernatural character of the spiritual events he portrayed, Caravaggio evoked a feeling for the mystical dimension within the ordinary world. He wanted his paintings to be accessible and self-explanatory, and for this purpose he brought the tumult of his own rowdy life to the stories of the Bible. Some of the clergy for whom he painted rejected his style; his emotional realism was too strong for people accustomed to idealized aristocratic images that demonstrated little more than gestures of piety.

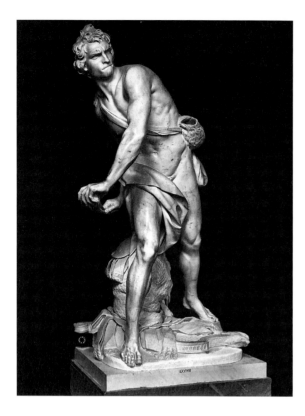

In post-Renaissance Rome, another artist who had as far-reaching an influence as Caravaggio was the sculptor and architect Gianlorenzo Bernini. Because Bernini's DAVID is life-size rather than monumental, viewers become engaged in the action. Rather than capture an introspective moment, as Michelangelo did (page 272), Bernini chose to depict David in a moment of tension, as he prepares to fling the stone at Goliath.

Bernini's elaborate orchestrations of the visual arts are the climax of Italian Baroque expression. The emotional intensity of his art is vividly apparent in his major work THE ECSTASY OF SAINT TERESA. It features a life-size marble figure of the saint and depicts one of her visions as she recorded it in her diary. In this vision, she saw an angel who seemed to pierce her heart with a flaming arrow of gold, giving her great pain as well as pleasure and leaving her "all on fire with a great love of God."[4] Bernini made the visionary experience vivid by portraying the moment of greatest feeling, revealing spiritual passion through physical expression. Turbulent drapery heightens the emotional impact. His departure from the naturalistic, classical norm soon influenced artists throughout Europe.

Flemish painter Peter Paul Rubens, a renowned diplomat and humanist, was the most influential Baroque artist in northern Europe. He studied painting in Antwerp, then traveled to Italy in 1600. During a stay of several years he was greatly influenced by the work of Michelangelo, and to a lesser degree by the work of Raphael, Leonardo, and Caravaggio. When Rubens returned north, he won increasing acclaim and patronage; being a sophisticated businessman, he enjoyed an aristocratic lifestyle. His work came to be in such demand by the nobility and royalty of Europe that he established a large studio with many assistants. Although Rubens was noted for the

405 Gianlorenzo Bernini. DAVID. 1623.
Marble. Life-size.
Galleria Borghese, Rome. Photograph: Alinari/Art Resource, NY.

406 Gianlorenzo Bernini.
THE ECSTASY OF SAINT TERESA.
Detail of the altar, Cornaro Chapel, Santa Maria della Vittoria, Rome. 1645–1652. Marble. Life-size.
Photograph: Scala/Art Resource, NY.

exuberant quality of his nudes, there was a tendency for everything in his paintings to take on a similar sensuality. His free brushwork influenced many painters.

In THE RAISING OF THE CROSS, we see his interpretation of a religious subject, painted for an important cathedral in his homeland. The composition is arranged along a diagonal anchored at the bottom right by the well-muscled figure. This and other taut bodies in the work show the results of the artist's recent visit to Italy, where he saw works by Michelangelo and Caravaggio. At the same time, there is a high degree of realistic detail in the foliage and the dog at the bottom left that show Rubens's Flemish heritage from Jan van Eyck and others. The action and drama in the work seem to burst out of the frame, led by the upward glance of Christ. This visual dynamism, extending the action of the work into the viewer's space, marks the best Baroque painting.

While Rubens traveled Europe from England to Italy, Diego Velázquez was content to spend his entire career in the service of Philip IV, King of Spain. Philip was a broad-minded monarch who took delight in his chief painter's sometimes adventurous works. Such a painting is THE MAIDS OF HONOR, in which Velázquez plays an elaborate game. At first it is unclear who is the subject, since the artist himself is staring out from behind a canvas, brush in hand. The maids of honor encircle the king's daughter, who stares coquettishly at us, as if expecting something. She seems to be the center of the composition, as she stands in the brightest light. Another courtier stands in an illuminated doorway in the background. It is only when we see the mirror on the far wall, with the faces of the royal couple reflected in it, that we realize that this is a court portrait changed into a visual riddle. Velázquez painted a portrait of himself making a royal portrait! Like other Baroque works,

407 Peter Paul Rubens.
 THE RAISING OF THE CROSS. 1610–1611.
 Onze Lieve Vrouwkerk, Antwerp Cathedral, Belgium.
 Oil on panel. 15'2" × 11'2" (462 × 339 cm).
 Photograph: Peter Willi/Bridgeman Art Library, International, Ltd.

408 Diego Velázquez.
 THE MAIDS OF HONOR. 1656.
 Oil on canvas. 10'5" × 9'.
 Museo del Prado, Madrid. Photograph: Erich Lessing/Art Resource, NY.

409 Rembrandt van Rijn.
RETURN OF THE PRODIGAL SON. c. 1668–1669.
Oil on canvas. 8'8" × 6'8" (265 × 205 cm).
Hermitage Museum, St. Petersburg. Photograph: Superstock.

As the result of recently won independence and booming international trade, Holland (part of The Netherlands) became a new type of society in the seventeenth century: predominantly middle class, wealthy, mercantile, materialistic, and Protestant. Among the middle and upper classes, there was widespread enjoyment of and investment in contemporary art. Many people collected, traded, and resold paintings at a profit. Favored subjects were the same ones enjoyed to this day: landscape, still life, genre scenes (depictions of everyday life), and portraits. Through Dutch painters, art became accessible and understandable in everyday terms.

Rembrandt remains one of the world's most revered artists. We can see why in his large work RETURN OF THE PRODIGAL SON. The story comes from the Bible: a disobedient son cuts himself off from his family, demands his inheritance early, wastes it in disorderly living, and ends up in dire poverty. When he reaches the end of his rope, he returns to his wealthy father and asks for a job feeding his hogs. The father is not scornful or judgmental, rather the opposite. He tenderly welcomes the haggard and forlorn young man. Rembrandt portrays this touching scene with great reserve and economy. We see the prodigal son's ragged clothing, and the father's gentle embrace. We also see standing at the right, hanging back guardedly, the father's other son.

Rembrandt's composition shows the influence of the Italian Baroque painters in its imbalance of light and dark. The story, however, is not of the miraculous vision of a saint, as in Caravaggio's CONVERSION OF ST. PAUL (page 279), but rather a miraculous restoration of affection between estranged people.

For Rembrandt, meaning is conveyed through composition and paint application as well as subject matter. He delighted in the visual excitement that could be created with paint alone. The force of his brushwork is readily seen in his SELF-PORTRAITS on pages 9 and 121 and in his brush drawing on page 112.

Rembrandt's work has long influenced many painters—and, more recently, photographers—who have found his lighting techniques useful in directing the viewer's attention.

this painting reaches out beyond its frame in a subtle dynamism of glance and image in which light and shadow play a major role.

We have seen that Baroque characteristics are found in art that depicts both religious and nonreligious subjects. This was primarily because artists no longer relied wholly on the church for their support; many worked for nobles and aristocrats. In The Netherlands, the major patrons of art were middle-class merchants and bankers.

Jan Vermeer, Rembrandt van Rijn, and their peers painted views of the rich interiors of merchant homes and portraits of the middle class and the wealthy. Along with the new emphasis on scenes of daily life, religious art continued as a strong current in what is now The Netherlands; see, for example, Rembrandt's etching of CHRIST PREACHING (page 133).

REMBRANDT VAN RIJN was born in the elegant Dutch city of Leiden, the ninth of ten children of a prosperous miller. He began his art studies at fifteen, was apprenticed for three years to minor local artists, then traveled to Amsterdam to study briefly with a painter named Pieter Lastman, from whom he absorbed the influence of Caravaggio secondhand.

At nineteen, Rembrandt returned to Leiden and set up his own studio. Success came quickly, and in 1631 he moved to Amsterdam, a larger city offering more opportunities. There he married Saskia van Ulenborch, a beautiful, wealthy young woman from a good family. If we judge from his paintings of her over the years, it was a happy marriage.

By the end of the decade Rembrandt was the most celebrated painter in the city. He bought a large house in a fine neighborhood, lived lavishly, and collected paintings, costumes, and precious objects on a grand scale. Among his portraits are many of himself in assorted costumes and guises. He had so many pupils that he had to rent a warehouse for their work space.

Rembrandt's happiness was marred by the early deaths of their first three children. In 1641 his fourth child, Titus, was born. The next year Saskia died, and the challenging turmoil of his later life began.

Rembrandt's art grew more introspective. He turned increasingly to biblical subjects and landscapes. Fashionable portraits, his bread and butter, interested him less and less. His style, no longer so popular, brought fewer commissions. When Geertge Dircx, a nurse he had hired to help with Titus, became his common-law wife, his personal life raised eyebrows. A few years later he fell in love with another household servant, Hendrickje Stoffels. Geertge's subsequent departure was an extended ordeal, involving lawsuits, countersuits, and criminal charges. Hendrickje had two children with the painter and stayed with him until the end of her life. Because of a clause in Saskia's will, he was unable to marry Hendrickje, but his drawings and paintings of her are as affectionate as those of Saskia.

Rembrandt had always stretched his finances to the limit; and when the Dutch economy entered a shaky period in the 1650s, he was forced into bankruptcy. His house and all his possessions were sold in a series of auctions. Ever loyal and supportive,

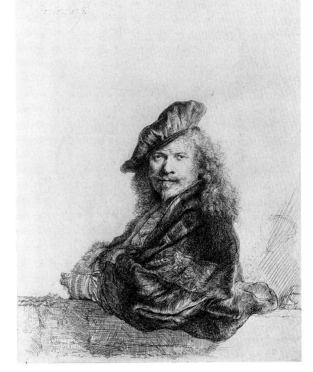

410　Rembrandt Harmensz van Rijn.
SELF-PORTRAIT LEANING ON A LEDGE. 1639.
Etching. 8⁵⁄₁₆" × 6⅝".
The Metropolitan Museum of Art. Bequest of Mrs. H. O. Havemeyer, 1929.
The H. O. Havemeyer Collection (29.107.25).

Titus and Hendrickje formed a partnership to employ Rembrandt and to sell his work, thus shielding him legally from creditors. He moved with them to a smaller house in a far humbler part of town, where he lived in modest circumstances, continuing as a respected artist and receiving important commissions. Hendrickje died soon after, in 1663; Titus died in 1668. The next year, Rembrandt died.

Over one thousand drawings, etchings, and paintings survive, attesting to Rembrandt's vast output. To the very end, Rembrandt's art grew deeper and more insightful. In his last self-portraits, he had the look of a man whom nothing—no further drop of suffering—could touch, and yet there is not the slightest hint of self-pity. The same understanding and compassion radiates from his biblical scenes and portraits, making Rembrandt one of the most warmly human of the great masters.

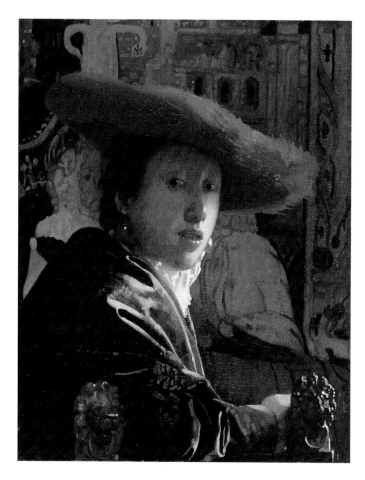

Jan Vermeer, another seventeenth-century Dutch painter, was also fascinated by light. His views of domestic life mark the high point of Dutch genre painting. Like Rembrandt, Vermeer was influenced by Caravaggio's use of light; unlike Caravaggio and Rembrandt, who used light for dramatic emphasis, Vermeer concentrated on the way light reveals each color, texture, and detail of the physical world. No one since Jan van Eyck demonstrated such passion for seeing or such love for the visual qualities of the physical world.

Experimenting to learn to see more accurately, Vermeer evidently used a table-model camera obscura (see page 142). His intimate portrait THE GIRL WITH THE RED HAT was painted on a small wooden panel similar in size to the frosted glass on which the image would have appeared if a camera obscura of the period were used. Thus, Vermeer may have taught himself to see with photographic accuracy by copying images from the ground glass. In THE GIRL WITH THE RED HAT, the focus has a narrow range. Only part of the girl's collar and the left edge of her cheek are in sharp focus; everything in front of and behind that narrow band becomes increasingly blurred. The carved lion's head on the arm of the chair in the foreground looks like shimmering beads of light, just as it would appear in an out-of-focus photograph.

Vermeer's understanding of the way light defines form enabled him to give his images a clear, luminous vitality. Much of the strength of THE KITCHEN MAID comes from a limited use of color: yellow and blue accented by red-orange surrounded by neutral tones. Vermeer gave equal attention to the details and the way each detail relates to the whole composition. Notice, for example, the immense care

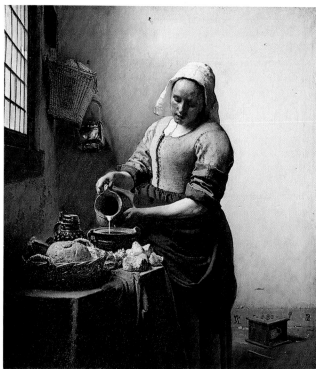

411 Jan Vermeer.
THE GIRL WITH THE RED HAT. c. 1665–1666.
Oil on panel, 9" × 7¹⁄₁₆".
Photograph: © 2001 Board of Trustees, National Gallery of Art, Washington, D.C. Andrew W. Mellon Collection. 1937.1.53.(53)/PA.

412 Jan Vermeer.
THE KITCHEN MAID. c. 1658.
Oil on canvas. 18" × 16⅛".
Rijksmuseum, Amsterdam.

given to the rendering of the subtle surface qualities of the wall with its nail holes and stains.

During the Baroque period, French artists adopted Italian Renaissance ideas but made them their own; by the end of the seventeenth century, France had begun to take the lead in European art.

We can glimpse another view of seventeenth-century European life in the royal architecture and garden design of the French imperial villa of VERSAILLES, built for King Louis XIV. The main palace and its gardens exemplify French Baroque architecture and landscape architecture. Throughout the palace and gardens, cool classical restraint and symmetry balance the romance of Baroque opulence and grand scale.

VERSAILLES expressed the king's desire to surpass all others in the splendor of his palace. It is an example of royal extravagance, originally set in fifteen thousand acres of manicured gardens, twelve miles south of Paris. The vast formal gardens, with their miles of clipped hedges, proclaimed the king's desire to rule even over nature. This palace, which was also a governmental center, played an important role in the program of absolute monarchy that Louis XIV personified. Never more than here is the Baroque style allied with aristocracy.

Early in eighteenth-century France, the heavy, theatrical qualities of Italian Baroque art gradually gave way to the decorative *Rococo* style, a light, playful version of the Baroque. The curved shapes of shells were copied for elegantly paneled interiors and furniture, and they influenced the billowing shapes found in paintings. The arts moved out of the marble halls of palaces such as VERSAILLES and into fashionable town houses (called hotels) such as the HÔTEL DE SOUBISE.

The enthusiastic sensuality of the Rococo style was particularly suited to the extravagant and often frivolous life led by the French court and aristocracy. Some of the movement, light, and gesture of the Baroque remained, but now the effect was one of lighthearted abandon rather than dramatic action or quiet repose. Rococo paintings provided romantic visions of life free from hardships, in which courtship, music, and festive picnics filled the days.

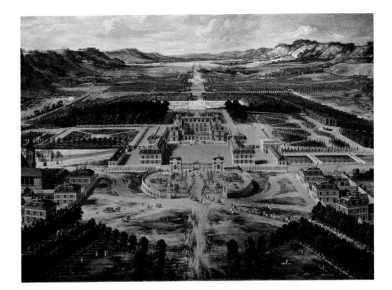

413 VERSAILLES. C. 1665.
Painting by Pierre Patel.
Chateau de Versailles et de Trianon, Versailles, France. Photograph: Giraudon/Art Resource, NY.

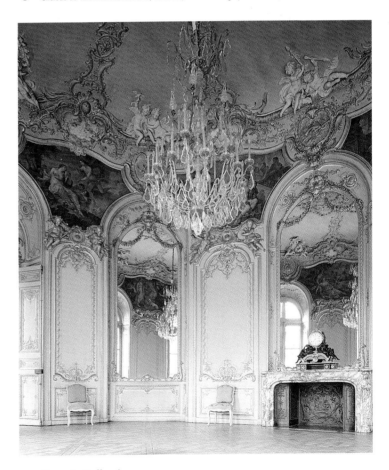

414 Germain Boffrand.
SALON DE LA PRINCESSE, HÔTEL DE SOUBISE.
Paris. Begun 1732.
Photograph: Hirmer Fotoarchiv, Munich, Germany.

415 Jean Honoré Fragonard.
THE SWING. 1767.
Oil on canvas. 31⅞" × 25¼".
Wallace Collection, London.

The aristocratic life of ease and dalliance is nowhere better depicted than in Jean-Honoré Fragonard's painting THE SWING. A well-dressed and idle young woman, attended by a dimly visible bishop, swings in a garden. At the lower left, a youth hides in the bushes and admires her. The story line of the work is provided by her flying shoe, which has come off and will soon land in the young man's lap. Fragonard learned the lessons of the Baroque well, as we can see in the off-balance composition arranged along the diagonal, and the contrasts of light and dark visible in the lush garden. But Baroque drama gives way here to the sensual abandon and light-as-air subject matter of the Rococo at its best.

Or worst. The next generation of French artists and intellectuals would rebel against the social irresponsibility portrayed in this type of art, which they saw as merely fluffy. The Enlightenment was already breaking out across western Europe, and its new ideas of social equality and scientific inquiry would soon shake European art and culture to its core.

THE CONDITIONS for producing great art—or for excelling in any discipline—include family support, educational opportunity, community support, and patronage, as well as aptitude. Many artists now considered "great" benefited from most of these advantages. Yet the situation has been and still is discouraging, even hostile at times, for anyone who is not born white, moderately affluent, and male. Obstacles begin with the attitudes of parents, teachers, and others in power. What is amazing is that so many women have achieved so much in the face of gender-based discrimination.

During the Renaissance in Italy, it became socially and politically acceptable for aristocrats to educate daughters a well as sons in the social arts. Although the idea was simply to produce women who could write poetry, dance, sing, paint, and excel in the art of conversation so that they would make good companions for aristocratic men, some women became highly accomplished artists. However, most were denied access to the training necessary for professional careers.

Sofonisba Anguissola was the first female artist of the Renaissance to achieve recognition throughout Europe. Anguissola studied with a portrait painter, and

her well-publicized success led other male artists to accept female students. While still in her twenties, she became court painter to King Philip II of Spain. Her SELF-PORTRAIT of 1556 employs subtle Mannerist qualities that evoke a mysterious mood.

European women artists were more numerous and better known during the Baroque period. Among the most remarkable was Artemisia Gentileschi, daughter of well-known artist Orazio Gentileschi. Although some of today's art historians consider Artemisia a better painter than her father, until recently her work received limited recognition because she was a woman.

Her painting JUDITH AND THE MAIDSERVANT WITH THE HEAD OF HOLOFERNES tells the Bible story of the heroic Judith who beheaded an enemy general. The intensity of the moment is communicated clearly in this Baroque work. The drama is intensified by bold use of theatrical light, sweeping curves, dramatic gestures, and warm colors.

Because women were not allowed to study from the nude in art academies, most of the women who achieved distinction in the visual arts depended on the help of fathers or close male friends who were artists. A list of such women includes Rosa Bon-

heur (see chapter 21) and Marietta Robusti, both daughters of artists; Berthe Morisot, an Impressionist who was closely associated with Edouard Manet; and Mary Cassatt (see page 135), who was a close friend of Edgar Degas.

The art world made great strides toward gender equality in the twentieth century, but the goal has not yet been achieved.

416 Sofonisba Anguissola.
SELF-PORTRAIT. 1556.
Oil on canvas. 66 × 57 cm.
Museum Zamek, Lancut Poland. © The Bridgeman Art Library International Ltd.

417 Artemisia Gentileschi.
JUDITH AND THE MAIDSERVANT WITH THE HEAD OF HOLOFERNES. c. 1625.
Oil on canvas. 6'½" × 4'7¾".
Photograph © 1984 The Detroit Institute of Arts. Gift of Mrs. Leslie H. Green.

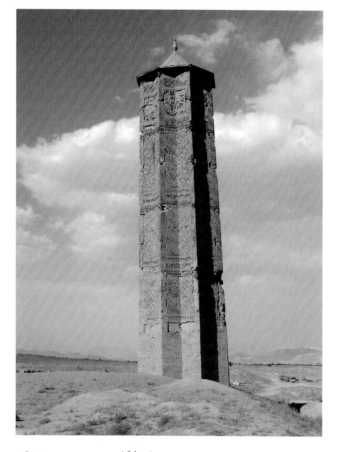

418 GHAZNI MINARET, Afghanistan.
Early twelfth century. Height 65'.
Photo courtesy World Monuments Fund, by Najim M. Azadzoi.
Architect/Planner, Azad Architects, Newton, MA.

MUCH OF THE ART of the past that we enjoy today would have perished but for those people in each generation who cared for it. Because art preserves tangible evidence of cultural history, preserving it is essential. But because art is subject to all the vicissitudes of nature and humanity, preserving it can also be very difficult.

A major work that has suffered grievously from both nature and humans is the beloved PARTHENON, a masterwork of world architecture (see page 244). After it served the Greeks as a temple of Athena, conquering Romans turned it into a brothel. Christians later used it as a church. The Turks of the Ottoman Empire refurbished it as a mosque for Muslim worship When the Venetians attacked in 1687, the Turks converted it into an ammunition dump. In that year it was hit by Italian artillery and exploded.

In 1803, the British ambassador to the Ottoman court removed most of the marble sculpture from the building and took it to London, where it now remains. On the way, one of his ships ran aground and had to be salvaged. Overzealous cleaners in the British Museum in the 1930s scrubbed the surface of the sculptures with wire brushes, hopelessly damaging them. Meanwhile, what remains of the original building languishes under the impact of Athenian air pollution.

Every kind of art material presents its own particular set of challenges to restorers. Most restorers of painting and sculpture today are trained in chemistry. They carefully analyze the surface and layers of works in their charge, often using a computer-aided process called *mass spectrography*. This chemical diagnosis informs them of the work's level of stability and suggests restorative methods.

Restorers' decisions about how to treat a work can be hotly debated. Restorers of the MONA LISA, for example, decided in the late 1990s not to remove the last layer of varnish from its surface, for fear of damaging Leonardo's paint underneath. This decision was hailed as respectful in some quarters and derided as too timid in others. In contrast, restorers of Leonardo's LAST SUPPER recently added watercolor to the surface of the work, fill-ing in gaps; this more assertive treatment was equally controversial for the opposite reasons.

However, for every high-profile work that is stabilized in a wealthy county, hundreds of others slowly decay in poorer areas where resources are not as plentiful. These threatened works include important buildings in addition to paintings and sculpture.

The World Monuments Fund watches out for these, and publishes a list of the world's *One Hundred Most Endangered Sites* every two years. Sites pictured in this book that have appeared on the list include the ancient city of Teotihuacan in Mexico; Machu Picchu in Peru; the Amenhotep Temple in Luxor, Egypt; the Roman city of Pompeii; Hagia Sophia in Istanbul; the Angkor Wat temple complex in Cambodia; and Borobudur in Indonesia. The Taj Mahal in India has been on the list twice.

The GHAZNI MINARETS in Afghanistan are on the most recent WMF list. Erected in the twelfth century, these towers rise some sixty-five feet above the surrounding desert, their star-shaped shafts coated in priceless terracotta decoration. The surface deterioration is serious in itself, yet the structures are located in an embattled country. Conservation of this and other monuments will require international cooperation.

TRADITIONAL ARTS OF ASIA

The human presence in Asia dates back to the Paleolithic period. In Asia there occurred a similar development of ancient cultures, from hunting and gathering to agricultural village societies, to Bronze Age kingdoms, and so on. (For examples of ancient Asian art, see Chapter 14.) Culturally as well as geographically, India is at the core of the continent. Many ideas that later permeated Asian societies originated in India and radiated outward. However, because each region of Asia also had its own local cultural forms, outright borrowing was rare. Rather, we can trace the passage of ideas and art styles across the continent as they were adapted and modified in various locations.

INDIA

In the 1930s, excavations at the sites of the ancient city of Harappā revealed the remains of a well-organized society with advanced city planning and a high level of artistic production. The two cities served as focal points for a civilization that extended for a thousand miles along the fertile Indus Valley between three thousand and five thousand years ago. (Most of this valley, where Indian culture began, became part of Pakistan after Indian independence in 1947.)

Ancient Indus Valley sculpture already shows the particularly sensual naturalism that characterizes much of later Indian art. This quality enlivens the small, masterfully carved MALE TORSO from Harappā. The lifelike surface gives the torso an energized quality, as if it were animated by *prana*, or life-giving breath, a concept central to the ancient tradition of hatha yoga.

Relatively few works of art survive from the period between 1800 B.C.E., when the Indus Valley civilization declined, and 300 B.C.E., when the first Buddhist art appeared. Nevertheless, the years in that interval were important ones for the development of Indian thought and culture.

Starting around 1500 B.C.E., the Indian subcontinent was infiltrated and gradually taken over by nomadic Aryan tribes from the northwest. The

419 MALE TORSO.
Harappā, Indus Valley.
c. 2400–2000 B.C.E.
Limestone.
Height 3½".
Photograph: Prithwish Neogy.
Courtesy of Duane Preble.

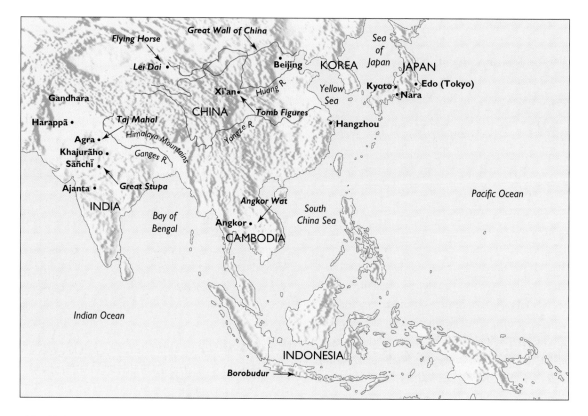

420 HISTORICAL MAP OF ASIA.

Aryans' beliefs, gods, and social structure formed the foundation of the subsequent development of Indian civilization. Key Aryan beliefs that influenced later Indian thought include the idea that the universe evolves in repeated cycles of creation and destruction; that individuals are reincarnated after death; and that there is one supreme form of wisdom. These beliefs were spelled out in the main forms of Aryan literature, the Vedas (hymns) and Upanishads (philosophical works)—texts still regarded as sacred by many Indians.

The Aryans, being nomads, left behind very little of what we might call art. What came into being as Indian art is a synthesis of indigenous Indian art forms and the religious ideas of the nomadic Aryans.

Many Indian religions developed from the core beliefs of the Aryans. Their literature, for example, was accepted as scripture by Hindus. In the sixth century B.C.E., two influential spiritual leaders preached variations on Hindu beliefs. They were Siddhartha Gautama (563–483 B.C.E.), founder of Buddhism, and Mahavira (599–527 B.C.E.), founder of Jainism. Although most Indians today are Hindus, Buddhism dominated the formative years of the development of Indian art, and it became a major cultural factor elsewhere in Asia.

Buddhist Art

The Buddhist religion began when Siddhartha Gautama achieved enlightenment. Seeking an answer to the question of human suffering, he arrived at what Buddhists call the Four Noble Truths: (1) Existence is full of suffering. (2) The cause of suffering is desire. (3) To eliminate suffering, one must eliminate desire. (4) To eliminate desire, one must follow the Eightfold Path of right views, right aspirations, right speech, right conduct, right livelihood, right effort, right mindfulness, and right contemplation. He also taught that if one achieves enlightenment, the endless cycle of death and rebirth will be broken, and the believer will experience a final rebirth in a pure spiritual realm. Siddhartha began to attract followers in

the late sixth century B.C.E.; they called him the "Enlightened One" or the Buddha.

Early Buddhism did not include the production of images. Eventually, however, religious practice needed visual icons as support for contemplation, and images began to appear. The many styles of Buddhist art and architecture vary according to the cultures that produced them. As Buddhism spread from India to Southeast Asia and across central Asia to China, Korea, and Japan, it influenced (and was influenced by) native religious and aesthetic traditions.

An excellent example of early Indian Buddhist art is the domelike structure called the *stupa*, which evolved from earlier burial mounds. At THE GREAT STUPA at Sāñchī, four gates are oriented to the four cardinal directions. The devout walk around the stupa in a ritual path, symbolically taking the Path of Life around the World Mountain. Such stupas were erected at sacred locations, and relics (items belonging to a holy person) were usually buried in their core.

The four gateways to THE GREAT STUPA include layers of sculpture in relief. These tell the story of the Buddha's life, but without depicting him directly. The characteristic sensuousness that we observed in the MALE TORSO from Harappā still enlivens these early monuments.

We can trace the EVOLUTION OF BUDDHIST ARCHITECTURE from its origin in India to its later

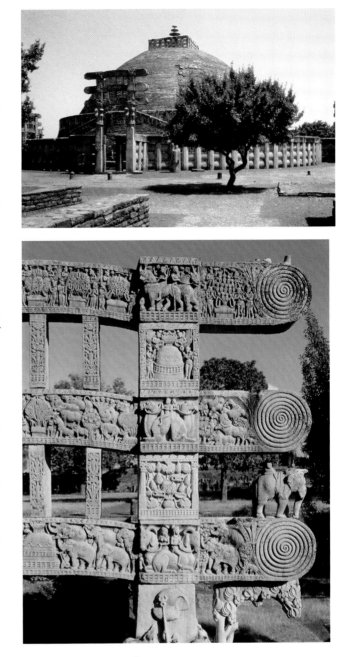

421 a. GREAT STUPA.
Sāñchī, India. 10 B.C.E.–15 C.E.
Photograph: Prithwish Neogy.
Courtesy of Duane Preble.

b. Eastern gate of THE GREAT STUPA.
Photograph: Borromeo/Art Resource, NY.

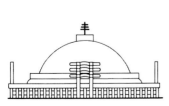

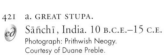
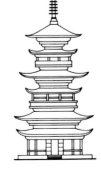

422 EVOLUTION OF BUDDHIST
ARCHITECTURE.
a. Early Indian stupa. 3rd century to early 1st century B.C.E.
b. Later Indian stupa. 2nd century C.E.
c. Chinese pagoda. 5th to 7th centuries C.E.
d. Japanese pagoda. 7th century C.E.

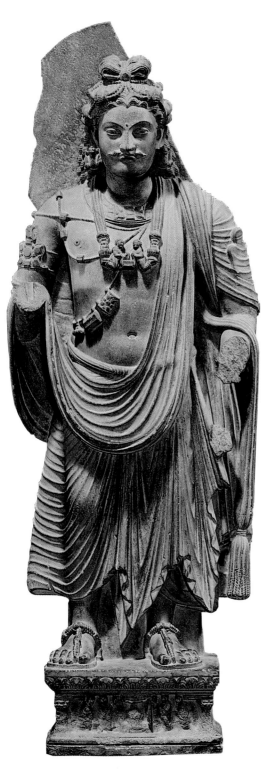

423 STANDING BODHISATTVA.
N.W. Pakistan, Gandhara region. Late 2nd century A.D.
Kushana period. Gray schist. Height 43⅛".
Courtesy, Boston Museum of Fine Arts, Boston. Helen and Alice Colburn Fund.
37.99. Reproduced with permission.
© Museum of Fine Arts, Boston. All rights reserved.

manifestations in other parts of Asia. Buddhist pagodas developed from a merging of the Indian stupa and the traditional Chinese watchtower. The resulting broad-eaved tower structure was in turn adopted and changed by the Japanese.

Indian art was influenced by Western art when Alexander the Great conquered large parts of what is now Pakistan and Afghanistan in the fourth century B.C.E. This region, called Gandhara, continued its contacts with the Roman Empire during its peak years. Buddhist sculptors in the region developed a distinctive style of working that owes about equal amounts to East and West; the STANDING BODHISATTVA is an excellent example. Here the sculptor shows a knowledge of the realism of Roman portraiture, as well as the classical Greek method of showing a subject's body beneath the folds of the drapery in the legs. The subject, however, is Buddhist. A *bodhisattva* is a person who is on the point of achieving enlightenment, but delays it in order to remain on earth and teach others. Bodhisattva are usually depicted wearing rich garments and jewels.

The Indian Gupta dynasty (c. 320–540) is notable for major developments in politics, law, mathematics, and the arts. In the visual arts, the Gupta style combines native Indian ways of seeing with the naturalism of the Gandhara. Although slightly damaged, the carved stone STANDING BUDDHA is a fine example of Gupta sculpture. In its cool, idealized perfection, the refined Gupta style marks a period of high achievement in Indian art. Once again, the simplified mass of the figure seems to push out from within as though the body were inflated with breath. The rounded form is enhanced by curves repeated rhythmically down the figure. The drapery seems wet as it clings to and accentuates the softness of the body.

We can see similar elegance and linear refinement in the noble figure known as the "BEAUTIFUL BODHISATTVA" PADMAPANI, part of a series of elaborate paintings in the Ajanta Caves in Central India. The fine linear definition of the figure accents full, rounded shapes, exemplifying the relaxed opulence of the Gupta style. This was the principal style exported when Buddhism began to spread to China and Southeast Asia.

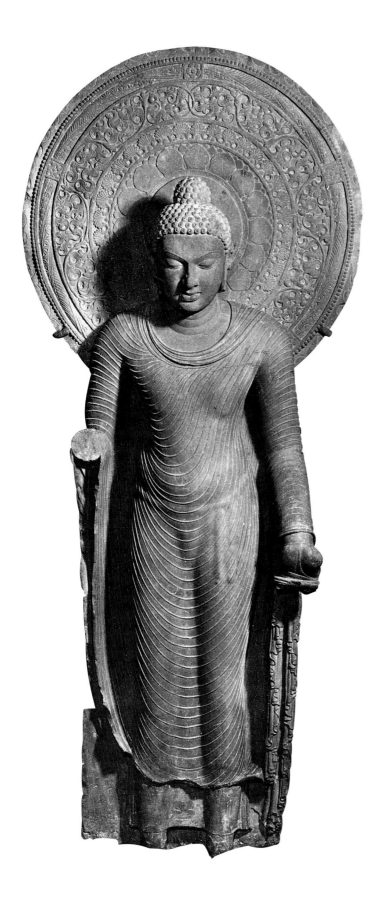

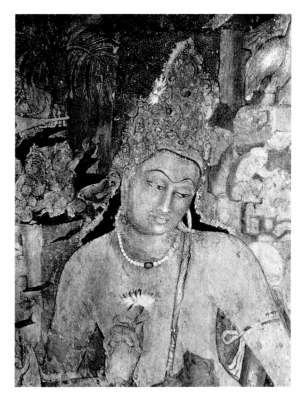

424 STANDING BUDDHA. 5th century.
Red sandstone. Height 5'3".
Indian Museum, Calcutta.

425 "BEAUTIFUL BODHISATTVA" PADMAPANI.
Detail of a fresco from Cave 1. Ajanta, India. c. 600–650.
Duane Preble.

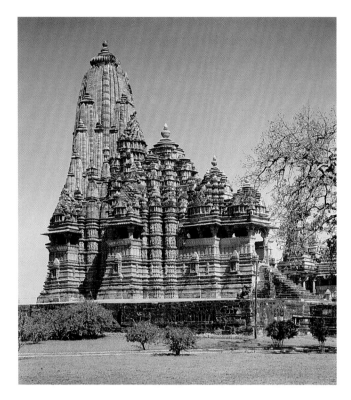

426 KANDARYA MAHADEVA TEMPLE.
Khajurāho, India. 10th–11th centuries.

a. Exterior
Photograph: Borromeo/Art Resource, NY.

b. Scene from KANDARIYA MAHADEVA TEMPLE.
Chandella dynasty, 1025–50 C.E. Khajuraho,
Madhya Pradesh, India.
Photograph: Borromeo/Art Resource, NY.

Hindu Art

Hinduism recognizes three principal gods: Brahma, the creator of all things; Vishnu, the sustainer; and Shiva, the destroyer. These three gods intervene in human affairs at appropriate moments either to guarantee the continuing evolution of the cosmos, or to restore the proper balance of good and evil forces in the world. Most Hindu devotional practices are done individually (rather than in a group as is common in Christian worship), and Shiva is the god most often venerated in architecture and sculpture.

The Hindu temple is a major architectural form of India, and one of the world's most distinctive. It typically includes two parts: a porch, for the preparation and purification of the worshiper, and the Womb Chamber, called in Sanskrit the *garba griha*, the sacred room where an image of the god is kept.

The KANDARYA MAHADEVA TEMPLE at Khajurāho in north central India is one of the most spectacular and best preserved. A stairway leads to not one, but several porches, which allow access to the *garba griha*. The sacred chamber is marked on the outside by a tall tower that has replicas of itself on its sides. The rounded projecting forms, symbolizing both male and female sexuality, seem to celebrate the procreative energy existing in nature and within ourselves.

Shown here is one of six erotic scenes from the abundant sculpture on the outside of KANDARYA MAHADEVA TEMPLE. To the Hindu worshiper, union with God is filled with a joy analogous to the sensual pleasure of erotic love. The natural beauty and fullness of the human figures emphasize maleness and femaleness. Fullness seems to come from within the rounded forms, as we saw in the more ancient MALE TORSO from Harappā. The intertwining figures symbolize divine love in human form—an allegory of ultimate spiritual unity.

The complex corps of Hindu gods and goddesses depicted in Indian art represents all aspects of

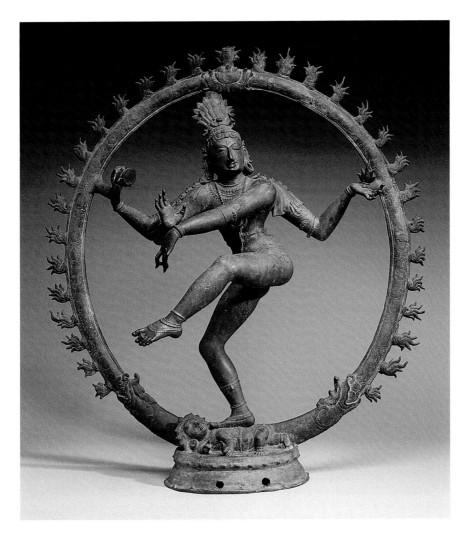

427 NĀTARĀJA: SHIVA AS KING SHIVA NĀTARĀJA, LORD OF THE DANCE.
South India, Chola Period, 11th century.
Bronze. Height 111.5 cm, (43⅛" × 40").
© 2001 The Cleveland Museum of Art.
Purchase from the J. H. Wade Fund (1930.331).

human aspiration and experience. In later Hindu belief, Shiva encompasses in cyclic time the creation, preservation, dissolution, and re-creation of the universe. To show these roles, Shiva has been given various forms in Hindu sculpture. In an eleventh-century image from South India, SHIVA NĀTARĀJA, LORD OF THE DANCE, performs the cosmic dance within the orb of the sun. He tramples on the monster of ignorance as he holds sacred symbols in his hands. The encircling flame is the purifying fire of destruction and creation. He taps on a small drum to mark the cosmic rhythm of death and rebirth. As he moves, the universe is reflected as light from his limbs. The sculpture implies movement so thoroughly that motion seems contained in every aspect of the piece. Each part is alive with the rhythms of an ancient ritual dance. Multiple arms increase the sense of movement, while his face is composed and impassive, indicating that there is nothing to fear.

Most of India was conquered by Islamic Mughal rulers in the early sixteenth century. The Mughal style of painting (to be discussed in the following chapter) influenced Indian art after the Mughal domain receded again in the seventeenth and eighteenth centuries. Several local Indian art styles arose in the foothills of the Himalaya as artists again took

428 THE APPROACH OF KRISHNA, c. 1660–1670.
Color, silver, and beetle wings on paper, 6⅞" × 10¼".
© The Cleveland Museum of Art, Edward L. Whittemore Fund. 1965.249.

up traditional Hindu subjects; we see the Basholi style to good advantage in THE APPROACH OF KRISHNA. A woman waits breathlessly for her lover, the blue-skinned god Krishna. Like many other Indian works, this painting uses erotic desire as a symbol for the spiritual longing for union with the divine. The inscription reads, "Friend, give up your waywardness of mind." The bright red and blue colors symbolize the emotional states of expectancy and desire for the crowned and bejeweled Krishna, who brings a fragrant flower.

We will consider Indian art in the twentieth century in Chapter 24.

SOUTHEAST ASIA

The Bronze Age in Southeast Asia began when that metal was first imported into the region about 800 B.C.E. Soon thereafter, the major cultural division of the region appeared: The eastern coast, encompassing most of what is now Vietnam, fell under Chinese influence; most of the remainder willingly adopted and transformed cultural influences from India.

Buddhism and Hinduism both spread southward and eastward from India with traders and merchants. Early Southeast Asian art is primarily Buddhist; later monuments combine motifs, gods, and figures from both religions. Each region of

429 BOROBUDUR. Java. c. 800.

a. Aerial view.
Photograph: Robert Harding Word Imagery.

b. CORRIDOR AT BOROBUDUR.
First Gallery.
Photograph: Werner Forman Archive, Ltd.

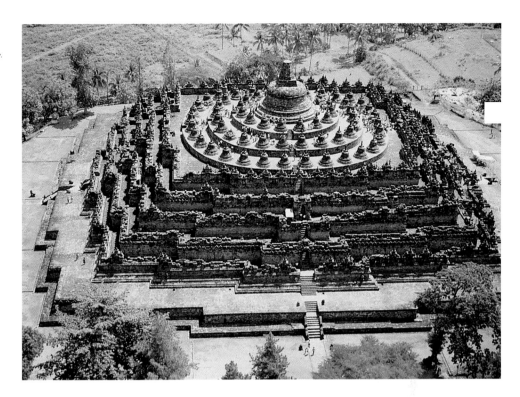

Southeast Asia developed its own interpretation of the major Indian styles.

By any standard, BOROBUDUR must rank among the major works of world art. Built about 800 C.E. on the island of Java (now part of Indonesia), it is an extremely elaborate version of an Indian stupa, or sacred mountain. Rising from a relatively flat plain, it stands above the local surroundings, measuring 105 feet high and 408 feet on a side. It is oriented to the four cardinal directions, with stairways at the four midpoints.

Pilgrims who come for spiritual refreshment may enter at any opening, and then walk around and climb the various terraces in a clockwise direction. More than ten miles of relief sculpture adorn the various CORRIDORS, telling stories that duplicate the journey to enlightenment. On the lower levels, the reliefs deal with the struggle of existence and the cycle of death and rebirth. Then come reliefs depicting the life of the Buddha. As pilgrims walk in these corridors, the high walls prevent them from seeing out, and the curves in the path limit the view ahead. Upper terrace reliefs depict the ideal world of paradise. However, there is still more to come.

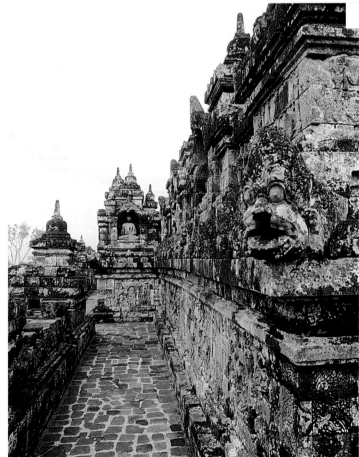

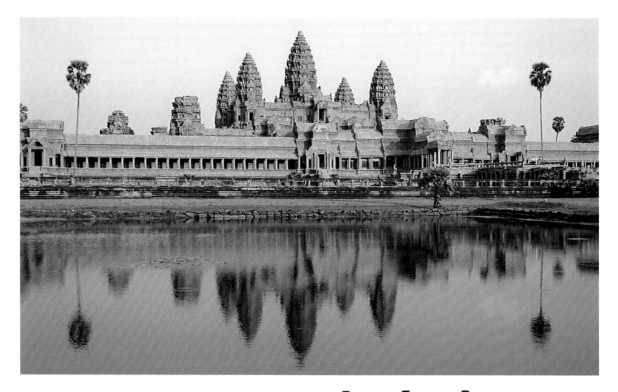

The final four circular levels permit the pilgrim to look out over the landscape and take in the broad view, suggesting enlightenment. Each of the seventy-two small hollow stupas contains a statue of a seated Buddha that is only dimly visible from the outside. At the very top is a sealed stupa whose contents the pilgrim can just guess at. Thus, BOROBUDUR presents the Buddhist conception of the pathway through the cycles of birth and death, which culminates in enlightenment.

The sacred mountain of BOROBUDUR was a principal influence on the Cambodian temple of ANGKOR WAT, which was erected in the twelfth century near the capital of the Khmer empire. This was the most prosperous period in Cambodia's history, as the rulers mastered the science of irrigation and were able to make the jungles produce abundant crops. The people at that time seemed to accord their rulers near-divine status since the many stone carvings of Buddhas, Bodhisattvas, and Hindu gods appear also to be portraits of real people. The two religions were apparently considered compatible.

430 ANGKOR WAT.
c. 1120–1150.

a. West entrance.
Photograph: John Elk III/
Bruce Coleman Inc.

b. Plan.

The temple, which faces due west, was originally surrounded by moats, as if to remind everyone that management of water was the source of wealth. The many corridors have corbelled roofs, and inside they are decorated with low relief sculpture depicting primarily Hindu myths about the god Vishnu. (See one of the best of these, ARMY ON THE MARCH, on page 176.) The ruler of Cambodia thought of him-

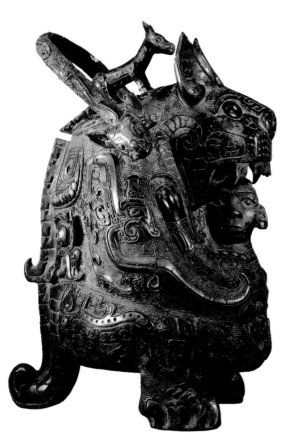

431 RITUAL VESSEL (LA TIGRESSE).
 China. Shang dynasty. c. 1100–1000 B.C.E.
 Cast bronze. Height 14".
 © Phototheque des Musées de la Ville de Paris.
 Marie de Paris.
 Photograph: L. De Graces.

self as a descendant of Vishnu, guarding the fertility of his domain. This emphasis on fertility in the design of ANGKOR WAT extends to the tops of the towers, which resemble sprouting buds.

CHINA

Chinese civilization up to the modern period was characterized by the interaction of three traditions: Confucianism, Daoism, and Buddhism. The first two are Chinese creations, while Buddhism came from India. All three have interacted and influenced each other, imparting richness and variety to Chinese culture. Before these traditions developed, however, distinctive Chinese arts were already flourishing.

Some of the world's finest cast-bronze objects were produced in China during the Shang dynasty (sixteenth to eleventh centuries B.C.E.). In the RITUAL VESSEL, there is an overall compactness. As on other Shang containers, surfaces are covered with an intricate composite of animal forms: sometimes fragments of animals are combined, sometimes complete animals are depicted. In this piece, a deer acts as a handle for the lid; just behind the deer, an elephant's trunk comes out of a tiger's mouth, providing a third support. The man seems about to be devoured—his head is shown within the ferocious jaw of the tiger spirit—yet at the same time his hands are relaxed as he reaches to the animal for protection. An intriguing aspect of this vessel is the gentle expression on the man's face in relation to the aggressive though protective power of the animal.

Most bronze vessels were used in rituals in honor of ancestors. The Chinese believed that one's ancestors live eternally in the spiritual realm, and from there they can influence worldly affairs for better or worse. These beliefs evolved into Confucianism, a moral and ethical system developed by Confucius (Kong Fuzi, 551–479 B.C.E.). Confucius was no mystic; asked once about honoring the spirits, he replied, "You do not even honor man; how can you honor the spirits!" Cautious innovation and respect for tradition characterize much Chinese art because of his influence.

In the hope of improving their afterlife, many persons were buried with most of their possessions. No one, however, was more vain in collecting objects for their burial than the emperor Qin Shihuangdi, who at the time of his death in 210 B.C.E. had unified China in something like its present form. (His dynastic name, Qin—pronounced chin—is the root of the word *China*.) So intent was he on guarding his afterlife that he ordered a massive army of life-size clay soldiers made for his protection. The TERRA COTTA WARRIORS (on the following page) number about six thousand in all, among them cavalrymen, archers, and foot soldiers. These lifelike figures in their huge tomb were discovered in 1974, in an extraordinary archaeological find.

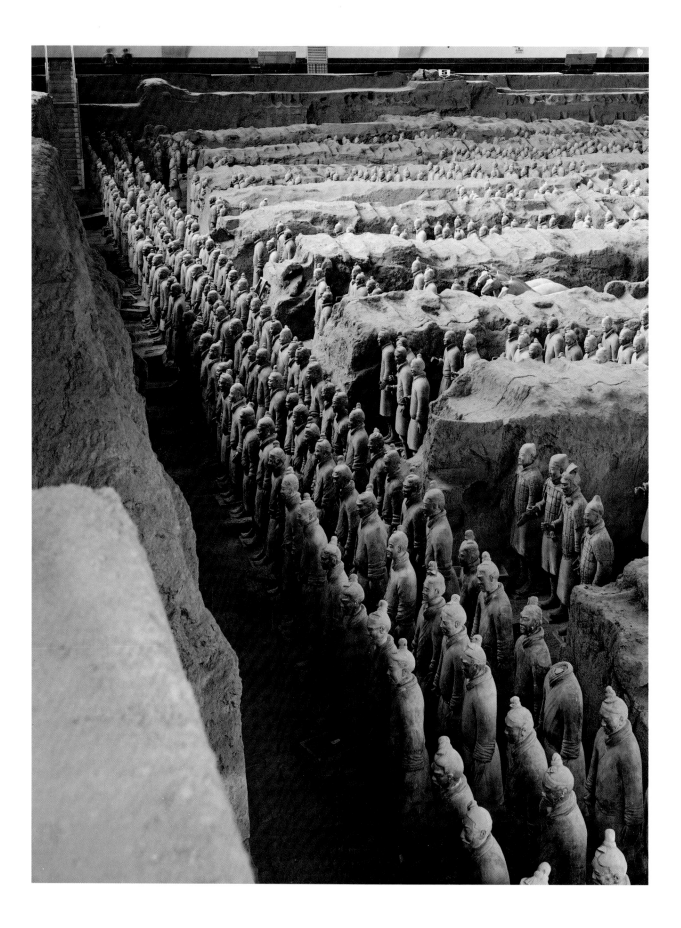

TRADITIONAL ARTS OF ASIA CHAPTER **seventeen**

432 TERRA COTTA WARRIORS.
Pit No. 1, Museum of the First Emperor of Qin.
Shaanxi Province, China. Qin Dynasty. c. 210 B.C.E.
Photograph: Hamilton Photography and Film Company.

The tombs from the Han dynasty (206 B.C.E.–221 C.E.) have yielded most of the surviving artwork from that period in China, and from these remains we can learn a great deal about what interested and motivated at least the upper classes.

A recently excavated work from this period is the magnificent second-century FLYING HORSE found in Gansu Province. The sculptor gave a feeling of weightlessness to the horse by delicately balancing it on one hoof atop an abstract representation of a flying swallow. The curvaceous form and powerful energy of this elegant horse is vividly captured in a way that is typically Chinese.

Horses were prized possessions of royalty and aristocracy. Throughout Chinese history, they frequently appear in art as strong, noble animals. The horse is one of the twelve signs of the traditional Chinese zodiac, and persons born in the Year of the Horse are said to possess strength, speed, and endurance.

Here the artist has understood the basic energy or life force of the animal, and rendered it faithfully. The quest to understand and depict this inner force, or *qi* in Chinese, animates a great deal of art production through the centuries in China.

The concept of *qi* derives from Daoist beliefs about the harmony of the universe. Daoists believe that the best life is one of harmony with the force

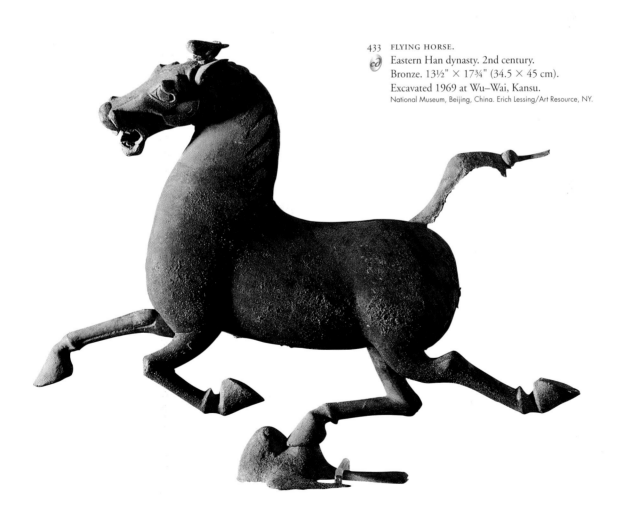

433 FLYING HORSE.
Eastern Han dynasty. 2nd century.
Bronze. 13½" × 17¾" (34.5 × 45 cm).
Excavated 1969 at Wu–Wai, Kansu.
National Museum, Beijing, China. Erich Lessing/Art Resource, NY.

434 MIRROR WITH XIWANGMU, Early Six Dynasties Period
(317–581). Bronze, diameter 7¼".
© Cleveland Museum of Art.
The Severance and Greta Millikin Purchase Fund, 1983.213.

that animates all created beings. According to traditional Daoism, achieving this harmony will make one immortal; the MIRROR WITH XIWANGMU honors such a person. Also known as the Queen Mother of the West, she achieved the Dao and dispensed immortality from her home on far-away Jade Mountain. The mirror (which is shiny on the other side) depicts Xiwangmu seated at the left of the mirror's central bulb. Opposite her is the Lord Duke of the East; according to Daoist mythology, the two meet each year on the seventh day of the seventh month. Just outside their circle, an inscription wishes good fortune to the mirror's owner. In the outer bands are other heavenly beings and circles of clouds which symbolize the endless cycle of time.

In painting, we see clearly the Chinese reverence for nature. Traditionally, Chinese painters sought to manifest the spirit residing in every form. According to Daoism, a secret force called the Dao (or "the way" in English) animates all creation. A painter was taught to meditate before wielding a brush in order to achieve a balance between the impression re-

ceived through the eyes and the perception of the heart and mind. After prolonged contemplation of nature, the artist painted from memory, working with ink and light color on silk or paper. Through painting, individuals nourished spiritual harmony within themselves and revealed divine energy to others. Daoism focuses on the relative nature of all things: There can be no death without life, no good without evil, no East without West. Behind the duality and illusion of the so-called real world is the unifying Dao. It is in this way that the universe functions, as one can see in the effortless flow of interacting forces of nature.

The Northern Song dynasty (960–1126) was a particularly important period for painting in China. During the eleventh century, a group of artist-intellectuals developed a new spirit in artistic expression. Many of these painters, who were poets, political leaders, and accomplished calligraphers, held that the artist's true character and emotions could be expressed through the abstract forms of calligraphic characters—and even through individual brush strokes. They were critical of those who painted for commercial rather than aesthetic reasons.

Long valued in China, calligraphy is traditionally considered an art equal to painting. Since ancient times, Chinese leaders of all kinds have been expected to express the strength of their character through elegant writing. By introducing calligraphic brush techniques for expressive purposes, painters sought to elevate painting to the levels that calligraphy and poetry had already attained. Huai-su, in AUTOBIOGRAPHY, and later masters drew inspiration from fourth-century Daoist poet, statesman, and master calligrapher Wang Xizhi. His style of writing, an improvement on earlier styles, has served as an inspirational model for generations of calligraphers to the present day. The stature of Wang Xizhi in China is comparable to that of Shakespeare and Rembrandt in the West and indicates the Chinese people's long-standing admiration for great calligraphy. Unfortunately, only a few original examples of his writing survive.

435 Huai-su.
Detail of AUTOBIOGRAPHY.
Tang dynasty, 7th–10th centuries.
Ink on paper.
National Palace Museum,
Taipei, Taiwan, Republic of China.

The flowering of calligraphy as an art form was due partly to the popularity of the new, looser style of writing that freed scholars from the angular formality of the characters that were used in official script. The fluid script enabled artists and poets to express themselves in a personal and spontaneous manner. With the spontaneous, gestural design of each brush stroke, the artist conveys the emotional as well as the intellectual content of the word or character being written. Poetry lies in the execution of the stroke as well as the phrase. In China, painting and writing are closely related, and Chinese artists often include poems within their paintings. The same brushes and ink are used for both, and in both each brush stroke is important in the total design. Artists "paint" their poems as much as they "write" their paintings.

Contemporaries of the court painter Fan Kuan regarded him as the greatest landscape painter of the Song dynasty. In his large hanging scroll

436 Fan Kuan.
TRAVELERS AMONG MOUNTAINS AND STREAMS.
Song dynasty. Early 11th century.
Hanging scroll, ink on silk. Height 81¼".
National Palace Museum, Taipei, Taiwan, Republic of China.

TRAVELERS AMONG MOUNTAINS AND STREAMS, intricate brushwork captures the spirit of trees and rocks. Artists used many kinds of brush strokes, each identified by descriptive names such as "raveled rope," "raindrops," "ax cuts," "nailhead," and "wrinkles on a devil's face." Here "raindrop" and other types of brush strokes suggest the textures of the vertical face of the cliff. Men and donkeys, shown in minute scale, travel a horizontal path dwarfed by high cliffs rising sharply behind them. To highlight the stylized waterfall as the major accent in the design, Fan Kuan painted the crevice behind the waterfall in a dark wash and left the off-white silk unpainted to suggest the falling water. The vertical emphasis of the composition is offset by the almost horizontal shape of the light area behind the rocks in the lower foreground. The massive centrality of the composition is typical of the efforts of Northern Song artists to capture the more powerful aspects of nature.

When a vertical line intersects a horizontal line, the opposing forces generate a strong center of interest. Fan Kuan took advantage of this phenomenon by extending the implied vertical line of the falls to direct the viewer's attention to the travelers. Figures give human significance to the painting and, by their small scale, indicate the vastness of nature. Fan Kuan achieved his monumental landscape in part by grouping the fine details into a balanced design of light and dark areas.

The painting embodies ideas of Daoism and Confucianism, China's two major philosophical and spiritual traditions, in which nature is both emptiness and substance, interacting passive and active forces (yin and yang) that regulate the universe. One achieves harmony on Earth through a balance of these forces—female and male, void and solid, dark and light.

In both central and southern China, steep, mist-shrouded peaks have inspired Chinese painters for centuries. In the seventeenth century, Li Li-Weng wrote, "First we see the hills in the painting, then we see the painting in the hills." His words remind us that, although art depends on our perception of nature, art also helps us to see nature with fresh eyes.

A Mongol invasion from the north dislocated China's Song dynasty rulers in 1125. (These were the

same Mongols who under Genghis Khan and his relatives eventually occupied an empire stretching from Korea to Eastern Poland and Baghdad to Siberia.) The Song court and art academy moved south to Hangzhou, where a new painting style arose.

If the earlier Northern Song style was monumental and philosophical, the Southern Song was intimate and personal, emphasizing poetic views of relatively smaller landscapes. One of the leaders in the new style was Ma Yuan, a fifth-generation descendant of academy teachers who was a favorite of the emperor. Ma's painting WATCHING THE DEER BY A PINE SHADED STREAM captures a contemplative moment in which a scholar or official enjoys a respite on a wooded path. Ma's way of depicting pine branches gives the work an etheral calm. The brushwork is as meticulous as in the preceding Northern Song, but the composition is relatively adventurous as it fades away into mist at the upper left. This composition is so off-balance that the artist's contemporaries referred to him as "one-corner Ma" because of his tendency to leave large area of his works unpainted. Such boldness responds to Daoist beliefs, however, because without the voids we would not appreciate the fullness.

Most of the important painters of the Song dynasty were associated with offical art academies or government service. During the following Yuan Dynasty (1279–368), the final conquest of China by Mongols radically altered this scenario. The most creative artists refused to paint or teach for the foreign government; rather, they lived outside official sponsorship. Devoting themselves to a life of art and poetry, they created a new style called *literati painting*.

The Yuan dynasty literati painters made many innovations in brushwork and subject matter. They used the brush in new ways and saw old subjects with fresh eyes. An example is Ni Zan's SIX GENTLEMEN, pictured on page 95. Ni's style was even more personal and idiosyncratic than that of Southern Song dynasty painters.

The literati also pioneered the painting of bamboo. They did this because they saw symbolic meanings in its resistance to wind and storms. Just as

437 Ma Yuan.
WATCHING THE DEER BY A PINE SHADED STREAM, c. 1200.
Album leaf, ink on silk, 9½" × 10".
© Cleveland Museum of Art. Gift of Mrs. A. Dean Perry, 1997.88.

438 Wu Chen.
ALBUM LEAF FROM MANUAL OF INK BAMBOO. 1350.
Ink on paper. 16⅞ × 20½".
National Palace Museum, Taipei, Taiwan, Republic of China.

bamboo bends without breaking, so must the creative artist in foreign-controlled China. A leading bamboo painter was Wu Chen, whose ALBUM LEAF is regarded as a masterpiece of the type.

女几山前野路横 松声偏合泉声 静里闲倾耳 便觉冲然道气生

李父母大人先生

治下唐寅画呈

439 Tang Yin.
WHISPERING PINES ON A MOUNTAIN PATH.
Ming dynasty. c. 1516.
Hanging Scroll. 76" × 40".
National Palace Museum, Taipei, Taiwan, Republic of China.

In order to help assimilate their rich tradition, Chinese painters often copy (with personal variations) the works of earlier artists. Even fully mature painters will often produce a work in the style of an older master they particularly admire. This tendency reveals one of the basic precepts of Confucianism—respect for the past. The idea that a painter must fully comprehend tradition before expressing individuality was a hallmark of the artists who worked for the Imperial court in the sixteenth and seventeenth centuries, and they produced many works in which this homage is clear.

One of the most successful of these academic painters was Tang Yin, who worked in the early sixteenth century during the Ming Dynasty (1368–1744). His painting WHISPERING PINES ON A MOUNTAIN PATH owes a great deal to Fan Kuan's work TRAVELERS AMONG MOUNTAINS AND STREAMS. The manner of painting the rocks and the overall composition clearly show that Tang was studying the work of Fan Kuan. In addition, Tang's inscribed poem shows his study of Daoism. The last three lines read:

The whispering pines dissolve in the rush of the waterfall.
I listen with quiet absorption
And feel the spirit of Dao rising within me.[1]

The Chinese have traditionally held ceramic arts in high regard, and the history of pottery in China is primarily the story of Imperial sponsorship and nearly continuous technical advances. During the Song Dynasty, Chinese potters first developed the splashed glaze effects that Japanese potters used to great advantage in their tea ceremony wares (see the TEA BOWL on page 193). This style of pottery production took advantage of small impurities in the glaze or clay to create a spontaneous and earthy look. Later in the same dynastic period, Chinese potters developed the creamy and rich blue-green glaze whose color is so indescribable

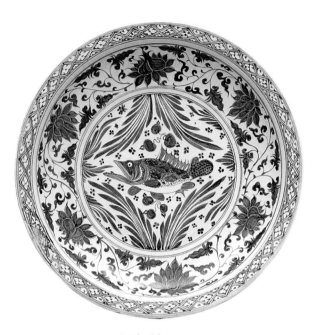

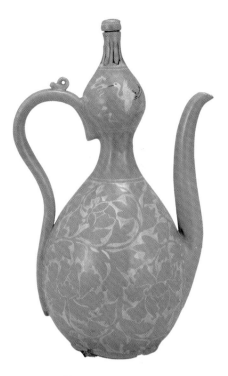

440 PORCELAIN PLATE. Mid-14th century.
Painted in underglaze blue. Diameter 18".
Metropolitan Museum of Art. Purchase, Mrs. Richard E. Linburn Gift.
Photograph: © 1989 Metropolitan Museum of Art. 1987.10.

441 WINE PITCHER. Korea.
Koryo dynasty. Mid-12th century.
Stoneware with celadon glaze and inlaid white and black slip.
Height 13½".
National Museum of Korea, Seoul. National Treasure No. 116.

that Westerners named it Celadon after the hero's garments in a famous French play.

Probably the best-known type of Chinese ceramic is porcelain, made from a rare type of clay that when fired becomes pure white. Early porcelains, such as the PORCELAIN PLATE pictured here, were decorated with blue because that was the only color that could withstand the high temperatures necessary to fire porcelain correctly. The Chinese were the first to develop this type of pottery. Porcelain emerges translucent from the oven, and it rings when struck; this led the Chinese to conclude that their best dishes contained music. After it was first imported into the Western world, European workshops tried for generations to duplicate its translucency and deep blue colors. In the Ming Dynasty,

potters discovered how to glaze porcelain in almost any color through multiple firings.

Throughout Asia, potters in different provinces and countries produced their own variations on Chinese ceramic styles. The WINE PITCHER shown here is an exquisite example of a Korean adaptation of the Chinese blue-green celadon, with the addition of a new style of decoration. The potter etched out the background behind the flower decorations in the lower part of the vessel, and also etched the shapes of the flying cranes above. The potter then filled these lowered areas with white and black *slip* (liquid clay) before firing the vessel for the final time. This slip-inlay technique is a Korean invention, and here the smooth surface complements the graceful curves of the double-gourd shape and

442 AVATAMASKA SUTRA, Vol. 12, 13th–14th century.
Korea, Goryeo period.
Gold and silver text on indigo blue paper. 12⅜" × 45⅛"
The Cleveland Museum of Art.
The Severance and Greta Millikin Purchase Fund, 1994.25.

elegant handle of the pitcher. The shapes and decorations of this piece work so well together that the Korean government designated the WINE PITCHER a national treasure.

Korea developed some of its own art forms despite the influential presence of nearby China and Japan. We see one of these in the AVATAMSAKA SUTRA, a book page produced in the mid-fourteenth century. A sutra is a book of Buddhist teachings, and this one includes the important teaching that all beings have the Buddha nature. The Korean artists who illustrated it used fine strands of gold and silver to depict a gallery of immortals and divine beings.

Chinese painting after the Yuan dynasty evolved down two parallel paths. Within the academies, artists copied old masters and innovated cautiously; outside them, the literati took a bolder and freer approach. One of the boldest of the latter was Bada Shanren, a descendant of Ming dynasty royalty who lived in the early part of the succeeding Qing dynasty (1644–1912). The Qing, like the Yuan, were foreign.

Since the Qing persecuted descendants of the Ming, Bada lived the life of a recluse, taking refuge in a monastery and later faking madness. Witnesses reported that he would wander the streets in rags, shouting. On the door of the abandoned building where he lived, he scrawled the word "dumb" (mute), and when visitors came he would laugh and drink with them, but would not talk. This behavior lasted about five years. In 1684, he gave up his faked insanity and lived in his provincial capital, trading paintings for food. His works, such as CICADA ON A BANANA LEAF, combine free execution with subtle political comments. The cicada is a symbol of rebirth in Chinese mythology, and in Bada's painting it signifies a hope for the resurrection of the failed Ming.

Bada's art remained almost unknown until the declining years of the Qing. Then, as artists began to radically question their tradition, Bada's wildness was an important precursor to more modern experiments in Chinese painting, as we shall see in Chapter 24.

JAPAN

Throughout its history, Japanese culture has been marked by alternating periods of nationalism, in which typically Japanese forms have prospered, and periods of open borrowing of foreign influences.

The indigenous religion of Japan is an ancient form of nature and ancestor worship called Shinto. In this religion, forests, fields, waterfalls, and huge stones are considered holy places where gods dwell. The Shinto shrines at Ise occupy a sacred site within a forest. With only a few lapses, the present MAIN SHRINE at Ise has been completely and exactly rebuilt every twenty years since the late seventh century. Builders take wood for the shrine from the forest with gratitude and ceremonial care. As a tree is cut into boards, the boards are numbered so that the wood that was joined in the tree is reunited in the shrine. No nails are used; the wood is fitted and pegged. In keeping with the Shinto concept of purity, surfaces are left unpainted and the roof is natural thatch. The shrines at Ise combine simplicity with subtlety. Refined craftsmanship, sculptural proportions, and spatial harmonies express the ancient religious and aesthetic values of Shinto.

The first major wave of cultural borrowing took place in the seventh century, when Japanese emperor Shotoku sent emissaries to China to study that civilization. They returned very impressed with many aspects of Chinese culture. For example, the emperor enthusiastically adopted Buddhism, making it the official religion. (Many Shinto gods became sacred beings in Japanese Buddhism.) Japanese Buddhist sculpture from this period was heavily influenced by Chinese sculpture, which the Japanese reinterpreted with subtle changes. Shotoku also encouraged the Japanese aristocracy to learn Chinese and use Chinese script. Confucian teachings about social order and respect for tradition were also adopted, along with many aspects of Chinese art and architecture. In fact, since much of Chinese ancient architecture has not survived, the best place to study it is in Japan on the Yamato plain near Kyoto, where Shotoku set up his capital and the emperors lived for centuries after.

443　Bada Shanren. CICADA ON A BANANA LEAF.
　　Qing dynasty. 1688–1689.
　　Leaf "f" from an album *Flowers and Birds*. Ink on paper.
　　Freer Gallery of Art, Smithsonian Institution, Washington, D.C. F1955.21e.

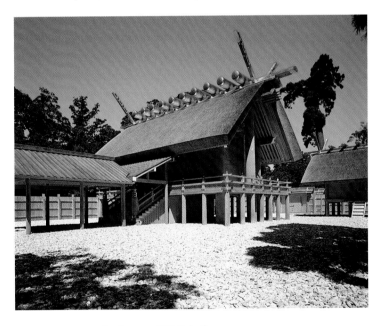

444　MAIN SHRINE. Ise, Japan. c. 685. Rebuilt every twenty years.
　　Photograph: Kyoto News International, Inc.

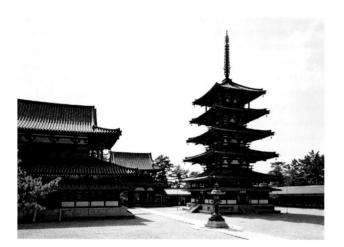

445 HORYUJI TEMPLE. Nara, Japan. c. 690.
a. Pagoda and a section of the lecture hall (Kondo).
Archivio Iconografico, S.A.
Corbis/Bettman.

The temple complex of HORYUJI exemplifies the Buddhist monastery as it existed in both China and Japan. In the center of the courtyard, we can see the many-storied pagoda, which has a symbolic function relating to its descent from Chinese watchtowers and Indian stupas (see page 291). Next to it is the KONDO, or Golden hall, a meditation hall where Buddha statues are kept. In the center of one wall is a gate house; opposite it along the back wall is a larger lecture hall, where monks hear religious teaching. The oldest parts of HORYUJI date from the late seventh century, and are among the world's oldest surviving wooden buildings.

To hold up a two-story structure with a heavy tile roof, Japanese architects (influenced by Chinese predecessors) developed an elaborate bracketing system for the KONDO at Horyuji. The empty second story is merely an accent to show the importance of the building, but it also demonstrates the skill of the architect.

Japan has the oldest surviving royal family of any society. This longevity has been made possible by frequent military interventions in which the generals ruled on behalf of the emperors, as in the Kamakura

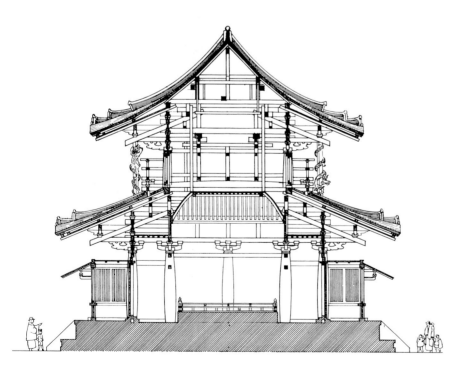

b. KONDO, Structural diagram.
From *The Art and Architecture of Japan*, Robert Treat Paine and Alexander Coburn Soper, Penguin, London, 1981.
By permission of Yale University Press, Pelican History of Art.

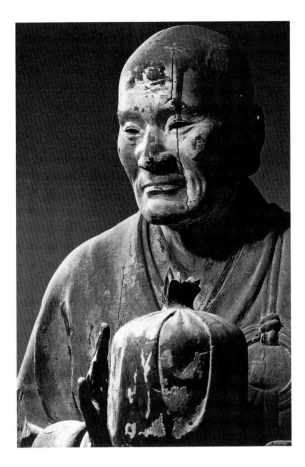

446 Unkei. Detail of MUCHAKU. c. 1208.
Wood. Height 75".
Kofuku-ji Temple, Nara, Japan.

447 BURNING OF THE SANJO PALACE. From the HEIJI
MONOGATARI EMAKI (illustrated Scrolls of the Events of the
Heiji Era), Japan. Second half of the 13th century.
Kamakura period. Handscroll, ink and colors on paper.
16¼" × 275".

period (1185–1333). The dominant taste of the
leaders at that time favored a vigorous realism in art,
and this is reflected in the wood portrait statue of the
detail of MUCHAKU. Unkei, one of the greatest sculp-
tors of Japan, created this life-size work depicting a
legendary Buddhist priest from India holding a cloth-
covered round box. The vividness of the facial ex-
pression and the delicacy of the hand gesture belie the
wooden material from which it is carved.

Japanese painters of this period found the hand-
scroll particularly effective for long narrative com-
positions that depict the passage of time. BURNING
OF THE SANJO PALACE is from the HEIJI MONOGATARI,

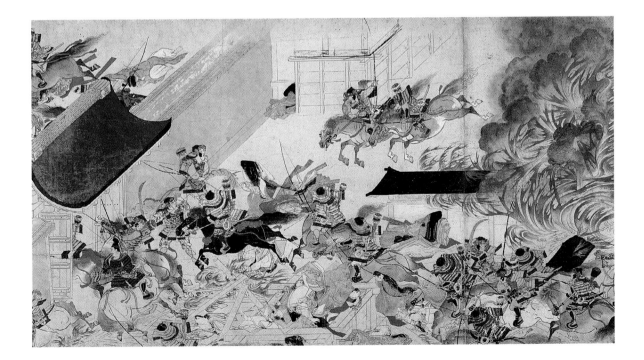

a scroll that describes the Heiji insurrection of 1160. As the scroll is unrolled from right to left, the viewer follows a succession of events expertly designed to tell the story. Through effective visual transitions, the horror and excitement of the action are connected. The story builds from simple to complex events, reaching a dramatic climax in the scene of the burning palace, a highly effective depiction of fire. The color of the flames emphasizes the excitement of the historic struggle. Parallel diagonal lines and shapes, used to indicate the palace walls, add to the sense of motion and provide a clear geometric structure in the otherwise frantic activity of this portion of the scroll. Today, such dramatic events are presented through film or television.

Zen Buddhism, which spread to Japan from China in the thirteenth century, provided a philosophical basis within which aesthetic activities were given meaning beyond their physical form. Zen teaches that enlightenment can be attained through meditation and contemplation. The influence of Zen on Japanese aesthetics can be seen in spontaneous and intuitive approaches to poetry, calligraphy, painting, gardens, and flower arrangements.

Zen Buddhist priest Sesshū is considered the foremost Japanese master of ink painting. In 1467, he traveled to China, where he studied the works of Southern Song masters and saw the countryside that inspired them. Chinese Chan (Zen) paintings, such as Mu Qi's SIX PERSIMMIONS (page 50) were greatly admired by the Japanese, and many were brought to monasteries in Japan.

Sesshū adapted the Chinese style and set the standard in ink painting for later Japanese artists. He painted in two styles. The first was formal and complex, while the second was a simplified, somewhat explosive style, later called *haboku*, meaning "flung ink." HABOKU LANDSCAPE is abstract in its simplification of forms and freedom of brushwork. Sesshū suggested mountains and trees with single, soft brush

448 Sesshū.
HABOKU LANDSCAPE. Hanging scroll, ink on paper.
28¼" × 10½" (71.9 × 26.7 cm).
© The Cleveland Museum of Art. The Norweb Collection, 1955.43.

449 Tawaraya Sōtatsu. WAVES AT MATSUSHIMA. 17th century. Edo period.
Folding screen, ink, color, gold, and silver on paper. Image, 59¹³⁄₁₆" × 145⅝" (152 × 369.9 cm; overall, 166 × 369.9 cm).
Courtesy of the Freer Gallery of Art, Smithsonian Institution, Washington, D.C. Gift of Charles Lang Freer, (F1906.231).

strokes. The sharp lines in the center foreground in-dicating a fisherman, and the vertical line above the rooftops representing the staff of a wine shop, are in contrast to the thin washes and darker accents of the suggested landscape.

In traditional Japan, folding screens provided privacy by separating areas within rooms. Artists have used the unique spatial properties of the screen format in highly original ways. In contrast to the European easel paintings that function like a window in the wall, a painted screen within the living space of a home becomes a major element in the interior.

Tawaraya Sōtatsu's large screen WAVES AT MAT-SUSHIMA consists of a pair of six-panel folding screens. The screens are designed so that together or separately they form complete compositions. The subject is a pair of islands where there were very old Shinto shrines.

In keeping with well-established Japanese artis-tic practices, Sōtatsu created a composition charged with the churning action of waves, yet as solid and permanent in its design as the rocky crags around which the waters leap and churn. He translated his sensitive awareness of natural phenomena into a

decorative, abstract design. Spatial ambiguity in the sky and water areas suggests an interaction that the viewer is to feel rather than to read as a literal tran-scription of nature. In addition to rhythmic pat-terns that fill much of the surface, boldly simplified shapes and lines are contrasted with highly refined details and eye-catching surprises. A flat, horizontal gold shape in the upper left, accentuated with a black line, signifies a cloud and reaffirms the picture plane. The strongly asymmetrical design, emphasis on repeated patterns, and relatively flat spatial qual-ity are all often used in Japanese painting from the sixteenth to the nineteenth centuries.

By the mid-seventeenth century, the art of woodcut printing had developed to meet the de-mand for pictures by the newly prosperous middle class. Japanese artists took the Chinese woodcut technique and turned it into a popular art form. For the next two hundred years, hundreds of thou-sands of these prints were produced. The prints are called *ukiyo-e*, meaning "pictures of the floating world," because they depict scenes of daily life, such as landscapes, popular entertainments, and portraits of theater actors.

姿見七人化粧

450 Utamaro Kitagawa.
REFLECTED BEAUTY, SEVEN BEAUTIES APPLYING MAKE-UP:
OKITA c. 1790. Woodblock print. 14¼" × 9½".
Honolulu Academy of Arts, Gift of James A. Michener, 1969 (15,490).

Kitagawa Utamaro's woodcut REFLECTED BEAUTY transforms the then ordinary subject into a memorable image consisting of bold, curving outlines and clear, unmodeled shapes. As with many Japanese paintings and prints, flat shapes are emphasized by the absence of shading. The center of interest is the reflected face of the woman, set off by the strong curve representing the mirror's edge. In contrast to Western composition with centered balance and subjects well within the frame, here the figure is thrust in from the right, and cut off abruptly by the edge of the picture plane, rather than being presented completely within the frame. This type of radically cropped composition was one of the elements of Japanese art that most intrigued European artists in the nineteenth century.

Japanese architects have also demonstrated the careful and subtle arrangement of clearly defined forms. KATSURA DETACHED PALACE, a seventeenth-century Japanese imperial villa, was built in Kyoto beside the Katsura River, whose waters were diverted into the garden to form ponds. All elements—land, water, rocks, and plants—were integrated in a garden design that blends human-made and natural elements. Because many of the palace walls are sliding screens, they can provide flexible interconnections between interior and exterior spaces.

In contrast to a European royal palace, KATSURA seems humble. The complex was planned with no grand entrance either to the grounds or to the buildings. Instead, one approaches the palace along garden paths, watching unexpected views open up. Earth contours, stones, and waterways are combined to symbolize—on a small scale—mountains, rivers, fields, inlets, and beaches. The tea house, which borrows from modest country dwellings, is constructed of common, natural materials. It provides the appropriate setting for the tea ceremony, which embodies the attitudes of simplicity, naturalness, and humility that permeate the entire palace grounds.

Domestic architecture has long been an important part of Japanese art. Modest houses, as well as palaces and Buddhist temples, have traditionally employed many of the structural and aesthetic prin-

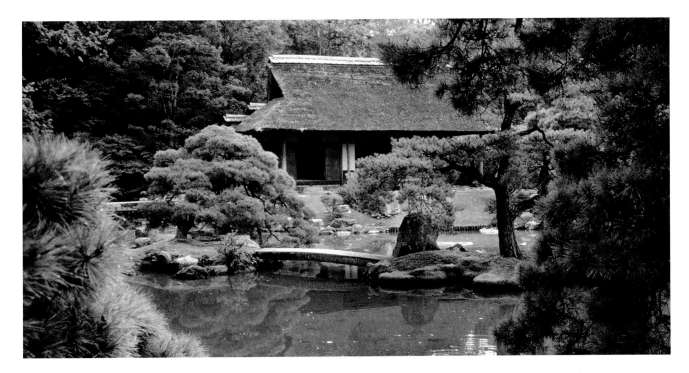

451 KATSURA DETACHED PALACE. Kyoto, Japan. 17th century.

a. Gardens and tea house.
Photograph: Ric Ergenbright/Henry Westheim Photography.

b. Imperial villa and gardens.
Photograph: Robert Holmes/Corbis.

c. Interior of tea house.
Photograph: Ric Ergenbright/Henry Westheim Photography.

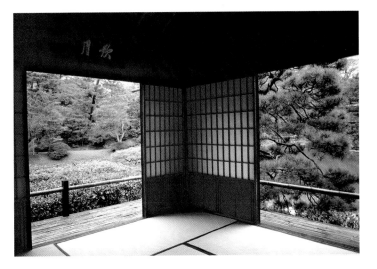

ciples of Shinto shrines. In the past, Japanese homes were related to the land and were often set in or built around a garden. Today, small gardens provide intimacy with natural beauty, even in crowded city environments.

Traditional Japanese houses, such as those at KATSURA, are built of wood using post-and-beam construction. The result is essentially a roof on posts, allowing walls to be sliding screens rather than supports. The Japanese use of unpainted wood and the concept of spatial flow between indoors and outdoors have been major influences on modern architects in the West.

In the nineteenth century, European commerce and missionary work began to have a decisive impact across Asia. Various parts of Asia reacted differently to this new influence. India submitted, not

452 Mitsutani Kunishiro.
UPSTAIRS. 1910.
Oil on canvas. 105 × 120 cm.
Collection of the Tokyo National Museum.

always willingly, to colonial status under England. The Chinese tried to severely limit foreign influence on their culture, leading to conflicts which lasted into the twentieth century. The Japanese, in contrast, welcomed foreigners while avoiding colonization. A revolt in 1868 restored the Emperor to power, and he began a vigorous program of cultural importation from the West which seems to be continuing even today.

The new policy of openness had an immediate impact on the arts. The government gave stipends for Japanese artists to study in Europe, and invited Western artists and scholars to teach in Japanese universities. We see the results of this hybridization in paintings such as UPSTAIRS by Mitsutani Kunishiro. He studied in Paris near the turn of the century, and the work reflects his knowledge of painting in natural light gleaned from looking at Impressionist and Post-Impressionist paintings. At the same time, the subject matter is Japanese.

Cultural trading between East and West continues into the present. We will consider some modern Asian artists in Chapter 24.

THE ISLAMIC WORLD

Islam is one of the three major world religions built on the teachings of the religious seers of the Middle East. Although based on the revelations to the prophet Mohammed, Islam shares fundamental beliefs and religious history with its predecessors Judaism and Christianity. An adherent of Islam is called a Muslim—Arabic for "one who submits to God."

The Islamic calendar begins in 622 C.E. with the Hegira, Mohammed's emigration to what is now the city of Medina on the Arabian peninsula. The new religion spread quickly into much of what was once the Eastern Roman and Byzantine empires, then fanned out to include North Africa, Spain, and parts of Europe. Within one hundred years of the Prophet's death, Christian armies were repelling Muslim troops from Tours in central France. Islam is now the principal religion in the Middle East, North Africa, and some parts of Asia.

The Muslims facilitated their rule by allowing the peoples of conquered lands to retain their own religions and cultures, as the Romans had done. This strategy enabled the Muslims, who had little art of their own in their early history, to adapt earlier artistic traditions. At its height, from the ninth through the fourteenth centuries, Islamic culture synthesized the artistic and literary traditions and scientific knowledge of the entire ancient world.

Unlike the medieval Christians, who rejected pre-Christian civilization and scholarship, Muslims adapted and built on the achievements of their predecessors. Muslim scholars translated the legacy of Greek, Syrian, and Hindu knowledge into Arabic, and Arabic became the language of scholarship from the eighth through the eleventh centuries for Muslims as well as many Christians and Jews. As medieval Europe languished from intolerance, isolationism, and feudalism, Islamic civilization flourished, producing outstanding achievements in the arts, sciences, administration, and commerce that were not attained in Europe until the height of the Renaissance, in the late fifteenth century.

Traditional Muslims frown upon the representation of human figures in art that will be used in a religious context. Many Muslims believe that if an artist were to try to recreate the living forms of humans, he or she would be competing with Allah (God) who created everything. Mohammed also prohibited any pictures of himself while he was alive, claiming that he was not in any way exceptional—he was only a messenger. Thus, figural arts are rare in Islamic religious art, where more attention was given to geometry and to writing.

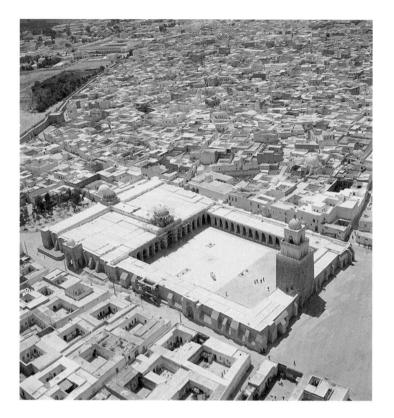

453 GREAT MOSQUE.

Kairouan, Tunisia. 836–875.
Photograph: Roger Wood/Corbis/Bettmann.

ARAB LANDS

When Islam first began to spread, local rulers took responsibility for building houses of worship in their territories. Early rulers often adapted abandoned buildings, converting them into *mosques*. (The word is based on the Arabic *masjid*, which means "place of prostration.") The typical mosque must be big enough to accommodate all male worshipers for Friday prayers, during which they hear a sermon and bow down in the direction of Mecca, Islam's most holy city. The basic plan of a mosque is based on the design of the Prophet's house, which had an open courtyard bordered by porches held up with columns. Often, mosques include one or more *minarets* (towers), which mark the building's location and are used by chanters who ascend and call the faithful to prayer.

An early mosque that still stands in something resembling its original condition is the GREAT MOSQUE in Kairouan, Tunisia. The open courtyard is surrounded by porches, with a minaret over the main entrance in the center of one short side. The deeper covered area opposite the minaret shelters the *mihrab*, the niche in the end wall that points the way to Mecca.

The ceramic arts are highly valued in Islam, and Arab potters in Iraq made a major advance when they perfected the luster technique, probably in the ninth century. This glaze effect, which imparts a metallic sheen to the surface of a vessel, is one of the most difficult to control in ceramics, and was equated in those days with alchemy, the effort to convert simple materials into gold. Most luster pottery was for the exclusive use of nobles and rulers. The PITCHER shown here has a very thin body, indicating that it was probably intended only for decorative purposes. The Arabic script on the piece expresses praise and good wishes to the owner.

454 PITCHER (SPOUTED EWER).
Kashan. Early 13th century.
Luster over tin glaze.
Height 6⅘".
Reproduced by permission of the Syndics of the
Fitzwilliam Museum, Cambridge, from the Ades Loan Collection.

SPAIN

Muslims first conquered Spain for Islam in the eighth century, but soon the region (together with bordering North Africa) became a distinct Muslim culture with important scientists, poets, philosophers, architects, and artists (see, for example, the Spanish LUSTER-PAINTED BOWL on page 82). Some of Europe's best libraries were in the Spanish Muslim cities of Córdoba and Granada, and respect for books and learning was higher here than in most other areas of the continent.

Calligraphy is a highly honored Islamic art because it is used to enhance the beauty of the word of God. The most respected practice for a calligrapher is the art of writing the words of the Koran, the sacred text of Islam, which Muslims believe was revealed in Arabic by Allah to Mohammed. In the Islamic world, the written TEXT OF THE KORAN is the divine word in visible form. According to Islamic tradition, God's first creation was the *qalam*, the slant-cut reed pen.

The decorative qualities of Arabic scripts combine well with both geometric and floral design motifs. We saw them combined in the PITCHER, but they work together with unforgettable effect in the COURT OF THE LIONS, which contains elaborate stucco arches resting on 124 white marble columns. Many of the walls seem to consist entirely of translucent webs of intricate decoration in marble, alabaster, glazed tile, and cast plaster. Light coming through the small openings in the decoration gives many of the rooms and courtyards a luminous splendor. Just above the columns is a horizontal band of calligraphy that says, "There is no victor save God." (For another example of Spanish Muslim decoration, see the DECORATIVE PANEL FROM THE ALHAMBRA on page 14.)

The COURT OF THE LIONS is part of the much larger Alhambra, the royal palace and fort of the Muslim rulers in Granada. Occupying a commanding hill, the Alhambra was a self-contained city, with meeting rooms, royal residences, gardens, and housing for workers of various kinds. This was one of the last strongholds of Muslim rule in Spain, and when the last ruler abandoned it in 1492, the Spanish rulers kept it intact.

455 TEXT OF THE KORAN.
North Africa or Spain. 11th century. Colors on parchment.
MS no. 1544. Reproduced by kind permission of the Trustees of the Chester Beatty Library, Dublin.

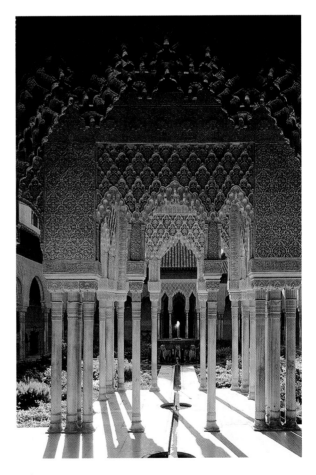

456 COURT OF THE LIONS, ALHAMBRA.
Granada, Spain. 1309–1354.
Photograph: SuperStock, Inc.

457 THE ISLAMIC WORLD.

PERSIA

Probably the best-known item of Persian art in the West is the carpet (see page 200 for the ARDABIL CARPET, one of the most impressive). Carpets were not only prized possessions; they were important to the history of Islamic arts as a means of spreading design ideas. Relatively portable, a carpet is a repository of motifs and compositions. Many decorative schemes on buildings or pottery were influenced by carpet design from distant regions.

Decorating architecture with tiles is an important offshoot of the ceramic arts, and this technique reached a peak of achievement in Persia. The MIHRAB shown here was taken from a mosque, where it pointed the way to Mecca for worshipers. The disavowal of images in the religious context means that the art cannot tell a story with human figures, as is common in the West. Instead, Islamic art uses extremely intricate designs that satisfy the sensuous urge for beauty while also engaging the mind's desire for order and pattern. Muslims often used writing, as seen here on the outer band which contains well-known verses from the Quran about the value of building mosques. In this way, a work such as this one can be absorbing to look at, spiritually uplifting, and aesthetically pleasing.

The MIHRAB has been separated from its original site, but it provides an example of the richness of

458 MIHRAB. Persia (Iran). c. 1354.
Glazed ceramic, cut and assembled in mosaic.
11'3" × 7'6".
The Metropolitan Museum of Art.
Harris Brisbane Dick Fund, 1939. (39.20).
Photograph: © The Metropolitan Museum of Art.

Persian decorative arts. Such techniques were often applied to entire buildings, as we see at the MIR-I-ARAB MADRASA in Uzbekistan. A *madrasa* is a Muslim theological school where the history of Islam and the interpretation of the Quran are taught. This one was named for its founder, a member of the philosophical Muslim sect known as Sufism.

The well-proportioned array of openings in two stories provides a counterpoint to the *iwan*, the large covered porch at the center. Behind are two domes, one marking the lecture hall and the other the founder's tomb. Most surfaces are dazzling with tiles in floral, geometric, and epigraphic patterns, showing how color is often integral to Islamic architecture.

Persian painters rank among the world's great illustrators, as they made pictures to accompany handwritten copies of their major literary works. These illustrated books were prized possessions of the aristocracy. One of the finest illustrations is SULTAN SANJAR AND THE OLD WOMAN, from the *Khamseh*, or "Five Poems," by Nizami (on the following page). The story is an allegory on vanity: The sultan was out riding with his courtiers one day when an old woman approached him, complaining that she had been robbed by one of his soldiers. Sanjar dismissed her, saying that her troubles were nothing compared to his with his military campaigns. The woman then confronted him, saying, "What good is conquering foreign armies when you can't make your own behave?"

The work is a careful composition with luxurious details in the fabrics, vegetation, and clouds. Subtle gestures help to tell the story, which takes place in the center. The method of rendering rocks in Persian painting owes a great deal to Chinese art, which the Persians knew (compare with TRAVELERS AMONG MOUNTAINS AND STREAMS on page 304), but the Persian artist made some of these resemble faces. These paintings were most often produced in workshops, so that we do not generally know the artists' names; but in this case it seems fairly certain that the work is by Sultan-Muhammad, one of the two or three most highly regarded painters of Safavid Persia.

459 MIR-I-ARAB MADRASA.
Bukhara, Uzbekistan. 1535–1536. Facade.
Photograph: David Flack.

INDIA: THE MUGHAL EMPIRE

Heirs to both Persian and Mongol traditions, the Mughal rulers of the Indian subcontinent governed a wide mix of cultures in the sixteenth and seventeenth centuries. Their subjects were Hindu, Jain, Zoroastrian, and even a few Christians. Only a minority (the upper classes) were Muslim. This meant that in the Mughal Empire, Islam evolved further from its Arab roots than anywhere up to that time.

Governing such a diverse people led the Mughal rulers to a level of tolerance unknown elsewhere in the world. Akbar, for example, who ruled from 1556 to 1605, ordered his ministers to learn about the various religions practiced in his realm, and he hired tutors to teach them. He also established a new religion that combined elements of all, and made himself the head of it, the better to resolve disputes. When Jesuit missionaries from Baroque Rome visited him, he entertained them lavishly, and bought Western religious prints from them for his art collection. He encouraged figural representation in art, saying that trying to copy God's handiwork by making pictures would lead artists to a deeper respect for divine creativity.

Under the influence of the empire's cultural mix, and the tolerant curiosity of most of its rulers,

460 Attributed to Sultan-Muhammad.
SULTAN SANJAR AND THE OLD WOMAN, from the KHAMSEH (FIVE POEMS) of Nizami, folio 181, 1539–1543.
Gouache on paper. 14½" × 10".
By permission of The British Library.

a Mughal painting style evolved that combined elements of European naturalism with Persian love of color and attention to detail. When a Portuguese trader brought to the court a turkey (which came not from Europe but the New World), the ruler Jahanghir ordered his favorite artist to make a picture of it. The result is TURKEY-COCK, one of the most vivid depictions of wildlife ever realized. The surrounding text tells the details of the gift. The boldness of its impact is equaled by the fineness of its details.

The last Mughal ruler to hold the realm together was Shah Jahan, who also created the most memorable piece of Mughal art, the TAJ MAHAL. Erected on the banks of a river between a guest house and a small mosque, the TAJ MAHAL (which means "Crown of the Palace") is a tomb for the ruler's favorite wife, who had died in childbirth. It sits at one end of a four-part paradise garden that recalls the description of Paradise in the Quran. The surface of the white marble exterior seems to change colors by catching sunlight at various angles. The proportions of the bulb-shaped dome make the building look light, as if it barely touches the ground. The walls seem paper-thin, with arch openings in a graceful rhythm. The paradise motif of the garden is continued in the long inscription over the central doorway arch, which contains the most important chapter from the Quran describing the afterlife. The TAJ MAHAL's combination of otherworldliness, beauty, and devotion draws visitors from across the world.

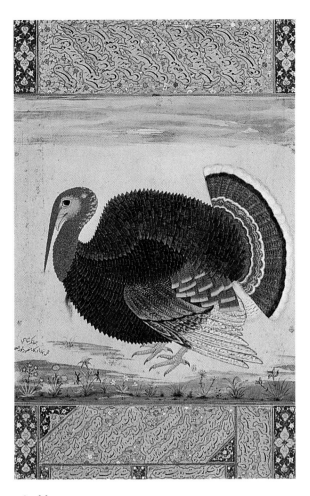

461 Mansur.
TURKEY-COCK. c. 1612.
Gouache on paper, painted image. 5¼" × 5".
Victoria and Albert Museum, London.
Courtesy of the Trustees of the Victoria and Albert Museum, IM 135–1921.
Victoria and Albert Picture Library.

462 TAJ MAHAL.
Agra, India. 1632–1648.
Library, Getty Research Institute.
Photograph: Wim Swaan Collection (96.P.21).

465 HEAD.
Nok culture, Nigeria.
500 B.C.E.–200 C.E.
Terra cotta.
Height 14½".
National Museum, Lagos, Nigeria.
Photograph: Werner Forman Archive.

466 MALE PORTRAIT HEAD.
Ife, Nigeria.
13th century. Bronze.
Height 11⁷⁄₁₆".
Photograph: Frank Willet.

467 BENIN HEAD. Nigeria.
16th century. Bronze.
8⅝" × 9¼".
The Metropolitan Museum of Art,
New York. The Michael C. Rockefeller
Memorial Collection. Bequest of Nelson
A. Rockefeller, 1979. (1979.206.86).
Photograph by Schecter Lee.
Photograph © 1986 The Metropolitan
Museum of Art.

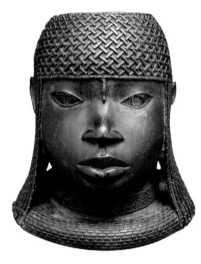

Tin miners digging in central Nigeria accidentally unearthed the oldest surviving examples of sub-Saharan art, such as the HEAD from the Nok culture. Archaeological evidence indicates that these works, of which hundreds have been found, date from the time of the Greeks and the Romans. Modeled in *terra cotta* (unglazed earthenware), they are nearly life-size. The heads, which are broken at the neck, were probably once attached to torsos. Their finely carved hair ornaments and facial features show that there had been sophisticated wood carving in that region. The vivid facial expression of the HEAD makes it seem like a portrait of an individual, but at the same time there is a degree of abstraction in the treatment of the eyes and nose. Little else has survived from the Nok culture. Although we know little about it, it seems to have heavily influenced other cultures of West Africa.

Concurrent with the Gothic era in twelfth-century Europe, a naturalistic style of court portraiture was being produced for the royal court of Ife, a sacred Yoruba city in southwestern Nigeria. The MALE PORTRAIT HEAD demonstrates the Ife skill in lost-wax bronze casting. Such thin-walled, hollow metal casting probably represents the culmination of generations of cultural influences. Scarification lines emphasize facial contours; rows of small holes are believed to have held a beaded veil.

Ife probably influenced the sculptural arts of neighboring Benin. The BENIN HEAD exemplifies another court style, developed in Benin, that was somewhat abstract in comparison to the naturalism of Ife portrait sculpture.

Bronze casting in Benin was an art form devoted exclusively to glorifying the king (or *oba*). The technology was a closely guarded secret which only licensed royal artisans could practice. Most of the

Benin heads are portraits of royalty or other distinguished ancestors. The heads were generally placed in altars that successive generations tended.

When sixteenth-century Europeans first arrived in the kingdom of Benin, they were impressed by cast bronze sculptures, palaces, and a city that compared favorably to their own capital cities. The ivory PENDANT MASK from Benin was carved in the sixteenth century, and modern versions are still worn on the oba's chest, or at his waist during ceremonies. This PENDANT MASK portrays a Queen Mother who stares out with a serene expression. She wears a crown which depicts alternating human heads and salamanders. The human heads are meant to represent Portuguese traders and sailors who regularly visited Benin and, at times, helped the king in diplomatic disputes with neighboring peoples. A close examination of the figures reveals round caps and long mustaches. The salamanders symbolize immortality, since they seem to rise up alive from the mud each year. The two vertical marks in the Queen Mother's brow are shallow slots which held consecrated ointments during ceremonies.

The Bamana people of Mali are renowned for their carved wooden antelope figure headdresses, which young men attach to basketry caps and wear on top of their heads during agricultural ceremonies. When a new field is cleared, the most diligent male workers are selected to perform a dance of leaps in imitation of the mythical *tyi wara*, who taught human beings how to cultivate crops. The dance always includes both male and female TYI WARA DANCERS: the female is identified by a baby on her back, the male by a stylized mane. Abstracted antelope bodies become energized, almost linear forms. Rhythmic curves are accented by a few straight lines in designs that emphasize an interplay of solid mass and penetrating space.

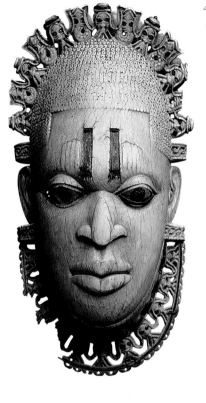

468 PENDANT MASK.
Nigeria. Early 16th century. Ivory, iron, copper. Height 9⅜".
The Metropolitan Museum of Art. The Michael C. Rockefeller Memorial Collection. Gift of Nelson A. Rockefeller, 1972 (1978.412.323). Photograph by Schecter Lee. © 1986 The Metropolitan Museum of Art.

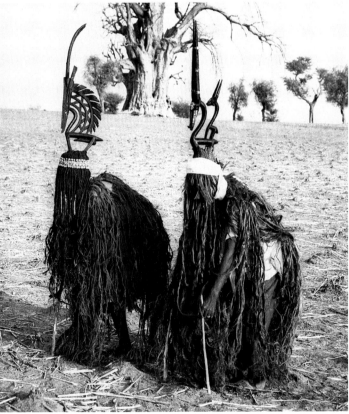

469 TYI WARA DANCERS.
Mali.
Photograph: Dr. Pascal James Imperato.

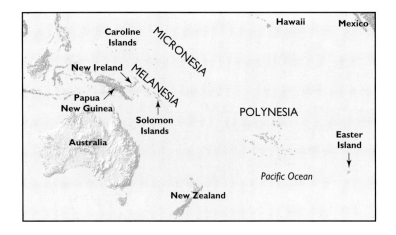

478 OCEANIA AND AUSTRALIA.

In New Ireland, masks are made for funerary rites that commemorate tribal ancestors, both real and mythical. In this MASK, the elaborately carved, openwork panels are painted in strong patterns that accentuate—and at times oppose—the dynamic forms of the carving. Snail-shell eyes give the mask an intense expression. As in the Solomon Islands CANOE PROW FIGURE, a bird plays a prominent role. In the wings of this mask, chickens hold snakes in their mouths, a reference to the opposition of sky and earth. Anthropologists believe that this mask was used to remove bad influences from a ceremonial house. Once it had fulfilled its function, it was regarded as "used up," and was discarded.

Carvings made in Micronesia and in much of Polynesia are streamlined and highly finished. The Kapingamarangi COCONUT GRATER shows a fine

479 MASK. New Ireland. c. 1920.
Painted wood, vegetable fiber, shell. 37½" × 21⅓".
Photograph by Don Cole. © UCLA Fowler Museum of Cultural History.

480 COCONUT GRATER.
Kapingamarangi, Caroline Islands. 1954.
Wood, shell blade attached with sennet.
Height 19.5".
Courtesy of Keahonui Rosehill Newhouse.

481 STANDING FEMALE FIGURE.
Nukuoro Atoll, Central
Carolines. 19th century.
Wood. Height 15⁹⁄₁₆".
Honolulu Academy of Arts by Exchange
1943 (4752).

482 MOAI.
Easter Island.
Photolibrary.com.
Photography: Nick Green.

483 AUMAKUA.
Wooden image from Forbes
Cave, Hawaii. Koa wood.
Height 29".
Seth Joel, Bishop Museum.

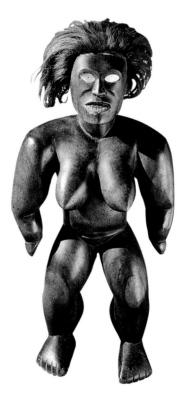

integration of form and function. One sits on the "saddle" of the animal-like form and grates coconuts using the serrated blade at its head. The STANDING FIGURE from Nukuoro Atoll has a similar distinctive spare quality. Although Kapingamarangi and Nukuoro are in the southern part of Micronesia, their culture is Polynesian.

Polynesia covers a large, triangular section of the Pacific, from New Zealand to Hawaii to Easter Island. Widely separated Polynesian islands and island groups developed greatly varied arts that include both delicate and boldly patterned bark cloth, featherwork, shell-work, woodcarvings, and huge rock carvings.

The original inhabitants of Easter Island left over 600 carved MOAI before European explorers first visited the island in the 1770s. These stone figures, which are up to seventy feet tall, are statues of torsos and heads, set on flat stone platforms. The meaning of these figures is unknown, but they are thought to represent ancestors who have taken on spiritual power. Many Polynesian cultures accord similar homage to ancestors, but none on the scale we see here.

An outstanding example of semi-abstract Hawaiian sculpture is the forceful AUMAKUA

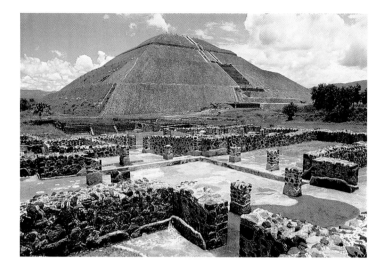

496 PYRAMID OF THE SUN.
Teotihuacan. 1st–7th century C.E.
700' wide, 200' high.
Photograph: John S. Flannery/Bruce Coleman Inc.

497 Detail of TEMPLE OF THE FEATHERED SERPENT.
Teotihuacan. 150–200 C.E.
Photograph: © Dr. E. R. Degginger/Color-Pic, Inc.

PRE-COLUMBIAN CENTRAL AND SOUTH AMERICA

A variety of agricultural civilizations flourished in Mexico from about the time of Christ until the Spanish conquest of the 1520s. These cultures influenced one another through trade and conquest, and as a result they share many cultural forms, among them pyramids, calendars, and some important gods and myths. The earliest was the Olmec, who inhabited the Gulf Coast near what is now Veracruz (see the Olmec MASSIVE STONE HEAD on page 181). Probably more influential were the people who built the city of Teotihuacan, located in the central valley about forty miles north of where Mexico City is today.

The PYRAMID OF THE SUN in Teotihuacan is among the largest in the world, covering slightly more ground than the largest of the Great Pyramids of Giza in Egypt. It rises only about half as high, and imitates the shape of the surrounding mountains. Many ancient Mexican cultures believed that humanity first emerged from a hole in the ground, and this pyramid may mark the spot: it sits over a deep cave. The pyramid is aligned to face the sunset on August 12, the date corresponding to the beginning of time in the Maya calendar. As we can see in the photograph, THE PYRAMID OF THE SUN was at the center of a large city, which archaeologists calculate was the world's sixth largest at its peak in 600 C.E.

At one end of the central avenue of Teotihuacan lies the TEMPLE OF THE FEATHERED SERPENT, which has sculptural decorations that influenced several other cultures. Alternating on the layers of the temple are relief heads of the Storm God, with its goggle eyes and scaly face, and the Feathered Serpent, its fanged head emerging from a plumed wreath. Teotihuacan itself was abandoned after burning in a mysterious fire in about the year 750 C.E. However, both of these gods were widely adopted by later cultures in ancient Mexico.

The Maya, whose descendants still live in what are now parts of Mexico, Guatemala, and Honduras, developed a written language, an elaborate calendar, advanced mathematics, and large temple complexes of stone.

The hundreds of stone temples at Tikal suggest that Maya priests had great power. TEMPLE 1, built during the classical Maya period, 300–900 C.E., rises over a great plaza in a Guatemalan rain forest. The two-hundred-foot-high pyramid has a temple at the top consisting of three rooms. Another Maya temple pyramid contained a burial chamber deep inside, similar to those found in Egyptian pyramids. Walls and roofs of Maya stone temples were richly carved and painted.

An excellent example of Maya sculpture from one such temple is LINTEL 24 from Yaxchilan, a site on the border between Mexico and Guatemala. This stone relief is best understood with the help of the written symbols along its edges, which have been recently decoded. Standing is the king, Lord Shield Jaguar, holding a flaming torch. The sculptor seems to have rendered effortlessly the casual fall of the feathers in his headdress. His wife Lady Xoc kneels before him performing a ritual. She draws blood from her pierced tongue, which she will blot with the pieces of paper in the basket in front of her. She wears richly patterned clothing that hints at highly developed textile arts of that time (none of which, unfortunately, survive). Her elaborate headdress is crowned with the goggle-eyed storm god, who looks almost directly upward from the back of Lady Xoc's head. Especially noteworthy are the sculptor's evocation of the fleshiness of the figures, their subtle interaction, and the rich textures of their clothing. The writing on the work describes the action and even gives its date, 28 October 709.

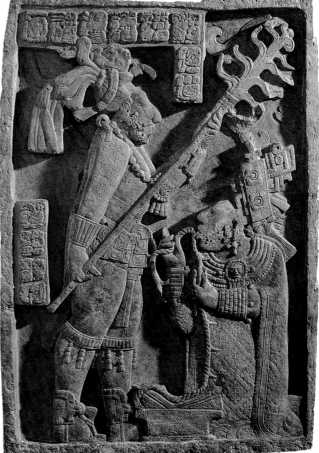

498 TEMPLE 1. Maya.
Tikal, Guatemala. c. 300–900 C.E.
Photograph: Hans Namuth/Photo Researchers, Inc.

499 LINTEL 24.
Yaxchilan, Maya. 709 C.E.
Limestone. Height: 43".
© Copyright British Museum.

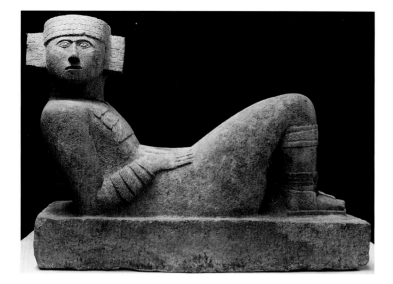

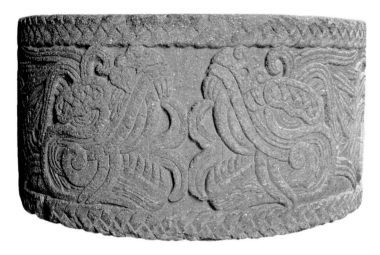

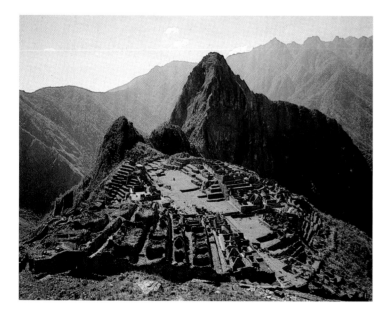

The Toltec civilization that developed in central Mexico between the ninth and thirteenth centuries forms a bridge between the decline of the Maya and the rise of the Aztecs. During a time of conflict and change, the Toltecs initiated a major new era in the highlands of central Mexico, distinguished by architectural innovations and massive carved figures. A Toltec form that also occurs in Aztec and Maya art is the recumbent figure from Chichen Itza known by the Mayan name CHACMOOL. The bowl at the figure's waist held sacrificial offerings. Reclining figures such as this one were a strong influence on the modern sculpture of Henry Moore, whose RECUMBENT FIGURE is pictured in Chapter 23.

The Aztecs were the most powerful kingdom in Mexico at the time of the Spanish Conquest; their art is in many respects a summation of preceding styles. The Aztecs (who called themselves the Mexica) settled in the early fourteenth century in the area where Mexico City now stands. Their principal temple was a dual pyramid in honor of the storm god and a war god, where they made human sacrifices of the prisoners they had taken in warfare with neighboring peoples. The Aztecs believed that such sacrifices were necessary in order to honor and recreate the self-sacrifice that the feathered serpent had performed in ancient times in order to ensure the continuation of the world. They believed that this original sacrifice had occurred at Teotihuacan, which they knew as an uninhabited ruin.

The feathered serpent is frequently depicted in Aztec sculpture, but rarely with more horrific effect than in the VESSEL OF THE FEATHERED SERPENT, a vessel for sacrificial offerings. Two snakes face each

500 CHACMOOL. 10th–12th century. Toltec.
Stone. Length 42".
Giraudon/Art Resource, NY.

501 VESSEL OF THE FEATHERED SERPENT QUETZALCOATL.
Aztec. 1450–1521. Stone.
Height 19".
Museo Nacional de Antropología, Mexico City.

502 MACHU PICCHU.
Inca. Peru. Early 16th century.
Photograph: Ewing Krainen.

other, their fangs and split tongues forming a symmetrical design. The rather menacing aspect of this piece is typical of much Aztec stone sculpture, which reflects the militaristic and regimented nature of Aztec society. When the Spanish first visited the Aztec capital, they found the city cleaner and better-governed than most European cities. The Aztec also had highly developed arts of poetry and literature.

In the Andes of South America, Inca culture flourished for several centuries prior to the Spanish conquest of 1532. Spanish reports from the time tell of the magnificence of Inca art, but most of the culture's exquisite gold objects were melted down soon after the conquest, and all but a few of the refined fabrics have perished with age and neglect.

The Incas are perhaps best known for their skillful shaping and fitting of stones. Their masonry is characterized by mortarless joints and the "soft" rounded faces of granite blocks. MACHU PICCHU, a royal retreat center was built on a ridge in the eastern Andes, in what is now Peru, at an elevation of eight thousand feet. The city, which escaped Spanish detection, was planned and constructed in such a way that it seems to be part of the mountain. Respect for stones is an integral part of Inca culture. According to the Inca creation myth, two of their early ancestors who emerged from the earth immediately turned themselves into stones. Some stone shrines were regarded as living things requiring offerings and care.

On a desert plateau overlooking Nazca Valley, there is a crisscrossing of geometric lines and patterns in the dry yellow sand, presumably carved by the people of an ancient culture known as the Nazca. There are perfectly straight lines, some almost five miles long, and geometric patterns such as spirals, trapezoids, and triangles as well as abstracted images of various known and unknown birds and other animals, including the HUMMINGBIRD shown here. This gigantic sketch pad dwarfs the seemingly insignificant Pan American Highway that crosses one corner. Not until the age of airplanes were people able to see even one of these individual images in its entirety.

One of the few Inca art forms to survive the Spanish conquest intact was the KERO CUP carved from wood. These cups and many other objects are

503 HUMMINGBIRD. Nazca Valley, Peru.
Photograph: Georg Gerster/Photo Researchers, Inc.

504 KERO CUP.
Peru. Late 16th–17th century. Wood with pigment inlay.
7⅜" × 6¹⁵⁄₁₆".
Brooklyn Museum of Art, Museum Expedition 1941,
Frank L. Babbott Fund. 41.1275.5.

now held in museums far from the lands where they were made. The fate of traditional art objects in the modern world of international commerce is the subject of the following essay.

505 FEATHERED SERPENT AND FLOWERING TREES.
Probably Metepec, A.D. 650–750, Teotihuacan, Techinantitla, Mexico.
Height 24¼".
Fine Arts Museums of San Francisco, Bequest of Harald J. Wagner, 1985.104.1a–d (detail).

MOST OF US would like to think that museums acquire all of their goods through purchase at fair market price or through bequest of generous donors. Indeed, that is how museums most often add to their collections, but not always. Occasionally, items are presented to them that come from suspicious sources that the donors cannot document. Sometimes museums acquire objects from countries whose governments would not permit the export of the goods if they could prevent it. In a few celebrated cases, governments have requested the return of items they believe were taken illegally from their territories. This issue, which is called the return of cultural property, is currently very controversial throughout the museum world, and it has been the subject of much international negotiation. Here are two cases that have been in the news in recent years:

1. The AUMAKUA pictured on page 333 has been the subjected of controversy in Hawaii for several years. It was found by an amateur explorer in 1908 in an ancient cave burial site and donated to the Bishop Museum, Hawaii's major repository of native arts and culture. The museum took legal title to the piece, but lent it in 2001 to a Native Hawaiian group who returned it to the cave where it was found. The group further announced that the piece would never be returned to the museum and that the cave (located in a remote location) would be guarded henceforth. While many urged the piece's return to public view and study, the native group declared that the original 1908 exploration amounted to grave robbing, and violated the sanctity of Native Hawaiian burial customs. Hence, the only morally justifiable course would be to treat the piece as its creators intended. Lawsuits have been filed on behalf of the museum and other native groups.

2. The de Young Museum in San Francisco received a telephone call in 1976 from the administrators of the estate of Harald J. Wagner, who had recently died. Wagner stated in his will that his art collection was to be donated to the de Young, and two curators visited the house that summer. There they found some seventy pieces of mural painting that had been taken off the walls of apartments in the ancient Mexican city of Teotihuacan. Among the fragments was FEATHERED SERPENT AND FLOWERING TREES. An examination revealed that the pieces had been pried off of the stucco walls with jack hammers or crowbars and loaded into trucks, and then somehow hauled out of Mexico. Wagner had sales receipts proving that he had bought them in Mexico in the 1960s, but removing these objects in the first place, and transporting them across the border, probably violated Mexican and American laws.

The de Young Museum invited Mexican experts to examine the mural paintings from Teotihuacan, and eventually returned more than half of them to the Mexican National Institute of Anthropology and History, the agency in charge of caring for historic sites. The Mexican government showed its gratitude to the de Young in 1993 by lending a large number of other works from Teotihuacan so that the museum could stage the largest exhibition ever held of works from that ancient city.

The international trade in art is often a very delicate matter involving issues of national pride and public morality. International law on the subject of art repatriation is vague and contradictory. Works of art are often hotly contested items, as much prized by their owners as coveted by those who would have them.

Fujishima Takeji. SUNRISE OVER THE EASTERN SEA. 1932.
Oil on canvas, 25½" × 35¾".
Bridgestone Museum of Art, Tokyo. Ishibashi Foundation.

The Modern World

CONSIDER...

What generalizations could you make about twentieth-century art after glancing at the reproductions in this book's last five chapters?

The invention of photography freed painting from the need to be realistic. Why do artists continue to paint portraits instead of simply using a camera to capture someone's likeness?

Do the "stationary" visual arts such as painting and sculpture still have an impact in a world dominated by film and television?

Is art today more or less difficult for the average person to understand than it was several hundred years ago? What changes might account for any difference?

Do artists build on the art of their predecessors in the way scientists build on the work of earlier scientists?

CHAPTER **twenty**

LATE EIGHTEENTH AND NINETEENTH CENTURIES

T hree revolutions—the Industrial Revolution, which began in Britain about 1760; the American Revolution in 1776; and the French Revolution in 1789—launched the period of great social and technological change we call the modern age. The Industrial Revolution brought about the most significant shift in the way people lived since the Neolithic agricultural revolution ten thousand years earlier. Since the start of the Industrial Revolution, technological change has occurred at an ever increasing rate.

The Enlightenment, or Age of Reason, as the late eighteenth century has been called, was characterized by a shift to a more rational and scientific approach to religious, political, social, and economic issues. Belief in the importance of liberty, self-determination, and progress brought about an emphasis on democracy and secular concerns. Consistent belief systems that tended to unify earlier societies became increasingly fragmented. Traditional values were challenged by the new atmosphere of independent investigation, by changes brought about by technology, and by the increased mixing of peoples and cultures. Artists both expressed and abetted these changes.

In the Western world, a new self-consciousness regarding styles led to increasing uncertainty about the place of art and artists in society. In earlier periods, within each society, artists generally adhered to a dominant style. Following the French Revolution

and the subsequent break with traditional art patronage in France, a variety of styles developed simultaneously. While freed from the artistic constraints imposed by their traditional patrons (royalty, aristocracy, wealthy merchants and bankers, and the church), artists were left to struggle financially until a new system of patronage emerged. Eventually, support came in the form of commercial galleries, private and corporate collectors, and museums.

NEOCLASSICISM

With the beginning of the French Revolution in 1789, the luxurious life that centered on the French court ended abruptly, and French society was disrupted and transformed. As the social structure and values changed, tastes also changed.

One of the artists who led the way to revolutions in both art and politics was painter Jacques-Louis David. Believing that the arts should serve a political purpose in a time of social and governmental reform, he rejected what he saw as the frivolous immorality associated with the aristocratic Rococo style. When he painted OATH OF THE HORATII, David used an austere style called *Neoclassicism*. The term refers to the emulation of classical Greek and Roman art; much of the subject matter in Neoclassical art was Roman because Rome represented a republican, or nonmonarchical, government.

The subject of OATH OF THE HORATII is a story of virtue and the readiness to die for liberty, in which

three brothers pledge to take the sword offered by their father to defend Rome. With such paintings, David gave revolutionary leaders an inspiring image of themselves rooted in history. "Take courage," was the painting's message, "your cause is a noble one and has been fought before."

David's Neoclassicism, seen in the rational, geometric structure of his composition, provides strong contrast to the lyrical softness of Rococo designs. The painting has the quality of classical (Greco-Roman) relief sculpture, with strong side light emphasizing the figures in the foreground. Even the folds in the garments are more like carved marble than soft cloth. The background arcade gives strength to the design and provides an historically appropriate setting for the Roman figures. The two center columns separate the three major parts of the subject. Vertical and horizontal lines parallel the edges of the picture plane, forming a stable composition that resembles a stage set.

The women at the right of the OATH OF THE HORATII seem overcome by emotion, unable to participate in the serious decisions required of men who would defend their homeland. This painting reflects what was commonly believed at that time: that women were unfit for public life. Their exclusion from most professions was also followed in the art world, where women were banned from academy classes in which unclothed models were used. If a woman did succeed as an artist, it was because she either could afford private study or came from an artistic family.

In the works of the Neoclassicist Angelica Kauffmann, who overcame such obstacles, we see a different vision of woman's abilities. Born in Switzerland and trained by her father, Kauffmann spent six years in Italy before settling in London in 1768. She was elected a full member of the British Royal Academy two years later, the last woman to be so honored until the 1920s. Her work CORNELIA, POINTING TO HER CHILDREN AS HER TREASURES was painted a year after David's OATH OF THE HORATII. Cornelia is at the center of the work, talking to a friend seated at the right. The friend shows a string of jewels as if boasting about them, to which

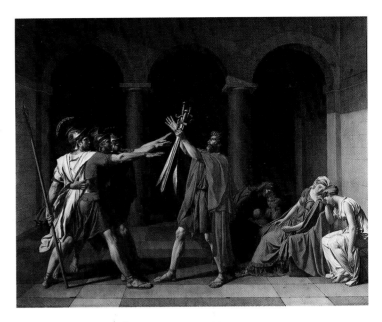

506 Jacques-Louis David.
 OATH OF THE HORATII. 1784.
 Oil on canvas. 10'10" × 14'.
 Musée du Louvre, Paris. Photograph: Scala/Art Resource, NY.

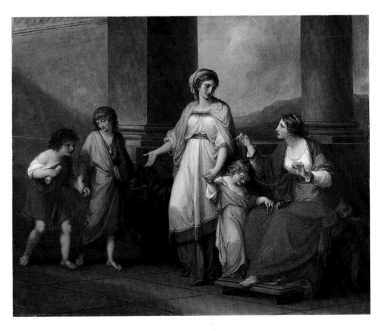

507 Angelica Kauffmann.
 CORNELIA, POINTING TO HER CHILDREN AS HER TREASURES.
 c. 1785. Oil on canvas. 40" × 50".
 Virginia Museum of Fine Arts, Richmond. The Adolf D. and Wilkins C. Williams Fund.
 Photograph: Ann Hutchison. © Virginia Museum of Fine Arts. 75.22/50669.2.

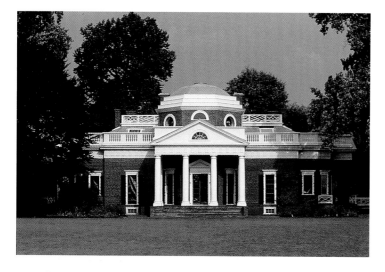

508 Thomas Jefferson.
MONTICELLO. Charlottesville, Virginia. 1793–1806.
Courtesy of the Thomas Jefferson Memorial Foundation, Inc.

Cornelia replies that her children are her jewels. Indeed, to a student of Roman history, this was true: Cornelia's children adopted her well-known democratic beliefs and went on to become important figures in the development of the Roman political system.

The new classical (that is, Neoclassical) spirit was also felt in architecture. American architecture achieved international stature for the first time with the work of statesman-architect Thomas Jefferson. His original design for his home, MONTICELLO, was derived from Palladio's Renaissance reinterpretation of Roman country-style houses (see page 227). Then, during his years in Europe as Minister to France (1784–1789), Jefferson was influenced by French, Italian, and Roman architecture. Thus, when he rebuilt his home between 1793 and 1806, he had the second story removed from the center of the building and replaced by a dome on an octagonal drum. He added a large Greco-Roman portico (a porchlike roof supported by columns), making the entire design reminiscent of the PANTHEON (see page 249) by way of contemporary French Neoclassical architecture. In comparison with the first MONTICELLO, the second version has a monumental quality that reflects Jefferson's increasingly classical conception of architecture.

Both MONTICELLO and Jefferson's designs for the University of Virginia show the Roman phase of Neoclassical American architecture, often called the Federal or Jeffersonian Style. Jefferson aimed for an architecture capable of expressing the values of the new American republic. In its fusion of classical Greek, Roman, Renaissance (Palladian), and eighteenth-century forms, his architecture shows an originality that sets it apart. Jefferson's Neoclassical style is reflected in much of American architecture before the Civil War. Neoclassical architecture can be found in practically every city in the United States, and it continues to dominate Washington, D.C.

ROMANTICISM

The Enlightenment celebrated the power of reason; however, an opposite reaction, Romanticism, soon followed. This new wave of emotional expression motivated the most creative artists in Europe from about 1825 to 1850. The word Romanticism comes from *romances,* popular medieval tales of adventure written in romance languages.

Whereas Neoclassicism refers to a specific style, *Romanticism* refers to an attitude that inspired a number of styles. Romantic artists, musicians, and writers held the views that imagination and emotion are more valuable than reason, that nature is less corrupt than civilization, and that human beings are essentially good. Romantics championed the struggle for human liberty and celebrated nature, rural life, common people, and exotic subjects in art and literature. They wanted to assert the validity of subjective experience and to escape Neoclassicism's fixation on classical forms.

Spanish artist Francisco Goya was a Romantic painter and printmaker. A contemporary of David, he was aware of the French Revolution and he personally experienced some of the worst aspects of the ensuing Napoleonic era, when French armies invaded Spain and much of the rest of Europe. Goya at first welcomed Napoleon's invading army because his sympathies were with the French Revolution and he had lost confidence in the king of Spain. But he soon discovered that the occupying army was destroying rather than defending the ideals he had

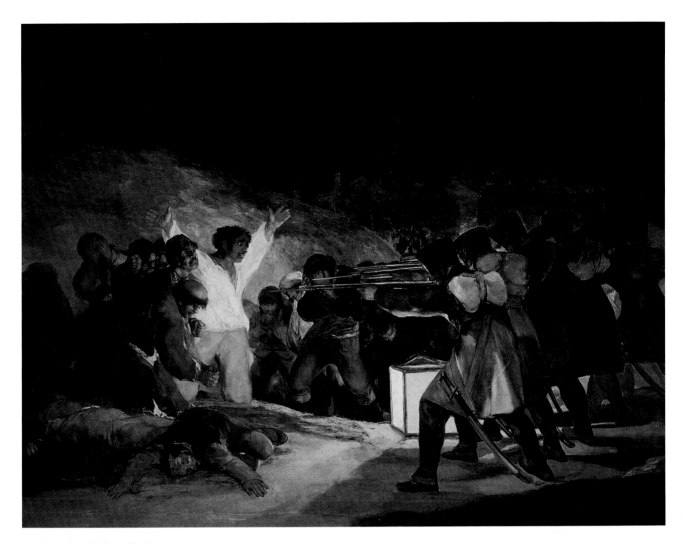

509 Francisco de Goya y Lucientes.
THE THIRD OF MAY 1808. 1814.
Oil on canvas. 8'9" × 13'4".
Museo del Prado, Madrid, Spain. Erich Lessing/Art Resource, NY.

associated with the Revolution. Madrid was occupied by Napoleon's troops in 1808. On May 2, a riot broke out against the French in the central square. Officers fired from a nearby hill, and the cavalry was ordered to cut down the crowds. The following night, firing squads were set up to shoot anyone who appeared in the streets. Later, Goya vividly and bitterly depicted these brutalities in his powerful indictment of organized murder, THE THIRD OF MAY 1808, painted in February 1814.

The painting is enormous, yet so well conceived in every detail that it delivers its message instantly. A structured pattern of light and dark areas organizes the scene, giving it impact and underscoring its meaning. Goya focuses attention on the soldiers by means of value shifts that define a wedge shape formed by the hill and the brightly lighted area on the ground. Mechanical uniformity marks the faceless firing squad, in contrast to the ragged group that is the target. From the soldiers' dark shapes, we are led by the light and the lines of the rifles to the man in white. The focal point is this man, raising his arms in a gesture of defiance. THE THIRD OF MAY 1808 is not a mere reconstruction of history; it is a universal protest against the brutality of tyrannical governments.

510 J. M. W. Turner. THE BURNING OF THE HOUSES OF LORDS AND COMMONS, 1834.
Oil on canvas, 36½" × 48½".
© Cleveland Museum of Art, Bequest of John L. Severance. 1942.647.

Goya's THIRD OF MAY deals with events that took place only seven years before the artist took up the brush; a preoccupation with current events (rather than a mythological past) is one characteristic of the Romantic movement. When the British houses of Parliament burned in a disastrous fire one night in 1834, the artist J. M. W. Turner witnessed the event and made several sketches that soon became paintings. His work THE BURNING OF THE HOUSES OF LORDS AND COMMONS typifies the Romantic movement in several ways.

The brushwork is loose and expressive, as if he created the painting in a storm of passion. The colors are bright and vivid. Although the work depicts an event that happened only a few months before,

the artist introduced distortions and exaggerations. According to contemporary reports, the flames did not leap up into the night as the artist shows them. Moreover, the Thames River has a bend in it that would partially block the view; Turner "straightened" the river to afford a wide horizon.[1] These departures from factual accuracy were done in order to convey the feeling of the event, as an English national symbol burned. This emphasis on feeling over fact is Romantic. Turner's loose painting style influenced the later Impressionist movement, but there are important differences between them, as we shall see.

Many Romantic artists also painted the landscape, finding there a reflection of their own

511 Thomas Cole.
THE OXBOW. 1836.
Oil on canvas.
51½" × 76".
The Metropolitan Museum of Art,
New York. Gift of Mrs. Russell Sage,
1908. (08.228).
Photograph: © 1995 The
Metropolitan Museum of Art.

512 Robert S. Duncanson.
BLUE HOLE, LITTLE MIAMI
RIVER. 1851.
Oil on canvas.
29¼" × 42¼".
Cincinnati Art Museum. Gift of
Norbert Heermann and Arthur
Helwig. 1926.18.

emotional states. Romantic landscape painting flourished especially in the United States, where Thomas Cole founded the Hudson River School in the 1830s. Like Turner, Cole began with on-site oil and pencil sketches, then made his large paintings in his studio. The broad, panoramic view, carefully rendered details, and light-filled atmosphere of paintings such as THE OXBOW became the inspiration for American landscape painting for several generations; see also Asher Durand's KINDRED SPIRITS on page 53.

In nineteenth-century America it was difficult to obtain the education necessary to become a professional artist; for an African-American it was almost impossible. Nevertheless, with the help of antislavery sponsors, a few succeeded.

Robert S. Duncanson was one of the first African-American artists to earn an international reputation. As the son of a Scots-Canadian father and an African-American mother, he may have had an easier time gaining recognition as an artist than those who did not straddle the color line. Prior to settling in Cincinnati, he studied in Italy, France,

and England, and he was heavily influenced by European Romanticism. With BLUE HOLE, LITTLE MIAMI RIVER, Duncanson reached artistic maturity. He modified the precise realism of the Hudson River School with an original, poetic softening. He orchestrated light, color, and detail to create an intimate and engaging reverie of a person in nature.

513 Eugène Delacroix.
THE DEATH OF SARDANAPALUS. 1827.
Oil on canvas. 12'1½" × 16'2⅞".
Musée du Louvre, Paris. Photograph: Kavaler/Art Resource, NY.

In France, the leading Romantic painter was Eugène Delacroix. Delacroix's painting THE DEATH OF SARDANAPALUS exhibits the many qualities that distinguish Romanticism from the Neoclassicism of David and his followers. The story is based on an imaginative piece of literature by Lord Byron: Sardanapalus is an Assyrian king in a hopeless military situation. Rather than surrender, he takes poison and orders all of his favorite possessions brought before him and destroyed in an orgy of violence. Delacroix composed this writhing work along a diagonal, and lit it using strong chiaroscuro in a way that recalls certain Baroque paintings (see page 282). His brushwork is loose and open, or *painterly,* not at all like the cool precision of Neoclassicism. Delacroix

used all of these devices in order to enhance the viewer's emotional response to a horrifying, if imagined, event. The Romantic painters in general stressed strong viewer involvement, use of color in painterly strokes, and dramatic movement, in contrast to the detached rationality and clear idealism of the Neoclassicists.

PHOTOGRAPHY

The camera, perfected by the painter Daguerre (see page 143), was initially seen by landscape and portrait painters as a threat to their livelihood. In fact, it freed painters from the roles of narrator and illustrator, allowing them to explore dimensions of visual experience that had been largely neglected in

514 Carleton E. Watkins.
THE THREE BROTHERS—4480 FEET—YOSEMITE. 1861.
Photograph.
Courtesy of the Library of Congress.

Western art since the Renaissance. Photography offered new opportunities to fuse images of objective reality with personal visions.

In its first two generations, the new medium was put to many uses. The perfection of glass-plate negatives in the 1850s made possible reproductions of photographs, though the technology was still quite cumbersome to use. Photographers had to smear glass plates with just the right amount of toxic chemicals, expose the plate for the correct number of seconds, and develop the negative almost immediately.

Carleton Watkins in 1861 journeyed into the Sierra Nevada to photograph the THREE BROTHERS in Yosemite valley. This image is part of a portfolio of landscape photographs that he made for sale, signing each one as if it were a painting. These photographs were widely circulated, and they influenced the U.S. Congress to set aside Yosemite as a national park.

Delacroix was one of the first to recognize the difference between camera vision and human vision. He believed that photography was potentially of great benefit to art and artists. In an essay for students, Delacroix wrote:

A daguerreotype is a mirror of the object; certain details almost always overlooked in drawing from nature take on in it characteristic importance, and thus introduce the artist to complete knowledge of construction as light and shade are found in their true character.[2]

Félix Tournachon, called Nadar, was—like many other photographers—an artist who came to prefer photography to drawing and printmaking. He gained fame as a balloonist, and from a hot air balloon he made the first aerial photographs. He even took the first underground photographs in the

In the academic painting PYGMALION AND GALATEA, Gérôme placed the woman, Galatea, on a pedestal, both literally and figuratively. The Greek myth of Pygmalion tells of a sculptor who carved a statue of a woman so beautiful that he fell in love with his sculpture. Pygmalion prayed to Aphrodite, goddess of love, who responded by making the figure come to life. The sentimental approach (note the cupid), smooth finish, and mild eroticism are typical of academic art. In his painting WILLIAM RUSH CARVING HIS ALLEGORICAL FIGURE, Eakins presented

520 Jean Léon Gérôme.
PYGMALION AND GALATEA. c. 1860.
Oil on canvas. 35" × 27".
The Metropolitan Museum of Art, New York. Gift of Louis C. Raegner, 1927.
Photograph: © 1989 The Metropolitan Museum of Art, 27.200.

521 Thomas Eakins. WILLIAM RUSH CARVING HIS ALLEGORICAL FIGURE OF THE SCHUYLKILL RIVER. 1876–1877.
Oil on canvas on Masonite. 20⅛" × 26⅛".
Philadelphia Museum of Art. Gift of Mrs. Thomas Eakins and Miss Mary A. Williams. 1929–184–27.
Photo by Graydon Wood, 2000.

a Realist view of the sculptor's trade: A model poses as the artist chisels away at the left; nineteenth-century decorum demanded that a chaperone be present. Eakins selected this subject because William Rush was the first American artist to use nude models, bringing controversy on himself in the 1820s.

We can see Eakins's influence in the work of his student and friend Henry Ossawa Tanner, who was the best known African-American painter before the twentieth century. At the age of thirteen, Tanner watched a landscape painter at work and decided to become a painter. While studying with Eakins at the Academy of Fine Arts in Philadelphia, Tanner changed his subject matter from landscapes to scenes of daily life. In 1891, after an exhibition of his work was largely ignored, Tanner moved to France, where he remained for most of the rest of his life. He found less racial prejudice in Paris than in the United States. His paper "The American Negro in Art," presented at the 1893 World's Congress on Africa in Chicago, voiced the need for dignified portrayals of blacks, and he offered his painting THE BANJO LESSON as a model.

The lively realism of THE BANJO LESSON reveals Tanner's considerable insight into the feelings of his subjects, yet he avoids the sentimentality that was common in many late nineteenth-century American paintings. This painting shows the influence of Eakins in its detail and the influence of the Impressionists in Tanner's use of light and color.

The most important predecessor of Impressionism in French art is without a doubt Edouard Manet, who was the most controversial artist in Paris in the 1860s. He studied with an academic master, but soon broke away from traditional teaching in an effort to update the art of the Old Masters (Tintoretto, Velázquez, and Rembrandt, for example) by infusing painting with a dose of realism inherited from Gustave Courbet. In addition, Manet often flattened out the figures in his paintings under the influence of the Japanese prints that he knew and admired. His loose, open brushwork and sometimes commonplace subjects were an inspiration to younger painters who led the Impressionist

522 Henry Ossawa Tanner.
THE BANJO LESSON. 1893.
Oil on canvas. 49" × 35½".
Hampton University Museum, Hampton, Virginia.

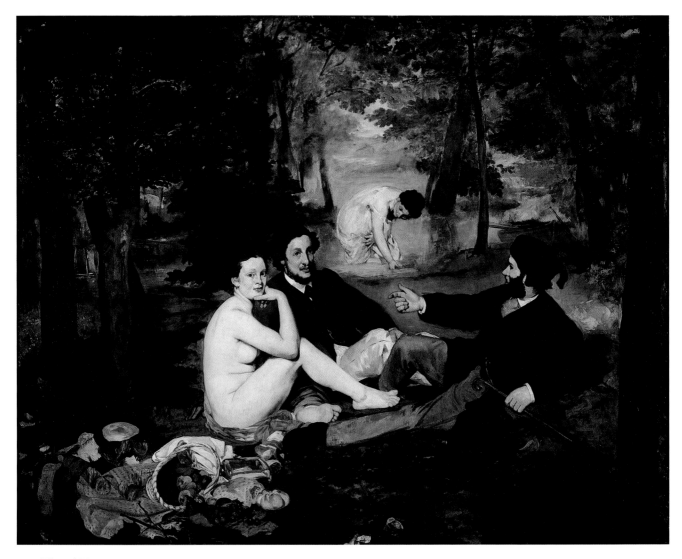

523 Edouard Manet.
LUNCHEON ON THE GRASS (LE DÉJEUNER SUR L'HERBE). 1863.
Oil on canvas. 84" × 106".
Photograph: Herve Lewandowski, Musée d' Orsay, Paris. © Reunion des Musées Nationaux/Art Resource, NY.

movement. Manet's painting LUNCHEON ON THE GRASS scandalized French critics and the public—because of the way it was painted as well as the subject matter. Manet painted the female figure without shading, employed flat patches of color throughout the painting, and left bare canvas in some places. He concentrated on the interplay among the elements of form that make up the composition: light shapes against dark, cool colors accented by warm colors, directional forces, and active balance. Manet's concern with visual issues over content or storytelling was revolutionary.

Renaissance illusion of depth is greatly diminished here. Manet's emphasis on the interaction of dark and light shapes and his deemphasis of both chiaroscuro and perspective cause us to look at the surface of the painting rather than simply through it as an illusionary window onto nature.

The juxtaposition of a female nude with males dressed in clothing of the time shocked viewers, but such a combination was not new. Nude and clothed figures in landscape derives from a tradition going back to Renaissance and even Roman compositions that depicted ancient myths or stories from the

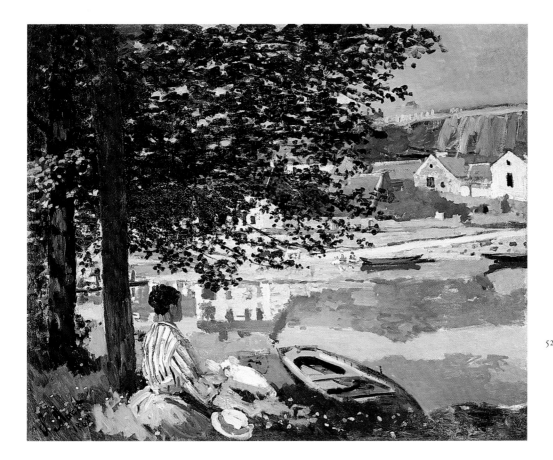

524 Claude Monet.
ON THE BANK OF THE
SEINE, BENNECOURT.
1868. Oil on canvas.
31¾" × 39¼".
Mr. and Mrs. Potter Palmer
Collection, 1922.427.
© 1998 The Art Institute of Chicago.
All rights reserved.

Bible. However, in Manet's painting, there is no allegory, no history, no mythology, and not even a significant title to suggest morally redeeming values. Manet based his composition (but not his meaning) on the figures in an engraving of a Renaissance drawing by Raphael, who in turn had been influenced by Roman relief sculpture.

It is ironic that Manet, who had such reverence for the art of the past, would be attacked by the public and the critics for his radical innovations. Simultaneously, he was championed by other artists as a leader of the avant-garde. Manet became the reluctant leader of an enthusiastic group of young painters who later formed the group known as the Impressionists.

Under Manet's influence, Claude Monet abandoned the use of heavy earth colors and broad-stroke painting techniques. Monet's painting ON THE BANK OF THE SEINE, like Manet's LUNCHEON, depicts figures outdoors. Monet had adopted Manet's color-patch technique and applied it to painting vivid colors generated by sunlight. Monet's idyllic glimpses of contemporary life, painted with an emphasis on qualities of light and color, are the beginnings of *Impressionism.*

IMPRESSIONISM

In 1874, a group of painters who had been denied the right to show in the Salon of 1873 organized an independent exhibition of their work. These artists, opposing academic doctrines and Romantic ideals, turned instead to the portrayal of contemporary life. They sought to paint "impressions" of what the eye actually sees rather than what the mind knows. This is no simple goal; we usually generalize what we think we see from the most obvious fragments. A river may become a uniform blue-green in our minds, whereas direct, unconditioned seeing shows a rich diversity of colors.

Landscape and ordinary scenes painted outdoors in varied atmospheric conditions, seasons, and times of day were among the main subjects of these artists.

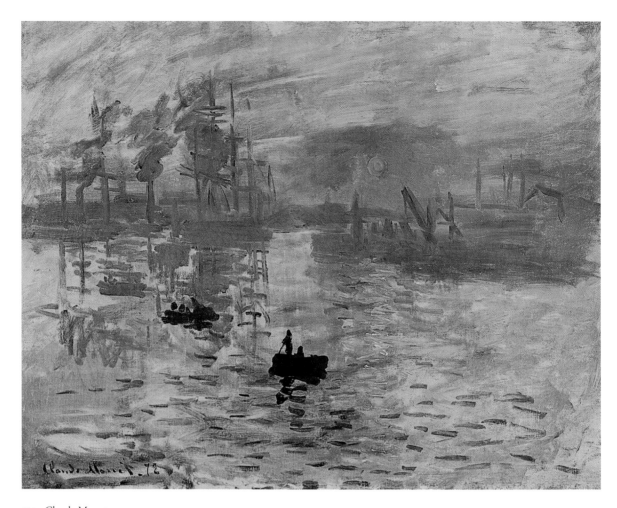

525 Claude Monet.

IMPRESSION: SUNRISE. 1872.

Oil on canvas. 19½" × 25½".

Musée Marmottan–Monet, Paris. The Bridgeman Art Library International Ltd.

They were dubbed Impressionists by a critic who objected to the sketchy quality of their paintings. The term was suggested by one of Monet's versions of IMPRESSION: SUNRISE. Although the critic's label was intended to be derogatory, the artists adopted the term as a fitting description of their work. The painterly application of Turner is applied to less emotional ends.

From direct observation and from studies in physics, the Impressionists learned that we see light as a complex of reflections received by the eye and re-assembled by the mind during the process of perception. Therefore they used small dabs of color that appear merely as separate strokes of paint when seen close up, yet become lively depictions of subjects when seen at a distance. Monet often applied strokes of pure color placed next to each other, rather than colors premixed or blended on the canvas. The viewer perceives a vibrancy that cannot be achieved with mixed color alone. The effect was startling to eyes accustomed to the muted, continuous tones of academic painting.

The Impressionists enthusiastically affirmed modern life. They saw the beauty of the world as a gift and the forces of nature as aids to human progress. Although misunderstood by their public, the Impressionists made visible a widely held optimism about the promise of the new technology.

526 CLAUDE MONET
on his eightieth birthday. 1920.
Collection Roger-Viollet.
Photograph: Liaison Agency.

CLAUDE MONET grew up in Le Havre, a bustling port town on the north coast of France. In high school, he developed a reputation for drawing caricatures. A local picture framer exhibited them in his shop, and there they caught the eye of a painter named Eugène Boudin.

Monet's senior by sixteen years, Boudin was a pioneer in the new practice of painting outdoors, working directly from nature. He encouraged Monet to pursue art seriously and invited him along on a painting excursion. The experience started Monet on the path he would follow all his life. "Boudin set up his easel and began to paint," Monet later recalled. "I looked on with some apprehension, then more attentively, and then suddenly it was as if a veil was torn from my eyes; I had understood. I had grasped what painting could be."[6]

Monet continued his studies in Paris, where he immersed himself in the lively artistic debates of the day. He met and admired the controversial painters Courbet and Manet. He met other art students, Renoir among them, who shared his passion for painting nature and modern life. In time, they would become famous as leading Impressionists.

Fame was long in coming, however; Monet was over forty before his paintings sold well enough to guarantee a living for himself and his family. In the meantime, life was difficult. From dawn to dusk he painted; in the evening, by lamplight, he wrote letters—letters asking for money, letters stalling creditors, letters trying to arrange for his work to be seen and sold.

As Monet's artistic vision deepened, he realized that every shift in light and atmosphere created a new subject. He would arrive at a site with as many as a dozen canvases, working on each one in turn as the light changed. His painting grew increasingly subjective as he strove to express not only light but his feelings about the changing qualities of light. Relentlessly self-critical, he was often driven to despair by his work, and he destroyed dozens of canvases he considered failures.

In back of his house at Giverny, the small town outside Paris where he finally settled, Monet created a water lily pond that became the favorite subject of his final years. In old age, he embarked on one of his most ambitious projects: a series of huge paintings of the water surface, its shimmering reflections of sky and clouds punctuated with floating flowers. Shown end to end, they form dazzling panoramas over six feet tall and twenty-eight feet long. Monet intended them as a gift to the French government, and one of his last acts before he died was to send a letter declaring them finished.

As you read in the next chapter about the radical movements that followed World War I, remember that the last and purest of the Impressionists was still painting from dawn to dusk every day, creating masterpieces of Impressionism long after the course of "art history" had moved on.

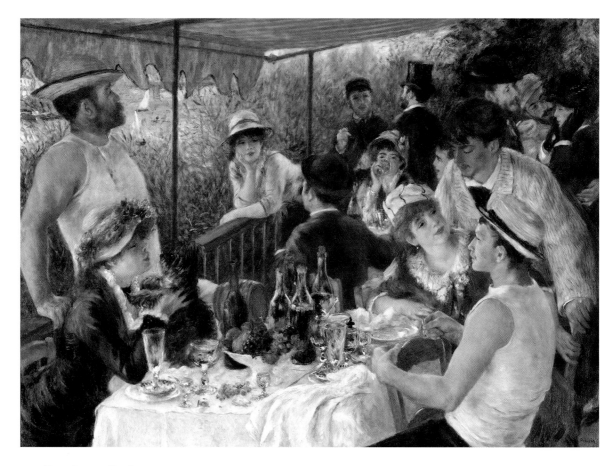

527 Pierre-Auguste Renoir.
THE LUNCHEON OF THE BOATING PARTY. 1876.
Oil on canvas. 51¼" × 68⅛".
The Phillips Collection, Washington, D.C.

Impressionism was strongest between 1870 and 1880. After 1880, it was Claude Monet who continued for more than forty years to advance Impressionism's original premise. Instead of painting from sketches, he and most of the others in the group painted outdoors. Monet returned to the same subjects again and again in order to record the moods and qualities of light at different times of day and at different seasons.

Renoir's THE LUNCHEON OF THE BOATING PARTY depicts a popular Impressionist theme: middle-class people enjoying leisure activities along the Seine, the river that flows through Paris. These paintings also reveal similarities and differences between the styles of the two painters.

Monet's concern with the visual phenomena of light and color contrasts with the later work by Renoir, who by then was more concerned with composition. In THE LUNCHEON OF THE BOATING PARTY, as in Monet's paintings, rich colors, highlights, and shadows create a lively surface. But by 1881, Renoir had begun to move away from the lighter, more diffuse Impressionist imagery of the 1870s toward more solid forms and more structured design. Renoir's disregard for true linear perspective, as seen in the lines of the railing and table top, reflects the declining interest in naturalistic illusions of depth. More obvious is his interest in portraying the solidity of the figures in a memorable composition.

The young men and women depicted are conversing, sipping wine, and generally enjoying the moment. The Industrial Revolution had created an urban middle class with leisure, a love of the new

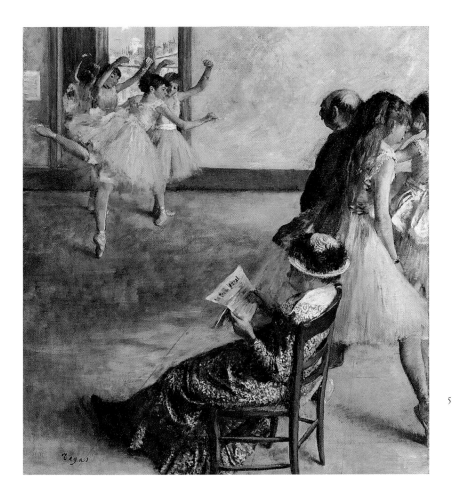

528 Edgar Degas.
THE BALLET CLASS.
c. 1879–1880.
Oil on canvas. 32⅜" × 30¼".
Philadelphia Museum of Art.
Purchased with the W. P. Wilstach Fund.
W1937–2–1.

technology, and a taste for fashion—and the Impressionists chronicled their lives.

Edgar Degas exhibited with the Impressionists, although his approach differed from theirs. He shared with the Impressionists a directness of expression and an interest in portraying contemporary life, but he combined the immediacy of Impressionism with a highly inventive structured approach to design not found in the work of those painters. Degas, along with the Impressionists, was influenced by the new ways of seeing and composing that he saw in Japanese prints and unposed street-scene photography.

Conventional European compositions placed subjects within a central zone. Degas, however, used surprising, lifelike compositions and effects that often cut figures at the edge. The tipped-up ground planes and bold asymmetry found in Japanese prints

inspired Degas to create paintings filled with intriguing visual tensions, such as those in THE BALLET CLASS, in which two diagonal groups of figures appear on opposite sides of an empty center.

Degas depicted ballet classes in ways that showed their unglamorous character. Often, as here, he was able to turn his great ability to the task of defining human character and mood in a given situation. The painting builds from the quiet, disinterested woman in the foreground, up to the right, then across to the cluster of dancing girls, following the implied sightline of the ballet master. The stability of the group on the right contrasts with the smaller, irregular shape of the girls before the mirror. Degas managed to balance spatial tensions between near and far and to create interesting contrasts between stable and unstable, large and small. He emphasized the line in the floor, which he brought

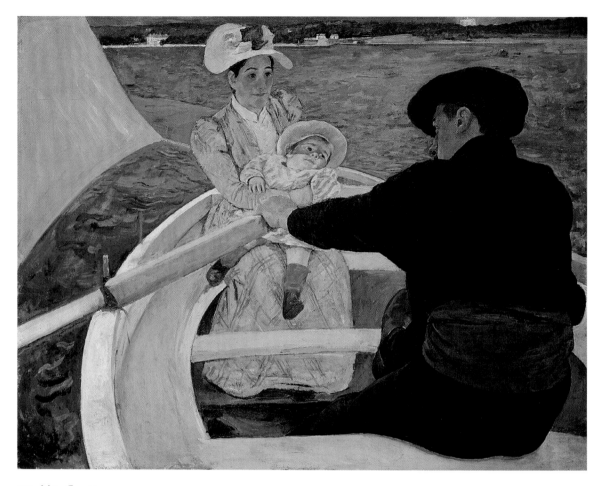

529 Mary Cassatt.
THE BOATING PARTY. 1893–1894.
Oil on canvas. 35⁷⁄₁₆" × 46⅛"; framed 44⅛" × 54¼".
Chester Dale Collection. Photograph: © 2001 Board of Trustees, National Gallery of Art,
Washington, D.C. 1963.10.94.(1758)PA.

together with the top of the woman's newspaper to guide the viewer's eye. The angle of the seated woman's foot brings us around to begin again.

American painter Mary Cassatt went to Paris in the late 1860s to further her artistic development. She was strongly influenced by the work of Manet and Degas. Following an invitation by Degas, she joined and exhibited with the Impressionists. Later, she was among the many European and American artists who were influenced by Japanese prints and casual compositions of late nineteenth-century do-it-yourself photography. A resemblance to Japanese prints is readily apparent in the simplicity and bold design of THE BOATING PARTY. Cassatt refined her subject in sweeping curves and almost flat shapes.

There is, in addition, subtle feminist content in this work. The difference in clothing styles between the woman and the man shows that she has hired him to take her and the child out for a boat ride. This was an unusually assertive thing for a woman to do for herself in those days, and the glances between all three persons in the painting show some of the social tension that would have accompanied this event. The work is typical of Cassatt in its focus on the world of women and their concerns.

Painters such as Manet, Monet, Renoir, Degas, and Cassatt rejected the artificial poses and limited color prescribed by the Academy. Because they rebelled against accepted styles, they made few sales in their early years. Many who were considered

outsiders, set apart from the conventional art of their time, we now consider masters of nineteenth-century art and precursors of twentieth-century art.

The Impressionist group disbanded after its exhibition in 1886, but its influence was immeasurable—in spite of the fact that Impressionist paintings were looked upon with indifference, even hostility, by most of the public and the critics until the 1920s. From the perspective of our time, Impressionism was the most important artistic movement of the nineteenth century.

French artist Auguste Rodin was at least as important to sculpture as his contemporaries, the Impressionist and Post-Impressionist painters, were to painting. Rodin became the first sculptor since Bernini (see page 280) to return sculpture to the status of a major art form, renewed with emotional and spiritual depth.

In 1875, after training as a sculptor's helper, Rodin traveled to Italy where he was impressed by the work of the Renaissance masters Donatello and Michelangelo. Rodin was the first to use Michelangelo's unfinished pieces (see page 181) as an inspiration for making rough finish an expressive quality. In contrast to Michelangelo, however, Rodin was primarily a modeler rather than a carver.

In 1880, he was commissioned to make a bronze door, *The Gates of Hell,* for a proposed museum of decorative arts. The large project was unfinished at Rodin's death, but many of the figures that are part of the door, including THE THINKER, modeled in clay and cast in bronze, and THE KISS, carved in marble (page 31), were enlarged as independent pieces. Of THE THINKER, Rodin wrote that his first inspiration had been Dante, but he rejected the idea of a thin, ascetic figure.

Guided by my first inspiration I conceived another thinker, a naked man, seated upon a rock, his feet drawn under him, he dreams. The fertile thought slowly elaborates itself within his brain. He is no longer dreamer, he is creator.[7]

In the place of Christ in judgment, often seen over the doorways of medieval churches, Rodin projects

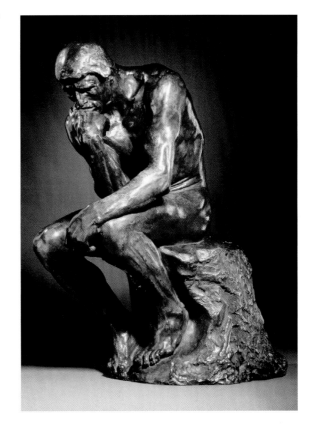

530 Auguste Rodin.
THE THINKER (LE PENSEUR). c. 1910.
Bronze. Life-size.
Christie's Images/Super Stock.

the universal artist/poet as creator, judge, and witness, brooding over the human condition. Rodin combined a superb knowledge of anatomy with modeling skill to create the fluid, tactile quality of hand-shaped clay. He restored sculpture as a vehicle for personal expression after it had lapsed into mere decoration and heroic monuments.

THE POST-IMPRESSIONIST PERIOD

Post-Impressionism refers to trends in painting starting in about 1885 that followed Impressionism. The Post-Impressionist painters did not share a single style; rather, they built on or reacted to Impressionism in highly individual ways. Some felt that Impressionism had sacrificed solidity of form and composition for the sake of momentary impressions. Others felt that Impressionism's emphasis on the direct observation of nature and everyday life did not

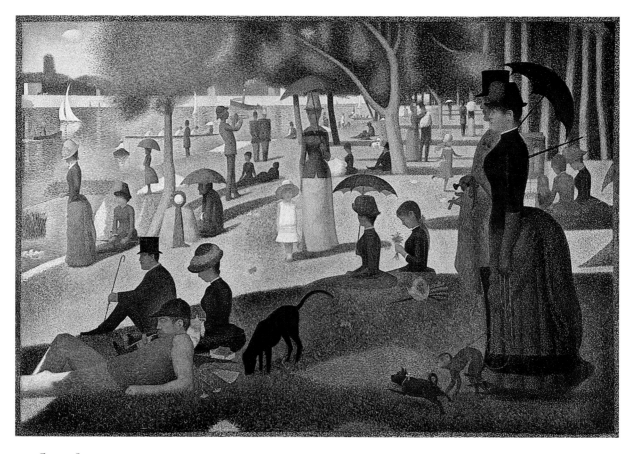

531 Georges Seurat.
A SUNDAY ON LA GRANDE JATTE. 1884–1886.
Oil on canvas. 81" × 120⅜".
Helen Birch Bartlett Memorial Collection. 1926.224.
Photograph: © The Art Institute of Chicago. All rights reserved.

leave enough room for personal expression or spiritual content. Among those whose works best exemplify Post-Impressionist attitudes were Dutch artist Vincent van Gogh and French artists Paul Gauguin, Georges Seurat, and Paul Cézanne.

Gauguin and van Gogh brought to their work expressive, emotional intensity and a desire to make their thoughts and feelings visible. They often used strong color contrasts, shapes with clear contours, bold brushwork, and, in van Gogh's case, vigorous paint textures. Their art greatly influenced twentieth-century expressionist styles.

Seurat and Cézanne were interested in developing formal structure in their paintings. Each in his own way organized visual form to achieve structured clarity of design. Their paintings influenced twentieth-century formalist styles.

Cézanne and Seurat based their work on the observation of nature, and both used visibly separate strokes of color to build rich surfaces. Seurat's large painting A SUNDAY ON LA GRANDE JATTE has the subject matter, light, and color qualities of Impressionism, but this is not a painting of a fleeting moment. It is a carefully constructed composition of lasting impact. Seurat set out to systematize the optical color mixing of Impressionism and to create a more solid, formal organization with simplified shapes. He called his method *divisionism*, but it is more popularly known as *pointillism*. With it, Seurat tried to develop and apply a "scientific" technique. He arrived at his method by studying the principles of color optics that were being formulated at the time. Through the application of tiny dots of color, Seurat achieved a vibrant surface based on optical mixture (see page 65 for a detail).

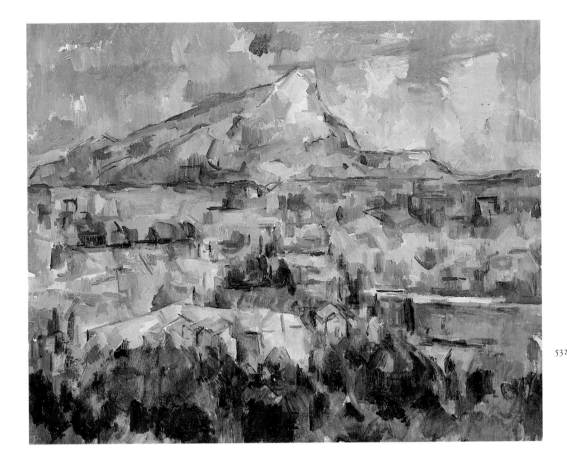

532 Paul Cézanne.
MONT SAINTE-VICTOIRE.
1902–1904.
Oil on canvas.
27½" × 35¼".
Philadelphia Museum of Art/
The George W. Elkins Collection.
E1936-1-1.

Seurat preceded A SUNDAY ON LA GRANDE JATTE with more than fifty drawn and painted preliminary studies in which he explored the horizontal and vertical relationships, the character of each shape, and the patterns of light, shade, and color. The final painting shows the total control that Seurat sought through the application of his method. The frozen formality of the figures seems surprising, considering the casual nature of the subject matter; yet it is precisely this calm, formal grandeur that gives the painting its strength and enduring appeal.

Like Seurat, Cézanne sought to achieve strength in the formal structure of his paintings. "My aim," he said, "was to make Impressionism into something solid and enduring like the art of the museums."[8]

Cézanne saw the planar surfaces of his subjects in terms of color modulation. Instead of using light and shadow in a conventional way, he relied on carefully developed relationships between adjoining strokes of color to show solidity of form and receding space. He questioned, then abandoned, linear and atmospheric perspective and went beyond the appearance of nature, to reconstruct it according to his own interpretation.

Landscape was one of Cézanne's main interests. In MONT SAINTE-VICTOIRE, we can see how he flattened space yet gave an impression of air and depth with some atmospheric perspective and the use of warm advancing and cool receding colors. The dark edge lines around the distant mountain help counter the illusion of depth. There is an important interplay between the illusion of depth and the fact of strokes of color on a flat surface. Cézanne simplified the houses and trees into patches of color that suggest almost geometric planes and masses. His open (not blended) brush strokes and his concept of a geometric substructure in nature and art offered a new range of possibilities to later artists. Of the many painters working in France around the turn of the century, Cézanne had the most lasting effect on the course of painting in the twentieth century. His art both built on, and departed from, Impressionism.

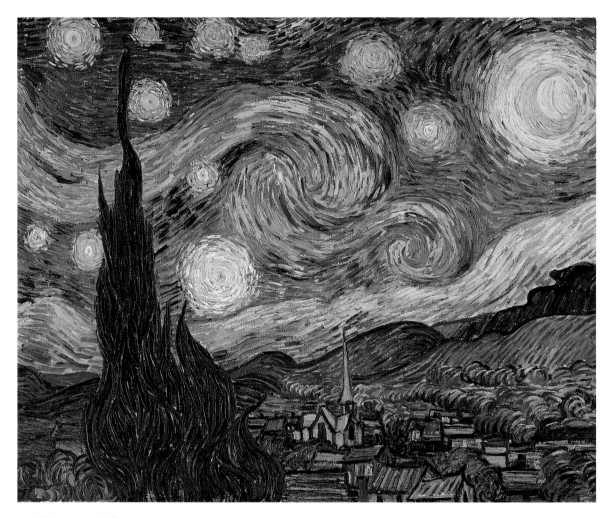

536 Vincent van Gogh.
THE STARRY NIGHT. 1889.
Oil on canvas. 29" × 36¼" (73.7 × 92.1 cm).
The Museum of Modern Art, NY/Licensed by Scala-Art Resource, NY.
Photograph: The Museum of Modern Art, New York.

A strong desire to share personal feelings and insights motivated van Gogh. In THE STARRY NIGHT, his observation of a town at night became the point of departure for a powerful symbolic image. Hills seem to undulate, echoing tremendous cosmic forces in the sky. The small town nestled into the dark forms of the ground plane suggests the scale of human life. The church's spire reaches toward the heavens, echoed by the larger, more dynamic upward thrust of the cypress trees in the left foreground. (The evergreen cypress is traditionally planted beside graveyards in Europe as a symbol of eternal life.)

All these elements are united by the surging rhythm of lines that express van Gogh's passionate spirit and mystical vision. Many know of van Gogh's bouts of mental illness, but few realize that he did his paintings between seizures, in moments of great clarity.

French artist Paul Gauguin, like van Gogh, was highly critical of the materialism of industrial society. This attitude led Gauguin to admire the honest life of the Brittany peasants of western France. In 1888, he completed THE VISION AFTER THE SERMON, the first major work in his revolutionary new style. The large, carefully designed painting shows Jacob and the angel

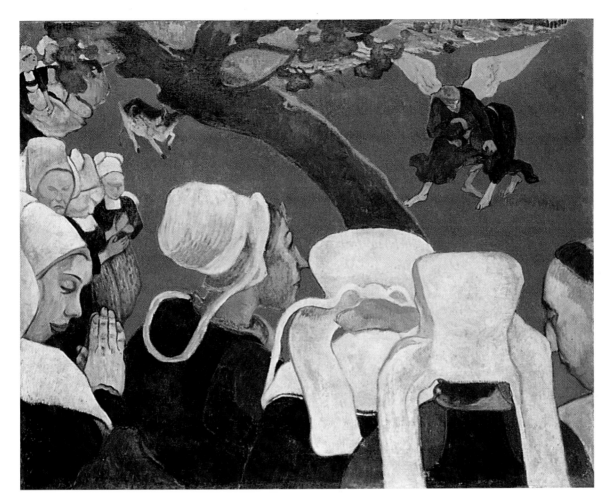

537 Paul Gauguin.
THE VISION AFTER THE SERMON (JACOB WRESTLING WITH THE ANGEL). 1888.
Oil on canvas. 28¾" × 36½".
National Gallery of Scotland, Edinburgh.

as they appear to a group of Brittany peasants in a vision inspired by the sermon in their village church.

The symbolic representation of unquestioning faith is an image that originated in Gauguin's mind rather than in his eye. With it, Gauguin took a major step beyond Impressionism. In order to avoid what he considered the distraction of implied deep space, he tipped up the simplified background plane and painted it an intense, "unnatural" vermilion. The entire composition is divided diagonally by the trunk of the apple tree, in the manner of Japanese prints. Shapes have been reduced to flat curvilinear areas outlined in black, with shadows minimized or eliminated.

Both van Gogh's and Gauguin's uses of color were important influences on twentieth-century painting. Their views on color were prophetic. The subject, Gauguin wrote, was only a pretext for symphonies of line and color.

In painting, one must search rather for suggestion than for description, as is done in music. . . . Think of the highly important musical role which colour will play henceforth in modern painting.[12]

Gauguin retained memories of his childhood in Peru that persuaded him that the art of ancient and non-Western cultures had a spiritual strength

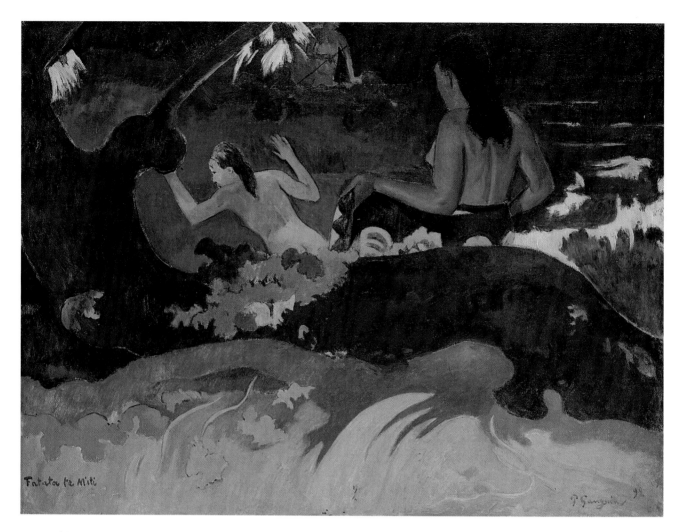

538 Paul Gauguin.
FATATA TE MITI (BY THE SEA). 1892.
Oil on canvas, 67.9 × 91.5 cm. (26¾" × 36").
Chester Dale Collection. Photograph © 2002 Board of Trustees, National Gallery of Art, Washington, D.C. 1963.10.149. (1813)/PA.

that was lacking in the European art of his time. He wrote:

Keep the Persians, the Cambodians, and a bit of the Egyptians always in mind. The great error is the Greek, however beautiful it may be.[13]

A great thought system is written in gold in Far Eastern art.[14]

Gauguin's desire to rejuvenate European art and civilization with insights from non-Western traditions would be shared in the early twentieth century by Matisse, Picasso, and the German Expressionists. They adopted Gauguin's vision of the artist as a spiritual leader who could select from the past, and from various world cultures, anything capable of releasing the power of self-knowledge and inner life.

At the end of his life, Gauguin tried to break completely with European civilization by going to Tahiti. In FATATA TE MITI, he combined flat, curvilinear shapes with tropical and fanciful colors.

For Gauguin, art had become above all a means of communicating through symbols, a "synthesis," he called it, of visual form carrying memory, feelings, and ideas. These beliefs link him to *Symbolism,* a

"**I want to establish** the right to dare everything," Gauguin wrote on the eve of his death.[15] Battered by bronchitis, neuralgia, syphilis, and a series of strokes, alone, impoverished, and halfway around the world from France, Gauguin had indeed dared everything—not only in his art, but in his life.

Paul Gauguin was twenty-three when a family friend introduced him to the world of art and artists. Immersing himself in the new art of his day, he collected works by Cézanne, Degas, and others, and he began to paint in his spare time. By 1879, he was exhibiting with the Impressionist artists he so admired. His job as a stockbroker had become an unbearable distraction, and when he lost it in the aftermath of a financial crash a few years later, he decided not to look for another: He would be an artist. He was then thirty-five, with a pregnant wife and four children. It quickly became clear that he could not support his family as an artist, and after two years of arguments and compromises, his wife moved back to her family, taking the children with her.

Gauguin sought a place to paint that would nourish his vision of an art in touch with the primal mysteries of life. He moved first to Brittany, drawn to the primitive lives of the Breton peasants. In 1887, he painted on the Caribbean island of Martinique, but he fell ill, ran out of money, and had to return to France. The following year he joined van Gogh in the south of France, but their idealistic plans for an artists' commune disintegrated into disastrous quarrels.

Convinced that he had to escape the "disease of civilization," Gauguin voyaged to Tahiti in 1891. He left its Westernized capital, Papeete, for a grass hut in a remote village, where he took a teenage bride, fathered a child, and steeped himself in the island's myths and legends. Despite the pressure of constant poverty, Gauguin transformed the raw material of Tahiti into a dream of earthly paradise, where a sensual people lived in harmony with their gods.

In 1893, Gauguin returned to France, confident that his Tahitian work would bring him success. It did not come. Lonely and disillusioned, he returned to Tahiti in 1895 and found it more Westernized than before. Frustrated and angry, he fought with the colonial authorities and railed against the missionaries. His health was failing rapidly, he was desperate for money, and he grew so despondent he attempted suicide. Again he set off in search of a simpler life, sailing in

539 Paul Gauguin.
PORTRAIT OF THE ARTIST WITH THE IDOL.
c. 1893.
Oil on canvas. 17¼" × 12⅞".
Collection of the McNay Art Museum, Bequest of Marion Koogler McNay.

1901 to the Marquesas Islands, where he died two years later.

"It is true that I know very little," Gauguin wrote to a friend. "But who can say if even this little, worked on by others, will not become something great?"[16] In Paris, in 1906, a large retrospective of Gauguin's work made the extent of his achievement clear for the first time. His achievement was considerable, and, built on by Picasso, Matisse, and many others, his "little" did indeed become something great.

540 Henri de Toulouse-Lautrec.
AT THE MOULIN ROUGE. 1892–1895.
Oil on canvas. 48⅜" × 55¼".

movement in literature and the visual arts that developed around 1885.

Reacting against both Realism and Impressionism, Symbolist poets and painters sought to lift the mind from the mundane and the practical. They employed decorative forms and symbols that were intentionally vague or open-ended in order to create imaginative suggestions. The poets held that the sounds and rhythms of words were part of their poems' deeper meaning; the painters recognized that line, color, and other visual elements were expressive in themselves. Symbolism, a trend rather than a specific style, provided the ideological background for twentieth-century abstraction; it has been seen as an outgrowth of Romanticism and a forerunner of Surrealism.

Henri de Toulouse-Lautrec, another Post-Impressionist, painted the gaslit interiors of Parisian nightclubs and brothels. His quick, long strokes of color define a world of sordid gaiety. Toulouse-Lautrec was influenced by Degas (see page 367), whose work he greatly admired. In AT THE MOULIN ROUGE, Toulouse-Lautrec used unusual angles, cropped images, such as the face on the right, and

expressive, unnatural color to heighten feelings about the people and the world he painted. His paintings, drawings, and prints of Parisian nightlife influenced twentieth-century's expressionist painters and his posters influenced graphic designers (see page 000).

Norwegian painter Edvard Munch traveled to Paris to study the works of his contemporaries, especially Gauguin, van Gogh, and Toulouse-Lautrec. What he learned from them, particularly from Gauguin's works, enabled him to carry Symbolism to a new level of expressive intensity. Munch's powerful paintings and prints explore depths of emotion—grief, loneliness, fear, love, sexual passion, jealousy, and death.

In THE SCREAM Munch takes the viewer far from the pleasures of Impressionism and extends considerably van Gogh's expressive vision. In this powerful image of anxiety, the dominant figure is caught in isolation, fear, and loneliness. Despair reverberates in continuous linear rhythms. Munch's image has been called the soul-cry of that age.

The nineteenth-century invention of photography, along with the discovery of non-Western art and the rediscovery of pre-Renaissance art, strongly affected the direction of Western art. As the century progressed, artists sought a deeper reality by breaking away from the artificial idealism of officially recognized academic art.

This fresh beginning was full of self-assurance, as seen in the optimistic mood of Impressionism. Yet the process of seeing the visual world anew brought with it added levels of awareness, as the appearance of things came to be less important than the relationship between viewer and reality. Once again, it became the artist's task to probe and reveal hidden worlds, to make the invisible visible. Artists gave increasing importance to the elements of form and to the formal structure of seen and invented imagery. Nature was internalized and transformed in order to portray a greater reality as the stage was set for even bigger changes in the twentieth century.

541 Edvard Munch.
THE SCREAM. 1893.
Casin on canvas, 37⅞" × 29". (91 × 73 cm).
National Gallery, Oslo. © 2003. The Munch Museum–Ellingsen Group/Artists Rights Society (ARS), NY/ADAGP, Paris. Scala/Art Resource, NY.

544 Henri Matisse.
JOY OF LIFE. 1905–1906.
Oil on canvas. 69⅛" × 94⅞" (175 × 241 cm).
Photograph © Reproduced with Permission of The Barnes Foundation™, Merion, PA.
SuperStock. © 2004 Succession H. Matisse, Paris/Artists Rights Society (ARS), NY.

Matisse's painting JOY OF LIFE is an early work in a long career and a masterpiece of Fauvism. Pure hues vibrate across the surface; lines, largely freed from descriptive roles, align with simplified shapes to provide a lively rhythm in the composition. The seemingly careless depiction of the figures is based on Matisse's knowledge of human anatomy and drawing. The intentionally direct, childlike quality of the form serves to heighten the joyful content. Matisse said, "What I am after, above all, is expression".

In Derain's LONDON BRIDGE, brilliant, invented color is balanced by some use of traditional composition and perspective. Derain spoke of intentionally using discordant color. It is an indication of today's acceptance of strong color that Derain's painting does not appear disharmonious.

The Fauve movement lasted little more than two years, from 1905 to 1907, yet it was one of the most influential developments in early twentieth-century painting. The Fauves took decisive step in freeing color from its traditional role of describing the natural appearance of an object. In this way, their work led to an increasing use of color as an independent expressive element.

We can categorize Fauvism as an expressive style. *Expressionism* is a general term for art that emphasizes inner feelings and emotions over objective

545 André Derain.
LONDON BRIDGE. 1906.
Oil on canvas. 26" × 39".
The Museum of Modern Art, NY/Licensed by Scala-Art Resource, NY.
Gift of Mr. and Mrs. Charles Zadok.
Photograph © 2002 The Museum of Modern Art, New York.
© 2002 Artists Rights Society (ARS), NY, ADAGP, Paris.

depiction. In Europe, romantic or expressive tendencies can be traced from seventeenth-century Baroque art to the early nineteenth-century painting of Delacroix, who in turn influenced the expressive side of Post-Impressionism (particularly van Gogh).

A few German artists at the beginning of the century shared the expressionist goals of the Fauves. Their desire to express attitudes and emotions was so pronounced and sustained that we call their art *German Expressionism*. They developed imagery characterized by vivid, often angular simplifications of their subjects, dramatic color contrasts, with bold, at times crude finish. These techniques added emotional intensity to their works. Like their Fauve counterparts, the German Expressionists built on the achievements of Gauguin and van Gogh and the soul-searching paintings of Munch. They felt compelled to use the power of expressionism to ad-

dress the human condition, often exploring such themes as natural life, sorrow, passion, spirituality, and mysticism. As their art developed, it absorbed formal influences from medieval German art, Fauvism, Slavic folk art, African and Oceanic art, and Cubism.

Two groups typified the German Expressionist movement of the early twentieth century: the Bridge (*die Brücke*) and the Blue Rider (*der blaue Reiter*). Ernst Ludwig Kirchner, architecture student turned painter, was the founder of the Bridge. The group included several of his fellow architectural students, Emil Nolde, and others. They appealed to artists to revolt against academic painting and establish a new, vigorous aesthetic that would form a bridge between the Germanic past and modern experience. They first exhibited as a group in 1905, the year of the first Fauve exhibition.

546 Ernst Ludwig Kirchner.
STREET, BERLIN. 1913.
Oil on canvas.
47½" × 35⅞".
The Museum of Modern Art, NY./
Licensed by Scala-Art Resource, NY. Purchase.
Photograph © 2002 The Museum of Modern Art, New York.

chopped out shapes, and rough, almost crude, brushwork heighten the emotional impact.

The Blue Rider group was led by Russian painter Wassily Kandinsky, who lived in Munich between 1908 and 1914 and who shared with his German associates a concern for developing an art that would turn people away from false values, toward spiritual rejuvenation. He believed that a painting should be "an exact replica of some inner emotion"; in BLUE MOUNTAIN, painted in 1908, he created a "choir of colors" influenced by the vivid, freely expressive color of the Fauves.[2]

Kandinsky's paintings evolved toward an absence of representational subject matter. In BLUE MOUNTAIN, subject matter had already become secondary to the powerful effect of the visual elements released from merely descriptive roles.

By 1910, Kandinsky had made the shift to totally nonrepresentational imagery in order to concentrate on the expressive potential of pure form freed from associations with recognizable subjects. He sought a language of visual form comparable to the independent aural language we experience in music. The rhythms, melodies, and harmonies of music please or displease us because of the way they affect us. By titling his painting WITH THE BLACK ARCH NO. 154, Kandinsky referred to the dominant visual element in the painting, which is similar to a composer's naming a composition "Symphony No. 2 in D Major." Weightless curves float across large free shapes in a painted world of interactive energies.

Kandinsky said that the content of his paintings was "what the spectator *lives* or *feels* while under the effect of the *form and color combinations* of the picture."[3] He was an outstanding innovator in the history of art, and his revolutionary nonfigurative works played a key role in the development of subsequent nonrepresentational styles. His purpose was not simply aesthetic: he saw his paintings as leading a way through an impending period of catastrophe to a great new era of spirituality. Kandinsky felt art could provide a spiritual nourishment for the modern world—a level of fulfillment no longer offered by religion.

Kirchner's concern for expressing human emotion gave his work a quality similar to that which he admired in Munch's work. Kirchner's early paintings employed the flat color areas of Fauvism; by 1913, he had developed a style that incorporated the angularities of Cubism (discussed presently), African sculpture, and German Gothic art. In STREET, BERLIN, elongated figures are crowded together with the use of repeated diagonal lines to create an urban atmosphere charged with energy. Dissonant colors,

547 Wassily Kandinsky.
BLUE MOUNTAIN (DER BLAUE BERG).
1908–1909.
Oil on canvas. 41¾" × 38".
The Solomon R. Guggenheim Museum, NY. Gift, Solomon
R. Guggenheim, 1941.41.505. Photograph by David Heald.
© The Solomon R. Guggenheim Foundation, NY.
© 2002 Artists Rights Society (ARS), NY/ADAGP, Paris.

548 Wassily Kandinsky.
WITH THE BLACK ARCH NO. 154. 1912.
Oil on canvas. 74" × 77⅛".
Cliche phototheque des Collections du Centre Georges
Pompidou/Musée national d'art moderne, Paris.
Photo: Phillippe Migeat © Centre G. Pompidou
© 2002 Artists Rights Society (ARS), NY/ADAGP, Paris.
© CNAC/MNAM/Dist. Reunion de Musées Nationaux/
Art Resource, NY.

CUBISM

While living in Paris, Spanish artist Pablo Picasso shared ideas and influences with French artist Georges Braque. Together they pursued investigations that led to Cubism, the most influential movement of the early twentieth century. Cubism heavily influenced the spatial design (basic visual structure) of many of the notable paintings and sculptures of the century. In terms of design, color contributes to but is secondary to structure. Through its indirect influence on architecture and the arts, Cubism has become part of our daily lives.

Picasso absorbed influences quickly, keeping only what he needed to achieve his objectives. His breakthrough painting, LES DEMOISELLES D'AVIGNON (on the following page), shows a radical departure from tradition. Rejecting the accepted European notion of ideal beauty, Picasso created an entirely personal vocabulary of form influenced by Cézanne's faceted

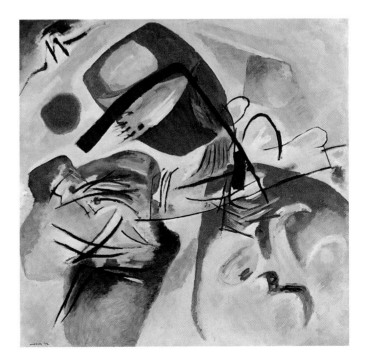

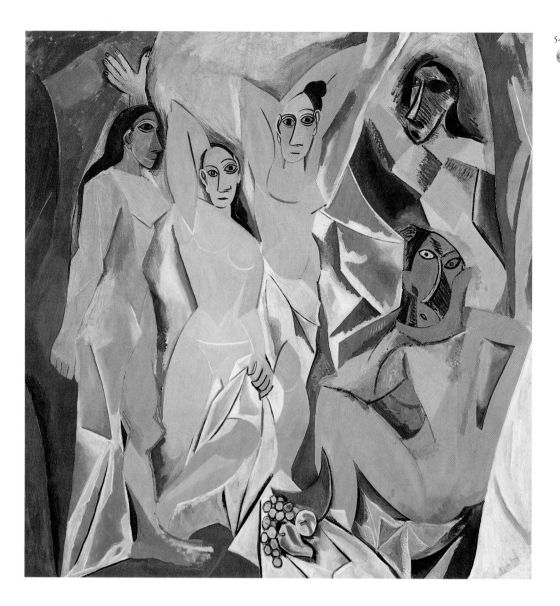

reconstructions of nature and by the inventive abstraction, vitality, and power he admired in African sculpture such as the KOTA RELIQUARY FIGURE and the MASK FROM IVORY COAST. While the meanings and uses of African sculpture held little interest for him, their form revitalized his art.

Picasso's new approach astonished even his closest friends. Georges Braque, who did as much as Picasso to develop Cubism, was appalled when he first saw LES DEMOISELLES in 1907. "You may give all the explanations you like," he said, "but your painting makes one feel as if you were trying to make us eat cotton waste and wash it down with kerosene."[4] In

LES DEMOISELLES D'AVIGNON, the fractured, angular figures intermingle with the sharp triangular shapes of the ground, activating the entire picture surface. This reconstruction of image and ground, with its fractured triangulation of forms and its merging of figure and ground was the turning point. With this painting, Picasso exploded the lingering Renaissance approach to the human figure in art and the legacy of Renaissance perspective. In short, he overturned many of the traditions of Western art. LES DEMOISELLES thus set the stage and provided the impetus for the development of Cubism. Though some art historians have come to decry the work's negative

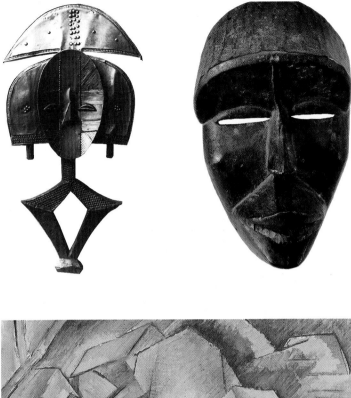

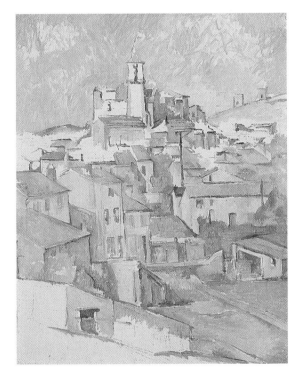

depiction of women, viewers are challenged by the painting's hacked-out shapes and overall intensity.

A comparison of two paintings—Cézanne's GARDANNE, completed in 1886, and Braque's HOUSES AT L'ESTAQUE, completed in 1908, shows the beginning of the progression from Cézanne's Post-Impressionist style to the Cubist approach developed by Braque and Picasso.

Picasso made the first breakthrough, but Braque did more to develop the vocabulary of Cubism. Braque admired Cézanne's continuous probing, his doubt, and his dogged determination to get at the truth of his subjects. In a series of landscapes painted in the south

553 Georges Braque.
 HOUSES AT L'ESTAQUE. 1908. Oil on canvas. 28½" × 23".
 Foundation RUPF, Bern, Switzerland. Giraudon/Art Resource, NY.
 © 2002 Artists Rights Society (ARS), NY/ADAGP, Paris.

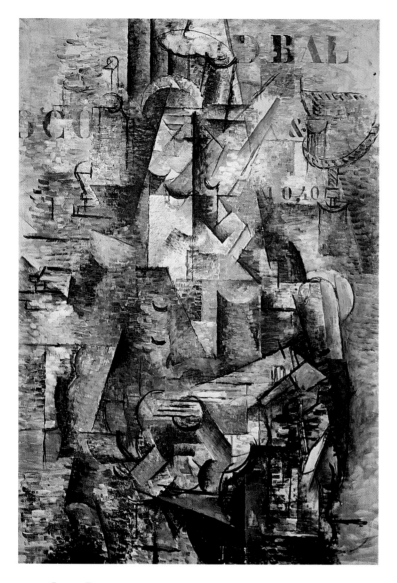

554 Georges Braque.
THE PORTUGUESE. 1911.
Oil on canvas. 46" × 32".
Kunstmuseum, Basel, Switzeland. Giraudon/Art Resource, NY.
© 2002 Artists Rights Society (ARS), New York/ADAGP, Paris.

name: When Matisse saw this painting, he declared it to be a bunch of little cubes. From 1908 to 1914, Braque and Picasso were jointly responsible for bringing Cubism to maturity. They worked for a time in increasingly neutral tones, in an effort to achieve formal structure devoid of the emotional distractions of color.

By 1910, Cubism had become a fully developed style. During the *analytical* phase of Cubism (1910 to 1911), Picasso, Braque, and others analyzed their subjects from various angles, then painted abstract, geometric references to these views. Because mental concepts of familiar objects are based on experiences of seeing many sides, they aimed to show objects as the mind, rather than the eye, perceives them. Georges Braque's THE PORTUGUESE is a portrait of a man sitting at a café table strumming a guitar. The subject is broken down into facets and recombined with the background. Figure and ground thus collapse into a shallow and jagged pictorial space.

Cubism was a rational, formalist counterpart to the subjective emphasis of the Fauves and other expressionists. Above all, it was a reinvention of pictorial space. The Cubists realized that the two-dimensional space of the picture plane was quite different from the three-dimensional space we occupy. Natural objects were points of departure for abstract images, demonstrating the essential unity of forms within the spaces that surround and penetrate them. Cubism is a reconstruction of objects based on geometric abstraction. By looking first at Cézanne's GARDANNE, then at Braque's HOUSES AT L'ESTAQUE, and finally at THE PORTUGUESE, we see a progression in which forms seem to build, then spread across the surface in interwoven planes.

A new kind of construction of planes in actual space came about when Picasso assembled his sheet-metal GUITAR and thereby extended the Cubist revolution to sculpture. It began a dominant trend toward sculptural construction: Before GUITAR, most sculpture was carved or modeled. Since GUITAR, much of contemporary sculpture has been constructed.

In 1912, Picasso and Braque modified Analytical Cubism with color, textured and patterned

of France (where Cézanne had worked), Braque took Cézanne's faceted planar constructions a step further.

Instead of the regular perspective that had been common in European painting since the Renaissance, Braque's shapes define a rush of forms that pile up rhythmically in shallow, ambiguous space. Buildings and trees seem interlocked in an active space that pushes and pulls across the picture surface.

HOUSES AT L'ESTAQUE, one of the first Cubist paintings, provided the occasion for the movement's

surfaces, and the use of cutout shapes. The resulting style came to be called Synthetic Cubism. Artists used pieces of newspaper, sheet music, wallpaper, and similar items, not re-presented but actually *presented* in a new way. The newspaper in THE VIOLIN is part of a real Paris newspaper. The shapes, which in earlier naturalistic, representational paintings would have been "background," have been made equal in importance to foreground shapes. Picasso chose traditional still-life objects; but rather than paint the fruit, he cut out and pasted printed images of fruit. Such compositions, called *papier colle* in French, or pasted paper, became known as *collage* in English. Analytical Cubism involved taking apart, or breaking down, the subject into its various aspects; Synthetic Cubism was a process of building up or combining bits and pieces of material.

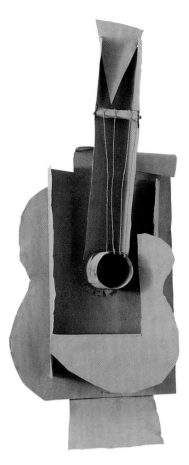

555 Pablo Picasso.
GUITAR. Paris, winter 1912–1913.
Construction of sheet metal and wire.
30½" × 13¾" × 7⅝".

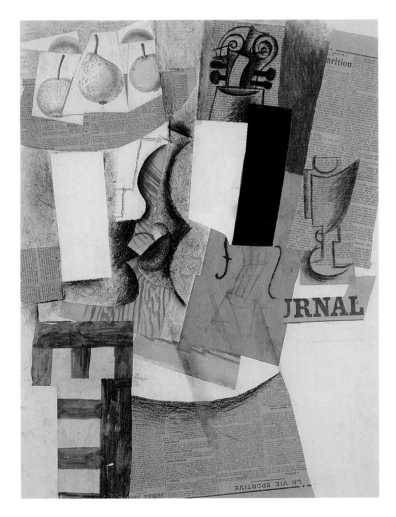

556 Pablo Picasso.
VIOLIN AND FRUIT. 1913.
Charcoal colored papers, gouache, painted paper collage. 25¼" × 19½".

557 PICASSO IN HIS STUDIO AT CANNES. C. 1965.
© Arnold Newman/Getty Images.

EVEN BEFORE HE COULD TALK, Pablo Picasso showed skill in drawing. Years later, he could remember the colors of things he saw in early childhood.

Born in the southern Spanish town of Málaga to artistic parents, Picasso first studied art with his father, a drawing teacher. At the age of ten he moved with his family to La Coruña on the Atlantic coast, then to Barcelona four years later, when the future Cubist was fourteen. Such was his skill at drawing, that upon arrival he passed the entrance examinations for the School of Fine Arts. He won his first gold medal at an exhibition in his home town in 1897.

At the age of sixteen he entered the Royal Academy in Madrid, but attended only briefly because he regarded the teaching methods as oppressive. Returning to Barcelona in 1899, he began to frequent the advanced art circles where Modern art was practiced and hotly debated. His own work evolved rapidly through Symbolism and Post-Impressionism to expressive portraits of social outcasts and poor people.

From 1904 to 1945 he lived in Paris. His early work shows his ability to assimilate varied influences and his interest in exploring new modes of expression.

Picasso became fascinated with art from outside Western traditions. He became particularly interested in the African and Oceanic sculpture that Gauguin and later the Fauves had "discovered."

Accounts vary regarding when and where Picasso first saw African sculpture. He claimed that his first encounter with African sculpture and masks was in an exhibition late in 1907, after he had finished LES DEMOISELLES. Other artists and writers, including Matisse and Gertrude Stein, told of showing Picasso African sculpture in 1906. His paintings and sculpture of the period certainly show a familiarity with sculpture and masks of the Ivory Coast and the metal-covered figures of the Gabon. By 1909 Picasso had become a serious collector of African art.

In their development of Cubism, Picasso and Braque drew inspiration from the inventive abstractions of African sculpture and the paintings of Cézanne.

Picasso exhibited in the first Surrealist exhibition in Paris in 1925, but he did not sign the group's manifesto. Like the Surrealists, he became increasingly involved with the political unrest in Europe during the 1930s. After a short period of rest and retreat, Picasso produced a series of drawings and paintings that expressed his anguish over the growing violence that led to World War II (see GUERNICA, page 106).

Any written biography of Picasso is only a footnote to the autobiographical content of much of his art. In his many variations on the themes of the artist at work and the artist with his model, we recognize that Picasso is commenting on his own experience. Within his images there is the ebb and the flow of Picasso's turbulent love life. Five different women, who shared his life, appear again and again in his art.

His later work included ceramics and huge numbers of prints and drawings in addition to many paintings. Hardworking and prolific until the end of his life, he gave expression to the essential character of his time. In its diversity, Picasso's art relates to most of the twentieth century's art movements. With his prodigious imagination and many changes in style and media, Picasso inspired generations of younger artists.

Picasso's stature in the twentieth century is comparable to Michelangelo's during the Renaissance: both artists lived nearly a century, both became famous early in life, both lived during periods of rapid change, and both were at the forefront of the artistic developments of their times.

TOWARD ABSTRACT SCULPTURE

Early twentieth-century sculpture continued the general shift from naturalistic to abstract art begun in the late nineteenth century. The comparison in Chapter 2 of two works of sculpture, both titled THE KISS (page 31), illustrates the transition from nineteenth- to twentieth-century thinking. Rodin, the leading sculptor of the nineteenth century, created a naturalistic work. Constantin Brancusi, produced an abstract interpretation.

A sequence of Brancusi's early work shows his radical break with the past. His SLEEP of 1908 has an appearance similar to Rodin's romantic naturalism. In his SLEEPING MUSE of 1911, Brancusi simplified the subject as he moved from naturalism to abstraction. THE NEWBORN of 1915 is stripped to essentials. Brancusi said, "Simplicity is not an end in art, but one arrives at simplicity in spite of oneself, in approaching the real sense of things."[5]

Comparisons can be made between Brancusi's work and Cycladic sculpture over four thousand years old. Ancient sculpture from the Cyclades (islands of the Aegean Sea) has a distinctive, highly abstract elegance similar to Brancusi's. It is known that Brancusi spent time in the Louvre studying the collection that included ancient sculpture, such as the CYCLADIC head.

558 Constantin Brancusi.
SLEEP. 1908.
Marble. 6½" × 12".
Photograph courtesy Musée National d'Art Moderne, Centre National d'Art de Culture Georges Pompidou. © VISARTA (The Romanian Visual Arts Copyright Collecting Society), Bucharest, Romania.
© 2002 Artists Rights Society (ARS), New York/ADAGP, Paris.

559 Constantin Brancusi.
SLEEPING MUSE I. 1909–1911.
Marble. 6¾" × 10⅝" × 8⅜".
Hirschhorn Museum and Sculpture Garden, Smithsonian Institution, Gift of Joseph H. Hirschhorn (1966). © 2002 Artists Rights Society (ARS), New York/ADAGP, Paris.

561 CYCLADIC II.
Female statuette.
2700–2300 B.C.E.
Syros group. Marble.
Height 10½".
Photograph: Herve Lewandowski.
Louvre Museum, Paris, France.
© Reunion des Musées Nationaux/
Art Resource, NY.

560 Constantin Brancusi.
THE NEWBORN. 1915.
Marble. 5¾" × 8¼" × 5⅞".
Philadelphia Museum of Art. The Louise and Walter Arensberg Collection, 1950. (1950–134–10) © 2002 Artists Rights Society (ARS), New York/ADAGP, Paris.

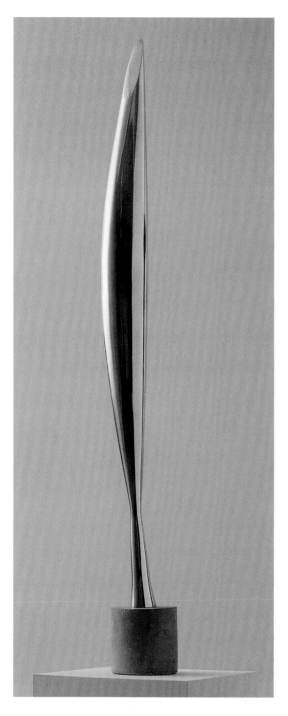

562 Constantin Brancusi.
BIRD IN SPACE. 1928.
Bronze (unique cast). Height 54" × 8½" × 6½".
The Museum of Modern Art, NY/Licensed by Scala-Art Resource, NY.
© 2002 Artists Rights Society (ARS), NY/ADAGP, Paris.

Brancusi shared with other leading Parisian artists an interest in African and other non-Western arts, but the main influence on his sculpture was the folk art of his native Romania and his childhood in a peasant community with a strong woodcarving tradition.

Brancusi sought to go beyond the surface embellishments that had dominated European sculpture since the Gothic period and to make viewers conscious of form. He brought about a revival of carving. Brancusi's expressive strength was achieved by carefully reducing forms to their essence. As a result, his sculptures invite contemplation.

In BIRD IN SPACE, Brancusi transformed inert mass into an elegant, uplifting form. The implied soaring motion of the "bird" embodies the idea of flight. The highly reflective polish given to the bronze surface adds considerably to the form's weightless quality. Brancusi started working on this visual concept about a decade after the Wright brothers initiated the age of human flight, but long before the world was filled with streamlined aircraft, cars, pens, and telephones. Brancusi said, "All my life I have sought the essence of flight. Don't look for mysteries. I give you pure joy."[6]

THE MODERN SPIRIT IN AMERICA

As Picasso and Braque took the steps that led to Cubism, American photographer Alfred Stieglitz was also reconsidering the geometry of design on the picture plane. When Picasso saw Stieglitz's photograph THE STEERAGE, he said, "This photographer is working in the same spirit as I am."[7]

THE STEERAGE looked "chopped up" to many people. Some of the artist's friends felt that it should have been two photographs rather than one. Stieglitz, however, saw the complex scene as a pattern of interacting forces of light, shade, shape, and direction. Aboard a ship headed for Europe, he saw the composition of this photograph as "a round straw hat, the funnel leaning left, the stairway leaning right, the white drawbridge with its railings made of circular chains, white suspenders crossing on the back of a man on the steerage below, round shapes

of iron machinery, a mast cutting into the sky, making a triangular shape. . . . I saw a picture of shapes and underlying that the feeling I had about life."[8] He rushed to his cabin to get his camera, hoping the relationships would not change. Nothing had shifted, and he made the photograph he considered his best.

Stieglitz made major contributions toward establishing photography as an art of comparable importance to traditional media (see page 145 for another work). He also played a key role in introducing the new European painting and sculpture to Americans. In 1907, he opened a gallery in New York and began showing the work of the most progressive European artists, including photographers. He was the first in America to show works by Cézanne, Matisse, Brancusi, Picasso, and Braque. Following the exhibition of art by these European pioneers, Stieglitz began to show work by those who would become leading American artists, including Georgia O'Keeffe (see biography on page 34).

O'Keeffe's work from the time of World War I was innovative, consisting mostly of abstractions based on nature. LIGHT COMING ON THE PLAINS, for example, uses fine gradations of tone to suggest the moments of anticipation before sunrise. She based this work on experiences living in the Texas panhandle where she taught school, but the painting also refers to what she later recalled as her earliest memory: a warm, enfolding, mystical light.

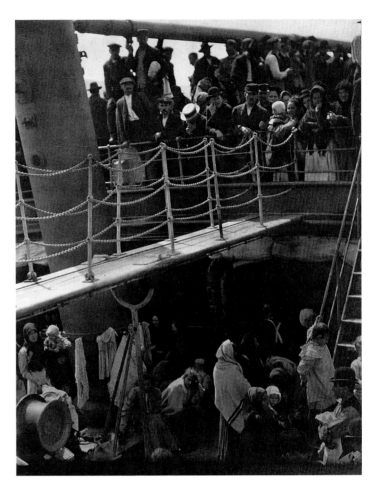

563 Alfred Stieglitz.
THE STEERAGE. 1907.
From *Camera Work, New York, No. 34,*
October 1911. Photogravure, 7¾" × 6½".
The Museum of Modern Art, NY/Licensed by Scala-Art Resource, NY.
Gift of Alfred Stieglitz.
Copy Print © 1999 The Museum of Modern Art, New York.

564 Georgia O'Keeffe.
LIGHT COMING ON THE PLAINS NO II. 1917.
Watercolor on newsprint. 11⅞" × 8⅞".
Amon Carter Museum, Fort Worth, Texas. 1966.32.
© 2002 The Georgia O'Keeffe Foundation/Artists Rights Society
(ARS), NY.

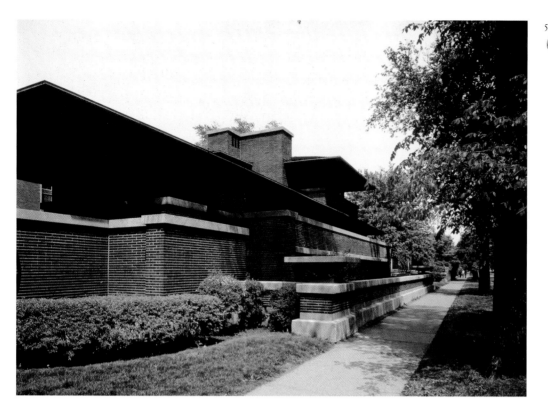

Between 1905 and 1910, traditional concepts of form in space were being challenged in architecture as well as in sculpture, painting, and photography. While Cubism was developing in painting, leading American architect Frank Lloyd Wright was designing "prairie houses," in which he often omitted or minimized walls between living and dining rooms and between interior and exterior spaces. Wright's concept of open plans has changed the way people design living spaces. In many contemporary homes, kitchen, dining room, and living room now join in one continuous space, and indoors often intermingles with outdoors.

In his ROBIE HOUSE of 1909, a striking canti-levered roof reaches out and unifies a fluid design of asymmetrically interconnected spaces. Through Wright's influence, the open flow of spaces became a major feature of contemporary architecture. To get a feeling of how far ahead of his time Wright was, imagine the incongruity of a new 1909 automobile that could have been parked in front of the ROBIE HOUSE the year it was completed. (For more on Frank Lloyd Wright and his architecture, see pages 222–23.)

The American public had its first extensive look at leading developments in European art during the Armory Show held in New York in 1913. In his show of over sixteen hundred works, American artists were able to see key works by Impressionists, Post-Impressionists, and Fauves—particularly Matisse, who was much maligned by critics. Also shown were paintings by Picasso and Braque, and sculpture by Brancusi. As a result, Cubism and other forms of abstract art spread to America.

FUTURISM AND THE CELEBRATION OF MOTION

The Italian Futurists were among the many artists who gained their initial inspiration from Cubism. To the shifting planes and multiple vantage points of Cubism, Futurists such as Giacomo Balla and Umberto Boccioni added a sense of speed and motion and a celebration of the machine.

By multiplying the image of a moving object, Futurists expanded the Cubist concepts of simultaneity of vision and metamorphosis. In 1909, the

poet Filippo Tommaso Marinetti proclaimed in the *Initial Manifesto of Futurism*: "the world's splendor has been enriched by a new beauty; the beauty of speed . . . a roaring motorcar . . . is more beautiful than the Victory of Samothrace."[9]

The Futurists translated the speed of modern life into works that captured the dynamic energy of the new century. Giacomo Balla intended his work ABSTRACT SPEED—THE CAR HAS PASSED to depict the rushing air and dynamic feeling of a vehicle passing. This "roaring motorcar" is passing at about 35 miles an hour, but at that time this was the pinnacle of speed.

An abstract sculpture of a striding figure climaxed a series of Umberto Boccioni's drawings, paintings, and sculpture. Boccioni insisted that sculpture should be released from its usual confining outer surfaces in order to open up and fuse the work with the space surrounding it. In UNIQUE FORMS OF CONTINUITY IN SPACE, muscular forms seem to leap outward in flamelike bursts of energy. During this period, the human experience of motion, time, and space was transformed by the development of the automobile, the airplane, and the movies. Futurist imagery reflects this exciting period of change.

French artist Marcel Duchamp, working independently of the Futurists, brought the dimension of motion to Cubism. His NUDE DESCENDING A STAIRCASE, NO. 2 (on the following page) was influenced by stroboscopic photography, in which sequential camera images show movement by freezing successive instants (see page 151 for an example).

Through sequential, diagonally placed, abstract references to the figure, the painting presents the movement of a body through space, seen all at once, in a single rhythmic progression. Our sense of gravity intensifies the overall feeling of motion. When the painting was displayed at the Armory Show in

566 Giacomo Balla.
ABSTRACT SPEED—THE CAR HAS PASSED. 1913.
Oil on canvas. 19¾" × 25¾".
Tate Gallery, London/Art Resource, NY. © 2002 Artists Rights Society (ARS), NY/SIAE, Rome.

567 Umberto Boccioni.
UNIQUE FORMS OF CONTINUITY IN SPACE. 1913.
Bronze (cast in 1931).
43⅞" × 34⅞" × 15¾"
(111.2 × 88.5 × 40 cm).
The Museum of Modern Art, NY/Licensed by Scala-Art Resource, NY.
Acquired through the Lillie P. Bliss Bequest.
Photograph © 2002 The Museum of Modern Art, New York.

574 Paul Klee.
INSULA DULCAMARA. 1938.
Oil and black paste on newspaper, mounted on burlap. 34⅝" × 69¼".
Courtesy of the Paul Klee Foundation, Berne.
© 2004 Artists Rights Society (ARS), NY/VG Bild-Kunst, Bonn.

GLOBAL INFLUENCES

Non-Western cultures continued to influence European modern art during the interwar period. Paul Klee exhibited with the members of the Blue Rider group prior to a trip to Tunisia in 1914. The effect of the desert light and the exposure to Muslim culture stayed with him for years to come; he wrote to a friend enthusiastically, "I am now a artist." He made several watercolors of the Great Mosque at Kairouan and later created some paintings that show influence of Islamic calligraphy, such as INSULA DULCAMARA. His curving and dipping lines are of course illegible, but they reveal his belief that writing uses the expressive power of line just as painting does.

English sculptor Henry Moore came to non-Western art through a different route. After serving in World War I, he used a veteran's grant to study art in London. While there, he spent long hours studying the collections of tribal arts in the British Museum and the Victoria and Albert Museum. His RECUMBENT FIGURE from 1938 is an elaboration of the CHACMOOL of the Toltecs (see page 344). Moore smoothed the stone into an organic abstract shape that suggests the human from without exactly depicting it. He also left voids in the center of the work to lighten the density of the stony mass.

SURREALISM

Italian painter Giorgio De Chirico was a precursor of Surrealism. In THE MYSTERY AND MELANCHOLY OF A STREET, De Chirico used distorted linear perspective, with conflicting vanishing points, to create an eerie space peopled by faceless shadows. The painting speaks the symbolic language of dreams and mystery. According to the artist,

everything has two aspects: the current aspect, which we see nearly always and which ordinary men see, and the ghostly and metaphysical aspect, which only rare individuals may see in moments of clairvoyance and metaphysical abstraction.[3]

De Chirico sought to create an alternative reality that could communicate with the unconscious by removing objects from the real world and presenting them in incongruous relationships.

575 Henry Moore.
 RECUMBENT FIGURE. 1938.
 Green hornton stone. 88.9 × 132.7 × 73.7 cm.
 © Henry Moore Foundation. Tate Gallery, London/Art Resource, NY.

576 Giorgio De Chirico.
 THE MYSTERY AND MELANCHOLY OF A STREET. 1914.
 Oil on canvas. 34¼" × 28⅛".
 Private collection. Photograph © Allan Mitchell
 © 2002 Artists Rights Society (ARS), NY/SIAE, Rome.

577 Salvador Dali.
THE PERSISTENCE OF MEMORY. 1931.
Oil on canvas. 9½" × 13".
The Museum of Modern Art, NY/Licensed by Scala-Art Resource, NY. Anonymous gift.
Photograph © 2002 The Museum of Modern Art, New York.
© 2002 Kingdom of Spain, Gala-Salvador Dali Foundation/Artists Rights Society (ARS), NY.

In the 1920s a group of writers and painters gathered to proclaim the omnipotence of the unconscious mind, thought to be a higher reality than the conscious mind. Their goal was to make visible the imagery of the unconscious. They were indebted to the shocking irrationality of Dadaism, and especially the dream images of De Chirico. They also drew heavily on the new psychology of Sigmund Freud.

The new movement, *Surrealism*, was officially launched in Paris in 1924 with the publication of its first manifesto, written by poet-painter André Breton. In it he defined the movement's purpose as

the future resolution of these two states, dream and reality, which are seemingly so contradictory, into a kind of absolute reality, a surreality, if one may so speak.[4]

Among the members of the Surrealist group were Spanish painters Salvador Dali and Joan Miró.

Dali's THE PERSISTENCE OF MEMORY evokes the eerie quality of some dreams. Mechanical time wilts in a deserted landscape of infinite space. The warped, headlike image in the foreground may be the last remnant of a vanished humanity. It may also be a self-portrait, complete with protruding tongue.

Dali and Miró represent two opposite tendencies operating in Surrealism. Dali's illusionary deep space and representational techniques create near-photographic dream images that make the impossible seem believable. The startling juxtaposition of unrelated objects creates a nightmarish sense of a superreality beyond the everyday world. This approach has been called Representational Surrealism. In contrast, Miró's Abstract Surrealism provides suggestive elements that give the widest possible play to the viewer's imagination and emphasize color and design rather than storytelling content.

To probe deep into the unconscious, Miró and others used automatic processes, sometimes called *automatism*, in which chance was a key factor. With the adoption of spontaneous and "automatic" methods, the Surrealists sought to expand consciousness by transcending limits of rational thought.

Miró's evocative paintings often depict imaginary creatures. He made them by scribbling on the canvas and then examining the results to see what the shapes suggested. The bold, organic shapes in WOMAN HAUNTED BY THE PASSAGE OF THE DRAGONFLY, BIRD OF BAD OMEN are typical of his mature work. The wild, tormented quality, however, is unusual for Miró and reflects his reaction to the times. Miró pointed out that this painting was done at the time of the Munich crisis that helped precipitate World War II. Even though there is a sense of terror here, Miró's underlying playful optimism is apparent.

Belgian Surrealist René Magritte used an illogical form of realism, similar to Dali's in surface appearance but quite different in content. Magritte's paintings engage the viewer in mind-teasing mystery and playful humor. Everything depicted in PORTRAIT is ordinary; the impact comes from the unsettling placement of an eye looking back at us from a plate of ham.

Mexican painter Frida Kahlo was adopted by the Surrealists even though her sources were closer to the folk arts of her native country. Her painting THE TWO FRIDAS shows herself as a split personality, divided between her European and Mexican heritage. As each stares back at us, we see their hearts plainly visible, joined by blood vessels. This is an allusion

578 Joan Miró.
WOMAN HAUNTED BY THE PASSAGE OF THE DRAGONFLY, BIRD OF BAD OMEN. 1938.
Oil on canvas. 31½" × 124".
The Toledo Museum of Art, Toledo, Ohio. Purchased with funds from the Libbey Endowment.
Gift of Edward Drummond Libbey. 1986.25
© 2002 Artists Rights Society (ARS), NY/ADAGP, Paris.

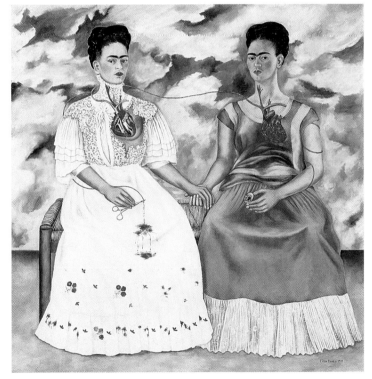

579 René Magritte.
PORTRAIT. 1935.
Oil on canvas. 28⅞" × 19⅞".
The Museum of Modern Art, NY/Licensed by Scala-Art Resource, NY. Gift
of Mrs. Kay Sage Tanguy. Photograph: © 2002 The Museum of Modern Art, NY.
© 2002 C. Herscovici, Brussels/Artists Rights Society (ARS), NY.

580 Frida Kahlo.
THE TWO FRIDAS. 1939.
Oil on canvas. 5'8½" square.
Schalkwijk/Art Resource, NY. © 2002 Banco de Mexico Diego Rivera & Frida Kahlo Museums Trust.
Av. Cinco de Mayo No. 2, Col. Centro, Del. Cuauhtemoc 06059, Mexico, D.F.
Reproduction authorized by the Instituto Nacional de Bellas Artes and Literature.

FRIDA Kahlo
(1907–1954)

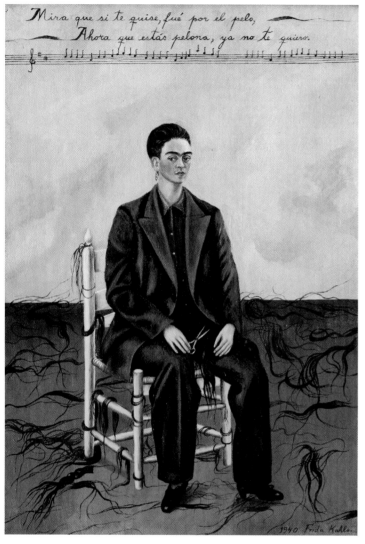

581 Frida Kahlo. SELF-PORTRAIT WITH CROPPED HAIR. 1940.
Oil on canvas, 15¾" × 11".
Museum of Modern Art, New York/Licensed by Scala-Art Resource, NY.
© 2004 Banco de Mexico Diego Rivera & Frida Kahlo Museums Trust. Av. Cinco de Mayo No. 2,
Col. Centro, Del. Cuauhtemoc 06059, Mexico, D.F. Reproduction authorized by the Instituto
Nacional de Bellas Artes and Literature.

FRIDA KAHLO WAS A STRONG-WILLED, determined woman in a society that taught women to be passive.

Born in a suburb of Mexico City, she was the child of a photographer of German descent and a part-Spanish, part-Indian mother. When she was six years old she was stricken with polio. The painful disease caused her to be isolated for nine months and left her with one leg shorter and thinner than the other. At age eighteen she was in a trolley car accident that was followed by ineffective orthopedic treatments and thirty-two operations over the course of her life.

Chronic physical suffering caused by her illness and the accident led to a preoccupation with her severely damaged body—often the central subject in her paintings. In spite of her pain, her art reveals her feelings of connection with nature and with the creative energy that flows through all life. In her paintings, details of nature are integrated with elements of dreams and fantasies.

When her work was shown in Paris in 1938, it received favorable attention from leading Surrealists. However, Kahlo's unique style is probably more indebted to Mexican narrative folk painting than to European Surrealism. Her paintings contain a mixture of folk art motifs, Surrealist elements, and autobiographical variations on the theme of mythical woman.

Her life was as unconventional as her art: she had two stormy marriages to the artist Diego Rivera, numerous affairs, and friendships with leading international leftist and Surrealist leaders.

After her divorce from Diego in 1940 she painted SELF-PORTRAIT WITH CROPPED HAIR, a declaration of independence from his infidelities. She sits staring back at us after putting on an oversized man's suit and snipping at her hair. The inscription above quotes a Mexican folk song ("Look, if I loved you it was because of your hair; since you no longer have hair I no longer love you"), reflecting the Mexican folk tradition of inscribing painting with lines of verse.

The work also shows the artist turning herself into a man, an image that hints at her bisexuality. She once said that she did not care if her works reflected Surrealist beliefs, as long as they reflected her life. She remarried Rivera the next year.

Kahlo's dramatic, bohemian personality enriched her distinctive painting style. Since her death in 1954, her international reputation has greatly increased. In the 1980s her psychologically loaded self-portraits found an appreciative new audience. Kahlo has become the heroine of the Mexican avant-garde and the subject of several books and a feature-length movie.

582 Fernand Léger.
THE CITY. 1919.
Oil on canvas. 91" × 177½".
Philadelphia Museum of Art. A. E. Gallatin Collection, 1952-61-58.
© 2002 Artists Rights Society (ARS), NY/ADAGP, Paris.

both to ancient Aztec human sacrifice and to the artist's own surgical traumas. Her many self-portraits provide insight to an exceptional person who lived life with passionate intensity in spite of incredible physical problems, as the accompanying essay shows.

THE INFLUENCE OF CUBISM

Cubism has been one of the most influential Modern art movements. Beginning in Paris, it spread to many parts of the world. This style makes possible many ambiguities between presence and absence, representation and abstraction, figure and ground. It suggests meanings that are relative and contingent. Far from presenting the world as stable and predictable, Cubism suggests constant change and evolution. An art historian wrote, "By devaluing subject matter, or by monumentalizing simple, personal themes, and by allowing mass and void to elide, the Cubists gave effect to the flux and paradox of modern life and the relativity of its values."[5] Thus, Cubism makes visible some important characteristics of modern life.

In his large painting THE CITY, Fernand Léger crushed jagged shapes together, collapsing space in a composition reminiscent of a Cubist portrait or still life. The forms in his paintings look machine-made, rounded and tubular; this is in keeping with the urban bustle that is the work's subject.

Russian artists took Cubism in the direction of complete abstraction. A leader there was Kazimir

590 Max Beckmann.
DEPARTURE. 1932–1933.
Oil on canvas; triptych, center panel 7'¾" × 45⅜"; side panels each 7'¾" × 39¼".
The Museum of Modern Art, NY/Licensed by Scala-Art Resource, NY. Given anonymously (by exchange).
Photograph: © 2002 The Museum of Modern Art, NY. © 2002 Artists Rights Society (ARS), NY/VG Bild-Kunst, Bonn.

In 1938, he emigrated to the United States. There, his ideas and works strongly influenced the post–World War II development of the rectilinear, metal-and-glass-sheathed, steel-frame skyscraper. His SEAGRAM BUILDING is pictured on page 217.

POLITICAL PROTEST

Expressionism continued as the dominant trend in German art despite the fact that the Bridge and Blue Rider groups were largely dispersed by the devastation of World War I. Reactions to the war and the social and political situation of the 1920s and 1930s led to some of Expressionism's major works. Two exponents of German Expressionism and its values were Paul Klee and Max Beckmann.

Beckmann's experience working in a field hospital during World War I led him to shift from his early Impressionist-influenced mode to an expressive style in which he could speak forcefully of the misery he saw.

After years of public acceptance and professional success, Beckmann was classified as a degenerate artist by the Nazis. Fifteen German museums were forced to remove his paintings. He painted his great triptych (three-panel painting) DEPARTURE in secret during the early years of the Nazi regime. Suggestions of Christian symbolism include the altarpiece-related triptych format and a Christlike fisherman-king. Beckmann's moral content and symbolism are presented with the direct vigor of a circus sideshow. When the triptych was shipped out of Germany in 1937, Beckmann fooled Hitler's inspectors by labeling it "Scenes from Shakespeare's *Tempest*." Beckmann, forced to go into hiding, fled first to Holland, then to the United States. In retrospect, we see DEPARTURE as an allegory of good and evil as well as a portrayal of Beckmann's personal experience and desire to escape a society gone mad.

Hitler's rise to power in the 1920s and 1930s all but destroyed the German Expressionist movement,

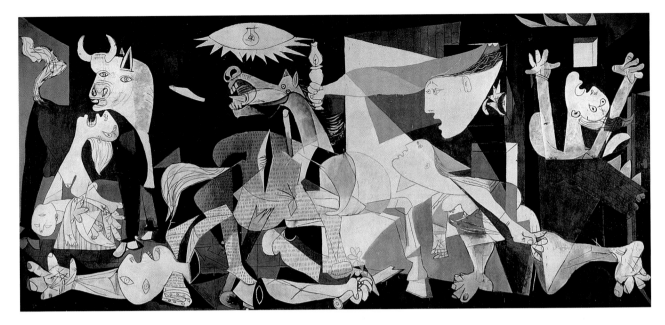

591　Pablo Picasso.
GUERNICA. 1937.
Oil on canvas. 11'5½" × 25'5¼".
Museo Nacional Centro de Arte Reina Sofía. Giraudon/Art Resource, NY.
© 2002 Estate of Pablo Picasso/Artists Rights Society (ARS), NY.

although many of its leading artists had already left Germany by then. The Bauhaus, the most influential art school of the early twentieth century, was closed by the Nazis in 1933. In 1938, about five thousand paintings and sculptures and twelve thousand prints and drawings by German Expressionist artists were confiscated.

Between 1936 and 1939, while Hitler held power in Germany, Spain underwent a bloody civil war. With military support from Germany and Italy, General Francisco Franco emerged as dictator.

Throughout the 1920s and into the 1930s, Spanish-born Pablo Picasso continued to produce innovative drawings, paintings, prints, posters, and sculptures. Many of these works were filled with strange distortions and dislocations related to Surrealism. In 1937, while the Spanish Civil War was in progress, Picasso was commissioned by the doomed Spanish democratic government to paint a mural for the Paris Exposition. For several months he was unable to begin work. Suddenly, on April 26, 1937, he was shocked into action by the "experimental" mass bombing of the defenseless Basque town of Guernica. To aid his bid for power, General Franco

had allowed Hitler to use his war machinery on the town as a demonstration of military power. The bombing, which leveled the fifteen-square-block city center, was the first incidence of saturation bombing in the history of warfare. Hundreds died, and more were strafed with machine gun fire from German aircraft as they fled the city into neighboring fields.

Picasso, appalled by this brutality against the people of his native country, called upon all his powers to create the mural-size painting GUERNICA. Although Picasso's GUERNICA stems from a specific incident, it is a statement of protest against the senseless brutality of all war.

GUERNICA covers a huge canvas more than 25 feet long. It is painted in somber black, blue-blacks, whites, and grays. A large triangle embedded under the smaller shapes holds the whole scene of chaotic destruction together as a unified composition. GUERNICA combines Cubism's intellectual restructuring of form with the emotional intensity of earlier forms of Expressionism and Abstract Surrealism. Details show some of the personal symbolism Picasso used to portray ideas and feelings beyond the protest of a single incident. In dream symbolism, a

During the Depression of the 1930s, the Works Progress Administration (WPA) set up community art centers in 100 cities. Jacob Lawrence was a product of one of these centers in Harlem, where he met most of the leaders of the Renaissance. In 1938, he made a series of forty-one paintings on Toussaint L'Ouverture, the black leader of the revolt that made Haiti the first independent nation in Latin America in 1804. GENERAL TOUSSAINT L'OUVERTURE DEFEATS THE ENGLISH AT SALINE shows his style, which he called "dynamic Cubism." Lawrence was not practicing the French Cubism of Braque and Picasso, however; he made his own investigation of African art and reinterpreted it in his own way.

Archibald Motley of Chicago took a realist view of African-American culture. His painting BARBECUE of 1934 is ebullient and full of notion, and also shows an interest in how figures look under artificial light. Motley specialized in depicting all aspects of the urban black experience, including on occasion gamblers and drinkers during Prohibition. Such subject matter did not endear him to pretentious art patrons, but Motley replied, "I have tried to paint the Negro as I have seen him and as I feel him, in my self without adding or detracting, just being frankly honest."[13]

The arrival of large numbers of refugees to the United States just before and after World War II caused a reexamination of the role of art in modern life. Expatriated European artists brought new ideas and purposes to America. As a result, the regional, narrative styles of painters lost favor, and New York became a new center for the exchange of creative ideas among artists from many nations.

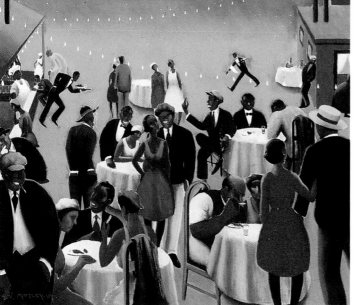

600 Jacob Lawrence.
GENERAL TOUSSAINT L'OUVERTURE DEFEATS THE ENGLISH AT SALINE. 1937–1938.
Gouache on paper, 19" × 11".
Aaron Douglas Collection, The Amistad Research Center, Tulane University, New Orleans.

601 Archibald Motley, Jr.
BARBECUE. 1934.
Oil on canvas. 36¼" × 40⅛".
Howard University Gallery of Art, Washington, D.C.

POSTWAR MODERN MOVEMENTS IN THE WEST

At the end of World War II, Europe lay in ruins—financially, emotionally, and physically. The war took the lives of over a quarter million English people, six hundred thousand French, five million Germans, and twenty million Russians. The Nazi holocaust alone consumed the lives of six million Jews, Romany (gypsies), and homosexuals. Refugees and displaced persons numbered forty million. England's wartime Prime Minister Winston Churchill in 1947 described Europe as "a rubble heap, a charnel house, a breeding ground for pestilence and hate." Many prominent European artists had fled from Nazi oppression to the United States, which emerged from the war economically strong and optimistic.

Among the artists who settled in New York were Mondrian, Léger, Duchamp, Dali, and Hans Hofmann. They worked, taught, exhibited, and generally stirred things up, opening new possibilities for American artists. The Solomon Guggenheim collection opened to the public in 1930 as the Museum of Non-Objective Art, specializing in abstract European works (today known as the Guggenheim Museum). The Museum of Modern Art opened in New York in 1929, showing a comprehensive history of the modern movement; ten years later it reopened in the larger space in midtown Manhattan that it still occupies. Mexican muralists Diego Rivera and David Siqueiros exhibited and taught in New York during the 1930s, encouraging artists away from traditional easel painting. Modernism was no longer a distant, European phenomenon; its leading practitioners were in the United States.

War had altered the consciousness of the developed world in subtle but profound ways. The Nazi genocide machine had taken human cruelty to a new low, and the atomic bomb gave humankind terrifying new powers: People were now living in a world they had the technology to destroy. These conditions formed the background for art and life in Europe and the United States for most of the postwar period.

ABSTRACT EXPRESSIONISM AND RELATED ART

The horrors of World War II, in which millions of people lost their lives in battle or in concentration camps, led artists to rethink the relationship between art and life. Again, dislocations caused by war led artists to explore visual realms other than the representational and narrative. The result was *Abstract Expressionism,* a culmination of the expressive tendencies in painting from van Gogh and Gauguin through Fauvism and German Expressionism. Immediate inspiration came from the motives and spontaneous methods of Surrealism—in particular, the abstract Surrealism of Miró.

The new émigrés influenced many American painters, leading them to move away from realist styles dominant in the 1930s and experiment with

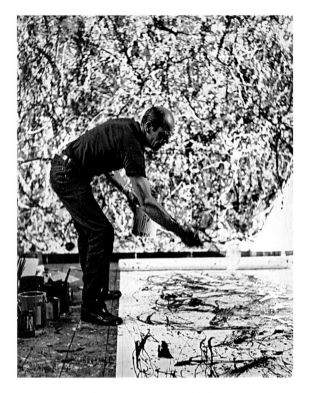

602 Hans Namuth. JACKSON POLLOCK. 1950.
Gelatin silver print.
National Portrait Gallery, Smithsonian Institution.
Gift of the Estate of Hans Namuth.

more expressive and inventive ways of creating art. The unparalleled crisis of the World War also led them to move away from public issues of history and social comment that Depression-era painting emphasized. As a result, they began to paint in styles that were both stylistically innovative and personal.

Jackson Pollock, the leading innovator of Abstract Expressionism, studied with Thomas Hart Benton in the 1930s. The rhythmic structure of Benton's style and Hofmann's early drip-and-pour techniques influenced Pollock's poured paintings of the late 1940s and early 1950s. Searching for ways to express primal human nature, Pollock also studied Navajo sand painting and psychologist Carl Jung's theories of the unconscious.

The act of painting itself became a major part of the content of Pollock's paintings. Pollock created AUTUMN RHYTHM by dripping thin paint onto the canvas rather than brushing it on. By working on huge canvases placed on the floor, Pollock was able to enter the space of the painting physically and psychologically. The huge format allowed ample room for his sweeping gestural lines. Pollock

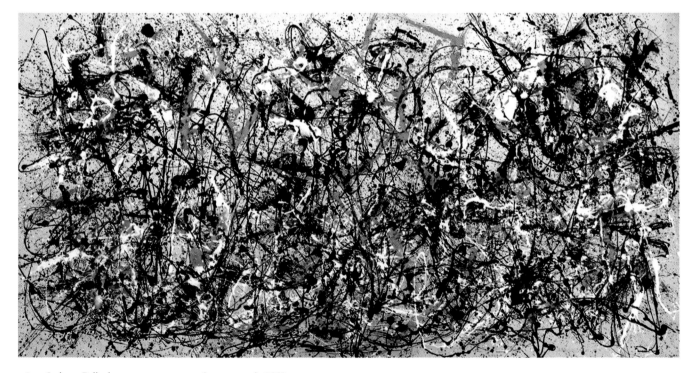

603 Jackson Pollock. AUTUMN RHYTHM. (NUMBER 30), 1950.
Oil on canvas. 105" × 207".
The Metropolitan Museum of Art, George A. Hearn Fund, 1957. (57.92).
Photograph © 1998 The Metropolitan Museum of Art. © 2004 The Pollock-Krasner Foundation/Artists Rights Society (ARS), NY.

dripped, poured, and flung his paint, yet he exercised control and selection by the rhythmical, dancing movements of his body. A similar approach in the work of many of his colleagues led to the term *action painting.*

A different, but related, painting style that evolved at about the same time was *color field,* a term for painting that consists of large areas of color, with no obvious structure, central focus, or dynamic balance. The canvases of color field painters are dominated by unified images, images so huge that they engulf the viewer. They are not about environments; they are environments in themselves.

Mark Rothko is now best known as a pioneer of color field painting, although his early works of the 1930s were urban scenes. By the 1940s, influenced by Surrealism, he began producing paintings inspired by myths and rituals. In the late 1940s, he gave up the figure and began to work primarily through color. In works such as BLUE, ORANGE, RED Rothko was able to use color to evoke moods ranging from joy and serenity to melancholy and despair. By superimposing thin layers of paint, he achieved a variety of qualities from dense to atmospheric to luminous. Rothko's paintings have sensuous appeal and monumental presence.

Helen Frankenthaler's work also evolved during the height of Abstract Expressionism. In 1952, she pioneered staining techniques as an extension of Jackson Pollock's poured paint and Mark Rothko's fields of color. Brush strokes and paint texture were eliminated as she spread liquid colors across horizontal, unprimed canvas. As the thin pigment soaked into the raw fabric, she coaxed it into fluid, organic shapes. Pale, subtle, and spontaneous, MOUNTAINS AND SEA marked the beginning of a series of paintings that emphasize softness and openness and the expressive power of color. The twenty-four-year-old Frankenthaler painted it in one day, after a trip to Nova Scotia.

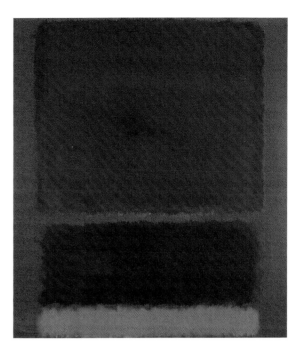

604 Mark Rothko.
BLUE, ORANGE, RED. 1961.
Oil on canvas. 90¼" × 81¼".
Hirschhorn Museum and Sculpture Garden, Smithsonian Institution, Washington, D.C. Gift of Joseph H. Hirschhorn Foundation (1966).
Photograph: Lee Stalsworth. © 2002 Kate Rothko Prizel and Christopher Rothko/Artists Rights Society (ARS), NY. HMSG 66.4420.

605 Helen Frankenthaler.
MOUNTAINS AND SEA. 1952.
Oil on canvas. 7'2⅝" × 9'9¼".
Collection of the artist, on loan to The National Gallery of Art, Washington, D.C.
© Helen Frankenthaler 1999.

606 Robert Motherwell.
ELEGY TO THE SPANISH REPUBLIC NO. 34, 1953–1954.
Oil on canvas. 80" × 100".
Albright-Knox Art Gallery, Buffalo, NY. Gift of Seymour H. Knox, Jr. (1957).
© Dedalus Foundation, Inc./Licensed by VAGA, NY.

Robert Motherwell's series of paintings titled ELEGY TO THE SPANISH REPUBLIC is permeated with a tragic sense of history. Unlike many Abstract Expressionists, Motherwell began with a specific subject as his starting point. His elegies brood over the destruction of the young Spanish democracy by General Franco in the bloody Spanish Civil War of the 1930s. Heavy black shapes crush and obliterate the lighter passages behind them.

The influence of Expressionist and Surrealist attitudes on Willem de Kooning's work is evident in his spontaneous, emotionally charged brushwork and provocative use of shapes. Throughout his career, De Kooning emphasized abstract imagery, yet he felt no compulsion to ban recognizable subject matter. After several years of working without subjects, he began a series of large paintings in which ferocious female figures appear. These canvases, painted with slashing attacks of the brush, have an overwhelming presence. In WOMAN AND BICYCLE, the toothy smile is repeated in a savage necklace that caps tremendous breasts. While it explodes with the energies of Abstract Expressionism, this work is controversial for the horrendous image of women that it presents.

Norman Lewis was an African-American artist who participated in Abstract Expressionism from its inception. Like most of the Abstract Expressionists, during the 1930s Lewis painted in a social realist style, depicting urban poverty that he observed in his neighborhood of Harlem. During and after World War II, he was increasingly influenced by Modern art. His UNTITLED work from 1947 documents his shift toward a more spontaneous and improvisational style. Lewis's art differs from other Abstract Expressionists in that it seems more poetic and reserved. In addition, his painting at times shows traces of nature or, as we see in this work, city life.

In the ten years following the end of the war, European art differed from American art in two principal ways: First, many Europeans ventured less into abstraction, often retaining some trace of the human figure in their art. A prime example of this is the sculptor Alberto Giacometti, whose MAN POINTING is illustrated on page 46. In painting, Danish

607 Willem de Kooning.
WOMAN AND BICYCLE.
1952–1953.
Oil on canvas. 76½" × 49".
Collection of Whitney Museum of Art, New York. Purchase, 55.35.
Photograph © 2000: Whitney Museum of American Art, NY.
© 2002 Willem de Kooning Revocable Trust/Artists Rights Society (ARS), NY.

608 Norman Lewis.
UNTITLED. c. 1947.
Oil on canvas. 30" × 36".
Private Collection, NY.
Courtesy Michael Rosenfeld Gallery, NY and Landor Fine Arts.

artist Asger Jorn made explosive figural works that often combined heavily worked paint surfaces with ironic titles. In his painting THE GREAT VICTORY, instead of a scene of triumph we see a group of leering, monstrous heads emerging from murky depths. With their art, Giacometti and Jorn often commented on the basic aloneness of individuals, and the disappointments of an exhausted and devastated postwar European society.

Second, some Europeans were more innovative than Americans in their use of materials. Alberto Burri, for example, used burlap sacks in a series of works in the early 1950s. His COMPOSITION includes tattered pieces of fabric crudely stitched to the surface of the canvas. During the war, the artist served in the Italian army as a doctor; his use of red is meant to symbolize blood, and the burlap represents a temporary bandage. Burlap had a further symbolic significance in that it held grain that the United States sent to Italy as postwar foreign aid. These burlap works are Burri's effort to symbolically bind up Europe's wounds after the havoc of the war.

609 Asger Jorn.
THE GREAT VICTORY. 1955–1956.
Oil on canvas. 50" × 41".
Photograph: Lars Bay. © Silkeborg Kunstmuseum, Silkeborg, Denmark.

610 Alberto Burri.
COMPOSITION, 1953.
Oil, gold paint, and glue on burlap and canvas, 33⅞" × 39½".
Solomon R. Guggenheim Museum, New York. Photograph by David Heald and Myles Aronowitz. © The Solomon R. Guggenheim Foundation, New York (FN53.1364).

David Smith, for many critics the most important American sculptor of the postwar period, took the formal ideas of Cubism and gave them an American vigor. His assembled metal sculpture balanced formal qualities with the elemental energy of Abstract Expressionist painting. His use of factory methods and materials provided new options for the next generation of sculptors. Smith's late work included the stainless steel CUBI series, based on cubic masses and planes balanced dynamically above the viewer's eye level. The scoured surfaces of the steel reflect light in ways that seem to dissolve their solidity. Smith intended the sculpture to be viewed outdoors in strong light, set off by green landscape.

PHOTOGRAPHY AND ARCHITECTURE AT MID-CENTURY

In the late 1940s, at the dawn of the age of television, camera imagery began to proliferate into what has become today's mass-media environment. During this period some "art" photographers made their own contributions to the way we see. Both straight and manipulated approaches to image making were employed as photographers explored new frontiers of experience. There was an active exchange of visual ideas among photographers and painters, another phase in the dialog between these artists that started when photography was invented.

American photographer Harry Callahan achieved images expressing "my feelings and visual relationships to life within me and about me."[1] His MULTIPLE TREES is a dance of moving energy related to, yet different from, the dynamic action communicated in the paintings of Abstract Expressionists.

611 David Smith.
 CUBI XVII. 1963.
 Polished stainless steel. 107¾" × 64⅜" × 38⅛".
 Dallas Museum of Art. The Eugene and Margaret McDermott Fund.
 © Estate of David Smith/Licensed by VAGA, NY.

612 Harry Callahan.
 MULTIPLE TREES. 1949.
 Gelatin silver multiple exposure photograph.
 9½" × 9⁷⁄₁₆".
 The Museum of Fine Arts, Houston. Museum purchase with funds
 provided by the Museum Collectors. ACC: 87.168. © The Estate of
 Harry Callahan, courtesy of Pace/McGill Gallery, NY.

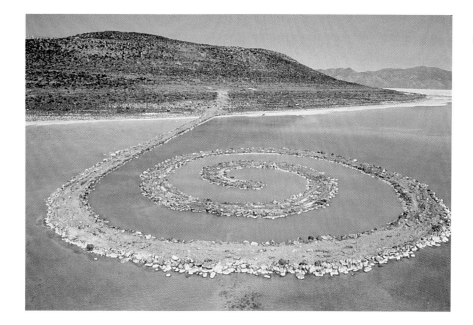

634 Robert Smithson.
SPIRAL JETTY.
Great Salt Lake, Utah. 1970.
Earthwork.
Length 1500', width 15'.
© Gianfranco Gorgoni Art. © Estate of Robert Smithson/Licensed by VAGA, New York, NY.

They are often very large, and they may be executed in remote locations. Earthworks are usually designed to merge with or complement the landscape. Many site works and earthworks show their creators' interest in ecology and in the earthworks of ancient America.

Robert Smithson was one of the founders of the earthworks movement. His SPIRAL JETTY, completed at Great Salt Lake, Utah, in 1970, has since gone in and out of view several times with changes in the water level. Its natural surroundings emphasize its form as willful human design. Although our society has no supportive, agreed-upon symbolism or iconography, we instinctively respond to universal signs like the spiral, which are found in nature and in ancient art.

The earthworks and site works movements have helped redirect relationships among architecture, sculpture, and the environment.

Although site-specific works can be commissioned, they are almost never resold unless someone buys the land of which they are a part. Artists who create conceptual art, earthworks, site works, and performance art share a common desire to subvert the gallery-museum-collector syndrome, to present art as an experience rather than as a commodity.

INSTALLATIONS AND ENVIRONMENTS

While some artists were creating outdoor earthworks and site works, others were moving beyond the tra-

ditional concepts of indoor painting and sculpture. Since the mid-1960s, artists from diverse backgrounds and points of view have fabricated interior installations and environments rather than portable works of art. Some installations alter the entire spaces they occupy; others are experienced as large sculpture; most of them assume the viewer to be a part of the piece.

James Turrell's installations challenge assumptions about the truth of what we see. By manipulating light and space, Turrell creates environments that cause shifts in viewers' perceptions. His work goes beyond the lean physical structures of Minimalism, and beyond Conceptualism's reliance on words and ideas, to dwell on the mysterious and at times awe-inspiring interaction of light, space, and time. Light becomes a tangible physical presence in works such as AMBA, where viewers are coaxed into paying attention to their own perceptions.

The work is about your seeing. It is responsive to the viewer. As you move within the space or as you decide to see it, one way or another, its reality can change.[9]

What really interests me is having the viewer make discoveries the same way the artist does . . . instead of having the viewer participate vicariously, through someone else. . . . You determine the reality of what you see. The work is the product of my vision, but it's about your

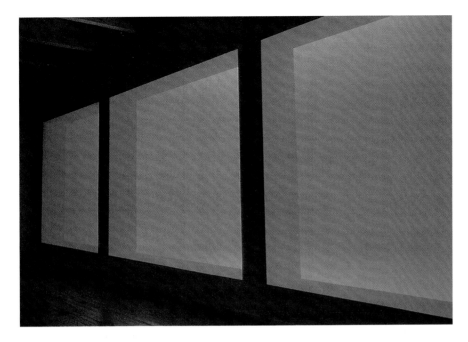

635　James Turrell.
AMBA. 1982.
Light installation.
Photograph courtesy of the artist.

636　Andy Goldsworthy.
STORM KING WALL. 1997–1998.
Field stone, approximately 5 × 2,278'.
Site-specific, permanent installation of
Storm King Art Center, Mountainuille,
New York.
© Andy Goldsworthy, Courtesy at Galerie Lelong,
New York.

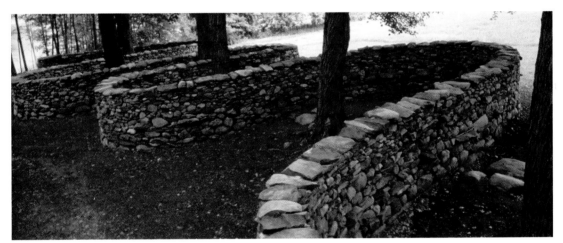

*seeing. The poles of the realm in which I operate are the
physical limitations of human vision and the learned
limits of perception, or what I call "prejudiced percep-
tion." Encountering these prejudices can be an amaz-
ing experience, and if someone can come to these
discoveries directly, the way the artist does, the impact
is greater and so is the joy.*[10]

Turrell has also created what he calls Skyspaces by re-
moving sections of ceilings to expose the sky. (One
is illustrated on page 190.)

British artist Andy Goldsworthy's outdoor in-
stallations are similarly subtle. He uses found mate-

rials to create works that recede into the environment
over time. Commissioned by the Storm King Art
Center in upstate New York to make a piece for the
sculpture garden, he picked up local stones to create
STORM KING WALL, a low, curving parapet that me-
anders nearly a half mile through the property. Many
of his creations are meant to change or decay as
nature itself does. He said:

*Looking, touching, material, place and form are all in-
separable from the resulting work. It is difficult to say
where one stops and another begins. The energy and
space around a material are as important as the energy*

and space within. The weather, rain, sun, snow, hail, mist, calm is that external space made visible. When I touch a rock, I am touching and working the space around it. It is not independent of its surroundings, and the way it sits tells how it came to be there.[11]

EARLY FEMINISM

In the late 1960s, many women artists began to speak out against the discrimination they faced in their careers. It was rare for women to be taken seriously in artists' groups; galleries were more willing to exhibit the work of men than of women; and museums collected the work of men far more often than that of women. Moreover, it seemed to the early feminists that making art about their experience as women might doom them to obscurity in a male-dominated art world. In the early 1970s in New York and California, they began to take action.

Lucy Lippard, an art critic and feminist, argues, "The overwhelming fact remains that a woman's experience in this society—social and biological—is simply not like that of a man. If art comes from the inside, as it must, then the art of men and women must be different, too."[12] The work of some women artists definitely is influenced by their gender and their interest in feminist issues.

California feminists tended to work collaboratively, and to make use of media that have been traditionally associated with "craft work" and with women: ceramics and textiles. THE DINNER PARTY was a collaboration of many women (and a few men), organized and directed by Judy Chicago over a period of five years. This cooperative venture was in itself a political statement about the supportive nature of female experience, as opposed to the frequently competitive nature of the male.

A large triangular table contains place settings for thirty-nine women who made important contributions to world history. These run a wide gamut, from Egyptian Queen Hatshepsut to Georgia O'Keeffe. The names of 999 additional women of achievement are inscribed on ceramic tiles below the table. Each place setting includes a hand-em-broidered fabric runner and a porcelain plate designed in honor of that woman. Some of the plates are painted with flat designs; others have modeled and painted relief motifs; many are explicitly sexual, embellished with flowerlike female genitalia.

East Coast feminists were more pointed in their protests. Some of them formed the group Women Artists in Revolution (WAR), which picketed museums. In response to private dealers who were reluctant to show work by women, they formed their own collaborative gallery, Artists in Residence (AIR). Nancy Spero, a leader in East Coast feminist circles, participated in both groups. Her work from the late 1960s and early 1970s used uncommon media such as paper scrolls, stencils, and printing to document subjects such as the torture and abuse of women. Her later scrolls, such as REBIRTH OF VENUS, attempt to present images of women different from those commonly seen in art. In the segment illustrated here, an ancient statue of the love goddess Venus is split open to reveal a woman sprinter who runs directly toward the viewer. The contrast between the two images is difficult to miss. Woman as love object gives way to woman as achiever. (Compare this work to Botticelli's Renaissance BIRTH OF VENUS on page 267.)

Feminists from both coasts combined their efforts with art historians in an effort to research, document, and celebrate the accomplishments of women artists of the past who had been neglected. One of the first woman artists "rediscovered" was still very much alive: sculptor Louise Bourgeois, whose work had been dealing with feminist issues for the preceding forty years.

Bourgeois depicts femaleness from within instead of looking at it from the outside, as male artists have done for centuries. Her sculpture describes the experience of being female in terms of organic shapes placed in tenuous relationships. It explores helplessness, fear, nurturing, and sexuality—as well as aggression, rage, and protest.

According to Bourgeois, the underlying motivations for her art stem from unresolved psychological

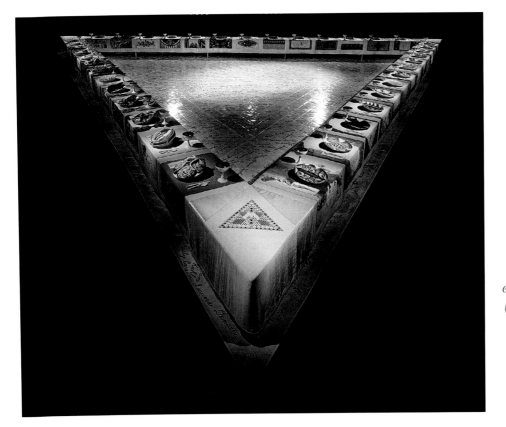

637 Judy Chicago.
THE DINNER PARTY.
1979. Mixed Media,
48' × 48' × 42' × 3' installed.
Triangular table on white tile floor.
Collection of the Brooklyn Museum
of Art, Gift of the Elizabeth A. Sackler
Foundation.
Photograph: © Donald Woodman. © 2005 Judy
Chicago/Artists Rights Society (ARS), NY.

638 Nancy Spero.
REBIRTH OF VENUS. Detail. 1984.
Handprinting on paper. 12" × 62'.
Courtesy of the artist.
Photograph: David Reynolds

POSTMODERNITY AND GLOBAL ART

n the late 1970s or early 1980s, the impulses and drives that caused modern art seemed spent. Just as the Italian Renaissance, the Gupta Dynasty in India, and the Nok Culture of West Africa all were eventually supplanted by new styles, new cultural values, or new sources of support, so was modern art.

Modern art was based on rejecting tradition and breaking rules. Each new movement found some rule to break: use of representational color, regular perspective, and recognizable subject matter are only a few of the rules that modern artists cast aside.

The impulse to depart from the norm lost its impact when it *became* the norm in most Western societies. In Western societies, we now look intently forward: to the next year, to the next presidential term, or to the next line of computers; not backward to the wisdom of our elders, ancient rituals, or eternal principles. Departing from the norm is widely seen as healthy. In fact, this was the slogan of a chain of fast food restaurants in the early 1990s: "Sometimes you just gotta break the rules."

At this time in the development of art, there are no rules left to break. One can do something new for only so long before repetition occurs. While it is still possible to employ themes that offend people today, it is difficult to make a new style such as Cu-bism, Expressionism, Constructivism, or Minimalism. Most artists have given up trying.

Today the public accepts most Modern art. Exhibitions of work by such former rule-breaking radicals as Henri Matisse, Paul Gauguin, Paul Cézanne, and Claude Monet fill museums with visitors. Nine of the ten most expensive paintings ever sold at auction are modern works (four by Picasso; three by van Gogh; one each, by Cézanne and Renoir). The modern-style Vietnam Veterans Memorial has become a national shrine. Modern art is no longer controversial.

The impact of this situation is not yet clear. Art of our own time is always the most difficult to evaluate. In general, most artists of the present generation do not appear intent on perfecting form, creating beauty, or fine-tuning their sense of sight. They mostly want to comment on life in all of its aspects. They want to create work that illuminates the relationships between what we see and how we think. Rather than being objects of timeless beauty, most art since the 1980s consists of objects laden with information about the period we live in. This chapter will present some movements of the present generation; many of the artists discussed in this chapter could be placed in more than one category, but most would prefer not to be categorized at all.

POSTMODERN ARCHITECTURE

The history of architecture has been characterized by refinements followed by overturnings, with the young and the imaginative always finding some degree of inadequacy in the work of their immediate predecessors. A growing discontent with the sterile anonymity of the mid-century International Style (see the LEVER HOUSE on page 426) led many architects to rebel and to look once again at meaning, history, tradition, and context. Their departure from architectural modernism was dubbed Postmodern in the late 1970s.

Postmodernists felt that the unadorned functional purity of the International Style made all buildings look the same, offering no identity relative to purpose, no symbolism, no meaning, no mystery, no excitement. Postmodern architects celebrate the very qualities of modern life that the proponents of machine aesthetics sought to escape: complexity, ambiguity, contradiction, nostalgia, romance, and the rich vulgarity of popular taste. One of the important Postmodern architects, Robert Venturi, wrote a book in 1972 that brought the entire profession to attention with its self-explanatory title: *Learning from Las Vegas.*

Postmodern architects embraced an eclectic mix of historical influences, decorative tendencies, and the popular styles of architecture and applied arts for the general public to relate to. The Postmodernists divorced themselves and their work from the accepted meanings of "traditional" and "modern" and did not value one more than the other. The attitudes associated with Postmodernism are a part of all the arts, including literature. In the visual arts, the Postmodern style is perhaps best seen in architecture.

Architect Philip Johnson's career has spanned both the Modern and Postmodern movements. He has been known since mid-century as an advocate of Modernism and, with Mies van der Rohe, designed the SEAGRAM BUILDING (page 217), a landmark of the International Style. But the pure glass-enclosed box, repeated a thousand times in cities throughout

654 Johnson and Burgee.
A.T. & T. BUILDING.
New York City. 1978–1984.
Photo by Gil Amiaga, NYC.

the world, became too severe, too limited for Johnson and his younger colleagues. In high-rise buildings such as the A.T. & T. BUILDING in New York City, he reversed himself. Here Johnson and John Burgee brought back warmth and delight with a decorative upper story that brings together elements from several historical styles.

655 Michael Graves.
PUBLIC SERVICES BUILDING.
Portland, Oregon. 1980–1982.
© Peter Aaron/Esto. All rights reserved.

656 Rem Koolhaas.
SEATTLE CENTRAL LIBRARY. 2004.
Benjamin Benschneider/The Seattle Times.

The architecture of Michael Graves reflects a personal blend of traditional classicism and inventive irony. His PUBLIC SERVICES BUILDING is both formal and playful. Its exterior makes reference to a pair of fluted classical columns sharing a single capital. These off-color vertical elements are set in a pool of reflecting mirror windows, which detaches them from any function in the building's structure. The remainder of the façade consists of anonymous rows of square openings, an ironic reference to the bureaucrats inside.

The SEATTLE CENTRAL LIBRARY by Rem Koolhaas is even more playful. At first sight it looks like a disorientingly skewed stack of books. The diagonal webbing on the exterior recalls the grid of the International Style (two such buildings are nearby), but it more closely resembles a set of fishnet stockings. This irregular exterior conceals four perfectly functional blocks that are easy to navigate. The sloping sheets of glass shelter huge, naturally lit study spaces.

PAINTING

As Modernism came to an end, many painters in America and Europe began to revive expressive, personal styles in a movement known as Neo-Expressionism. This was partly in response to the impersonality and generally aesthetic orientation of movements such as Conceptual Art and Minimalism, and to the ironic, tongue-in-cheek quality of Pop Art and related trends.

One of the first Neo-Expressionists was Susan Rothenberg, who in the 1970s began making symbolic, heavily brushed works in which subject matter teeters on the brink of recognizability. After the cleansing blankness of Minimalism, Rothenberg could return to figurative images with original vision; what emerges is almost ethereal.

Elizabeth Mu[...]
with explosively i[...]
MORE THAN YOU [...]
the time between t[...]
ever, beyond the [...]
two red chairs, th[...]
perience of mothe[...]
is only the launch[...]
array of canvas fr[...]
but still seem to c[...]
berant paintings le[...]
viewer to make up[...]

Kerry James N[...]
jects in Alabama a[...]
correct a popular [...]
ridden. His 1994 v[...]
DENS is part of a se[...]
Chicago housing [...]
"garden" in their n[...]
Wentworth Garden[...]
down a flowered pa[...]
left is a fenced area [...]
den. Three of the [...]
across the upper p[...]
peaceful. Whateve[...]
jects, they are plac[...]
hood feeling, he se[...]

Yet for all its o[...]
in this work. The p[...]
white blotches over [...]
flowered entry with [...]
of complexity to [...]
shadow over its swe[...]
the upper right rem[...]
tration, and a paint[...]
ously composed. I[...]
horizontals, vertica[...]
the work is optimist[...]
ing an idealistic sce[...]

PHOTOGRAP[...]
The Postmodern m[...]
fluence on recent p[...]
insight that Postmo[...]

She works in a narrow range of tones, using a muted palette of white, beige, silvery or dark gray, with a bit of blue. Her BLUE HEAD, which outlines a horse's head in front of a human hand, is a haunting image that resists explanation. It is a primal sign operating between the material world and the mystery beyond.

Eric Fischl is another master of painterly brushwork. Like Rothenberg, he moved from abstract art to representation. His UNTITLED view of children washing sand from their bathing suits shows a love of gesture and color. Fischl paints with direct fluidity, drawing the viewer into the magical process of creating pictures out of paint. His seductive paint application is often overshadowed by subject matter that sometimes shocks viewers with its psychological and sexual implications.

The German painter Anselm Kiefer combines the aggressive paint application of Abstract Expressionism with nineteenth-century feelings for history and mythology. Kiefer gives equal attention to moral and aesthetic issues. A student of performance artist Joseph Beuys, Kiefer, in the late 1960s, did a highly controversial series of performances that he called *Occupations,* which he documented with photographs. For these performances, he donned a military uniform and stood in various famous places across Europe, giving a Nazi salute. He said that he wanted to better understand Fascism by re-enacting some of its rituals. His paintings, loaded with symbolism, mythology, and religion, probe the German national conscience and reveal the grim confusion felt by many postwar Germans. Kiefer sees art as having the power to provide a spiritual catharsis; yet his disturbing work presents more questions than answers.

657 Susan Rothenberg.
BLUE HEAD. 1980–1981.
Acrylic on canvas. 114" × 114".
Virginia Museum of Fine Arts, Richmond.
Gift of The Sydney and Frances Lewis Foundation.
© Virginia Museum of Fine Arts.
© 2002 Susan Rothenberg/Artists Rights Society (ARS), NY.

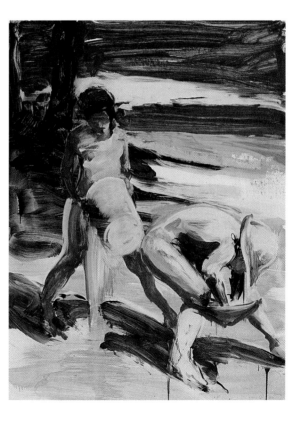

658 Eric Fischl.
UNTITLED. 1986.
Oil on paper. 46" × 35".
Private collection. Courtesy Mary Boone Gallery, New York.

659 Anselm Kiefer.
OSIRIS AND ISIS.
Oil, acrylic, emu
San Francisco Museum
Fund. Photograph by Be

O:

myth
bolize
accorc
pieces
Osiris
burial
Isis co
life. In
tached
nects t
board
surfac
and bi

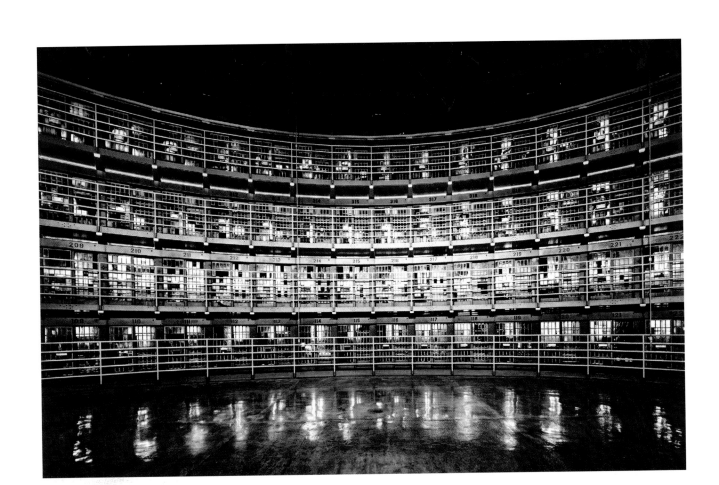

662 Andreas Gursky.
STATEVILLE, ILLINOIS. 2002.
C-Print mounted on plexiglas in artist's frame, 81" × 120½".
Courtesy of Matthew Marks Gallery, New York, and Monika Spruth/Philomene Magers, Cologne/Munich.
© 2004 Andreas Gursky/Artists Rights Society (ARS), NY/VG Bild-Kuns, Bonn.

was the perhaps unsurprising notion that a photograph is not merely a "straight" record of fact. There are ways of composing, taking, developing, and printing pictures that serve to encode information and influence viewers. Photographers influenced by Postmodernism show through their pictures that they know their medium is not an objective one. Even the most straightforward scenes can have hidden meanings. Postmodernists want to show us that the camera can influence us in ways we may not suspect, and the camera itself has a certain way of seeing.

Andreas Gursky's photographs use the latest technological tricks to depict modern, sterile spaces. Using the new Cibachrome process, he stretched STATEVILLE, ILLINOIS out to seven by ten feet, as big as a mural. The space he photographed looks lived-in, but curiously hushed. This is a prison that could be almost anywhere on earth. Gursky achieved this spotless, tightly focused look with the help of digital editing; he typically removes blemishes, adjusts lighting, adds or removes people, and improves contrast, much as a painter may manipulate the surface of a canvas. His most common subject is the public spaces that we all use today: airports, auditoriums, stores. His pictures are dazzling in a way that the "reality" is not; in this regard his works resemble advertising photography, but the world they create is eerie.

If Gursky's photos construct a frozen world where the clocks have stopped, Carrie Mae Weems uses the camera to tell resonant stories. As much a

student of African-American culture as of the techniques of art, she often creates series works that mingle cultural history with autobiography. After a recent trip to Cuba, for example, she created a set of works that seem like meditations on history. In ANCIENT RUINS OF TIME, we see her wearing a nineteenth-century gown as she wanders through a colonnaded porch. She seems to inhabit the world before the twentieth century, when the island was a colony of Spain. The sequence of pictures suggests a narrative, but we wonder what it is.

Cindy Sherman's photographs of the late 1970s were among the first to be called Postmodern. She took black-and-white photos of herself, posing with props in scenes that corresponded to stereotyped female characters from popular culture. In UNTITLED FILM STILL #48, for example, she stands on a deserted road at dusk, her back to us, hastily packed suitcase at her side. As in many "teen movies" of the 1950s and 1960s, she is the misunderstood daughter running away from home. Other photos from the series depict the girl next door, daddy's little girl, the anxious young career woman, the oppressed housewife. Without referring to specific movies, Sherman's photos are imagined stills from popular film types that have helped to form stereotypical images of women. She seems to be saying that our culture typecasts women in certain roles, and thus keeps women from realizing themselves.

Sherman's work is influenced about equally by Pop Art, Performance Art, and Feminism. She differs from the early feminists, though, in presenting women as a product of the culture and not of biology. In her eyes, culture has a much larger role in forming women than does nature.

SCULPTURE

The range of options available to sculptors has rarely been wider. Partly in reaction to the simplicity of Minimal and Conceptual art, sculptors today draw on a range of techniques and materials. One task that seems to motivate many sculptors in recent years is exploring the symbolic value of shapes. How can a shape "mean something"? What range of memories and feelings are viewers likely to attach to a given fig-

663 Carrie Mae Weems.
ANCIENT RUINS OF TIME, from series DREAMING IN CUBA. 2002.
Three gelatin silver prints, each 20" × 20."
Courtesy of the artist and P.P.O.W. Gallery, New York.
Photograph: © 2003 D. James Dee.

664 Cindy Sherman. UNTITLED FILM STILL #48. 1979.
Black and white photograph.
Courtesy Cindy Sherman and Metro Pictures.

ure? At what point does a form "take shape" so that a viewer can recognize it? Are they likely to see what the creator had in mind? These are some of the questions that sculptors have been posing with their pieces in recent years.

Martin Puryear, an African American, thoughtfully probes such questions. Combining elegant craftsmanship, organic creativity, and humor, Puryear's deceptively simple sculptures include references to shelters, canoes, trestle bridges, coffins, and basketry. Puryear's work has a distinctly American eloquence that arises from the pioneer traditions

665 Martin Puryear.
OLD MOLE. 1985.
Red cedar. 61" × 61" × 32".
Philadelphia Museum of Art. Purchased with gifts (by exchange) of Samuel S. White 3rd and
Vera White, and Mr. and Mrs. C.G. Chaplin and with funds contributed by Marion Boulton Stroud,
Mr. and Mrs. Robert Kardon, Mr. and Mrs. Dennis Alter and Mrs. H. Gates Lloyd. 1986-70-1.

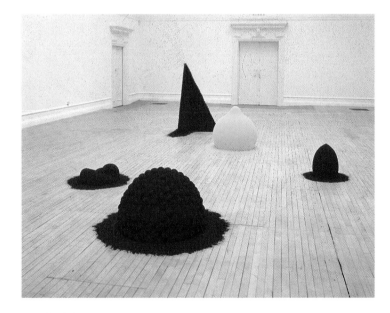

666 Anish Kapoor.
TO REFLECT AN INTIMATE PART OF THE RED. 1981.
Pigment and mixed media. Installation: 78" × 314" × 314".
Photo: Andrew Penketh, London. Courtesy Barbara Gladstone.

of self-reliance and craftsmanship. His OLD MOLE recalls the delicate skeleton of an animal as it combines the whimsical humor of a folk tale with the austere sophistication of Minimalist sculpture.

Indian-born English sculptor Anish Kapoor takes such explorations in a more ritualistic direction in his work TO REFLECT AN INTIMATE PART OF THE RED. He deployed across a gallery floor several shapes that allude to ancient religious structures such as Maya pyramids, Indian stupas, and onion-shaped domes. Kapoor sprinkled his sculpture with powder, an action that also seems ritualistic. The translation of these shapes into an art gallery context raises questions about how their spiritual meanings come about, and how much of that meaning persists in the new context.

Probably the most potent symbol in sculpture is the human body, and many artists today continue to find new meaning in the figure as a subject. These sculptors see it not as a vehicle for idealism or beauty, but rather for commenting on the ways in which culture shapes our bodies and how we think about them.

Kiki Smith is a hero to many feminists because of the way she has modeled, in resin, wax, and papier mâché, full-body depictions of wounded women. These pieces drew attention to the silent suffering of many victims of domestic violence, but in recent years she has broadened her focus. She is as likely now to concentrate attention on the inside of the body and its functions, some of which are infrequently dealt with in art. Like many artists today, she is also influenced by current events. In 1995, when the frozen body of a Stone Age man was found intact in the Alps, she fashioned ICE MAN as a commentary. The piece, showing the unclothed man in the frozen position in which he was found, is modeled life-size and cast in silicon bronze. The material gives the surface a dark color similar to that of the dead man's skin. Smith simplified the facial features, leaving the work's title the only sure clue to the source of the piece. She hung the work on the wall of the gallery, slightly above eye level, attached by its back. Thus it became for viewers an object of curiosity, a specimen, just as the frozen Stone Age man was for the anthropologists who studied it.

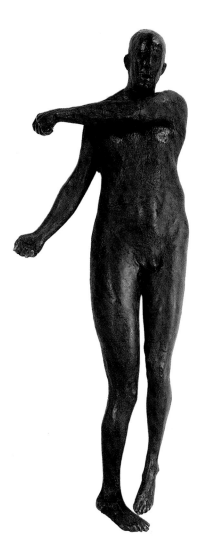

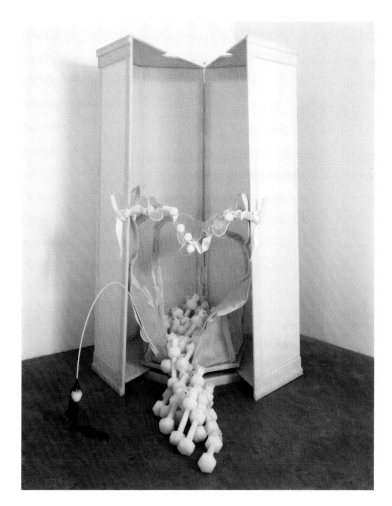

667 Kiki Smith.
ICE MAN. 1995.
Silicon bronze. 80" × 29¼" × 12"
(203.2 × 74.3 × 30.5 cm).
© 1995 Kiki Smith. Photograph: Ellen Page Wilson. Courtesy of Pace Wildenstein.

668 Matthew Barney.
THE CABINET OF HARRY HOUDINI, from CREMASTER 2. 1999.
Cast nylon, salt, epoxy, polypropylene, plastic, and beeswax,
83⅝" × 64" × 73".
Courtesy of Barbara Gladstone Gallery.
© 1999 Matthew Barney.

Matthew Barney makes mixed media sculpture for sets and props in elaborately plotted films. CREMASTER 2 tells the story of Gary Gilmore, convicted in 1977 in Utah for murdering a gas station attendant. The plot begins at his execution (staged as a bull ride in the Utah salt flats) and goes backward in time to 1893, when the famous magician Harry Houdini performed a daring escape from a locked box at the Chicago World's Fair. THE CABINET OF HARRY HOUDINI is a prop from CREMASTER 2, which the artist described as a "Gothic Western." The plot is complicated, but it suggests that Houdini may have been Gilmore's grandfather. Other themes explored are the lives of honeybees and the sexual differentiation of a fetus in the womb. The plots of the CREMASTER cycle films (five in all) seem vaguely reminiscent of other film, novels, or television news, but Barney draws epochal themes from the welter of associations.

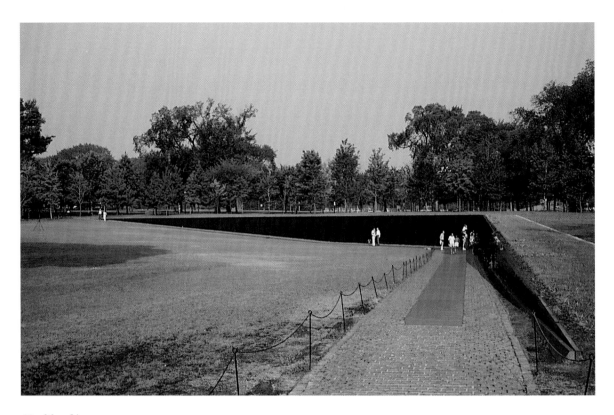

669 Maya Lin.
VIETNAM VETERANS MEMORIAL.
The Mall, Washington, D.C. 1980–1982. Black granite. Each wall 10'1" × 246'9".
Photograph: Duane Preble.

PUBLIC ART

The idea of public art goes back to ancient times. Government and religious leaders have commissioned many of history's best-known artists to execute works for the public. However, only in recent decades have commissions for public art gone to large numbers of American artists.

During the 1960s, government leaders began to spend money in new areas. Since the arts are considered beneficial for individuals and communities, it seemed appropriate that city, state, and national governments become involved in bringing the arts to the public. A high percentage of today's public art is now commissioned by government agencies.

Among the largest sponsors of public art is the federal government's General Services Administration (GSA) Art-in-Architecture program, begun in 1962. The program requires that one-half of one percent of the cost of each new government building

be spent for art to be located in or around the new building. States, cities, and counties subsequently implemented similar programs, with varying percentages designated for the purchase or commissioning of works of art.

The VIETNAM VETERANS MEMORIAL, located on the Mall in Washington, D.C., has become America's best-known public art. The 250-foot-long, V-shaped black granite wall bears the names of the nearly sixty thousand American servicemen and women who died or are missing in Southeast Asia. The nonprofit Vietnam Veterans Memorial Fund, Inc. (VVMF) was formed in 1979 by a group of Vietnam veterans who believed that a symbol of recognition of the human cost of the war would help speed the process of national reconciliation.

After examining 1,421 entries, the jury of internationally recognized artists and designers unanimously selected the design of twenty-one-year-old

R. M. Fischer

Battery Park City in New York is an effort to combine the expertise of specialists with input from citizens to integrate public art into a mixed commercial and residential area. This new neighborhood, which took shape in the early 1980s, was planned as a redevelopment project in a rundown area of Manhattan. Apartments, hotels, schools, and shops now occupy the 982-acre site.

R. M. Fischer's RECTOR GATE marks a strategic location between an apartment complex and a riverside park. Visitors and residents walking from one to the other pass under this fanciful structure, which is laden with symbolic motifs from science fiction movies, heroic engineering projects, and more practical TV towers or antennae.

670 R. M. Fischer.
RECTOR GATE. 1988.
Stainless steel, bronze, granite, lighting. 50' × 28'.
Courtesy of the artist.

Maya Ying Lin of Athens, Ohio, then a student at Yale University. Lin had visited the site and created a design that would work with the land rather than dominate it. "I had an impulse to cut open the earth . . . an initial violence that in time would heal. The grass would grow back, but the cut would remain, a pure, flat surface, like a geode when you cut it open and polish the edge. . . . I chose black granite to make the surface reflective and peaceful."[1]

Lin's bold, eloquently simple design creates a memorial park within a larger park. It shows the influence of Minimalism and Site Works of the 1960s and 1970s. The polished black surface reflects the surrounding trees and lawn, and the tapering segments point to the Washington Monument in one direction and the Lincoln Memorial in the other. Names are inscribed in chronological order by date of death, each name given a place in history. As visitors walk toward the center, the wall becomes higher and the names pile up inexorably. The monument, visited by thousands each day, has—for many—the power to console and heal.

The fragmented nature of contemporary American culture presents a dilemma for both artists and those who sponsor public art. Should the freedom of the artist be unquestioned, with the hope that the public will follow, or at least accept, the art that results? Or should the public have a voice in setting guidelines for selection or actually select the art that becomes part of the public environment—particularly when the art is paid for by tax dollars? Just how democratic should the process be? On the one hand, we could rely entirely on experts, whose tastes are often different from those of the public; at the other extreme, with a lot of public input, we might yield to the lowest common denominator of popular taste.

ISSUE-ORIENTED ART

Many artists in the last twenty years have sought to link their art to current social questions. Issue-oriented artists believe that if they limit their art to aesthetic matters, then their work will be only a distraction from pressing problems. Furthermore, they recognize that what we see influences how we think, and they do not want to miss an opportunity to influence both.

Mierle Laderman Ukeles, spurred by New York's ongoing garbage crisis and her own experiences as a

mother, began to consider the importance to society of "maintenance work," the repetitive tasks such as garbage collection that are necessary for social functioning. (See also page 445.) Since 1978, Ukeles has been an unsalaried artist-in-residence for the New York City Department of Sanitation, where she makes pieces that are based on the apparent everydayness of Conceptual Art. In 1979 and 1980 she joined the daily rounds of sanitation workers and their supervisors; then for eleven months she completed an eight-hour-a-day performance piece in which she shook the hands of the more than 8,500 workers taking care of New York's mountains of garbage. With each handshake she said, "Thank you for keeping New York City alive."

For a parade, Ukeles covered the sides of a garbage truck with mirrors, creating THE SOCIAL MIRROR. The piece enabled people to see themselves as the starting point of the process, the source of the garbage.

Photographer Richard Misrach is similarly motivated by concern for the environment. His photograph SUBMERGED LAMPPOST, SALTON SEA captures the silent yet ironic beauty of a small town in California that was flooded by a misguided irrigation

671 Mierle Laderman Ukeles.
THE SOCIAL MIRROR. New York. 1983.
20-cubic yard garbage collection truck fitted with hand-tempered glass mirror with additional strips of mirrored acrylic.
Courtesy The New York City Department of Sanitation.
Photograph: D. James Dee.

672 Richard Misrach.
SUBMERGED LAMPPOST, SALTON SEA. 1985.
Photograph (chromogenic color print).
Courtesy of the Robert Mann Gallery. © Richard Misrach.

system. In other works he has documented in chilling detail the bloated carcasses of animals killed on military proving grounds in Nevada. His brand of nature photography is in opposition to the common calendars that include soothing views of pristine landscapes. He wants us to know that such scenes are fast disappearing.

Barbara Kruger was trained as a magazine designer, and this profession shows in her piece UNTITLED (I SHOP THEREFORE I AM). She invented the slogan, which sounds as though it came from advertising. The position of the hand, too, looks like it came from an ad for aspirin or sleeping medication. Do our products define us? Are we what we shop for? Often we buy a product because of what it will say about us and not for the thing itself. These are some of the messages present in this simple yet fascinating work. Perhaps its ultimate irony is that the artist had it silkscreened onto a shopping bag.

Artists who create works about racism and class bias show how common practices of museum display contribute to such problems. In 1992, the Maryland Historical Society invited African-American artist Fred Wilson to rearrange the exhibits on one floor to create an installation called MINING THE MUSEUM. He spent a year preparing for the show, rummaging through the Society's holdings and documentary records; the results were surprising. He found no portraits, for example, of noted African-American Marylanders Benjamin Banneker (who laid out the boundaries of the District of Columbia), Frederick Douglass (noted abolitionist and journalist), or Harriet Tubman (founder of the Underground Railroad). He found instead busts of Henry Clay, Andrew Jackson, and Napoleon Bonaparte, none of whom ever lived in Maryland. He exhibited those three busts next to three empty pedestals to symbolize the missing African Americans. He set out a display of Colonial Maryland silverware and tea utensils, but included a pair of slave shackles. This lesser-known form of metalwork was perhaps equally vital to the functioning of nineteenth-century Maryland. He dusted off the Society's collection of wooden cigar-store Indians and stood them, backs to viewers, facing photographs of real Native Americans

673 Barbara Kruger.
UNTITLED (I SHOP THEREFORE I AM). 1987.
Photographic silkscreen/vinyl. 111" × 113".
Courtesy Mary Boone Gallery, New York.

674 Fred Wilson.
MINING THE MUSEUM. 1992.
Installation. Cigar Store Indians facing photographs of Native American Marylanders.
Museum and Library of Maryland History.
Photograph: Jeff D. Goldman.

who lived in Maryland. In an accompanying exhibition brochure he wrote that a museum should be a place that can make you think. When MINING THE MUSEUM was on display, attendance records soared.

THE GLOBAL PRESENT

Communication and travel technologies are making the world seem smaller and smaller. The Internet, air travel, mobile phones, cable television, and international migration are bringing us all into ever closer proximity. Since the fall of communism, the world is not as divided as it was for the preceding half-century, thus contributing to a more fluid world culture. Many businesses, for example, are not confined by national boundaries anymore; they may raise money in one country, buy raw materials in another, set up manufacturing facilities in a third, and sell the final product around the world.

The trend toward globalization has had some interesting consequences: Mexican soap operas are extremely popular in the Philippines. Residents of Papua New Guinea can watch reruns of the 1980s television show *Dallas* in local bars. Latin American novels influenced Chinese filmmakers of the 1980s and 1990s. During the invasion of Iraq, Saddam Hussein followed the conflict on CNN. The world's tallest building is a bank in Shanghai. Ethnic

"minorities" already make up the majority of students in many American public school systems. By the year 2015, according to the United Nations, only one of the world's fifteen largest urban areas will be located in the United States (New York City, tied for eighth place with Tianjin, China). None of the top fifteen will be European. To function successfully and to live peacefully, it is increasingly necessary that we understand cultures beyond our own.

The globalization of culture has had a profound impact on art. Contemporary art forms such as conceptual, installation, and performance art have spread around the world. Innovative work is emerging in unexpected places, as artists in many countries employ increasingly international modes of expression to interpret the contemporary world in the light of their own traditions. This union of the cosmopolitan and the local is a major source of the new creative effort that has always fertilized art. A few examples from disparate continents will have to suffice to indicate the directions that art is taking.

William Kentridge's animated films trace the emergence of a new South Africa as it comes to grips with its history of apartheid. HISTORY OF THE MAIN COMPLAINT tells a story of a real estate speculator who is rendered semi-conscious in an auto accident. As he slowly comes to himself in the hospital, his gradually clarifying memory tells him in flashbacks that others died in the crash, and also that he was the cause of it. The protagonist's story is an allegory of South Africa itself as it slowly awakens from the grim reality of racism. The artist made this film laboriously, in the fashion of an old cartoon, drawing hundreds of the story's moments in charcoal on paper and then photographing them in sequence.

Probably Kentridge's real estate speculator would prefer to hook himself up to WAVE UFO by Japanese artist Mariko Mori. Her piece is a teardrop-shaped vessel that appears to have arrived from outer space to land in the lobby of a Manhattan office building. Viewers (three at a time) enter in order to experience technological enlightenment. They lie on couches connected to brain-wave detectors, where computer

675 William Kentridge.
Drawing from HISTORY OF THE MAIN COMPLAINT. (Title Page). 1996.
Charcoal and pastel on paper. 60 × 122 cm.
Courtesy of the Goodman Gallery, South Africa.

programs convert their brain activity into light displays. These last three minutes, followed by four more of abstract film designed by the artist to show a "cosmic dream world." Buddhist meditation meets high technology in this work, which drew harried office workers for two months.

Native American artist Jaune Quick-to-See Smith reflects on identity in a more expressive way in THE RED MEAN: SELF PORTRAIT. We notice first the two black outlined figures that resemble police crime scene drawings, except that they also come from a famous drawing by Leonardo da Vinci. Superimposed over them is a bold red X which symbolizes both negation and the Native American spiritual concept of the four directions. At the center is a large sign proclaiming "Made in USA" together with the artist's tribal identification number. Pasted across the surface of this mixed media work are articles from Native American tribal newspapers that discuss issues of importance on the artist's reservation. From this mixture of the sacred and the profane, of the transcendental and the everyday, the artist constructs her identity.

Issues now causing soul searching for many people in this shrinking world are the interlocking questions of personal and ethnic identity. Does an artist from one part of the world need to stick with the traditional styles still associated with that part of the world? Is it appropriate for an American artist to paint in a traditional Chinese style or visa versa?

676 Mariko Mori.
WAVE UFO. 2003.
Installation in New York City.
The Public Art Fund.
Photograph: Tom Powel Imaging.

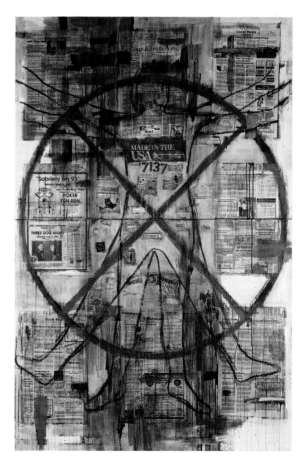

677 Jaune Quick-to-See Smith.
THE RED MEAN: SELF-PORTRAIT. 1992.
Acrylic, newspaper collage and mixed media on canvas,
90" × 60".
Smith College Museum of Art, Northampton, MA.
Part gift from Janet Wright Ketcham, class of 1953, and part purchase from
the Janet Wright Ketcham, class of 1953, Fund, 1993.

Shahzia Sikander answers many of these questions by taking a middle ground, drawing on her roots while giving her work a contemporary look. Born in Pakistan, she was trained first as a traditional illustrator in the ancient gouache medium (see page 332 for an example). After moving to the West in the mid-1990s, she studied at the Rhode Island School of Design. Her 2001 painting PLEASURE PILLARS is a layered arrangement of women in various guises and poses. At the center we see a headless figure in traditional garb flanked by a classical Greek nude. At the top center is a tail view of the airliner that facilitates travel between these two worlds. Other figures allude to traditional dance movements and domestic scenes. The symbolic ram's head and bird imagery complete the inventory of this work but not its metaphoric meanings.

The Iranian-born Shirin Neshat similarly reflects on the complex question of a woman's identity in today's global society. She grew up before the Islamic revolution of 1979, studied in the West, and has returned to Iran several times since. She works in various media, but most recently has made films. PASSAGE tells a story of death and rebirth in the

678 Shahzia Sikander.
PLEASURE PILLARS. 2001.
Watercolor, dry pigment on
Wasli paper, 12" × 10".
Brent Sikkema Gallery, New York.

679 Shirin Neshat.
PASSAGE. 2001.
Still from film.
© 2001 Shirin Neshat.
Courtesy of the Gladstone Gallery.

desert. This 11-minute film, shot without dialogue, shows a line of men in uniform carrying a body toward a group of veiled mourning women who have dug a shallow grave. A young girl, symbolizing the next generation, sits a few yards away. She arranges stones in a circle and places sticks at the center, symbolically yet playfully re-enacting the burial. As the black-clad men approach the women and deposit the body, a ring of fire encircles all except the girl.

Senegalese artist Fodé Camara feels that his work does not have to be recognizable as African. When asked if he saw himself as African, Camara replied, "Yes, I am very African because Africa is above all amalgamation and recycling."[2] In PARCOURS–TRICOLORE II, Camara presents a large, colorful, boldly designed painting depicting an abstract standing figure, his own silhouette, with imprints of his hands, and suggestions of Goré, the former slave depot island off Dakar. By painting in sections, on three horizontal panels and then dividing his image in four vertical bands, Camara has provided a visual structure for his strong color and active brushwork. His use of symbols is personal and thought provoking.

If Camara embraced painting, today's artists are equally likely to mix media. The Argentine artist Fabian Marcaccio makes large works that combine painting with sculpture, installation, sculptural casting, and digital media. He calls them "paintants" to describe the expanded form of the traditional medium, as he did in his 2001 installation PREDATOR. Marcaccio keeps a bank of digital images on a computer that he can manipulate and project onto the surface of the work as he creates it. He then adds brush strokes, armatures, or flat spaces as

680 Fodé Camara.
PARCOURS–TRICOLORE II. 1988.
Oil on canvas. 82" × 47".
Collection Abdourahim Agne. Courtesy of the artist
and The Museum for African Art, NY.
Photograph: Jerry L. Thompson.

681 Greg Lynn and Fabian Marcaccio.
THE PREDATOR. 2001.
Installation at Wexner Center for the Arts,
Ohio State University, Columbus, OH.
Courtesy Wexner Center for the Arts and Greg Lynn Form.

682 Rafael Lozano-Hemmer.
VECTORIAL ELEVATION. 1999–2000.
Multimedia installation, Mexico City.
Courtesy Bitforms Gallery, New York.

needed. The title of this work came from a movie starring Arnold Schwarzenegger, and indeed it resembles an oddly mutated life form cast from synthetic material. It is displayed with sound accompaniment by D. J. Spooky. As viewers encounter the work, they "edit" their experience of it by moving through it at will and focusing on different aspects. Hence there is no correct way to see it, and no cohesive message that it communicates. In this way, the artist says, the experience of the work parallels today's multimedia reality, which forces us to make sense of multiple inputs at the same time.

Empowering and interacting with viewers in new ways is an important focus of contemporary art. Mexican artist Rafael Lozano-Hemmer created VECTORIAL ELEVATION with viewer input during the passing of the millennium on the evenings surrounding January 1, 2000. Viewers anywhere in the world could go to a Web site and program the array of adjustable light fixtures he installed on the roofs of the historic buildings in the central square of Mexico City. Web site visitors designed an array and entered it along with their names and e-mail addresses, and Lozano-Hemmer's computer programmed and displayed each viewer's input in the square in real time for six seconds. The crush of incoming data was so great that he extended the event in order to show everyone's designs. VECTORIAL ELEVATION was programmed by the artist, but crated by people around the world. Today's global society makes possible such instant interaction. The piece has been re-enacted in three more cities since its premiere, most recently in 2004 in Dublin for the celebration of European Union expansion.

The final piece of art in this book is part of the rebuilding plan for Ground Zero at the site of the September 11 attacks. Spanish architect Santiago Calatrava used digital three-dimensional modeling to create the WORLD TRADE CENTER TRANSPORTATION HUB, an inspiring design that will be aligned with the sun's position at the moment the first hijacked airliner hit. The spreading exterior skeleton is based on birds' wings, and the roof is mechanically retractable to allow an opening fifty feet wide to take advantage

of favorable weather. The glass and steel structure will allow sunlight to penetrate sixty feet to the underground tracks of commuter trains and subways that are projected to serve eighty thousand people per day when completed in 2009. Even in its planning stage, the building's dramatic curves and light-filled, soaring appearance are already creating hope in the place where the tragedy occurred.

This book has attempted to present a small portion of the boundless variety of art that characterizes human expression. We have seen that art comes from basic feelings that all of us share. Through their work, artists interact with life, to find purpose and meaning in it. Art and human life vary considerably across time and space, but the art endures. Creative expression is a response to being alive.

Appreciation for the artistic dimension within each of us is as important as the recognition of the roles of art and artists in society at large. In the process of strengthening our understanding and appreciation for the art produced by recognized masters, we must not neglect the art within ourselves. To prevent such a dead end, it is necessary to give equal care and attention to the development of the artist within.

Art offers us a way to go beyond mere physical existence. The ideas, values, and approaches that constitute the basis of the visual arts can continue to enrich our lives and surroundings. We form art. Art forms us.

683 Santiago Calatrava.
WORLD TRADE CENTER TRANSPORTATION HUB. 2006–2009.
New York City.
Port Authority of New York and New Jersey.

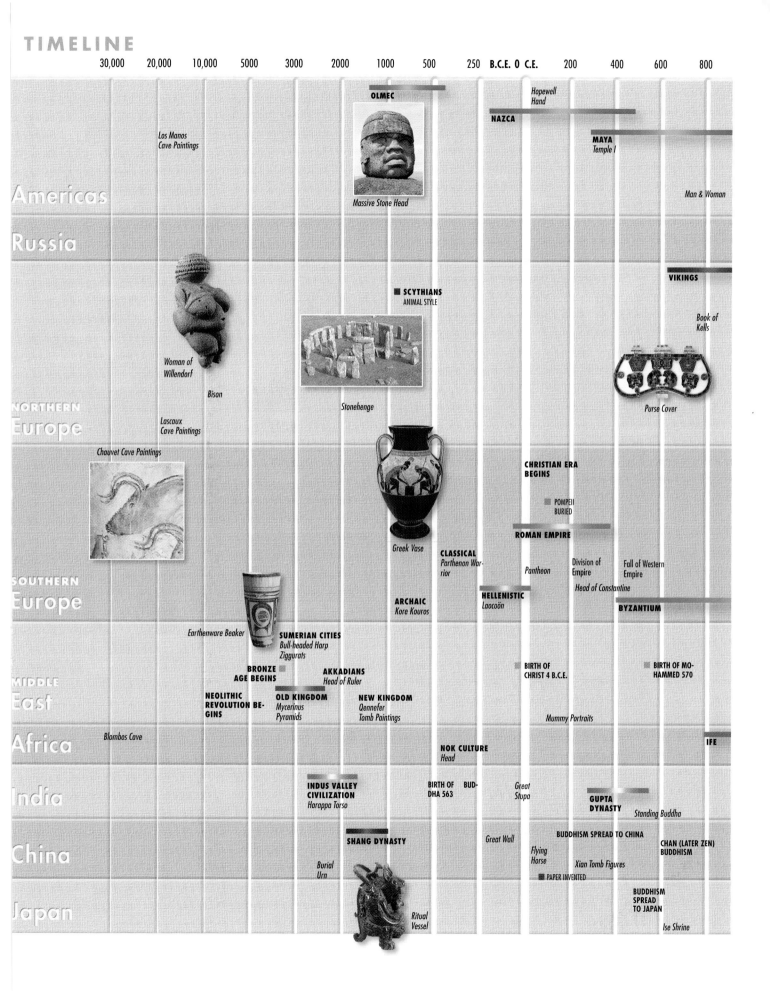

TIMELINE

| 30,000 | 20,000 | 10,000 | 5000 | 3000 | 2000 | 1000 | 500 | 250 | B.C.E. 0 C.E. | 200 | 400 | 600 | 800 |

Americas

OLMEC

Massive Stone Head

Los Manos
Cave Paintings

Hopewell
Hand

NAZCA

MAYA
Temple I

Man & Woman

Russia

Northern Europe

VIKINGS

Book of
Kells

Woman of
Willendorf

Bison

■ **SCYTHIANS**
ANIMAL STYLE

Stonehenge

Purse Cover

Lascaux
Cave Paintings

Chauvet Cave Paintings

**CHRISTIAN ERA
BEGINS**

■ POMPEII
BURIED

ROMAN EMPIRE

Greek Vase

CLASSICAL
Parthenon War-
rior

Pantheon

Division of
Empire

Fall of Western
Empire

Head of Constantine

Southern Europe

ARCHAIC
Kore Kouros

HELLENISTIC
Laocoön

BYZANTIUM

Earthenware Beaker

SUMERIAN CITIES
Bull-headed Harp
Ziggurats

**BRONZE
AGE BEGINS**

AKKADIANS
Head of Ruler

■ BIRTH OF
CHRIST 4 B.C.E.

■ **BIRTH OF MO-
HAMMED 570**

Middle East

**NEOLITHIC
REVOLUTION BE-
GINS**

OLD KINGDOM
Mycerinus
Pyramids

NEW KINGDOM
Qennefer
Tomb Paintings

Mummy Portraits

Africa

Blombos Cave

NOK CULTURE
Head

IFE

India

**INDUS VALLEY
CIVILIZATION**
Harappa Torso

**BIRTH OF BUD-
DHA 563**

Great
Stupa

**GUPTA
DYNASTY**

Standing Buddha

China

SHANG DYNASTY

Burial
Urn

Great Wall

Flying
Horse

BUDDHISM SPREAD TO CHINA

Xian Tomb Figures

**CHAN (LATER ZEN)
BUDDHISM**

■ PAPER INVENTED

Japan

Ritual
Vessel

**BUDDHISM
SPREAD
TO JAPAN**

Ise Shrine

The following terms are defined according to their usage in the visual arts. Words in *italics* are also defined in the glossary.

abstract art Art that departs significantly from natural appearances. Forms are modified or changed to varying degrees in order to emphasize certain qualities or content. Recognizable references to original appearances may be very slight. The term is also used to describe art that is *nonrepresentational*.

Abstract Expressionism An art movement, primarily in painting, that originated in the United States in the 1940s and remained strong through the 1950s. Artists working in many different styles emphasized spontaneous personal expression in large paintings that are *abstract* or *nonrepresentational*. One type of Abstract Expressionism is called *action painting*. See also *Expressionism*.

abstract Surrealism See *Surrealism*.

academic art Art governed by rules, especially works sanctioned by an official institution, academy, or school. Originally applied to art that conformed to standards established by the French Academy regarding composition, drawing, and color usage. The term has come to mean conservative and traditional art.

academy An institution of artists and scholars, originally formed during the Renaissance to free artists from control by guilds and to elevate them from artisan to professional status. In an academy, art is taught as a humanist discipline along with other disciplines of the liberal arts.

achromatic Having no color (or *hue*); without identifiable hue. Most blacks, whites, grays, and browns are achromatic.

acrylic (acrylic resin) A clear plastic used as a *binder* in paint and as a casting material in sculpture.

action painting A style of *nonrepresentational* painting that relies on the physical movement of the artist by using such gestural techniques as vigorous brushwork, dripping, and pouring. Dynamism is often created through the interlaced directions of the paint's impact. A subcategory of *Abstract Expressionism*.

additive color mixture The mixture of colored light. When light colors are combined (as with overlapping spot lights), the mixture becomes successively lighter. Light primaries, when combined, create white light. See also *subtractive color mixture*.

additive sculpture Sculptural form produced by adding, combining, or building up material from a core or *armature*. Modeling in clay and welding steel are additive processes.

aerial perspective See *perspective*.

aesthetic Pertaining to the sense of the beautiful and to heightened sensory perception in general.

aesthetics The study and philosophy of the quality and nature of sensory responses related to, but not limited by, the concept of beauty. Within the art context: The philosophy of art focusing on questions regarding what art is, how it is evaluated, the concept of beauty, and the relationship between the idea of beauty and the concept of art.

afterimage The visual image that remains after an initial stimulus is removed. Staring at a single intense *hue* may cause the cones, or color receptors, of the eye to become fatigued and perceive only the complement of the original hue after it has been removed.

airbrush A small-scale paint sprayer that allows the artist to control a fine mist of paint.

analogous colors or **analogous hues** Closely related *hues*, especially those in which a common hue can be seen; hues that are neighbors on the color wheel, such as blue, blue-green, and green.

analytical Cubism See *Cubism*.

aperture In photography, the *camera* lens opening and its relative diameter. Measured in f-stops, such as f/8, f/11, etc. As the number increases, the size of the aperture decreases, thereby reducing the amount of light passing through the *lens* and striking the film.

apse A semicircular end to an aisle in a *basilica* or a Christian church. In Christian churches an apse is usually placed at the eastern end of the central aisle.

aquatint An *intaglio* printmaking process in which value areas rather than lines are etched on the printing plate. Powdered resin is sprinkled on the plate, which is then immersed in an acid bath. The acid bites around the resin particles, creating a rough surface that holds ink. Also, a *print* made using this process.

arcade A series of *arches* supported by columns or piers. Also, a covered passageway between two series of arches or between a series of arches and a wall.

arch A curved structure designed to span an opening, usually made of stone or other masonry. Roman arches are semicircular; Islamic and Gothic arches come to a point at the top.

armature A rigid framework serving as a supporting inner core for clay or other soft sculpting material.

art criticism The process of using formal analysis, description, and interpretation to evaluate or explain the quality and meanings of art.

Art Nouveau A style that originated in the late 1880s based on the sinuous curves of plant forms. It was used primarily in architectural detailing and the applied arts.

artist's proof A trial print, usually made as an artist works on a plate or block, to check the progress of a work.

assemblage Sculpture using preexisting, sometimes "found" objects that may or may not contribute their original identities to the total content of the work.

asymmetrical Without *symmetry*.

atmospheric perspective See *perspective*.

automatism The condition of being automatic; action without conscious control. Employed by *Surrealist* writers and artists to allow unconscious ideas and feelings to be expressed.

balance An arrangement of parts achieving a state of equilibrium between opposing forces or influences. Major types are symmetrical and asymmetrical. See *symmetry*.

Baroque The seventeenth-century period in Europe characterized in the visual arts by dramatic light and shade, turbulent composition, and exaggerated emotional expression.

barrel vault See *vault*.

bas relief See *relief sculpture*.

Basilica A roman town hall, with three aisles and an *apse* at one or both ends. Christians appropriated this form for their churches.

Bauhaus German art school in existence from 1919 to 1933, best known for its influence on design, leadership in art education, and its radically innovative philosophy of applying design principles to machine technology and mass production.

beam The horizontal stone or timber placed across an architectural space to take the weight of the roof or wall above; also called a *lintel*.

binder The material used in paint that causes *pigment* particles to adhere to one another and to the *support*; for example, linseed oil or acrylic polymer.

bodhisattva A type of Buddhist holy person who is about to achieve enlightenment, but postpones it to remain on earth to teach others. Frequently depicted in the arts of China and Japan.

buttress A *support*, usually exterior, for a wall, *arch*, or *vault* that opposes the lateral forces of these structures. A flying buttress consists of a strut or segment of an arch carrying the thrust of a vault to a vertical pier positioned away from the main portion of the building. An important element in *Gothic* cathedrals.

Byzantine art Styles of painting, design, and architecture developed from the fifth century C.E. in the Byzantine Empire of ancient eastern Europe. Characterized in architecture by round *arches*, large *domes*, and extensive use of *mosaic*; characterized in painting by formal design, *frontal* and *stylized* figures, and rich use of color, especially gold, in generally religious subject matter.

calligraphy The art of beautiful writing. Broadly, a flowing use of line, often varying from thick to thin.

camera A mechanical or digital device for taking photographs. It generally consists of a light-proof enclosure with an *aperture*, which allows a controlled light image to pass through a shuttered *lens* and be focused on a photosensitive material.

camera obscura A dark room (or box) with a small hole in one side, through which an inverted image of the view outside is projected onto the opposite wall, screen, or mirror. The image is then traced. This forerunner of the modern camera was a tool for recording an optically accurate image.

cantilever A beam or slab projecting a substantial distance beyond its supporting post or wall; a projection supported only at one end.

capital In architecture, the top part, cap stone, or head of a column or pillar.

cartoon 1. A humorous or satirical drawing. 2. A drawing completed as a full-scale working drawing, usually for a *fresco* painting, *mural*, or tapestry.

carving A *subtractive* process in which a sculpture is formed by removing material from a block or mass of wood, stone, or other material, with the use of sharpened tools.

casting A substitution or replacement process that involves pouring liquid material such as molten metal, clay, wax, or plaster into a mold. When the liquid hardens, the mold is removed, and a form in the shape of the mold is left.

catacombs Underground burial places in Ancient Rome. Christians and Jews often decorated the walls and ceilings with paintings.

ceramics Clay hardened into a relatively permanent material by firing. A practitioner of the ceramic arts is a ceramist.

chiaroscuro Italian word meaning "light-dark." The gradations of light and dark *values* in *two-dimensional* imagery; especially the illusion of rounded, three-dimensional form created through gradations of light and shade rather than line. Highly developed by *Renaissance* painters.

chroma See *intensity*.

cinematography The art and technique of making motion pictures, especially the work done by motion picture camera operators.

classical 1. The art of ancient Greece and Rome. In particular, the style of Greek art that flourished during the fifth century B.C.E. 2. Any art based on a clear, rational, and regular structure, emphasizing horizontal and vertical directions, and organizing its parts with special emphasis on balance and proportion. The term classic is also used to indicate recognized excellence.

closed form A self-contained or explicitly limited form; having a resolved balance of tensions, a sense of calm completeness implying a totality within itself.

coffer In architecture, a decorative sunken panel on the underside of a ceiling.

collage From the French *coller*, to glue. A work made by gluing various materials, such as paper scraps, photographs, and cloth, on a flat surface.

colonnade A row of columns usually spanned or connected by *beams* (lintels).

color field painting A movement that grew out of *Abstract Expressionism*, in which large stained or painted areas or "fields" of color evoke aesthetic and emotional responses.

color wheel A circular arrangement of contiguous spectral *hues* used in some color systems. Also called a color circle.

complementary colors Two *hues* directly opposite one another on a *color wheel* which, when mixed together in proper proportions, produce a neutral gray. The true complement of a color can be seen in its *afterimage*.

composition The combining of parts or elements to form a whole; the structure, organization, or total form of a work of art. See also *design*.

Conceptual art An art form in which the originating idea and the process by which it is presented take precedence over a tangible product. Conceptual works are sometimes produced in visible form, but they often exist only as descriptions of mental concepts or ideas. This trend developed in the late 1960s, partially as a way to avoid the commercialization of art.

content Meaning or message contained and communicated by a work of art, including its emotional, intellectual, symbolic, thematic, and narrative connotations.

contrapposto Italian for "counterpose." The counterpositioning of parts of the human figure about a central vertical axis, as when the weight is placed on one foot causing the hip and shoulder lines to counterbalance each other—often in a graceful S-curve.

cool colors Colors whose relative visual temperatures make them seem cool. Cool colors generally include green, blue-green, blue, blue-violet, and violet. Warmness or coolness is relative to adjacent hues. See also *warm colors*.

crosshatching See *hatching*.

Cubism The most influential style of the twentieth century, developed in Paris by Picasso and Braque, beginning in 1907. The early mature phase of the style, called analytical Cubism, lasted from 1909

through 1911. Cubism is based on the simultaneous presentation of multiple views, disintegration, and geometric reconstruction of subjects in flattened, ambiguous pictorial space; figure and ground merge into one interwoven surface of shifting planes. Color is limited to *neutrals*. By 1912, the more decorative phase called synthetic or collage Cubism began to appear; it was characterized by fewer, more solid forms, conceptual rather than observed subject matter, and richer color and texture.

curtain wall A non-load-bearing wall.

curvilinear Formed or characterized by curving lines or edges.

cutting ratio The ratio of film actually used in a movie after editing to the amount that was shot during production.

Dada A movement in art and literature, founded in Switzerland in the early twentieth century, which ridiculed contemporary culture and conventional art. The Dadaists shared an antimilitaristic and anti-aesthetic attitude, generated in part by the horrors of World War I and in part by a rejection of accepted canons of morality and taste. The anarchic spirit of Dada can be seen in the works of Duchamp, Man Ray, Hoch, Miro, and Picasso. Many Dadaists later explored *Surrealism*.

daguerreotype An early photographic process developed by Louis Daguerre in the 1830s which required a treated metal plate. This plate was exposed to light, and the chemical reactions on the plate created the first satisfactory photographs.

depth of field The area of sharpness of focus in front of and behind the subject in a photograph. Depth of field becomes greater as the aperture is decreased and the f-stop number is increased.

De Stijl A Dutch purist art movement begun during World War I by Mondrian and others. It involved painters, sculptors, designers, and architects whose works and ideas were expressed in De Stijl magazine. *De Stijl*, Dutch for "the style," was aimed at creating a universal language of *form* that would be independent of individual emotion. Visual form was pared down to primary colors plus black and white, and rectangular shapes. The movement was influential primarily in architecture.

direct painting Executing a painting in one sitting, applying wet over wet colors.

divisionism See *Pointillism*.

dome A generally hemispherical roof or *vault*. Theoretically, an *arch* rotated 360 degrees on its vertical axis.

dressed stone Stone used for building that is cut to fit into a masonry wall.

drypoint An *intaglio* printmaking process in which lines are scratched directly into a metal plate with a steel needle. Also, the resulting *print*.

earthenware A type of clay used for ceramics. It fires at 1100–1150°C, and is porous after firing.

earthworks Sculptural forms made from earth, rocks, or sometimes plants, often on a vast scale and in remote locations. Some are deliberately impermanent.

eclecticism The practice of selecting or borrowing from earlier styles and combining the borrowed elements.

edition In printmaking, the total number of *prints* made and approved by the artist, usually numbered consecutively. Also, a limited number of multiple originals of a single design in any medium.

elevation In architecture, a scale drawing of any vertical side of a given structure.

encaustic A painting medium in which *pigment* is suspended in a *binder* of hot wax.

engraving An *intaglio* printmaking process in which grooves are cut into a metal or wood surface with a sharp cutting tool called a burin or graver. Also, the resulting *print*.

entasis In *classical* architecture, the slight swelling or bulge in the center of a column, which corrects the illusion of concave tapering produced by parallel straight lines.

etching An *intaglio* printmaking process in which a metal plate is first coated with acid-resistant wax, then scratched to expose the metal to the bite of nitric acid where lines are desired. Also, the resulting *print*.

Expressionism The broad term that describes emotional art, most often boldly executed and making free use of distortion and symbolic or invented color. More specifically, Expressionism refers to individual and group styles originating in Europe in the late nineteenth and early twentieth centuries. See also *Abstract Expressionism*.

Fauvism A style of painting introduced in Paris in the early twentieth century, characterized by areas of bright, contrasting color and simplified shapes. The name *les fauves* is French for "the wild beasts."

feminism In art, a movement among artists, critics, and art historians that began in an organized fashion in the 1970s. Feminists seek to validate and promote art forms that express the unique experience of women, and to redress oppression by men.

feng shui An ancient Chinese method of interior design that seeks to align spiritual forces within the space to be arranged.

figure Separate shape(s) distinguishable from a background or *ground*.

flying buttress See *buttress*.

folk art Art of people who have had no formal, academic training, but whose works are part of an established tradition of style and craftsmanship.

font The name given to a style of type. The text of *Artforms* is printed in the Adobe Garamond font.

foreshortening The representation of *forms* on a *two-dimensional* surface by shortening the length in such a way that the long axis appears to project toward or recede away from the viewer.

form In the broadest sense, the total physical characteristics of an object, event, or situation.

format The shape or proportions of a *picture plane*.

fresco A painting technique in which *pigments* suspended in water are applied to a damp lime-plaster surface. The pigments dry to become part of the plaster wall or surface. Sometimes called *true fresco* or *buon fresco* to distinguish it from painting over dry plaster.

frieze A narrow band of *relief sculpture* that usually occupies the space above the columns of a classical building.

frontal An adjective describing an object that faces the viewer directly, rather than being set at an angle or *foreshortened*.

Futurism A group movement that originated in Italy in 1909. One of several movements to grow out of *Cubism*. Futurists added implied motion to the shifting planes and multiple observation points of the Cubists; they celebrated natural as well as mechanical motion and speed. Their glorification of danger, war, and the machine age was in keeping with the martial spirit developing in Italy at the time.

gesso A mixture of glue and either chalk or plaster of Paris applied as a *ground* or coating to surfaces in order to give them the correct properties to receive paint. Gesso can also be built up or molded into *relief* designs, or carved.

glaze In *ceramics*, a vitreous or glassy coating applied to seal and decorate surfaces. Glaze may be colored, transparent, or opaque. In oil painting, a thin transparent or translucent layer brushed over another layer of paint, allowing the first layer to show through but altering its color slightly.

Gothic Primarily an architectural style that prevailed in western Europe from the twelfth through the fifteenth centuries, characterized by pointed *arches*, ribbed *vaults*, and flying *buttresses*, which made it possible to create stone buildings that reached great heights.

gouache An opaque, water-soluble paint. *Watercolor* to which opaque white has been added.

ground The background in two-dimensional works—the area around and between *figure(s)*. Also, the surface onto which paint is applied.

Happening An event conceived by artists and performed by artists and others, usually unrehearsed and without a specific script or stage.

hard-edge A term first used in the 1950s to distinguish styles of paintings in which shapes are precisely defined by sharp edges, in contrast to the usually blurred or soft edges in *Abstract Expressionist* paintings.

hatching A technique used in drawing and linear forms of printmaking, in which lines are placed in parallel series to darken the value of an area. Crosshatching is drawing one set of hatchings over another in a different direction so that the lines cross.

Hellenistic Style of the later phase of ancient Greek art (300–100 **B.C.E.**), characterized by emotion, drama, and interaction of sculptural forms with the surrounding space.

hierarchic proportion Use of unnatural *proportions* or *scale* to show the relative importance of figures.

high key Exclusive use of pale or light *values* within a given area or surface.

horizon line In linear *perspective*, the implied or actual line or edge placed on a *two-dimensional* surface to represent the

place in nature where the sky meets the horizontal land or water plane.

hue That property of a color identifying a specific, named wavelength of light such as green, red, violet, and so on. Often used synonymously with *color*.

humanism A cultural and intellectual movement during the *Renaissance*, following the rediscovery of the art and literature of ancient Greece and Rome. A philosophy or attitude concerned with the interests, achievements, and capabilities of human beings rather than with the abstract concepts and problems of theology or science.

icon An image or symbolic representation (often with sacred significance).

iconography The symbolic meanings of subjects and signs used to convey ideas important to particular cultures or religions, and the conventions governing the use of such forms.

impasto In painting, thick paint applied to a surface in a heavy manner, having the appearance and consistency of buttery paste.

implied line A line in a composition that is not actually drawn. It may be a sight line of a figure in a composition, or a line along which two *shapes* align with each other.

Impressionism A style of painting that originated in France about 1870. (The first Impressionist exhibit was held in 1874.) Paintings of casual subjects were executed outdoors using divided brush strokes to capture the light and mood of a particular moment and the transitory effects of natural light and color.

installation A type of art medium in which the artist arranges objects or artworks in a room, thinking of the entire space as the medium to be manipulated. Also called *environments*.

intaglio Any printmaking technique in which lines and areas to be inked and transferred to paper are recessed below the surface of the printing plate. *Etching*, *engraving*, *drypoint*, and *aquatint* are all intaglio processes. See also *print*.

intensity The relative purity or saturation of a *hue* (color), on a scale from bright (pure) to dull (mixed with another hue or a *neutral*).

intermediate color A *hue* between a primary and a secondary on the color wheel, such as yellow-green, a mixture of yellow and green.

International Style An architectural style that emerged in several European countries between 1910 and 1920. Related to purism and *De Stijl* in painting, it joined structure and exterior design into a noneclectic form based on rectangular geometry and growing out of the basic function and structure of the building.

Isometic perspective See *perspective*.

iwan A high, vaulted porch frequently used in Islamic architecture to mark an important building or entrance.

kachina One of many deified ancestral spirits honored by Hopi and other Pueblo Indians. These spiritual beings are usually depicted in doll-like forms.

kiln An oven in which pottery or *ceramic* ware is fired.

kinetic art Art that incorporates actual movement as part of the design.

kore Greek for "maiden." An archaic Greek statue of a standing clothed young woman.

kouros Greek for "youth." An archaic Greek statue of a standing nude young male.

lens The part of a *camera* that concentrates light and focuses the image.

linear perspective See *perspective*.

linoleum cut A *relief* process in printmaking, in which an artist cuts away negative spaces from a block of linoleum, leaving raised areas to take ink for printing.

lintel See *beam*.

literati painting In Asian art, paintings produced by cultivated amateurs who are generally wealthy and devoted to the arts, including calligraphy, painting, and poetry. Most commonly used to describe work of painters not attached to the royal courts of the Yuan, Ming, and Qing dynasties (fourteenth to eighteenth centuries) in China.

lithography A planographic printmaking technique based on the antipathy of oil and water. The image is drawn with a grease crayon or painted with *tusche* on a stone or grained aluminum plate. The surface is then chemically treated and dampened so that it will accept ink only where the crayon or tusche has been used.

local color The actual color as distinguished from the apparent color of objects and surfaces; true color, without shadows or reflections. Sometimes called *object color*.

logo Short for "logotype." Sign, name, or trademark of an institution, a firm, or a publication, consisting of letter forms, borne on one printing plate or piece of type.

loom A device for producing cloth by interweaving fibers at right angles.

lost wax A *casting* method. First a model is made from wax and encased in clay or casting plaster. When the clay is fired to make a mold, the wax melts away, leaving a void that can be filled with molten metal or other self-hardening liquid to produce a cast.

madrasa In Islamic tradition, a building that combines a school, prayer hall, and lodging for students.

Mannerism A style that developed in the sixteenth century as a reaction to the classical rationality and balanced harmony of the High *Renaissance*; characterized by dramatic use of space and light, exaggerated color, elongation of figures, and distortions of *perspective*, *scale*, and *proportion*.

mass Three-dimensional form having physical bulk. Also, the illusion of such a form on a *two-dimensional* surface.

mat Border of cardboard or similar material placed around a picture as a neutral area between the frame and the picture.

matte A dull finish or surface, especially in painting, photography, and *ceramics*.

medium (pl. media or mediums) 1. A particular material along with its accompanying technique; a specific type of artistic technique or means of expression determined by the use of particular materials. 2. In paint, the fluid in which *pigment* is suspended, allowing it to spread and adhere to the surface.

mihrab A niche in the end wall of a *mosque* that points the way to the Muslim holy city of Mecca.

minaret A tower outside a *mosque* where chanters stand to call the faithful to prayer.

Minimalism A *nonrepresentational* style of sculpture and painting, usually severely restricted in the use of visual elements and often consisting of simple geometric shapes or masses. The style came to prominence in the late 1960s.

mixed media Works of art made with more than one *medium*.

mobile A type of sculpture in which parts move, often activated by air currents. See also *kinetic art*.

modeling 1. Working pliable material such as clay or wax into *three-dimensional* forms. 2. In drawing or painting, the effect of light falling on a three-dimensional object so that the illusion of its *mass* is created and defined by *value* gradations.

monochromatic A color scheme limited to variations of one *hue*; a hue with its *tints* and/or *shades*.

montage 1. A composition made up of pictures or parts of pictures previously drawn, painted, or photographed. 2. In motion pictures, the combining of separate bits of film to portray the character of a single event through multiple views.

mosaic An art medium in which small pieces of colored glass, stone, or ceramic tile called *tessera* are embedded in a background material such as plaster or mortar. Also, works made using this technique.

mosque House of public prayer in the Muslim religion. From the Arabic *masjid*, "place of prostration."

mural A large wall painting, often executed in *fresco*.

narrative editing A filmmaking process in which a film editor makes a version of a scene by combining many shots from various camera angles.

naturalism An art style in which the curves and contours of a subject are accurately portrayed.

nave The tall central space of a church or cathedral, usually flanked by side aisles.

negative shape A background or *ground* shape seen in relation to foreground or *figure* shape(s).

Neoclassicism New classicism. A revival of classical Greek and Roman forms in art, music, and literature, particularly during the eighteenth and nineteenth centuries in Europe and America. It was part of a reaction against the excesses of *Baroque* and *Rococo* art.

Neolithic art A period of ancient art after the introduction of agriculture but before the invention of bronze. *Neolithic* means "new stone age" to distinguish it from *Paleolithic*, or "old stone age."

neutrals Not associated with any single *hue*. Blacks, whites, grays, and dull gray-browns. A neutral can be made by mixing complementary hues.

nonobjective See *nonrepresentational art*.

nonrepresentational Art without reference to anything outside itself—without representation. Also called "nonobjective"—without recognizable objects.

object color See *local color*.

offset lithography Planographic printing by indirect image-transfer from photomechanical plates. The plate transfers ink to a rubber-covered cylinder, which "offsets" the ink to the paper. Also called photo-offset and offset lithography.

oil paint Paint in which the *pigment* is held together with a *binder* of oil, usually linseed oil.

opaque Impenetrable by light; not transparent or translucent.

open form A form whose contour is irregular or broken, having a sense of growth, change, or unresolved tension; form in a state of becoming.

optical color mixture Apparent rather than actual color mixture, produced by interspersing brush strokes or dots of color instead of physically mixing them. The implied mixing occurs in the eye of the viewer and produces a lively color sensation.

organic shape An irregular, non-geometric shape. A shape that resembles any living matter. Most organic shapes are not drawn with a ruler or a compass.

original print A print done by an artist or under his or her direct supervision. Not a reproduction.

painterly Painting characterized by openness of form, in which shapes are defined by loose brushwork in light and dark color areas rather than by outline or contour.

Paleolithic art A very ancient period of art coincident with the Old Stone Age, before the discovery of agriculture and animal herding.

pastels 1. Sticks of powdered pigment held together with a gum binding agent. 2. Pale colors or *tints*.

performance art Dramatic presentation by visual artists (as distinguished from theater artists such as actors and dancers) in front of an audience, usually apart from a formal theatrical setting.

persistence of vision An optical illusion that makes cinema possible. The eye and mind tend to hold seen images for a fraction of a second after they disappear from view.

Quick projection of slightly differing images creates the illusion of movement.

perspective A system for creating an illusion of depth or *three-dimensional* space on a *two-dimensional* surface. Usually used to refer to linear perspective, which is based on the fact that parallel lines or edges appear to converge and objects appear smaller as the distance between them and the viewer increases. Atmospheric perspective (aerial perspective) creates the illusion of distance by reducing color saturation, value contrast, and detail in order to imply the hazy effect of atmosphere between the viewer and distant objects. *Isometric perspective* is not a visual or optical interpretation, but a mechanical means to show space and volume in rectangular forms. Parallel lines remain parallel; there is no convergence. A work executed in *one-point perspective* has a single *vanishing point*. A work in *two-point perspective* has two of them.

photomontage The process of combining parts of various photographs in one photograph.

photorealism A style of painting that became prominent in the 1970s, based on the cool objectivity of photographs as records of subjects.

photo screen A variation of *silkscreen* in which the stencil is prepared photographically.

picture plane The *two-dimensional* picture surface.

pigment Any coloring agent, made from natural or synthetic substances, used in paints or drawing materials.

plate mark An impression made on a piece of paper by pressing a printing plate onto it. A plate mark is usually a sign of an *original print*.

Pointillism A system of painting using tiny dots or "points" of color, developed by French artist Georges Seurat in the 1880s. Seurat systematized the divided brushwork and *optical color mixture* of the *Impressionists* and called his technique "Divisionism."

Pop Art A style of painting and sculpture that developed in the late 1950s and early 1960s, in Britain and the United States; based on the visual cliches, subject matter, and impersonal style of popular mass-media imagery.

porcelain A type of clay for ceramics. It is white or grayish and fires at 1350–1500°C.

After firing, it is translucent and rings when struck.

positive shape A *figure* or foreground shape, as opposed to a *negative* ground or background shape.

post-and-beam system (post and lintel) In architecture, a structural system that uses two or more uprights or posts to support a horizontal beam (or lintel) which spans the space between them.

Post-Impressionism A general term applied to various personal styles of painting by French artists (or artists living in France) that developed from about 1885 to 1900 in reaction to what these artists saw as the somewhat formless and aloof quality *Impressionist* painting. Post-Impressionist painters were concerned with the significance of form, symbols, expressiveness, and psychological intensity. They can be broadly separated into two groups—expressionists, such as Gauguin and van Gogh, and formalists, such as Cezanne and Seurat.

Post-Modern An attitude or trend of the 1970s, 1980s, and 1990s. In architecture, the movement away from or beyond what had become boring adaptations of the *International Style*, in favor of an imaginative, eclectic approach. In the other visual arts, Post-Modern is characterized by influence from all periods and styles, including modernism, and a willingness to combine elements of all styles and periods. Although modernism makes distinctions between high art and popular taste, Post-Modernism makes no such value judgments.

primary colors Those *hues* that cannot be produced by mixing other hues. *Pigment* primaries are red, yellow, and blue; light primaries are red, green, and blue. Theoretically, pigment primaries can be mixed together to form all the other hues in the spectrum.

prime In painting, a primary layer of paint or sizing applied to a surface that is to be painted.

print (artist's print) A multiple original impression made from a plate, stone, wood block, or screen by an artist or made under the artist's supervision. Prints are usually made in *editions*, with each print numbered and signed by the artist.

proportion The size relationship of parts to a whole and to one another.

realism 1. A type of *representational art* in which the artist depicts as closely as possible

what the eye sees. 2. Realism. The mid-nineteenth-century style of Courbet and others, based on the idea that ordinary people and everyday activities are worthy subjects for art.

registration In color printmaking or machine printing, the process of aligning the impressions of blocks or plates on the same sheet of paper.

reinforced concrete (ferroconcrete) Concrete with steel mesh or bars embedded in it to increase its tensile strength.

relief printing A printing technique in which the parts of the printing surface that carry ink are left raised, while the remaining areas are cut away. Woodcuts and linoleum prints (linocuts) are relief prints.

relief sculpture Sculpture in which *three-dimensional* forms project from the flat background of which they are a part. The degree of projection can vary and is described by the terms high relief and low relief.

Renaissance Period in Europe from the late fourteenth through the sixteenth centuries, which was characterized by a renewed interest in human-centered *classical* art, literature, and learning. See also *humanism*.

representational art Art in which it is the artist's intention to present again or represent a particular subject; especially pertaining to realistic portrayal of subject matter.

reproduction A mechanically produced copy of an original work of art; not to be confused with an original *print* or art print or artist's print.

rhythm The regular or ordered repetition of dominant and subordinate elements or units within a design.

ribbed vault See *vault*.

Rococo From the French "rocaille" meaning "rock work." This late *Baroque* (c. 1715–1775) style used in interior decoration and painting was characteristically playful, pretty, romantic, and visually loose or soft; it used small *scale* and ornate decoration, *pastel* colors, and asymmetrical arrangement of curves. Rococo was popular in France and southern Germany in the eighteenth century.

Romanesque A style of European architecture prevalent from the ninth to the twelfth centuries with round *arches* and barrel *vaults* influenced by Roman

architecture and characterized by heavy stone construction.

Romanticism 1. A literary and artistic movement of late eighteenth- and nineteenth-century Europe, aimed at asserting the validity of subjective experience as a countermovement to the often cold formulas of *Neoclassicism*; characterized by intense emotional excitement, and depictions of powerful forces in nature, exotic lifestyles, danger, suffering, and nostalgia. 2. Art of any period based on spontaneity, intuition, and emotion rather than carefully organized rational approaches to form.

Salon An official art exhibition in France, juried by members of the offical French *Academy*.

santero Literally "saint-maker." A person in Hispanic traditions who carves or paints religious figures.

saturation See *intensity*.

scale The size or apparent size of an object seen in relation to other objects, people, or its environment or *format*. Also used to refer to the quality or monumentality found in some objects regardless of their size. In architectural drawings, the ratio of the measurements in the drawing to the measurements in the building.

screenprinting (serigraphy) A printmaking technique in which stencils are applied to fabric stretched across a frame. Paint or ink is forced with a squeegee through the unblocked portions of the screen onto paper or other surface beneath.

secondary colors Pigment secondaries are the *hues* orange, violet, and green, which may be produced in slightly dulled form by mixing two *primaries*.

serif Any short lines that end the upper and lower strokes of a letter.

serigraphy See *screenprinting*.

setback The legal distance that a building must be from property lines. Early setback requirements often increased with the height of a building, resulting in step-like recessions in the rise of tall buildings.

shade A *hue* with black added.

shape A *two-dimensional* or implied two-dimensional area defined by line or changes in value and/or color.

shutter In photography, the part of the *camera* that controls the length of time the

light is allowed to strike the photosensitive film.

silk screen See *screenprinting*.

simultaneous contrast An optical effect caused by the tendency of contrasting forms and colors to emphasize their difference when they are placed together.

site-specific art Any work made for a certain place, which cannot be separated or exhibited apart from its intended environment.

size Any of several substances made from glue, wax, or clay, used as a filler for porous material such as paper, canvas, or other cloth, or wall surfaces. Used to protect the surface from the deteriorating effects of paint, particularly oil paint.

slip Clay that is thinned to the consistency of cream, and used as paint on *earthenware* or *stoneware* ceramics.

stoneware A type of clay for ceramics. Stoneware is fired at 1200–1300°C and is nonporous when fired.

storyboard A series of drawings or paintings arranged in a sequence, used by directors and editors to help visualize the narrative flow of a film or video.

stupa The earliest form of Buddhist architecture, a dome-like structure probably derived from Indian funeral mounds.

style A characteristic handling of *media* and elements of form, which give a work its identity as the product of a particular person, group, art movement, period, or culture.

stylized Simplified or exaggerated visual *form* which emphasizes particular or contrived design qualities.

subtractive color mixture Mixture of colored *pigments* in the form of paints, inks, pastels, and so on. Called subtractive because reflected light is reduced as pigment colors are combined. See *additive color mixture*.

subtractive sculpture Sculpture made by removing material from a larger block or form.

support The physical material that provides the base for and sustains a *two-dimensional* work of art. Paper is the usual support for drawings and prints; canvas or panels are supports in painting.

Surrealism A movement in literature and visual arts that developed in the mid-1920s

and remained strong until the mid-1940s; grew out of *Dada* and *automatism*. Based upon revealing the unconscious mind in dream images, the irrational, and the fantastic, Surrealism took two directions: *representational* and *abstract*. Dali's and Magritte's paintings, with their uses of impossible combinations of objects depicted in realistic detail, typify representational Surrealism. Miro's paintings, with his use of abstract and fantastic shapes and vaguely defined creatures, are typical of abstract Surrealism.

symbol A form or image implying or representing something beyond its obvious and immediate meaning.

symmetry A design (or composition) with identical or nearly identical form on opposite sides of a dividing line or central axis; formal *balance*.

Synthetic Cubism See *Cubism*.

tempera A water-based paint that uses egg, egg yolk, glue, or casein as a *binder*. Many commercially made paints identified as tempera are actually *gouache*.

tessera Bit of colored glass, ceramic tile, or stone used in a *mosaic*.

texture The tactile quality of a surface or the representation or invention of the appearance of such a surface quality.

three-dimensional Having height, width, and depth.

throwing The process of forming clay objects on a potter's wheel.

tint A *hue* with white added.

trompe l'oeil French for "fool the eye." A *two-dimensional* representation that is so naturalistic that it looks actual or real (or *three-dimensional*).

true fresco See *fresco*.

truss In architecture, a structural framework of wood or metal based on a triangular system, used to span, reinforce, or support walls, ceilings, piers, or beams.

tunnel vault (barrel vault) See *vault*.

tusche In *lithography*, a waxy substance used to draw or paint images on a lithographic stone or plate.

two-dimensional Having the dimensions of height and width only.

typography The art and technique of composing printed materials from type.

unity The appearance of similarity, consistency, or oneness. Interrelational factors that cause various elements to appear as part of a single complete form.

value The lightness or darkness of tones or colors. White is the lightest value; black is the darkest. The value halfway between these extremes is called middle gray. Sometimes called "*tone*."

vanishing point In linear *perspective*, the point on the *horizon line* at which lines or edges that are parallel appear to converge.

vantage point The position from which the viewer looks at an object or visual field; also called "observation point" or "viewpoint."

vault A masonry roof or ceiling constructed on the principle of the *arch*. A tunnel or barrel vault is a semicircular arch extended in depth; a continuous series of arches, one behind the other. A groin vault is formed when two barrel vaults intersect. A ribbed vault is a vault reinforced by masonry ribs.

vehicle Liquid emulsion used as a carrier or spreading agent in paints.

vertical placement A method for suggesting the third dimension of depth in a two-dimensional work by placing an object above another in the composition. The object above seems farther away than the one below.

video art An art form first developed in the 1970s, in which artists use video equipment to stage and film performances or capture spontaneous events.

volume 1. Space enclosed or filled by a three-dimensional object or figure. 2. The implied space filled by a painted or drawn object or figure. Synonym: *mass*.

warm colors Colors whose relative visual temperature makes them seem warm. Warm colors or *hues* include red-violet, red, red-orange, orange, yellow-orange, and yellow. See also *cool colors*.

warp In weaving, the threads that run lengthwise in a fabric, crossed at right angles by the *weft*. Also, the process of arranging yarn or thread on a *loom* so as to form a warp.

wash A thin, transparent layer of paint or ink.

watercolor Paint that uses water-soluble gum as the *binder* and water as the *vehicle*. Characterized by transparency. Also, the resulting painting.

weft In weaving, the horizontal threads interlaced through the *warp*. Also called woof.

woodcut A type of *relief print* made from an image that is left raised on a block of wood.

Magdalena Abakanowicz (mahg-dah-*lay*-nuh ah-bah-kah-*no*-vich)

Ácoma (*ah*-koh-mah)

Alhambra (al-*am*-bra)

Tarsila do Amaral (tar-*see*-lah doo ah-mah-*rahl*)

Angkor Wat (*ang*-kohr waht)

Sofonisba Anguissola (so-fah-*niss*-bah ahn-*gwees*-so-la)

Ardabil (ar-*dah*-bil)

Arroyo Hondo (ar-*roy*-yo ohn-doh)

'Aumakua (ahow-mah-*koo*-ah)

avant garde (ah-vahn *gard*)

Judy Baca (*bah*-kah)

Giacomo Balla (*jah*-koh-moh *bahl*-la)

Jean-Michel Basquait (jawn mee-*shell* bos-kee-ah)

Bauhaus (*bow*-house)

Benin (ben-een)

Gianlorenzo Bernini (jahn-low-*ren*-tsoh ber-*nee*-nee)

Joseph Bueys (*yo*-sef boyce)

Umberto Boccioni (oom-*bair*-toh boh-*choh*-nee)

Bodhisattva (boh-dee-*saht*-vah)

Germaine Boffrand (zher-*main*-bof-*frohn*)

Rosa Bonheur (buhn-*er*)

Borobudur (boh-roh-boo-*duhr*)

Sandro Botticelli (bought-tee-*chel*-lee)

Louise Bourgeois (boorzh-*wah*)

Constantin Brancusi (*kahn*-stuhn-teen brahn-*koo*-see)

Georges Braque (zhorzh brahk)

Pieter Bruegel (*pee*-ter broy-guhl)

Michelangelo Buonarroti, see *Michelangelo*

Alberto Burri (ahl-*bair*-toe boo-ree)

Cai Guo Qiang (tseye gwoh *chyang*)

Callicrates (kah-*lik*-rah-teez)

Fodé Camara (foe-day cah-*mah*-rah)

Annibale Carraci (ahn-*nee*-bahl-lay cah-*rah*-chee)

Michelangelo da Caravaggio (mee-kel-*an*-jay-loe da car-ah-*vah*-jyoh)

Rosalba Carriera (roh-*sal*-bah car-*yair*-ah)

Henri Cartier-Bresson (on-*ree* car-tee-*ay* bruh-*sohn*)

Mary Cassatt (cah-*sat*)

Paul Cézanne (say-*zahn*)

Marc Chagall (shah-gahl)

Chartres (*shahr*-truh)

Chauvet (show-*vay*)

Dale Chihuly (chi-*hoo*-lee)

Chilkat (*chill*-kaht)

Giorgio de Chirico (*johr*-jyo de *key*-ree-co)

chola (*choh*-lah)

Christo (*kree*-stoh)

Constantine (*kahn*-stuhn-teen)

conté (kahn-tay)

contrapposto (kohn-trah-*poh*-stoh)

Gustave Courbet (*goos*-tahv koor-*bay*)

Cycladic (sik-*lad*-ik)

Louis Jacques Mandé Daguerre (loo-*ee* zhahk mon-*day* dah-*gair*)

Honoré Daumier (awn-ohr-*ay* doh-mee-ay)

Jacques-Louis David (*zhahk* loo-*ee* dah-*veed*)

Edgar Degas (ed-gahr duh-*gah*)

Willem de Kooning (*vill*-em duh *koe*-ning)

Eugène Delacroix (oo-*zhen* duh-lah-*kwah*)

André Derain (on-*dray* duh-*ran*)

de Stijl (duh steel)

Richard Diebenkorn (*dee*-ben-korn)

Donatello (dohn-ah-tell-loh)

Marcel Duchamp (mahr-*sell* doo-*shahm*)

Albrecht Dürer (*ahl*-brekht *duh*-ruhr)

Thomas Eakins (*ay*-kins)

Sergei Eisenstein (sair-gay *eye*-zen-schtine)

M. C. Escher (*esh*-uhr)

Fan Kuan (fahn kwahn)

feng shui (fung shway)

Eric Fischl (*fish*-il)

Jean-Honoré Fragonard (zhon oh-no-*ray* fra-go-*nahr*)

Helen Frankenthaler (frank-en-*thahl*-er)

fresco (*fres*-coh)

Ganges (*gan*-jeez)

Gao Jianfu (gow jen-*foo*)

Paul Gauguin (go-*gan*)

Frank Gehry (*ger*-ree)

Artemisia Gentileschi (ahr-tuh-*mee*-zhyuh jen-till-*ess*-kee)

Jean Léon Gérôme (zhon lay-on zhay-*roam*)

Lorenzo Ghiberti (low-*rent*-soh ghee-*bair*-tee)

Alberto Giacometti (ahl-*bair*-toh jah-ko-*met*-tee)

Giotto di Bondone (*joht*-toe dee bone-*doe*-nay)

Francisco Goya (fran-*sis*-coe go-yah)

Walter Gropius (*val*-tuhr *grow*-pee-us)

Guan Yin (*gwan* yeen)

Guernica (*gwar*-nih-kah)

Zaha Hadid (*zah*-hah hah-*deed*)

Hagia Sophia (hah-zhah so-*fee*-ah)

Hangzhou (hung-joe)

Suzuki Harunobu (soo-*zoo*-key hah-roo-*noh*-boo)

Hatshepsut (hah-*shep*-soot)

Heiji Monogatari (hay-jee mo-no-gah-*tah*-ree)

Hannah Höch (*hahn*-nuh hohk)

Hokusai (hohk-*sy*)

Pieter de Hooch (*pee*-tuhr duh *hohk*)

Victor Horta (*veek*-tohr ore-tah)

Horyuji (hohr-*yoo*-jee)

Ictinus (ick-*tee*-nuhs)

Inca (eenk-ah)

Ise (*ee*-say)

Arata Isozaki (ahr-ah-tah ee-so-*zah*-kee)

Asger Jorn (*az*-ger yorn)

Ilya Kabakov (*ill*-ya *kob*-ah-kohv)

kachina (kah-*chee*-nah)

Frida Kahlo (*free*-dah *kah*-loh)

Kandarya Mahadeva (gan-dahr-reeah mah-hah-*day*-vuh)

Vasily Kandinsky (vass-see-lee can-*din*-skee)

Anish Kapoor (ah-*neesh*-kah-*puhr*)

Katsura (kah-*tsoo*-rah)

Khamerernebty (kahm-er-er-*neb*-tee)

Anselm Kiefer (*ahn*-sehlm *kee*-fuhr)

Ernst Ludwig Kirchner (*airnst loot*-vik *keerkh*-ner)

Paul Klee (clay)

Torii Kiyonobu (tor-ee-ee kee-oh-*noh*-boo)

Torii Kiyotada (tor-ee-ee kee-oh-*tah*-dah)

Rem Koolhaas (cole-hahss)

Krishna (*krish*-nuh)

Mistutani Kunishiro (meet-soo-*tah*-nee koo-nee-*shee*-roh)

Laocoön (lay-*ah*-koh-ahn)

Lascaux (lass-coe)

Le Corbusier (luh core-boo-zee-ay)

Fernand Léger (fair-*non* lay-*zhay*)

Li Hua (lee hwa)

Roy Lichtenstein (*lick*-ten-steen)

Maya Lin (*my*-uh *lin*)

Fra Filippo Lippi (frah fill-*leep*-poh *leep*-pee)

Marshall Lomokema (loh-moh-kem-ah)

Machu Picchu (*mah*-choo *peek*-choo)

René Magritte (ruh-*nay* muh-*greet*)

mandala (mahn-dah-lah)

Edouard Manet (ay-*dwahr* mah-*nay*)

Mansur (mahn-soor)

Maori (mow-ree)

Marisol (mah-ree-*sohl*)

Masaccio (mah-*sach*-chyo)

Henri Matisse (on-*ree* mah-*tees*)

Mato Tope (*mah*-toh *toh*-pay)

Chaz Maviyane-Davies (mah-vee-*yah*-neh)

Maya (*my*-uh)

de Medici (deh *meh*-dee-chee)

Ana Mendieta (*ah*-nah men-*dyet*-ah)

Michelangelo Buonarroti (mee-kel-*an*-jay-loe bwoh-nah-*roe*-tee)

Ludwig Mies van der Rohe (*loot*-vik *mees* vahn dair *roh*-eh)

Mihrab (*mee*-rahb)

Richard Misrach (*miz*-rahk)

Moai (moe-eye)

Piet Mondrian (*peet* mohn-dree-ahn)

Claude Monet (*klohd* muh-*nay*)

Berthe Morisot (*bairt* moh-ree-*zoh*)

mosque (mahsk)

Vera Mukhina (*vir*-ah moo-*kee*-nah)

Edvard Munch (*ed*-vard *moonk*)

Mu Qi (moo-chee)

Eadweard Muybridge (*ed*-wurd *my*-brij)

Mycerinus (miss-uh-*ree*-nuhs)

Nadar (Felix Tournachon) (nah-*dar fay*-leeks toor-nah-*shohn*)

Nampeyo (nam-pay-oh)

Ni Zan (knee dzahn)

Emil Nolde (*ay*-meal *nohl*-duh)

Notre Dame de Chartres (*noh*-truh dahm duh *shahr*-truh)

Uche Okeke (*oo*-chay oh-*keh*-keh)

Claes Oldenburg (klahs ol-den-burg)

Olmec (*ohl*-mek)

José Clemente Orozco (ho-*say* cleh-*men*-tay oh-*rohs*-coh)

Ouattara (wah-*tar*-ah)

Nam June Paik (nahm joon pahk)

Andrea Palladio (ahn-*dray*-uh pahl-*lah*-dyo)

Giovanni Paolo Pannini (jyo-*vahn*-nee *pah-oh*-lo pah-*nee*-nee)

parfleche (par-*flesh*)

Parvati (par-*vah*-tee)

Pablo Picasso (pab-lo pee-*cah*-so)

Jackson Pollock (*pah*-lock)

Polyclitus (pol-ee-*cly*-tus)

Pompeii (pahm-*pay*)

Pont du Gard (pohn duh *gahr*)

Nicholas Poussin (nee-coh-*law* poo-*san*)

pietá (pee-ay-*tah*)

Qennifer (*ken*-eh-fer)

Qi Baishi (chee bye-shr)

Quetzalcoatl (kets-ahl-*kwah*-til)

Radha (*rad*-dah)

Robert Rauschenberg (*roh*-shen-buhrg)

Gerrit Reitveld (*gair*-it *ryt*-velt)

Rembrandt van Rijn (*rem*-brant van *ryne*)

Pierre August Renoir (pee-*err* oh-*goost* ren-*wahr*)

Gerhardt Richter (*gair*-hart *rick*-ter)

Diego Rivera (dee-*ay*-goh ree-*vay*-rah)

Sabatino Rodia (roh-*dee*-uh)

Francois August Rodin (frahn-*swah* oh-*goost* roh-*dan*)

Henri Rousseau (on-*ree* roo-*soh*)

Andre Rublev (*ahn*-dray *ru*-blof)

Niki de Saint Phalle (*nee*-kee duh san *fall*)

Ibrahim Salahi (ee-brah-*heem* sah-*lah*-hee)

Sāñchī (*sahn*-chee)

Raphael Sanzio (ra-fay-el *sahn*-zee-oh)

Sassetta (suh-*set*-tuh)

scythian (*sith*-ee-ahn)

Sesshū (seh-shoo)

Georges Seurat (zhorzh sir-*ah*)

Bada Shanren (*bah*-dah *shan*-ren)

Shiva Nātarāja (*shih*-vuh nah-tah-*rah*-jah)

Katsukawa Shunsho (kaht-soo-*kah*-wah *shun*-so)

Sinan (*see*-nahn)

Tawaraya Sōtatsu (tah-wa-*rah*-ya *soh*-taht-soo)

Alfred Stieglitz (*steeg*-lits)

stupa (*stoo*-pah)

Toshiko Takaezu (tosh-ko tah-kah-*ay*-zoo)

Tang Yin (tahng yin)

Kenzo Tange (ken-zo tahn-gay)

Vladimir Tatlin (vlah-*dee*-meer taht-lin)

Teotihuacan (tay-oh-tee-wah-*cahn*)

Jean Tinguely (zhon tan-*glee*)

Jacobo Tintoretto (*ha*-coh-boh teen-toh-*ray*-toh)

Tlingit (*kling*-git)

Félix Gonzáles Torres (*feh*-leeks gohn-*sa*-les *tohr*-res)

Henri de Toulouse-Lautrec (on-*ree* duh too-*looz* low-*trek*)

tuku-tuku (*too*-koo-*too*-koo)

James Turrell (tuh-*rell*)

Tutankhamen (too-tahn-*kahm*-uhn)

Unkei (ung-kay)

Mierle Laderman Ukeles (merl lay-duhr-man *yoo*-kuh-lees)

Ur (er)

Kitagawa Utamaro (kit-ah-*gah*-wah ut-ah-*mah*-roh)

Theo van Doesburg (*tay*-oh van dohz-*buhrg*)

Jan van Eyck (*yahn* van *ike*)

Vincent van Gogh (*vin*-sent van goe; also, van *gawk*)

Diego Velázquez (dee-*aye*-goh bay-*ahth*-kehth; also, vay-*las*-kes)

Robert Venturi (ven-*tuhr*-ee)

Jan Vermeer (*yahn* ver-*mair*)

Versailles (vair-*sy*)

Elizabeth Vigee-Lebrun (vee-*zhay* leh-*broon*)

Leonardo da Vinci (lay-oh-*nahr*-doh dah *veen*-chi)

Peter Voulkos (*vool*-kohs)

Wang Xizhi (shee-jur)

Andy Warhol (*wohr*-hohl)

Willendorf (*vill*-en-dohrf)

Xu Bing (shoo bing)

Yang Zimou (dzee-moe)

ziggurat (*zig*-uh-raht)

NOTES

CHAPTER 1

1. Kenneth C. Lindsay and Peter Vergo, eds., *Kandinsky, Complete Writings on Art* (Boston: G.K. Hall, 1982), 383.

2. Wassily Kandinsky, "Concerning the Spiritual in Art," translated by K. C. Lindsay and Vergo, *Art in Theory 1900–1990,* edited by Charles Harrison and Paul Wood (London: Blackwell, 1992), 94.

3. Georgia O'Keeffe, *Georgia O'Keeffe* (New York: Viking, 1976), opposite plate 13.

4. Charles Glueck, "A Brueghel from Harlem," *New York Times* (February 22, 1970): sec. 2, 29.

5. Quoted in "Romare Bearden," *Current Biography* (1972): 30.

6. Julia Marcus, "Romare Bearden," *Smithsonian* (March 1981): 74.

7. Ibid., 72.

8. Félix González-Torres, interview with Tim Rollins, in *Félix González-Torres* (New York: Artpress, 1993), 23.

9. Clive Bell, "The Aesthetic Hypothesis," *Art in Theory 1900–1990,* edited by Charles Harrison and Paul Wood (London: Blackwell, 1992), 115.

10. *Concise Oxford English Dictionary.* Tenth Edition, Revised ed. Judy Pearsall (London: Oxford University Press, 2002), 75.

CHAPTER 2

1. Don Fabun, *The Dynamics of Change* (Englewood Cliffs, N.J.: Prentice Hall, 1968), 9.

2. Lawrence Weschler, *Seeing Is Forgetting the Name of the Thing One Sees: A Life of Contemporary Artist Robert Irwin* (Berkeley: University of California Press, 1982), 64.

3. Edward Weston, *The Daybooks of Edward Weston,* edited by Nancy Newhall (Millerton, N.Y.: Aperture, 1973), vol. 2, 181.

4. Henri Matisse, "The Nature of Creative Activity," *Education and Art,* edited by Edwin Ziegfeld (New York: UNESCO, 1953), 21.

5. Douglas Davis, "New Architecture: Building for Man," *Newsweek* (April 19, 1971): 80.

6. Betty Burroughs, ed., *Vasari's Lives of the Artists* (New York: Simon & Schuster, 1946), 191.

7. Leo Tolstoy, *What Is Art?* (London: Walter Scott, 1899), 50.

8. Bergen Evans, *Dictionary of Quotations* (New York: Delacorte Press, 1968), 340.

9. Erich Fromm, "The Creative Attitude," *Creativity and Its Cultivation,* edited by Harold H. Anderson (New York: HarperCollins, 1959), 44.

10. Andrew Derain, *ArtNews* (April 1995): 118.

11. John Holt, *How Children Fail* (New York: Pitman, 1964), 167.

12. Oswald Sirén, *The Chinese on the Art of Painting* (New York: Schocken, 1963), 56.

13. Gyorgy Kepes, *The Language of Vision* (Chicago: Paul Theobald, 1944), 9.

14. "Notes d'un peintre sur son dessin," *Le Point* IV (1939): 14.

15. Jean Schuster, "Marcel Duchamp, vite," *le surréalisme* (Spring 1957): 143.

16. Georgia O'Keeffe, *Georgia O'Keeffe* (New York: Viking, 1976), opposite plate 23.

CHAPTER 3

1. Maurice Denis, *Theories 1870–1910* (Paris: Hermann, 1964), 13.

2. Quoted in "National Airport: A New Terminal Takes Flight," *Washington Post* (July 16, 1997). http://www.washingtonpost.com/wp-srv/local/longterm/library/airport/architect.htm, accessed May 14, 2000.

3. Faber Birren, *Color Psychology and Color Theory* (New Hyde Park, N.Y.: University Books, 1961), 20.

CHAPTER 4

1. R. G. Swenson, "What Is Pop Art?" *Art News* (November 1963): 62.

2. Elizabeth McCausland, "Jacob Lawrence," *Magazine of Art* (November 1945): 254.

3. Jack D. Flam, *Matisse on Art* (New York: Dutton, 1978), 36; originally in "Notes d'un peintre," *La Grande Revue* (Paris, 1908).

4. Ibid.

5. Henri Matisse, "Notes of a Painter," translated by Alfred H. Barr, Jr., *Problems of Aesthetics,* edited by Eliseo Vivas and Murray Krieger (New York: Holt, 1953), 259–260; originally in "Notes d'un peintre."

6. Ibid., 260.

CHAPTER 5

1. "Invisible Ink: Art Criticism and the Vanishing Public," forum at American Craft Museum, New York, May 15, 1996.

CHAPTER 6

1. Frederick Franck, *The Zen of Seeing: Seeing/Drawing as Meditation* (New York:Vintage, 1973), 6.

2. Vincent to Theo van Gogh, April 1884, Letter 184. *Vincent van Gogh: The Complete Letters.* http://www.vangoghgallery.com, accessed Oct. 21, 2004. Edited by Robert Harrison.

3. Robert Wallace. *The World of Van Gogh* (New York: Time-Life, 1969), 90.

4. Anthony Blunt, *Picasso's Guernica* (New York: Oxford University Press, 1969), 28.

5. Ichitaro Kondo and Elsie Grilli, *Katsushika Hokusai* (Rutland, Vt.: Tuttle, 1955), 13.

CHAPTER 7

1. Quoted in Erika Doss, *Spirit Poles and Flying Pigs: Public Art and Cultural Democracy in American Communities* (Washington, D.C.: Smithsonian Institution Press, 1995), 176.

2. Ibid., 179.

3. Ibid., 180.

CHAPTER 9

1. Minor White, Foreword to *Ansel Adams,* edited by Liliane De Cock (New York Graphic Society, 1972).

2. "Edwin Land," *Time* (June 26, 1972): 84.

3. Henri Cartier-Bresson, *The Decisive Moment* (New York: Simon & Schuster, 1952), 14.

4. Margaret Bourke-White, *Portrait of Myself* (New York: Simon & Schuster, 1963), 13.

5. Ibid., 64.

6. Ibid.

7. Ibid., 142.

8. Ibid., 308.

CHAPTER 10

1. "Do You Know Your ABCs?" *Advertising Age,* June 19, 2000.

2. All quotes this article from "Chaz Maviyane-Davies, Artist and Designer," *The Idea: Indian Documentary of Electronic Arts* No. 5, July 2002.

CHAPTER 11

1. Henry Hopkins, *Fifty West Coast Artists* (San Francisco: Chronicle Books, 1981), 25.

2. Ruth Butler, *Western Sculpture: Definitions of Man* (New York: HarperCollins, 1975), 249; from an unpublished manuscript in the possession of Roberta Gonzáles, translated and included in the appendices of a Ph.D. dissertation by Josephine Whithers, "The Sculpture of Julio González: 1926–1942" (New York: Columbia University, 1971).

3. Brassaï, *Conversations with Picasso* (Paris: Gallimard, 1964), 67.

4. Brandon Taylor, *Avant-Garde and After: Rethinking Art Now* (New York: Prentice Hall, 1995), 157.

CHAPTER 12

1. Quoted in Thalia Gouma-Peterson, *Miriam Schapiro: Shaping the Fragments of Art and Life* (New York: Abrams, 1999), 29.

2. Ruth Bunzel, *The Pueblo Potter* (New York: Columbia University Press, 1929), 56.

3. Quoted in Rose Slivka and Karen Tsujimoto, *The Art of Peter Voulkos* (Tokyo: Kodansha, 1995), 50.

4. John Coyne, "Handcrafts," *Today's Education* (November–December 1976): 75.

5. Grace Glueck, "In Glass, and Kissed by Light," *New York Times*, Aug. 29, 1997: Bl.

6. Quoted in *Expressions in Wood: Masterworks from the Wornick Collection* (Oakland: Oakland Museum of California, 1996), 64.

7. Kathleen McCann, "Diane Itter: Paying Tribute to the Artist," *Fiberarts* (September–October 1992): 46. Reprinted by permission of the publisher, Altamont Press, Inc., Asheville, N.C.

8. *Abakanowicz* (New York: Abbeville, 1982), 127.

9. Faith Ringgold, *We Flew Over the Bridge: The Memoirs of Faith Ringgold* (Boston: Little, Brown, 1995), 26.

10. Ibid.

11. Ibid.

CHAPTER 13

1. Louis Sullivan, "The Tall Office Building Artistically Considered," *Lippincott Monthly Magazine*, March 1896: 408.

2. *Zaha Hadid: Complete Buildings and Projects* (New York: Rizzoli, 1998), 43.

3. Frank Lloyd Wright, *The Future of Architecture* (New York: Horizon Press, 1953), 227.

CHAPTER 14

1. "Picasso Speaks," *The Arts* (May 1923): 319.

CHAPTER 15

1. Titus Burckhardt, *Chartres and the Birth of the Cathedral* (Bloomington, Ind.: World Wisdom Books, 1996), 47.

CHAPTER 16

1. David Piper, *The Illustrated History of Art* (New York: Crescent Books, 1991), 130.

2. Jacob Bronowski, "Leonardo da Vinci," *Renaissance Profiles*, edited by J. H. Plumb (New York: HarperCollins, 1976), 84.

3. *The World of Michelangelo* (New York: Time-Life Books, 1966), 192.

4. Saint Teresa of Jesus, *The Life of Saint Teresa of Jesus*, translated by David Lewis, edited by Benedict Zimmerman (Westminster, Md.: Newman, 1947), 266.

5. Linda Nochlin, "Why Have There Been No Great Women Artists?" *Art News* (January 1971): 22–39: ff.

6. Mira Bank, *Anonymous Was a Woman* (New York: St. Martins, 1979).

CHAPTER 17

1. Wen C. Fong, "The Literati Artists of the Ming Dynasty," Wen C. Fong and James C. Y. Wyatt, *Possessing the Past: Treasures from the National Palace Museum, Taipei* (New York: Metropolitan Museum of Art, 1996), 387.

CHAPTER 18

1. McGuire Gibson, "Cultural Tragedy in Iraq: A Report on the Looting of Museums, Archives, and Sites," *IFAR Journal* 6, nos. 1–2 (2003): 41–47.

2. "Stealing Undiscovered History in Iraq." http://english.aljzeera.net, accessed April 13, 2004.

CHAPTER 20

1. Katherine Solender, *Dreadful Fire! The Burning of the Houses of Parliament* (Cleveland: Cleveland Museum of Art, 1984), 42–56.

2. Beaumont Newhall, "Delacroix and Photography," *Magazine of Art* (November 1952): 300.

3. Margaretta Salinger, *Gustave Courbet, 1819–1877, Miniature Album XH* (New York: Metropolitan Museum of Art, 1955), 24.

4. From *Reminiscences of Rosa Bonheur*, published in 1910 and quoted in Wendy Slatkin, ed., *The Voices of Women Artists* (Englewood Cliffs, N.J.: Prentice Hall, 1993), 132.

5. Ibid.

6. William Seitz, *Claude Monet* (New York: Abrams, 1982), 13.

7. Albert E. Elsen, *Rodin* (New York: Museum of Modern Art, 1963), 53; from a letter to critic Marcel Adam, published in an article in *Gil Blas* (Paris: July 7, 1904).

8. John Rewald, *Cézanne: A Biography* (New York: Abrams, 1986), 208.

9. Michael Howard, *Cézanne* (London: Bison Group, 1990), 6.

10. *Cézanne and the Post-Impressionists, McCall's Collection of Modern Art* (New York: McCall Books, 1970), 5.

11. Vincent van Gogh, *Further Letters of Vincent van Gogh to His Brother, 1886–1889* (London: Constable, 1929), 139, 166.

12. Ronald Alley, *Gauguin* (Middlesex, England: Hamlyn, 1968), 8.

13. Paul Gauguin, *Lettres de Paul Gauguin à Georges-Daniel de Monfried* (Paris: Georges Cres, 1918), 89.

14. John Russell, *The Meanings of Modern Art* (New York: HarperCollins, 1974), 35.

15. Jean Leymarie, "Paul Gauguin," *Encyclopedia of World Art* (London: McGraw-Hill, 1971), vol. 6, 42.

16. Yann Le Pichon, *Gauguin: Life, Art, Inspiration* (New York: Abrams, 1987), 240.

CHAPTER 21

1. Wassily Kandinsky, "Reminiscences," *Modern Artists on Art*, edited by Robert L. Herbert (Englewood Cliffs, N.J.: Prentice Hall, 1964), 27.

2. William Fleming, *Art, Music and Ideas* (New York: Holt, 1970), 342.

3. Ibid.

4. Roland Renrose, *Picasso: His Life and Work* (New York: Schocken, 1966), 125.

5. Alfred H. Barr, Jr., ed., *Masters of Modern Art* (New York: Museum of Modern Art, 1955), 124.

6. H. H. Arnason, *History of Modern Art*, rev. ed. (New York: Abrams, 1977), 146.

7. Nathan Lyons, ed., *Photographers on Photography* (Englewood Cliffs, N.J.: Prentice Hall, 1966), 133.

8. Beaumont Newhall, *The History of Photography* (New York: Museum of Modern Art, 1964), 111.

9. Joshua C. Taylor, *Futurism* (New York: Museum of Modern Art, 1961), 124.

CHAPTER 22

1. Hans Richter, *Dada 1916–1966* (Munich: Goethe Institut, 1966), 22.

2. Paride Accetti, Raffaele De Grada, and Arturo Schwarz, *Cinquant'annia Dada—Dada in Italia 1916–1966* (Milan: Galleria Schwarz, 1966), 39.

3. William Fleming, *Art, Music and Ideas* (New York: Holt, 1970), 346.

4. André Breton, *Manifestos of Surrealism*, translated by Richard Seaver and Helen R. Lane (Ann Arbor: University of Michigan Press, 1972), 14.

5. Sam Hunter and John Jacobus, *Modern Art* (New York: Harry N. Abrams, 1985), 148.

6. Lael Wertenbaker, *The World of Picasso* (New York: Time-Life Books, 1967), 130.

7. Herbert Read, *A Concise History of Modern Painting* (New York: Praeger, 1959), 160.

8. Betram Wolfe, *The Fabulous Life of Diego Rivera* (New York: Stein and Day, 1963), 18.

9. *Diego Rivera: A Retrospective* (New York: Norton, 1986), 19.

10. Wolfe, *The Fabulous Life of Diego Rivera*, 277.

11. *The Concise Oxford Dictionary of Art and Artists* (Oxford: Oxford University Press, 1990), 398.

12. *San Francisco Chronicle,* 6 October 1935; quoted in Evangeline Montgomery, "Sargent

Claude Johnson," *Ijele: Art Journal of the African World* (2002), 1–2.

13. Romare Bearden and Harry Henderson, *A History of African American Artists from 1792 to the Present* (New York, 1993), 152.

CHAPTER 23

1. Sherman Paul, *Harry Callahan* (New York: Museum of Modern Art, 1967), 6.

2. Barbara Rose, *An Interview with Robert Rauschenberg* (New York: Vintage, 1987), 9.

3. Edward Lucie-Smith, *Sculpture Since 1945* (London: Phaidon, 1987), 77.

4. Calvin Tomkins, *The World of Marcel Duchamp* (New York: Time-Life Books, 1966), 162.

5. Richard Hamilton, *Catalogue of an Exhibition at the Tate Gallery*, March 12–April 19, 1970 (London: Tate Gallery, 1970), 31.

6. R.G. Swenson, "What Is Pop Art?" *Art News* (November 1963): 25.

7. Claes Oldenberg, "I am for an art . . ." from *Store Days*, Documents from the Store (1961) and Ray Gun Theater (1962), selected by Claes Oldenberg and Emmett Williams (New York: Something Else Press, 1967).

8. Donald Judd, "Specific Objects," *Arts Yearbook* 8 (1965): 78.

9. Julia Brown, *Occluded Front: James Turrell* (Los Angeles: Fellows of Contemporary Art, Lapis Press, 1985), 15.

10. Patricia Failing, "James Turrell's New Light on the Universe," *Art News* (April, 1985): 71.

11. "Quotes from Andy Goldsworthy," Center for Global Environmental Education, Hamline University. http://cgee.hamline.edu/see/goldsworthy/see_an_andy.html, accessed July 23, 2004.

12. Lucy R. Lippard, *From the Center: Feminist Essays on Women's Art* (New York: Dutton, 1976), 48.

13. *Louise Bourgeois* (New York: Museum of Modern Art, 1982), 95.

CHAPTER 24

1. Christina Chu, "The Lingnan School and Its Followers: Radical Innovation in Southern China"; Julia F. Andrews and Kuiyi Shen, *A Century in Crisis: Modernity and Tradition in the Art of Twentieth-Century China* (New York: Guggenheim Museum, 1998), 70.

2. Quoted in Vivian Sundaram, "Amrita Sher-Gil: Life and Work;" *Sikh Art*, http://www.sikh-heritage.co.uk/arts/amritashergil/amshergil.htm, accessed June 21, 2004.

3. Daniel Herwitz, *Husain* (Bombay, 1988), 17.

4. Uche Okeke, "Natural Synthesis," Art Society, Zaire, Nigeria, October 1960. Found in Okui Enwezor, *The Short Century: Independence and Liberation Movements in Africa, 1945–1994* (Munich: Prestel, 2001), 453.

CHAPTER 25

1. Joel L. Swerdlow, "To Heal a Nation," *National Geographic* (May 1985): 557.

2. Susan Vogel, *Africa Explores, 20th Century African Art* (New York: Prestel), 184.

SUGGESTED READING

General Reference

Barnet, Sylvan. *A Short Guide to Writing About Art*, 5th ed. New York: Longman, 1997.

Dictionary of Art, The. 34 vols. New York: Grove's Dictionaries, 1996.

Dissanayake, Ellen. *Homo Aestheticus: Where Art Comes From and Why.* New York: Free Press, 1992.

Goldwater, Robert, and Marco Treves, eds. *Artists on Art.* New York: Pantheon, 1958.

Lucie-Smith, Edward, ed. *The Thames and Hudson Dictionary of Art Terms.* New York: Thames and Hudson, 1984.

Read, Herbert, and Nikos Stangos, eds. *The Thames and Hudson Dictionary of Art and Artists.* London: Thames and Hudson, 1985.

Summers, David. *Real Spaces: World Art History and the Rise of Western Modernism.* New York: Phaidon, 2003.

PART 1
Art Is . . .

Canaday, John. *What Is Art? An Introduction to Painting, Sculpture & Architecture.* New York: Knopf, 1980.

Edwards, Betty. *Drawing on the Artist Within: A Guide to Innovation, Invention and Creativity.* New York: Simon & Schuster, 1986.

Johnson, Jay. *American Folk Art of the Twentieth Century.* New York: Rizzoli, 1983.

London, Peter. *No More Secondhand Art: Awakening the Artist Within.* Boston: Shambhala, 1989.

Lowenfeld, Viktor. *Creative and Mental Growth*, 8th ed. New York: Macmillan, 1987.

May, Rollo. *The Courage to Create.* New York: W. W. Norton, 1975.

McKim, Robert. *Experiences in Visual Thinking*, 2nd ed. Monterey, California: Brooks/Cole, 1980.

Samuels, Mike, M.D., and Nancy Samuels. *Seeing with the Mind's Eye: The History, Techniques and Uses of Visualization.* New York: Random House, 1975.

PART 2
The Language of Visual Experience

Anderson, Donald M. *The Art of Written Forms.* New York: Holt, Rinehart & Winston, 1969.

Arnheim, Rudolf. *Art and Visual Perception*, rev. ed. Berkeley: University of California Press, 1974.

Baudrillard, Jean. *The Ecstasy of Communication*, tr. Bernard and Caroline Schutze. Brooklyn, NY: Semiotext(e), 1988.

Doszci, Gyorgy. *The Power of Limits: Proportional Harmonies in Nature, Art and Architecture.* Boulder: Shambhala, 1981.

Gage, John. *Color and Meaning: Art, Science, and Symbolism.* Berkeley: University of California Press, 1999.

Kepes, Gyorgy. *Language of Vision.* Chicago: Paul Theobald, 1949.

Nelson, George. *How to See.* Boston: Little, Brown, 1977.

Shahn, Ben. *The Shape of Content.* New York: Random House, 1957.

Varley, Helen, ed. *Colour.* London: Mitchell Beazley, 1980.

PART 3
The Media of Art

Bacon, Edmund N. *The Design of Cities*, rev. ed. New York: Penguin, 1976.

Burgoyne, Patrick. *The New Internet Design Project: The Best of Graphic Art on the Web.* New York: Rizzoli, 1999.

Camusso, Lorenzo, and Sandro Bortone, *Ceramics of the World: From 4000 B.C. to the Present.* New York: Abrams, 1991.

Cartier-Bresson, Henri. *The Decisive Moment.* New York: Simon & Schuster, 1952.

Castleman, Riva. *Prints of the Twentieth Century*, rev. ed. New York: Thames and Hudson, 1988.

Cooper Union for the Advancement of Science and Art, *Techo-Seduction.* New York: Cooper Union, 1997.

Franck, Frederick. *The Zen of Seeing: Drawing as Meditation.* New York: Random House, 1973.

Gardiner, Stephen. *Introduction to Architecture.* Oxford: Equinox, 1983.

Goldstein, Nathan. *The Art of Responsive Drawing*, 4th ed. Englewood Cliffs, N.J.: Prentice Hall, 1992.

Hollis, Richard. *Graphic Design: A Concise History.* New York: Thames and Hudson, 2001.

Ivins, William M. *Prints and Visual Communication.* New York: Plenum, 1969.

Le Normand-Romain, Antoinette, et al. *Sculpture: The Adventure of Modern Sculpture in the Nineteenth and Twentieth Centuries.* New York: Rizzoli, 1986.

London, Barbara, with John Upton. *Photography*, 5th ed. New York: Longman, 1994.

Lucie-Smith, Edward. *The Story of Craft: The Craftsman's Role in Society.* Ithaca, N.Y.: Cornell University Press, 1981.

Lupton, Ellen. *Mixing Messages: Graphic Design in Contemporary Culture.* New York: Cooper-Hewitt National Design Museum, 1996.

Macaulay, David. *Cathedral: The Story of Its Construction.* Boston: Houghton Mifflin, 1973.

Mast, Gerald. *A Short History of the Movies.* New York: Macmillan, 1986.

Mayer, A. Hyatt. *Prints and People: A Social History of Printed Pictures.* Princeton: Princeton University Press, 1980.

Mayer, Barbara. *Contemporary American Craft Art.* Salt Lake City: Gibbs M. Smith, 1988.

Mayer, Ralph. *Artists Handbook of Materials and Techniques*, 5th ed. New York: Viking, 1991.

Newhall, Beaumont. *The History of Photography*, rev. ed. New York: Museum of Modern Art, 1982.

Raizman, David. *History of Modern Design.* Upper Saddle River, N.J.: Prentice Hall, 2004.

Rubinstein, Charlotte Streifer. *American Women Sculptors: A History of Women Working in Three Dimensions.* Boston: G. K. Hall, 1990.

Rush, Michael. *New Media in Late 20th-Century Art.* New York, Thames and Hudson, 1999.

Salvadori, Mario. *Why Buildings Stand Up.* New York: W. W. Norton, 1980.

Scully, Vincent, Jr. *Modern Architecture: The Architecture of Democracy.* New York: Braziller, 1977.

Smith, Stan, and Friso Ten Holt, eds. *The Artist's Manual: Equipment, Materials, Techniques.* New York: Mayflower Books, 1980.

Speight, Charlotte and John Toki. *Hands in Clay: An Introduction to Ceramics*, 3rd ed. Mountain View, Calif.: Mayfield, 1994.

Thomas, Michel, Cristine Mainguy, and Sophie Pommier. *Textile Art.* New York: Rizzoli, 1985.

Turcotte, Bryan Ray, ed. *Fucked Up and Photocopied: Instant Art of the Punk Movement.* Corte Madera, Calif.: Ginko Press, 1999.

Watkin, David A. *A History of Western Architecture.* London: Barrie & Jenkins, 1986.

Wilson, Marjorie. *Teaching Children to Draw: a Guide for Teachers & Parents.* Englewood Cliffs, N.J.: Prentice Hall, 1982.

Wines, James. *De-Architecture.* New York: Rizzoli, 1987.

Wye, Deborah. *Thinking Print: From Books to Billboards, 1980–95.* New York: Abrams and Museum of Modern Art, 1996.

PART 4
Art as Cultural Heritage

Bahn, Paul G. *Journey Through the Ice Age.* Berkeley: University of California, 1997.

Blair, Sheila, and Jonathan M. Bloom. *The Art and Architecture of Islam, 1250–1800.* New Haven: Yale University Press, 1994.

Blier, Suzanne Preston. *The Royal Arts of Africa: The Majesty of Form.* New York: Abrams, 1998.

Chadwick, Whitney. *Women, Art, and Society*, 2nd rev. ed. London: Thames and Hudson, 1996.

Coe, Ralph T. *Lost and Found Traditions: Native American Art 1965–1985.* New York: American Federation of the Arts, 1986.

Cole, Herbert M. *Icons: Ideals and Power in the Art of Africa.* Washington, D.C.: Smithsonian, 1989.

Dreamings: The Art of Aboriginal Australia. New York: Braziller and the Asia Society Galleries, 1988.

Ettinghausen, Richard. *The Art and Architecture of Islam, 650–1250*. New York: Penguin, 1987.

Feest, Christian. *Native Arts of North America*. New York: Thames and Hudson, 1992.

Fine, Elsa H. *Women and Art: A History of Women Painters and Sculptors from the Renaissance to the 20th Century*. Montclair, N.J.: Allanheld & Schram, 1978.

Gombrich, E.H. *The Story of Art*, 15th ed. Englewood Cliffs, N.J.: Prentice Hall, 1989.

Guerrilla Girls, *The Guerrilla Girls' Bedside Companion to the History of Western Art*. New York: Penguin, 1998.

Heller, Nancy G. *Women Artists: An Illustrated History*. New York: Abbeville, 1987.

Kennedy, Jean. *New Currents, Ancient Rivers: Contemporary African Artists in a Generation of Change*. Washington, D.C.: Smithsonian, 1992.

Lee, Sherman. *A History of Far Eastern Art*, 5th rev. ed. Englewood Cliffs, N.J.: Prentice-Hall, 1997; New York: Abrams, 1997.

Mead, S. M. *Exploring the Visual Arts of Oceania*. Honolulu: University Press of Hawaii, 1979.

Metropolitan Museum of Art. *Mexico: Splendors of Thirty Centuries*. New York: Metropolitan Museum, 1990.

Pfeiffer, John E. *The Creative Explosion: An Inquiry into the Origins of Art and Religion*. New York: Harper & Row, 1982.

Reti, Ladislao, ed. *The Unknown Leonardo*. New York: McGraw-Hill, 1974.

Ruspoli, Mario. *The Cave of Lascaux: The Final Photographic Record*. London: Thames and Hudson, 1987.

Stanley-Baker, Joan. *Japanese Art*. New York: Thames and Hudson, 1984.

Stokstad, Marilyn. *Art History*. New York: Abrams, 1995.

Sullivan, Michael. *The Arts of China*, 3d ed. Berkeley: University of California Press, 1984.

Visona, Monica Blackmun et al. *A History of Art in Africa*. Upper Saddle River, N.J.: Prentice Hall, 2001.

PART 5
The Modern World

Ali, Wijdan. *Modern Islamic Art: Development and Continuity*. Gainesville: University Press of Florida, 1997.

Andrews, Julia F. and Kuiyi Shen. *A Century in Crisis: Modernity and Tradition in the Arts of Twentieth-Century China*. New York: Guggenheim Museum, 1996.

Arnason, H. H. *History of Modern Art: Painting, Sculpture, Architecture, Photography*, 4th ed. New York: Abrams, 1986.

Beardsley, John. *Earthworks and Beyond*. New York: Abbeville, 1984.

Bearden, Romare, and Harry Henderson. *A History of African-American Artists from 1792 to the Present*, New York: Pantheon, 1993.

Blazwick, Iwona, ed. *Century City: Art and Culture in the Modern Metropolis*. London: Tate Gallery, 2001.

Broude, Norma, and Mary D. Garrard, eds. *The Expanding Discourse: Feminism and Art History*. New York: HarperCollins, 1992.

Canaday, John. *Mainstreams of Modern Art*, 2nd ed. New York: Henry Holt, 1981.

Cockcroft, Eva, John Weber, and James C. Cockcroft. *Toward a People's Art: A Contemporary Mural Movement*. New York: Dutton, 1977.

Enwezor, Okwui. *The Short Century: Independence and Liberation Movements in Africa, 1945–1994*. Munich: Prestel, 2001.

Fineberg, Jonathan. *Art Since 1940: Strategies of Being*. Upper Saddle River, N.J.: Prentice Hall, 2000.

Friedman, Mildred. *De Stijl: 1917–1931*. New York: Abbeville, 1992.

Goldberg, Vicki. *The Power of Photography: How Photographs Changed Our Lives*. New York: Abbeville, 1991.

Henri, Adrian. *Total Art: Environment, Happenings, and Performance*. New York: Praeger, 1974.

Hughes, Robert. *American Visions: The Epic Story of Art in America*. New York: Knopf, 1997.

Lancaster, Clay. *The Japanese Influence in America*. New York: Abbeville, 1985.

Neff, Terry Ann R. *In the Mind's Eye: Dada and Surrealism*. New York: Abbeville, 1985.

Quirarte, Jacinto. *Mexican American Artists*. Austin: University of Texas Press, 1973.

Ramírez, Mari Carmen, and Héctor Olea, eds. *Inverted Utopias: Avant-Garde Art in Latin America*. New Haven: Yale University Press, 2004.

Richter, Hans. *Dada: Art and Anti-Art*. New York: Abrams, 1970.

Rickey, George. *Constructivism: Origins and Evolution*. New York: Braziller, 1967.

Rosenblum, Naomi. *A History of Women Photographers*. New York: Abbeville, 1994.

———. *A History of Photography*, 3d ed. New York: Abbeville, 1997.

Sandler, Irving. *American Art of the 1960s*. New York: Harper & Row, 1988.

Sonfist, Alan, ed. *Art in the Land: A Critical Anthology of Environmental Art*. New York: Dutton, 1983.

Stern, Robert A. M. *American Architecture: Innovation and Tradition*. New York: Rizzoli, 1985.

Stiles, Kristine, and Peter Selz. *Theories and Documents of Contemporary Art: A Sourcebook of Artists' Writings*. Berkeley: University of California Press, 1996.

Sullivan, Edward J., ed. *Latin American Art in the Twentieth Century*. London: Phaidon, 1996.

Tuchman, Maurice, *The Spiritual in Art: Abstract Painting 1890–1985*. New York: Abbeville, 1986.

PART 6
The Postmodern World

Asia Society Galleries. *Contemporary Art in Asia: Traditions/Tensions*. New York: Asia Society, 1996.

Beckett, Wendy. *Contemporary Women Artists*. New York: Universe, 1988.

Fleming, Ronald Lee, and Renata von Tscharner. *Place Makers: Creating Public Art That Tells You Where You Are*. New York: Harcourt, Brace, Jovanovich, 1986.

Foster, Hal, ed. *The Anti-Aesthetic: Essays on Postmodern Culture*. Seattle: Bay Press, 1983.

Jencks, Cahrles. *The Language of Post-Modern*. New York: Rizzoli, 1991.

Kocur, Zoya, and Simon Leung, eds. *Theory in Contemporary Art Since 1985*. London: Blackwell, 2005.

Lippard, Lucy. *Mixed Blessings: New Art in a Multicultural America*. New York: Pantheon, 1990.

Lovejoy, Margot. *Postmodern Currents: Art and Artists in the Age of Electronic Media*. Englewood Cliffs, N.J.: Prentice Hall, 1992.

Pelfrey, Robert H., with Mary Hall-Pelfrey. *Art and Mass Media*. New York: Harper & Row, 1985.

Rose, Aaron, ed. *Beautiful Losers: Contemporary Art and Street Culture*. New York: Iconoclast and Distributed Art Publishers, 2004.

Sander, Irving. *Art of the Postmodern Era*. New York: Icon, 1996.

Spelman College. *Bearing Witness: Contemporary Works by African American Women Artists*. New York: Rizzoli, 1996.

SUGGESTED WEB SITES

General Reference

The Web Museum
http://sunsite.unc.edu/wm/

Words of Art
http://www.arts.ouc.bc.ca/fiar/glossary/gloshome.html

Researching Your Art Object
http://www.ilpi.com/artsource/weidman.html

Mark Harden's Artchive
http://www.artchive.com

The Artcyclopedia
http://www.artcyclopedia.com

Metropolitan Museum of Art Timeline of Art History
http://www.metmuseum.org/toah

Mother of All Art and Art History Links
http://art-design.umich.edu/mother/

Major Museum Web Sites

Detroit Institute of Art
http://www.dia.org

The Louvre Museum, Paris
http://www.louvre.fr

The Prado Museum, Madrid
http://museoprado.mcu.es/prado/

Hermitage Museum, St. Petersburg
http://www.hermitagemuseum.org

Art Institute of Chicago
http://www.artic.edu/aic/index.html

PART 1
Art Is . . .

Kandinsky: Compositions
http://www.glyphs.com/art/kandinsky/

Museum of International Folk Art
http://www.moifa.org

PART 2
The Language of Visual Experience

Color Matters
http://www.colormatters.com/

The Web Museum: Impressionism
http://sunsite.unc.edu/wm/paint/glo/impressionism/

Claes Oldenburg: An Anthology
http://www.artnetweb.com/oldenburg/contents.html

Museum of Bad Art
http://www.glyphs.com/moba

PART 3
The Media of Art

TypoGRAPHIC
http://www.rsub.com/typographic

George Eastman House
http://www.geh.org

Walker Art Center Gallery 9
http://www.walkerart.org/gallery9

One Thousand Words
http://spot.colorado.edu/~johnsoja/1KWords.html

Spencer Museum Graphic Arts Page
http://www.ku.edu/~sma/prints.html

The Henry Moore Foundation
http://www.henry-moore-fdn.co.uk/hmf/

Christo and Jeanne-Claude Home Page
http://www.christojeanneclaude.net/

Nineteenth-Century Sculpture
http://www.bc.edu/bc_org/avp/cas/fnart/art/19th_sculp.html

How Paint is Made
http://www.theblueprinter.com/artcolony/makepaint.htm

Origins of American Animation
http://lcweb2.loc.gov/ammem/oahtml/oahome.html

Green Building Council: Project List
https://www.usgbc.org/LEED/Project/project_list.asp

Design Museum, London
http://designmuseum.org

PART 4
Art as Cultural Heritage

The Chauvet Cave
http://www.culture.gouv.fr/culture/arcnat/chauvet/en/index.htm/

Universes in Universe
http://www.universes-in-universe.de/e_map.htm

Islamic and Arab Arts and Architecture
http://islamicart.com/

Kyoto Museum of Art
http://www.kyohaku.go.jp/indexe.htm

National Palace Museum, Taiwan
http://www.npm.gov.tw/english/index-e.htm

World Monuments Fund Watch List
http://wmf.org/html/programs/watchlist2004.html

Vatican Museums: The Sistine Chapel
http://mv.vatican.va/3_EN/pages/CSN/CSN_Main.html

Pompeii Forum Project
http://pompeii.virginia.edu

British Library Manuscript Pages
http://www.bl.uk/collections/treasures/digitisation2.html

The Modern World

The Age of Enlightenment
http://mistral.culture.fr/files/imaginary_exhibition.html

The On-Line Picasso Project
http://www.tamu.edu/mocl/picasso/

The Andy Warhol Museum
http://www.warhol.org

A.I.R. Gallery
http://www.airnyc.org/history.cfm

The International Dada Archive
http://www.lib.uiowa.edu/dada

Smithsonian American Art Museum
http://nmaa-ryder.si.edu/home.html

Vincent Van Gogh Gallery
http://www.vangoghgallery.com/

Diego Rivera Web Museum
http://www.diegorivera.org

The Postmodern World

Artnet Magazine
http://www.artnet.com/magazine/frontpage.asp

Art Crimes / Graffiti
http://www.graffiti.org

010101: Art in Technological Times
http://010101.sfmoma.org/

Museum of Contemporary Art, Los Angeles
http://www.moca-la.org

Contemporary Arts Center, Cincinnati
http://www.contemporaryartscenter.org

INDEX